F. C. Gundlach – The Photographic Work

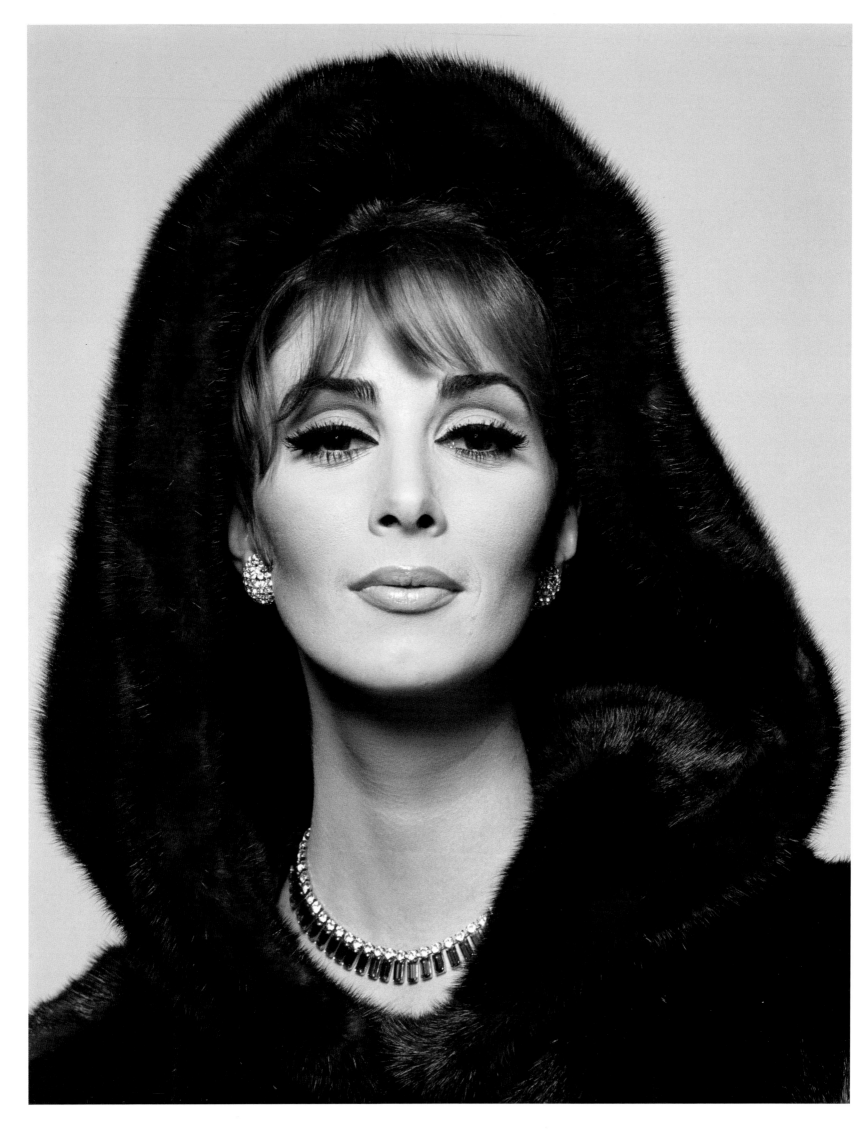

The Photographic Work

F.C. GUNDLACH

Edited by

Klaus Honnef

Hans-Michael Koetzle

Sebastian Lux and

Ulrich Rüter

STEIDL

frontispiece: Wilhelmina, dark mink coat by Berger, Hamburg 1964

Content

PREFACE

When compiling a retrospective together with a book you are usually faced with gaps in the material and information available, and the problem of filling them. In the case of F.C. Gundlach's photographic oeuvre, essentially the opposite was true. In line with Picasso's adage that "one is what one preserves" ("On est ce que l'on garde"), throughout his life the great photographer F.C. Gundlach collected everything which he considered worthy of keeping: personal documents and photographs, diary-like notes, scribbles, correspondence, but above all and almost completely the negatives of his photographs. In addition, his whole array of vintage prints, slides, numerous contact sheets in large, medium and small formats ... not to forget the newspapers, magazines and advertising brochures which disseminated his photographs in printed form.

We were thus quite literally able to draw from a wealth of material. First, however, we needed to find some inroads into the material. The staff at the F.C. Gundlach Foundation have in recent years established an archive system and this provided us with the basis from which to explore all the various aspects of F.C. Gundlach's oeuvre. Complementary research in Hamburg at the Public Records Office, in the Hanover State Library and the Federal Archives in Berlin gave us a new insight into the cultural and media climate of the era in which the photographer worked for a period of almost forty years.

The exhibition and book "F.C. Gundlach. The photographic Work" is not the first project to deal with the photographer's pictures. It is, however, the first endeavour which F.C. Gundlach has not influenced either as curator or co-curator. Instead, he left the selection of the pictures and the concept of the retrospective and the book up to two external curators and two curators from his foundation, and the four brought their ideas to bear quite independently of him. It goes without saying that this resulted in many enlightening discussions with the creator of the photos, considering that F.C. Gundlach was indispensable for the success of the undertaking as a close and observant witness of the day and an utterly inexhaustible source of information.

Nevertheless, compared with earlier projects such as „ModeWelten", „Fashion Photography" and „Bilder machen Mode" our perspective on his photographic work was different from the very outset. The years spent focusing on Gundlach's oeuvre have spawned a considerably more complex and in certain respects also surprising new picture of the oeuvre which many had considered already exhaustively documented. The focus shifted from the history of fashion and fashion photography to the special aesthetic quality of the respective images. We concentrated on the aesthetic dimension of Gundlach's pictures and not on the fashion they illustrate. The photographer's extraordinary visual idiom, its position in the photographic frame of the day, its innovative thrust, the potential for modernization and the leading role F.C. Gundlach played in German (and also international) photojournalism after World War II were all core themes in our critical appraisal.

It was thus obvious from the start that we would not be limiting ourselves to photographs from the fashion world. We also included experimental examples from the first phase of his work as a photographer, namely from Paris in the 1950s, the striking portraits of leading actors/actresses and directors of West German and international cinema, early reportage and excellent pictures of children, due to their aesthetic value. The concept also entailed giving priority to more convincing shots than the well-known image motifs, and also pictures which the photographer had himself not thus far considered to be of specific aesthetic value. In the perspective of a later generation they gain an exceptional significance as a key trailblazer of future trends in photography.

The exhibition and book also focus on the phenomenon of the printed image, an aspect which is usually

treated en passant in photographic exhibitions or not dealt with at all. F.C. Gundlach, however, was always a thoroughly convinced, professional photographer working on assignment. It was therefore only logical that the covers of the leading fashion magazines he worked for and a rich selection of double-page spreads be included along with the original photographs. For the first time the photographed fashion picture was reflected here as a medium for communicating fashion in high-circulation magazines whereby cropping, layout, typography and printing also play a role, as they set the stage for the image proper.

F.C. Gundlach accompanied the project from the start with curiosity and commitment yet at a pleasant distance. It was, of course, not always easy for the creator of the pictures and experienced curator to understand all the curators' decisions. But the fact that he still accepted them, although sometimes seasoned with a comment, documents his sovereignty and at the same time bears witness to the confidence he has placed in us. We owe F.C.Gundlach our heartfelt thanks for this, but above all for his unerring readiness to assist us with useful advice and information and for the extremely pleasant and inspiring work climate he fostered.

For our part, there was never a doubt that the exhibition "F.C. Gundlach. The photographic Work" would premier in the House of Photography / Deichtorhallen in Hamburg, the city in which he worked for more than four decades and also promoted, collected and supported the work of other photographers. While the House of Photography owes its existence not least of all to Gundlach's untiring input, with its spacious and elegant architecture it also provides an appropriate setting in which his pictures can unfold their magic. We would like to thank the former Director of the Deichtorhallen, Dr. Robert Fleck and his team for realizing our suggestions. With this newly conceived exhibition in the Martin Gropius Bau, the work of F. C. Gundlach returns to the city that was once a world capital of fashion like Paris, a role Berlin has today readopted by hosting international events such as Berlin Fashion Week and Bread & Butter. We would like to thank the director of the Martin Gropius Bau Gereon Sievernich and his dedicated staff for their support of our curatorial work. This catalogue and the exhibition have enabled us to revisit and re-appreciate Gundlach's oeuvre.

Our thanks are equally due to Gerhard Steidl, who instantly agreed to publish the accompanying monograph, which is now the most comprehensive and thorough publication on the photographs of F.C. Gundlach. We would also like to specifically thank Melanie Heusel and Jan Strümpel for the editing, Bernard Fischer for the production and Julia Braun for the scans. The publishers decided to interlace image and text throughout the book, avoiding a purely chronological series of plates. We owe our thanks to the untiring commitment of Claas Möller for translating these ideas into the clear design here at hand. Our very personal thanks go to Barbara Buffa, Rosemarie Günther, Gitta Schilling, Karin Stilke, Klaus Gerwin and F.C. Piepenburg, who participated in interviews and offered valuable references, to Gudrun Hamann and Kurt Kirchner who shared their recollections of the work for and with F.C. Gundlach and who represent all the assistants and staff who accompanied F.C. Gundlach in his work, to Gesine Pannhausen and Jasmin Seck from the F.C. Gundlach Foundation for all their help, to Mirko Topolko, who dealt with the culinary side during preparations and last but not least, Gabriele Honnef-Harling, Michaela Baer-Koetzle, Regine Voigt and Peter Veit, without whom the editors would not have been able to achieve their task.

Klaus Honnef and Hans-Michael Koetzle
Sebastian Lux and Ulrich Rüter

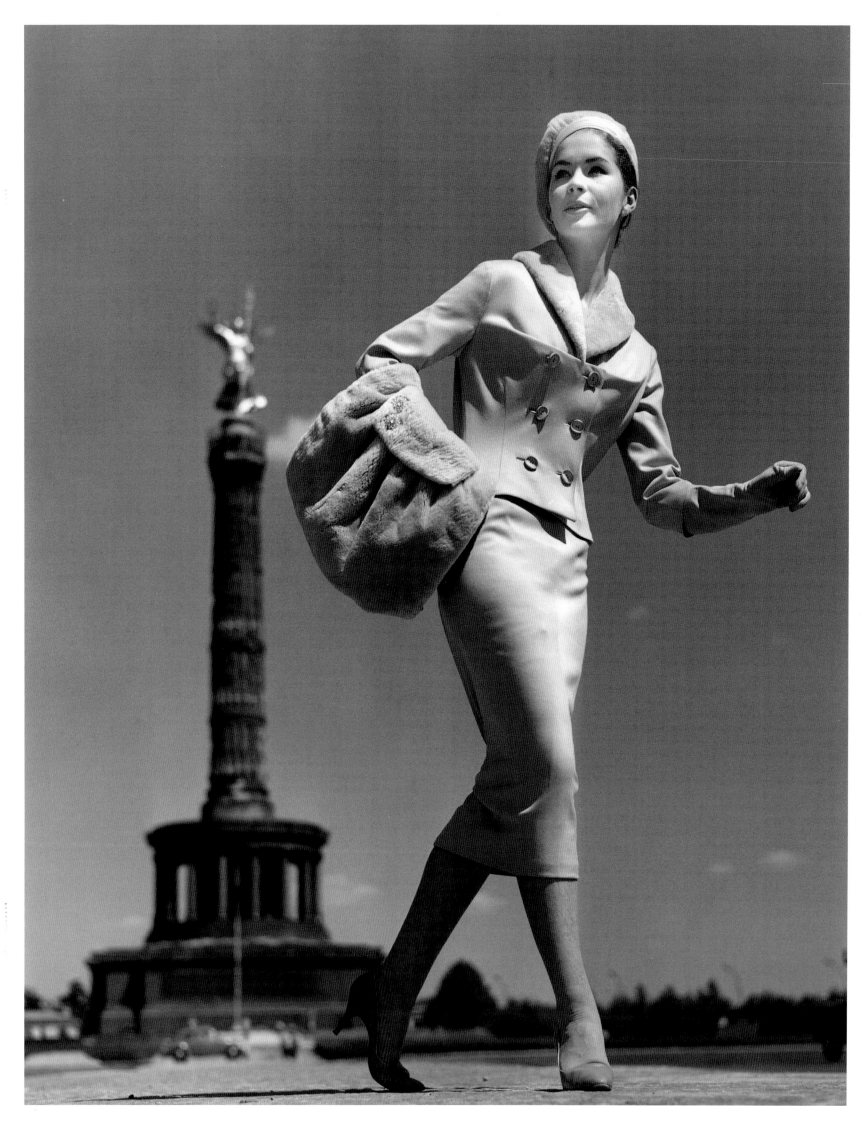

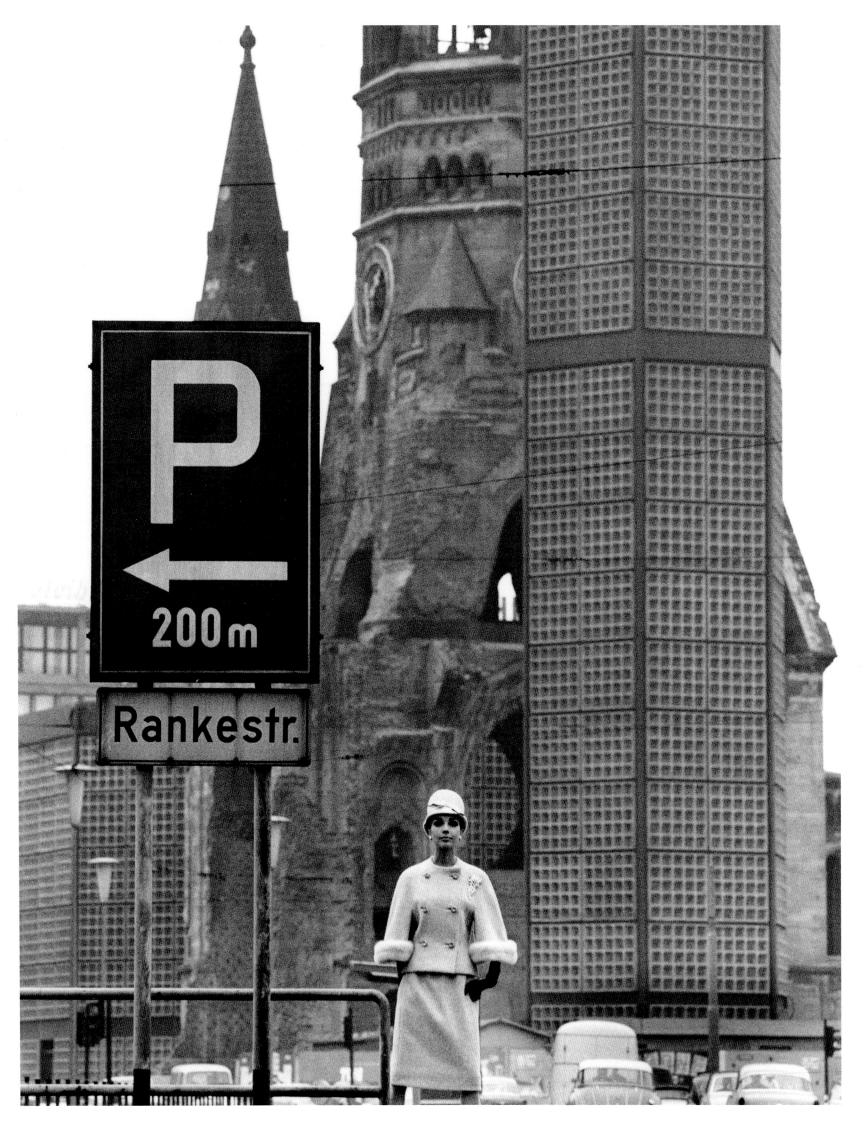

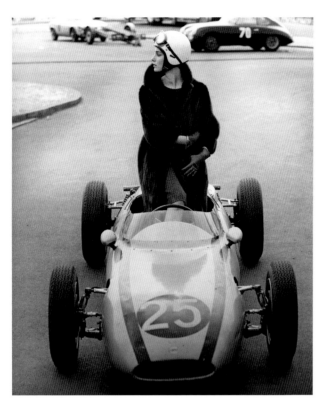

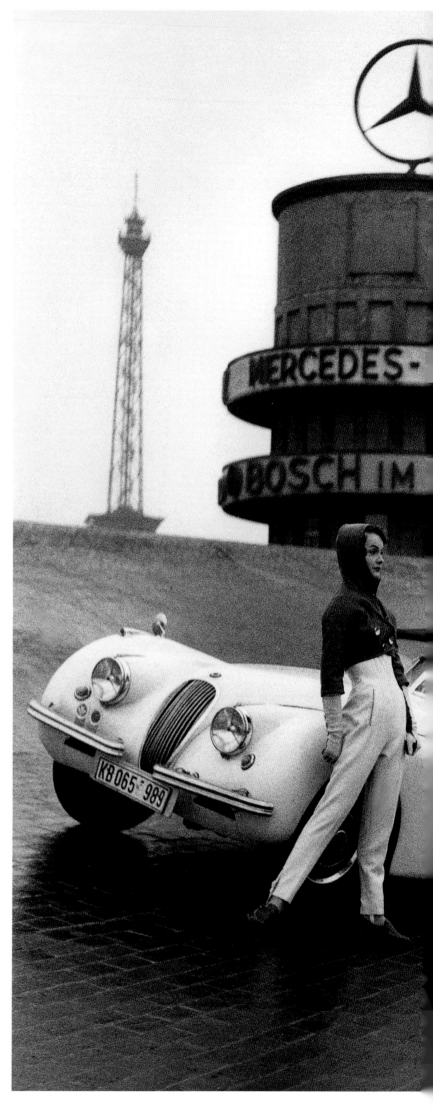

Judy Dent, dark mink coat by Saga, Berlin Avus 1962
Ingeborg Prinz, Berlin Avus 1962
"Après Ski on the Avus", pantsuits by Staebe-Seger, Berlin 1956,
in: *Film und Frau* spring/summer 1956

previous spread: "New perspectives", costume by S & E -
Uli Richter, Berlin 1957, in: *Film und Frau* fall/winter 1957/58
"P Rankestraße", Biggi, costume with mink applications by
Uli Richter, Berlin 1963

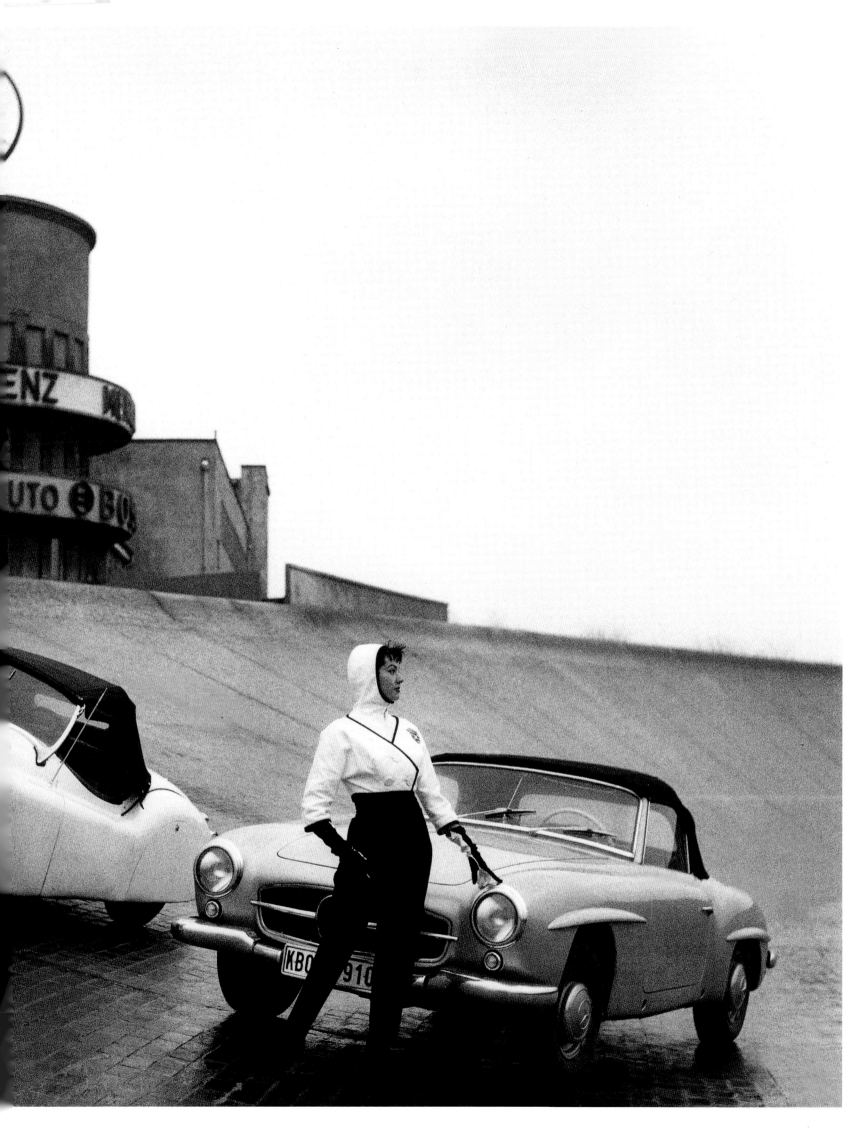

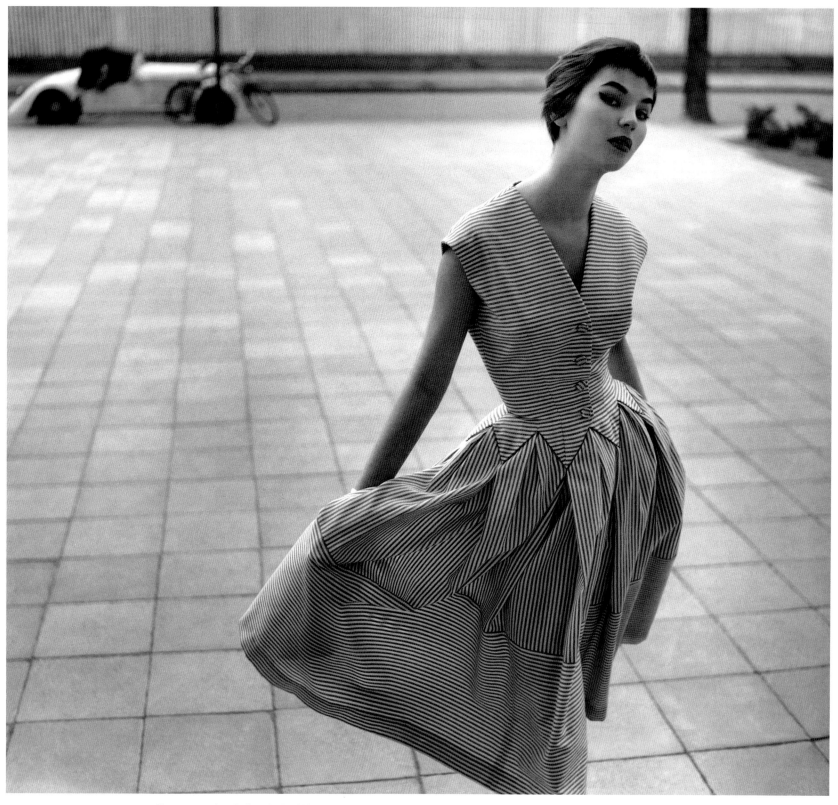

Biene, summer dress by Horn, Berlin 1955, in: *Film und Frau* 13/1955

"Everything the young lady likes", Bambi, cocktail dress by Lindenstaedt & Brettschneider, Berlin 1953, in: *Film und Frau* 22/1953

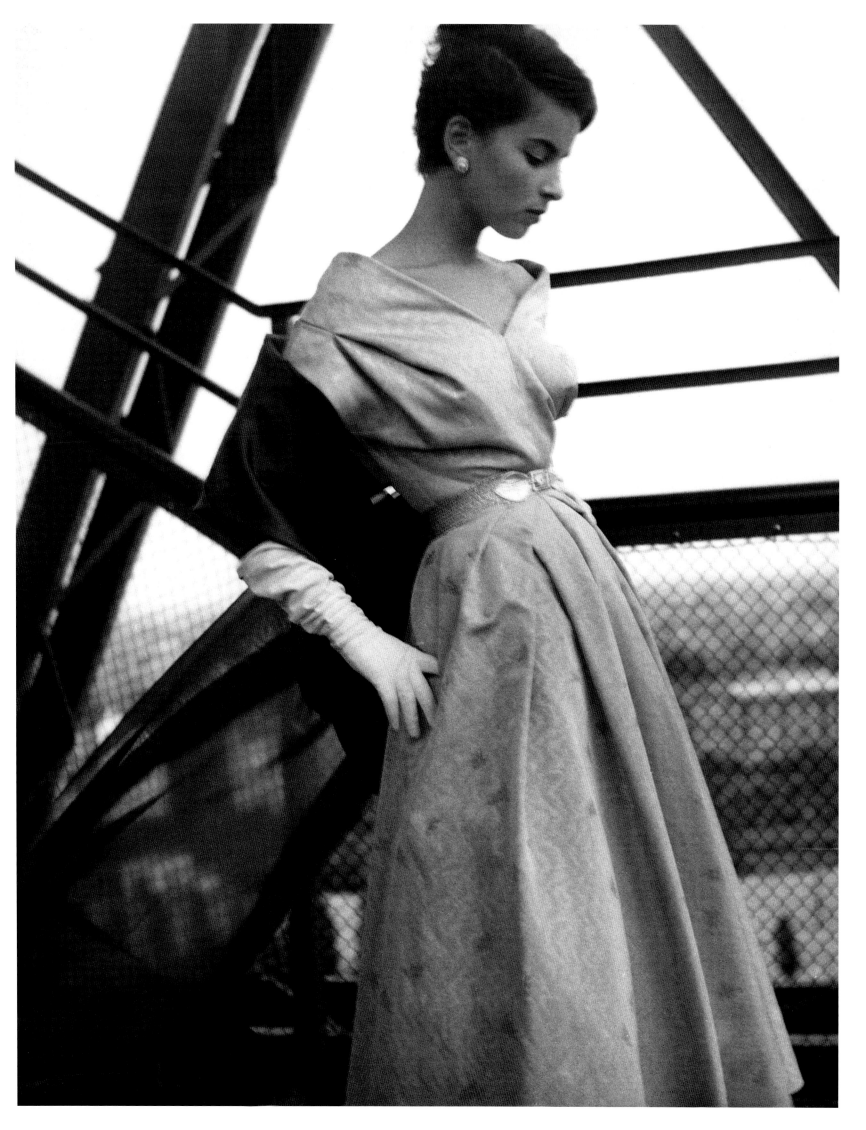

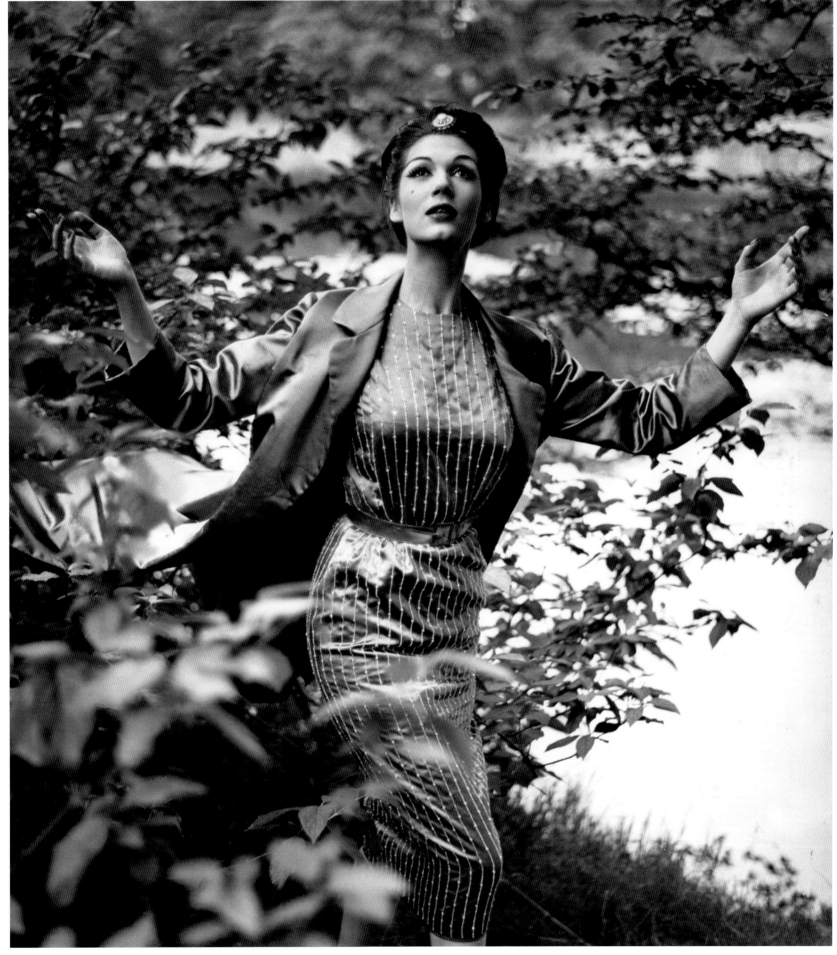

Simone d'Aillencourt, evening dress by Horn, Berlin 1957, in: *Film und Frau* fall/winter 1957/58

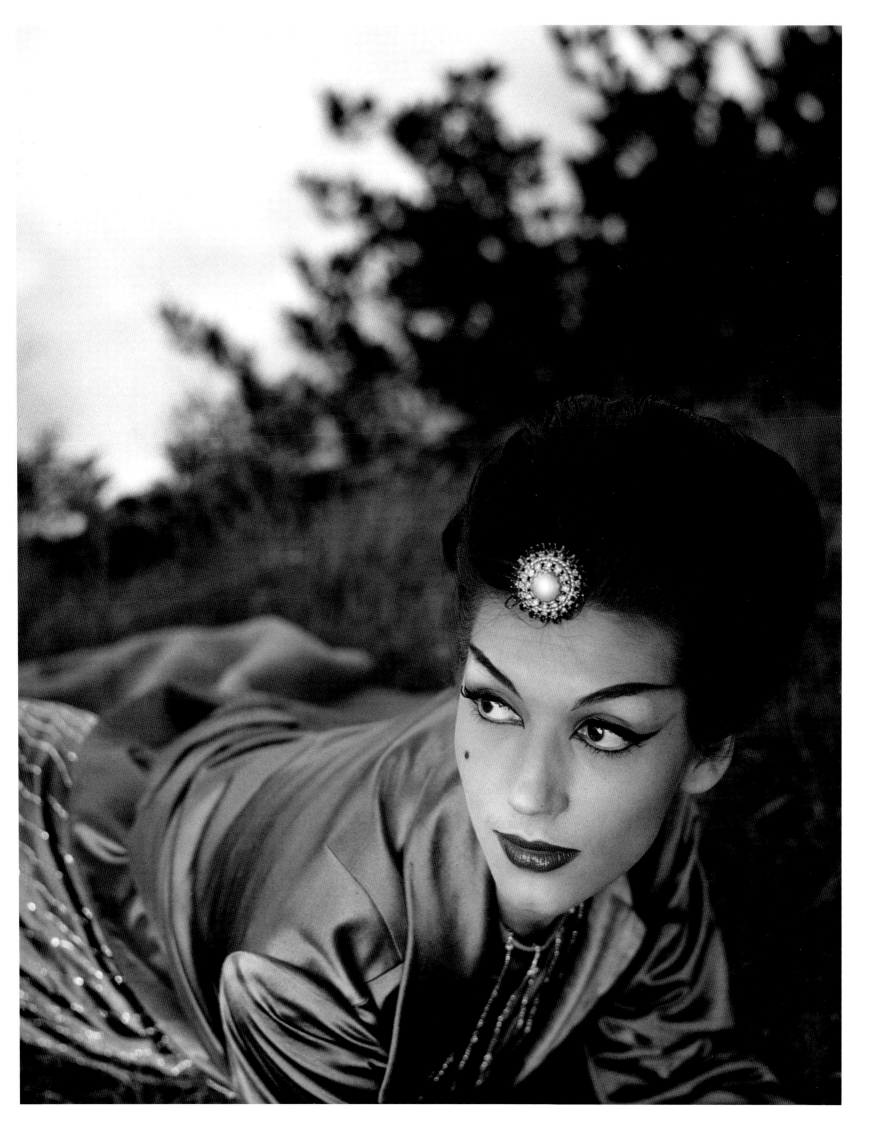

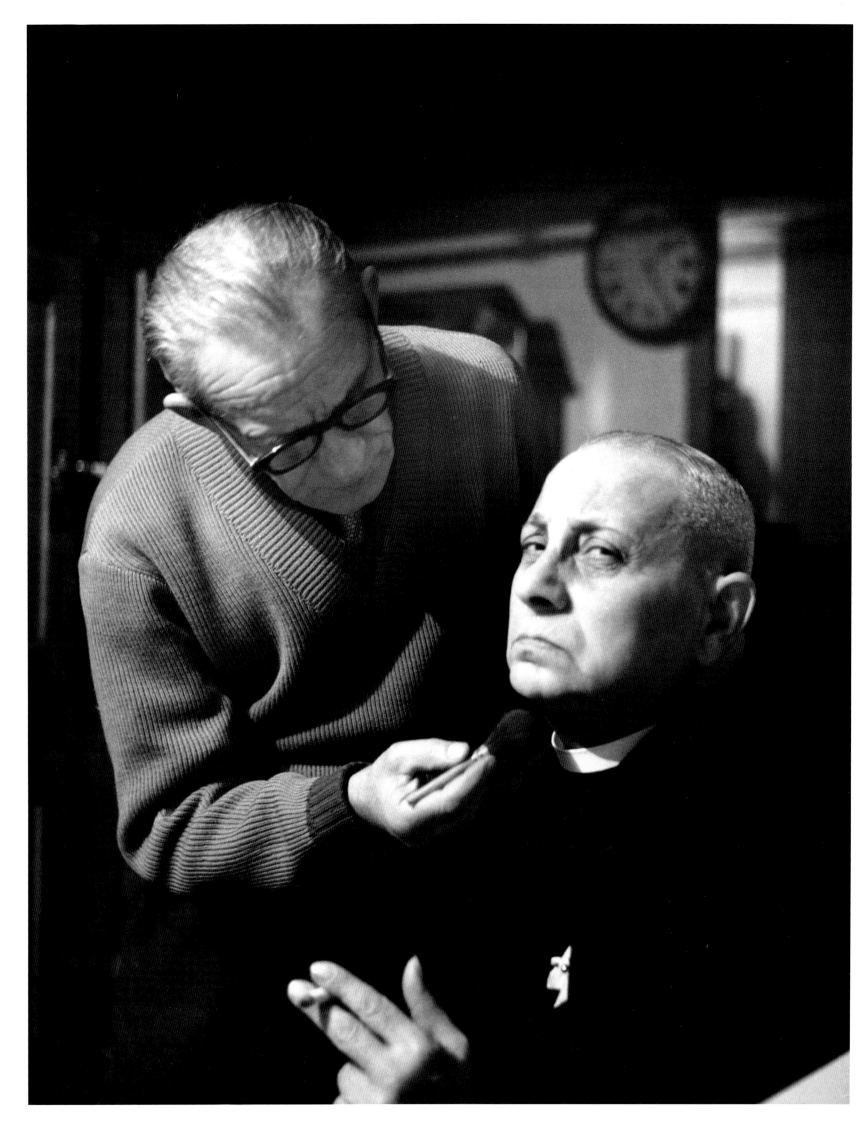

F. C. GUNDLACH

Klaus Honnef

Von is facing the photographer. Lurking, disparaging, his piercing eyes half closed. His protruding chin pointing ahead, the corners of his mouth drooping, he has turned his shaven skull to the left and towards the camera. Von plays his role as a dubious character with a tendency to violence even before the lens of the photographer who caught him backstage; while having his face made up, in a moment between reality and appearance, between real life and the world of the silver screen. Von is a cinematographic legend. Erich von Stroheim gave himself the aristocratic upgrade. Friends and foes in Hollywood therefore used to refer to him as Von or Von Stroh. "Five out of the nine films directed by Stroheim are true masterpieces."[1] Mutilated and poorly copied, they were slumbering in archives and film libraries when F.C. Gundlach took him in. At the time, Stroheim was forced to make a living on odd jobs after he was banned from Hollywood. In 1953, for instance, he played alongside Hildegard Knef

in the petty German production Alraune. It was on the set of this motion picture that the two image architects had their memorable encounter – captured in a small masterpiece of portrait photography.

The outstanding quality of this shot is not merely attributed to a creative process that culminated in an image that was original and aesthetically impressive. In fact, it raises subtle doubts as to the validity of the generally accepted assumption that a striking portrait can actually reflect a particular person's character. This is because the portrait featuring Erich von Stroheim depicts yet another portrait in the making. Or put more precisely: It describes the in-between phase. To begin with, the picture is a double portrait. The make-up artist preparing the actor for his role in the movie is his partner in the photograph – in fact, he assumes the more active part. That said, formally, he merely provides the frame and backdrop for the main character. The light directed at the striking head from the left

Erich von Stroheim while shooting "Alraune" (directed by Arthur Maria Rabenalt), Munich 1952

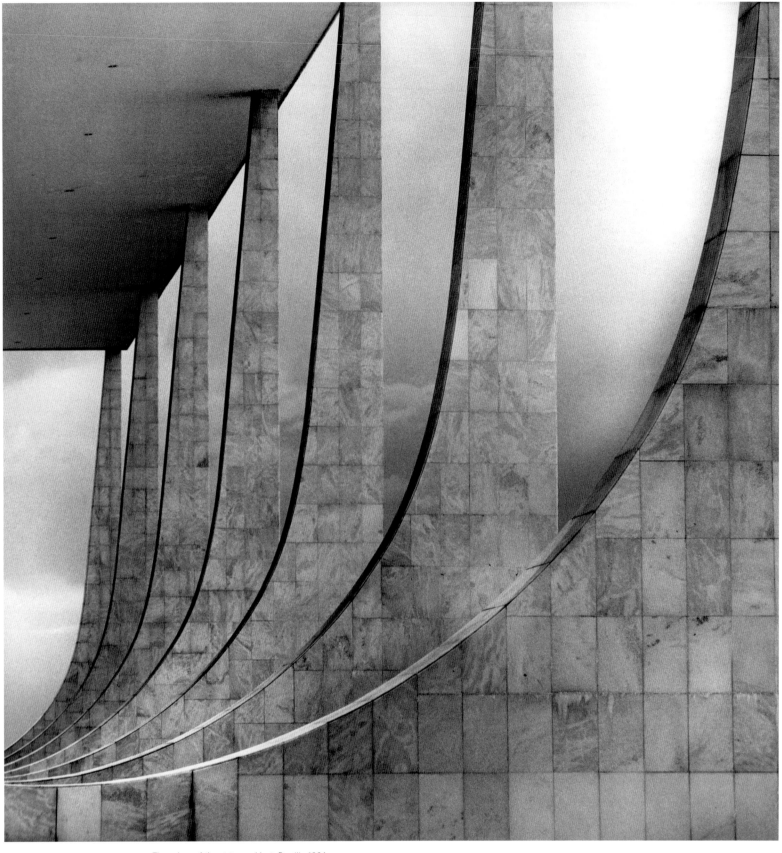

The palace of the state president, Brasilia 1964

serves to accentuate von Stroheim and the image focus lends him extra depth. The make-up artist's hand holding the paintbrush resembles a pointing gesture and enhances the work's formal intensity, which is further enlivened by contrasts. The careful image composition and the spontaneity of the snapshot work well together to create an incredibly dynamic relationship.

The portrait's clue, however, is revealed through a complex symbolic structure. Von Stroheim, who was overlooked as a genius filmmaker and who as an

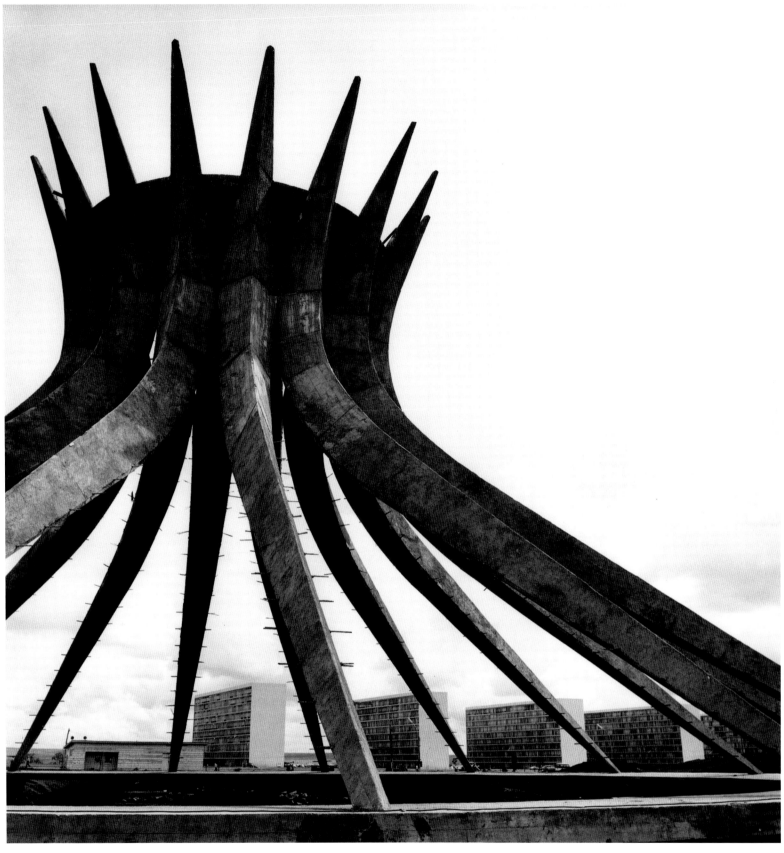

The cathedral *Nossa Senhora Aparecida*, Brasilia 1964

apparent villain fulfilled the usual movie clichés in many of his inferior roles, now played the very role generally expected of him: posing for a photograph intended for publication in a glossy magazine or use in movie advertising.

The person 'Erich von Stroheim' disappears beneath the commonplace symbolic images denoting the "portrait" genre – the model "plays" a portrait. Above it all is his own glittering personality. The image symbols take on a life of their own, as it were,

turning the picture into a quasi-portrait, similar to the snapshot connotations that are being evoked. None of the different portrait options show Stroheim as an authentic figure. That said, neither is there a "different personality" hiding behind a mask, as we would find in carnival. Rather, the mask is morphing into the "real" face while the supposedly natural becomes a mask. F.C. Gundlach resisted the temptation of opting for psychological representation. Beneath the skin, the composition of a portrait emerges. A structure revealing yet another structural process – the shot refers back to itself or watches itself, as it were. For those who never knew Erich von Stroheim will get to know him in the image as a man who is not easy to get along with.

Even though the above-described ambiguous portrait is not one of F.C. Gundlach's better-known photographs, it is nonetheless significant for two reasons. First, this relatively early shot already conveys the essential aesthetic characteristics that were to become crucial for his photography. Second, beneath the glossy surface the subliminal driving and controlling mechanisms for Gundlach's main motifs are reflected, namely film and fashion. His remarkable pictures contain a conceptual core. They require us to take a second look before they will reveal their composition. There is something elusive about these pictures. Only through their formal structure will they bridge the gap to the reality of the living world. In many of the images, the transfer is manifested through eye-contact with the models. It insinuates a dialog between the picture and the spectator, potentially elevating the spectator on a par with those portrayed, emphasizing their identity.

Not surprisingly, as a young boy F.C. Gundlach was torn between wanting to become an architect and a photographer. It was probably for pragmatic reasons that he eventually opted for photography. However, his love of architecture did not end. Not only would he often turn his attention to extraordinary achievements in common residential architecture, but he was also among the first to celebrate Oscar Niemeyer's Brasília, the drawing board vision of the South American capital, on a grand scale and with impressive pictures. And yet it would be wrong simply to attribute his decision in favor of photography to pragmatic reasons. Even as a pupil, Franz Christian Gundlach (in photographic circles named F.C. soon thereafter) tried his hand as an amateur photographer. When still a boy living at home, he set up a darkroom and a small studio for himself in his parents' house. As literature on photography that combined practical tips with a theoretical background was hard to come by, he simply resorted to *learning by doing.* Cut off from leading photography developments outside of Nazi Germany, he had no choice but to use what was before him for inspiration. The autograph postcards of film stars prompted him to try his hand at portrait photography. The human image fascinated him. It stood at the heart of his entire photographic work and it is therefore no coincidence that it dominated his outstanding collection of photographic images. His mother made for a popular and usually dramatically illuminated model. Aside from Walther Heering's book *Im Zauber des Lichts*[2], it was mostly *Mein Objektiv sieht Europa* by Erich Borchert[3] that helped him perfect his technique. Borchert's aesthetic standards were high and representative of the ambivalent aestheticism prevailing in the 'Third Reich', of the pretty appearance that served to conceal its crimes. The aesthetic quality of Borchert's pictures could be apostrophized bluntly as a jazzed up high-contrast version of avant-garde photography in watered-down fashion. Emotional emphasis obscured the clarifying gaze. The critical-analytic impulses of the New Vision – the photographic avant-garde of the 1920s – had been unloaded in visual effects. The images conformed perfectly to the two-faced Nazi regime

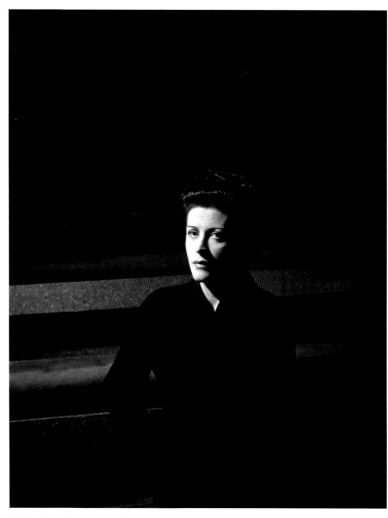

Sybille Schmitz in the Theater *Beate von Molo*, Munich 1952

and it's ideology. Historian Peter Reichel explains: "The two-facedness of the Third Reich can only be conveyed as a contradictory entity if we indeed comprehend the Nazi state as a reactionary modern regime."[4] German fashion photography of the post-war era was of the same character.

Following some technical training in Kassel, Gundlach worked as an assistant in several German studios before he established himself as a freelance photographer in Stuttgart. His own initiative was crucial in shaping his training in aesthetic photography. In the Amerika Haus in Stuttgart he finally made up for what had previously been denied him – and established contact with the world of international photography. In devastated post-war Germany, the Swabian metropolis briefly came to be in the cultural spotlight, particularly as regards photography, visual art, theater and literature.

Gundlach created an extraordinary portrait of one of the outstanding representatives of the movement of artistic awakening that followed the cultural eradication during the Nazi period: With a tied apron, Willi Baumeister is stooping over an empty picture frame as if he were some respectable master artisan. Only the abstract painting that is casually leaning against a wall in the background draws our attention to the artistic connection almost incidentally. There is nothing conventional about this shot. The portrait of the painter, graphic artist and photographer, whose work was massively influential for both architecture and painting and whose book *Das Unbekannte in der Kunst*[5] was crucial in shaping the art discourse in West Germany, works on multiple levels. With his left foot, the painter is stepping through the painting's frame and into the image space of the photograph that holds him; capturing a moment of frozen movement. The creative technique of the picture-within-a-picture was to feature time and again in Gundlach's photographic oeuvre. Whether deliberately or subconsciously, he connected with the

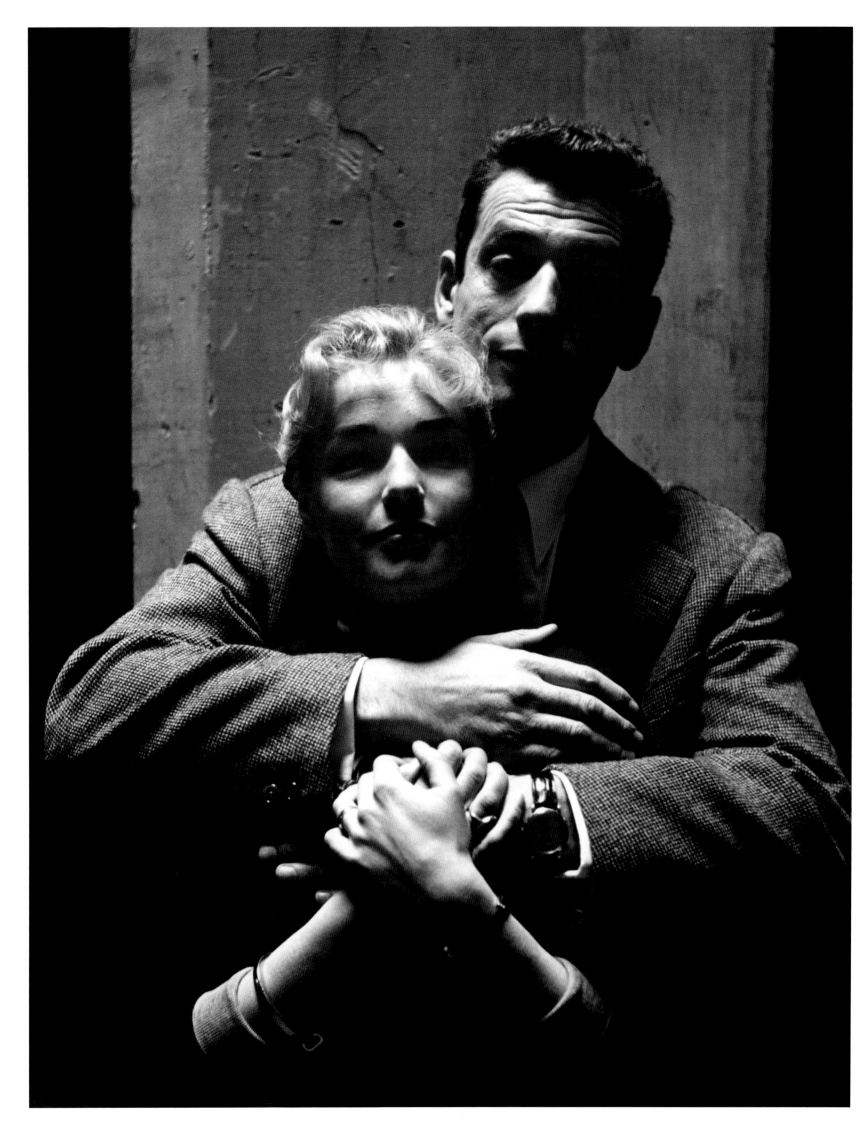

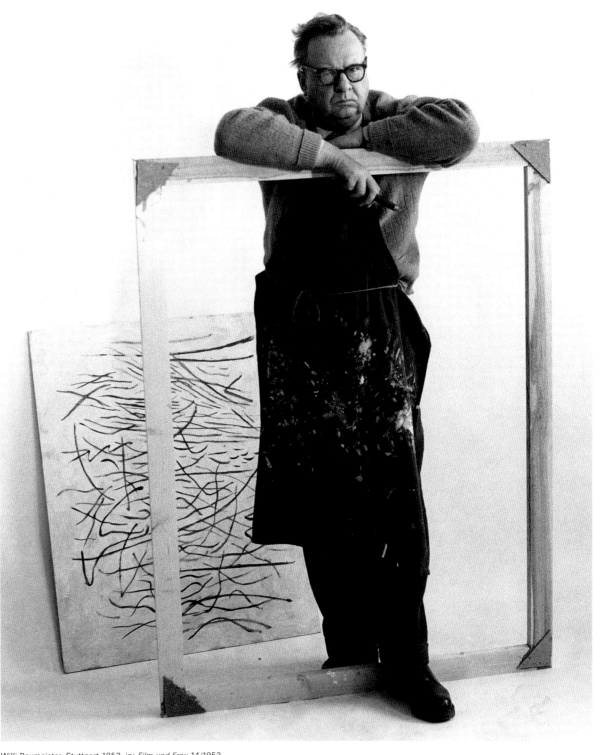

Willi Baumeister, Stuttgart 1953, in: *Film und Frau* 14/1953

advanced photography of the New Vision by drawing the beholders' attention to the circumstances of perception, not simply to the object of photographic representation. This intellectual-conceptual element marks the strongest break away from the photography of the 'Third Reich'.

Without decided artistic intention, the young and up-and-coming photographer worked to begin with as a freelancer for illustrated magazines, which also included radio programs for the broadcasting companies that were crucial in pushing cultural renewal at the time. Gundlach tried his hand at various genres of press photography, spanning from portraits to features, and quickly saw success. Often his photographs would grace the front or back covers of magazines. He would soon become so sought-after that

Simone Signoret and Yves Montand while shooting "Thérèse Raquin" (directed by Marcel Carnés), Paris 1953, in: *Film und Frau* 6/1953

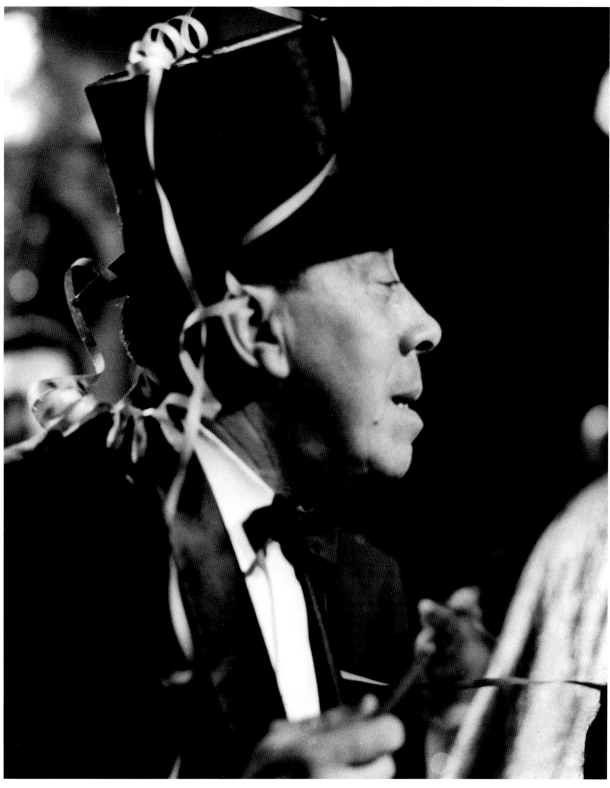

Fernandel, Carnival in Estoril 1960, in: *Film und Frau* 7/1960

he chose to work under several pseudonyms so as to prevent the inflationary use of his name. Most of these features were at home in the arts and entertainment sections.

We can safely assume that his practical experience in journalism had a lasting effect on the composition of Gundlach's human image photographs. While his mother's portraits still reflect his slight inclination to psychological meaning, employing stark contrasts of light and shadow in order to provoke a definitive statement, he was now seeking the equivalent of Lessing's "fruitful moment". This required capturing a symptomatic external characteristic of the photographed person without evoking any kind of cliché but leaving ample room for interpretation: The animalistic horse face of the wonderful Fernandel in

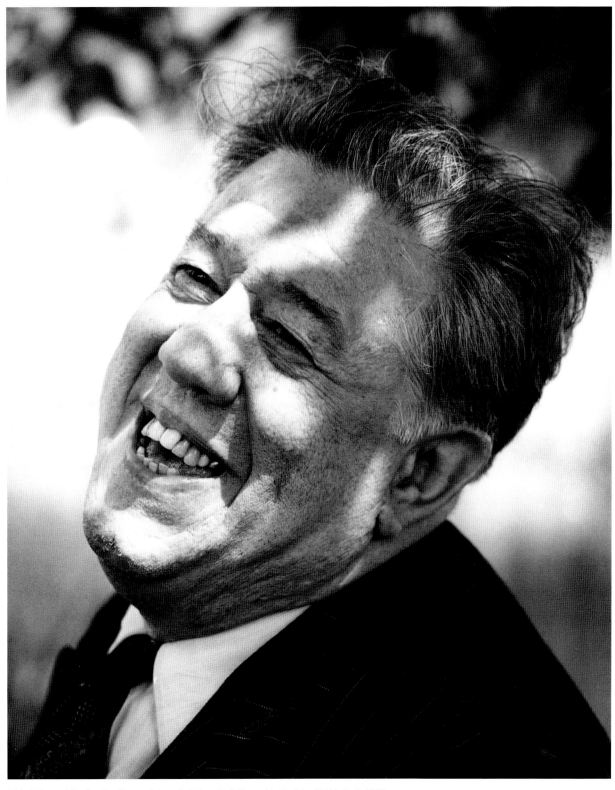

Michel Simon while shooting "Es geschah am hellichten Tag" (directed by Ladislao Vajda), Berlin 1958,
in: *Film und Frau* 20/1958

profile transcends his elegant outfit, while the amazing Gérard Philipe's contagious youthfulness puts the diamond-shaped grid in the dark background into perspective. He chose to portray Jean Cocteau, that all-round talent who so loved taking the limelight, behind a bulging staircase; the almost transparent shadows of a tree fall upon the undistorted friendliness of the unique Michel Simon and his hidden

passions, and Yves Montand is holding his wife Simone Signoret in a tender (albeit almost suffocating!) embrace. With his kids in tow, the clown Charlie Rivel even gets to parade in a full sequence of exciting images without taking off his mask even once. The sequence visualizes something far more crucial than could ever be expressed in a conventional psychological portrait. Only one of the young clowns

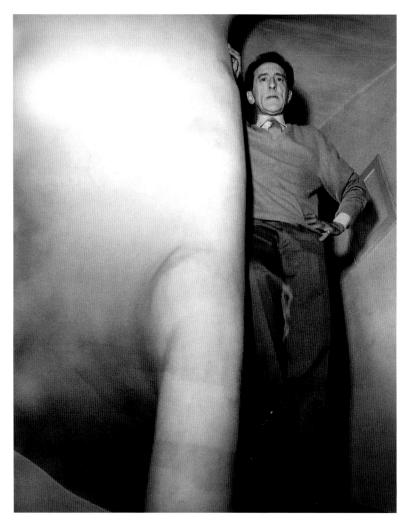

Jean Cocteau, Milly-la-Forêt 1951, in: *Film und Frau* 9/1951

Jean Marais, Paris 1951, in: *Film und Frau* 4/1951

was captured by the camera backstage in the same manner as Erich von Stroheim – showing a young person whose identity is not yet fixed. Perhaps this aspect is the reason for the photographer's preference for portraying children. Many of the children's images contribute to his outstanding achievements as a photographer. Also within the portrait genre, the idea of working with picture sequences instead of individual images does not stand in isolation in Gundlach's work, reflecting, along with his keen use of reflexive image structures, his resolute stance to embrace modern times.

The heyday of those illustrated all-rounder magazines was soon to be over. The sheer incredible range of topics covered by those magazines undoubtedly benefited his photographic beginnings. However, despite their – partly proclaimed – optimism they cast a somewhat contradictory light on the Federal Republic of Germany. These were the years of reconstruction and collective amnesia, of the "economic miracle" and

of cultural leveling, of authoritarian structures in state and society, and – something that is hardly mentioned – of embedding democracy and modernism in society and culture. Not to forget, these were also the years of consumerism as regards food, clothing and furniture, the years of stark demonstrations, of social conflict and of escapism in cinema. Restorative trends and sudden bouts of modernization struck a balance between new beginnings and continuity.[6] Not only in the domestic sphere did society oscillate uneasily between a rustic homeliness and the "modern style" personified, for example, by colourful standard lamps.[7]

In West Germany, an abundance of different magazines came out in each region. The early phase of Gundlach's photographic work reflects this spectrum like a kaleidoscope. The Western Allies deliberately only issued licenses to those editors and publishers who had not been involved with Nazi machinations. The wide range of magazines offered ambitious photographers immense scope for their work.

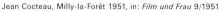
Jacques Hébertot, Paris 1951

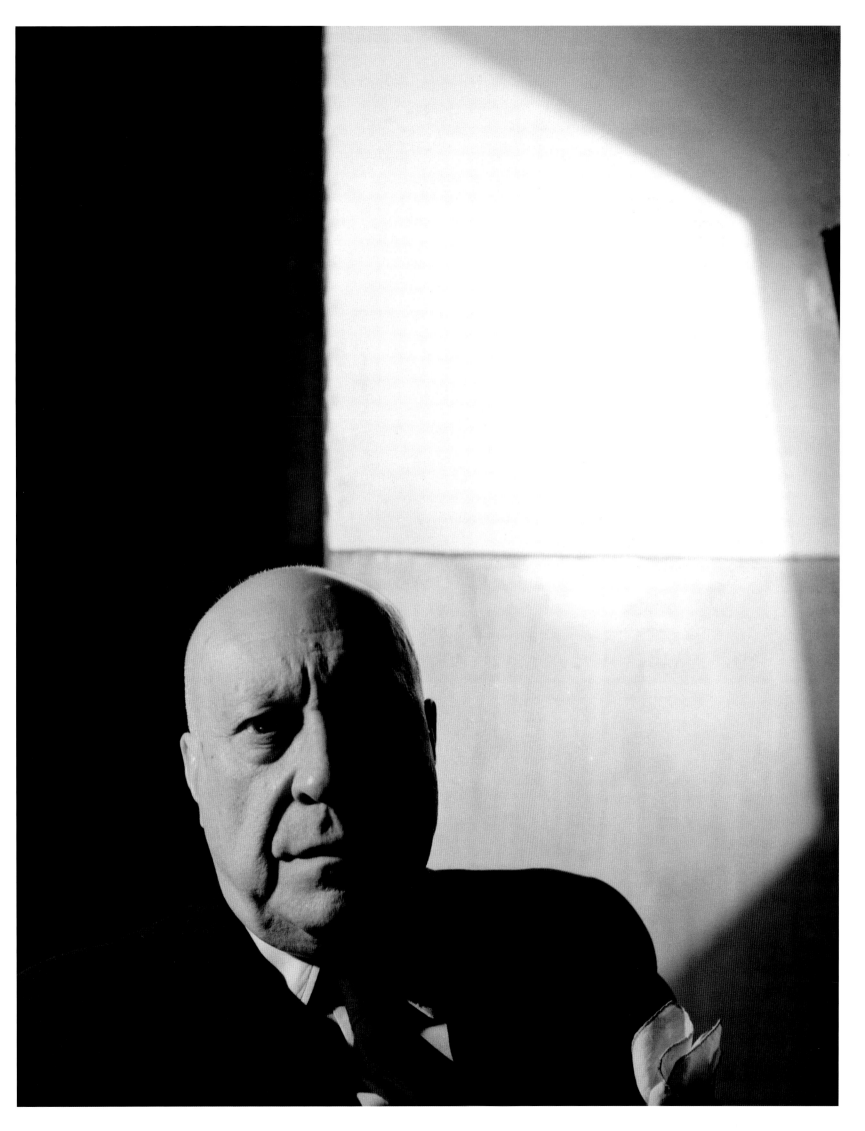

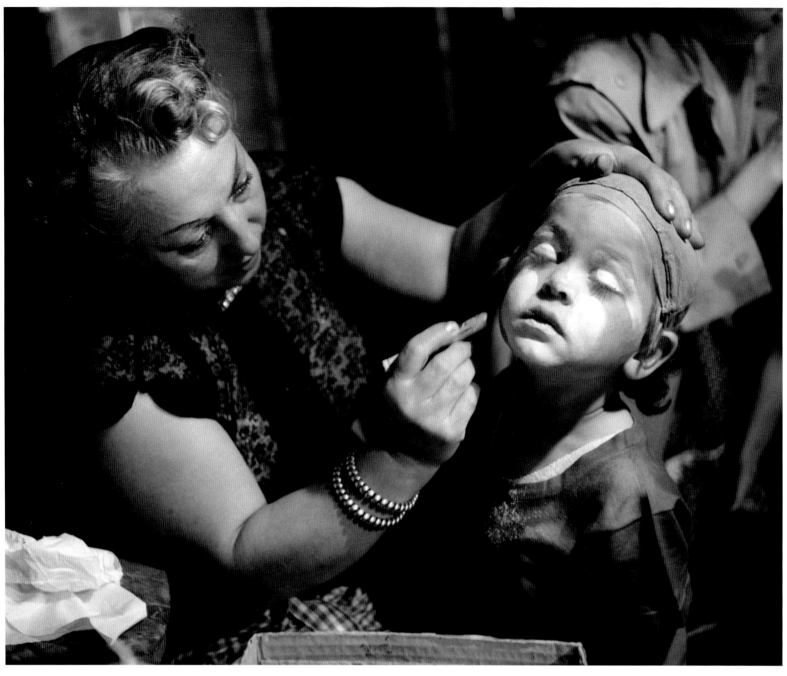

"Laughing in tears", Charlie Rivel, Berlin 1955, in: *Film und Frau* 26/1955

Two years into his career, Gundlach established his own independent studio in Stuttgart. At the same time, he broadened his terrain to include magazines such as *Elegante Welt* and other illustrated papers. Moreover, for a while he carried out photographic work for distribution companies such as Union Film, Gloria, RKO and others, including film stills for cinemas, advertising images for the press, or star portraits for fans. One of his autograph postcards featuring Sophia Loren with pursed lips and alluring eyes for Columbia shaped the public image of the Italian actress that was to become her trademark. Gundlach used jobs like these to create for himself a perfectly functioning network within the movie world, something that he would often fall back on.

At times, the photographer also followed a film shoot with his camera. During the staging of the 1955 movie *Mädchen ohne Grenzen* he created a very typical double portrait of the movie's main character, Sonja Ziemann. One image reflects the slick and heavily made-up masquerade of an air hostess, while the other shows the actress with unkempt hair and no make-up. Even though the latter shot appears to depict the famous actress in private, the image was nonetheless intended for the public – with the film star wearing a more natural mask, as it were. Per-

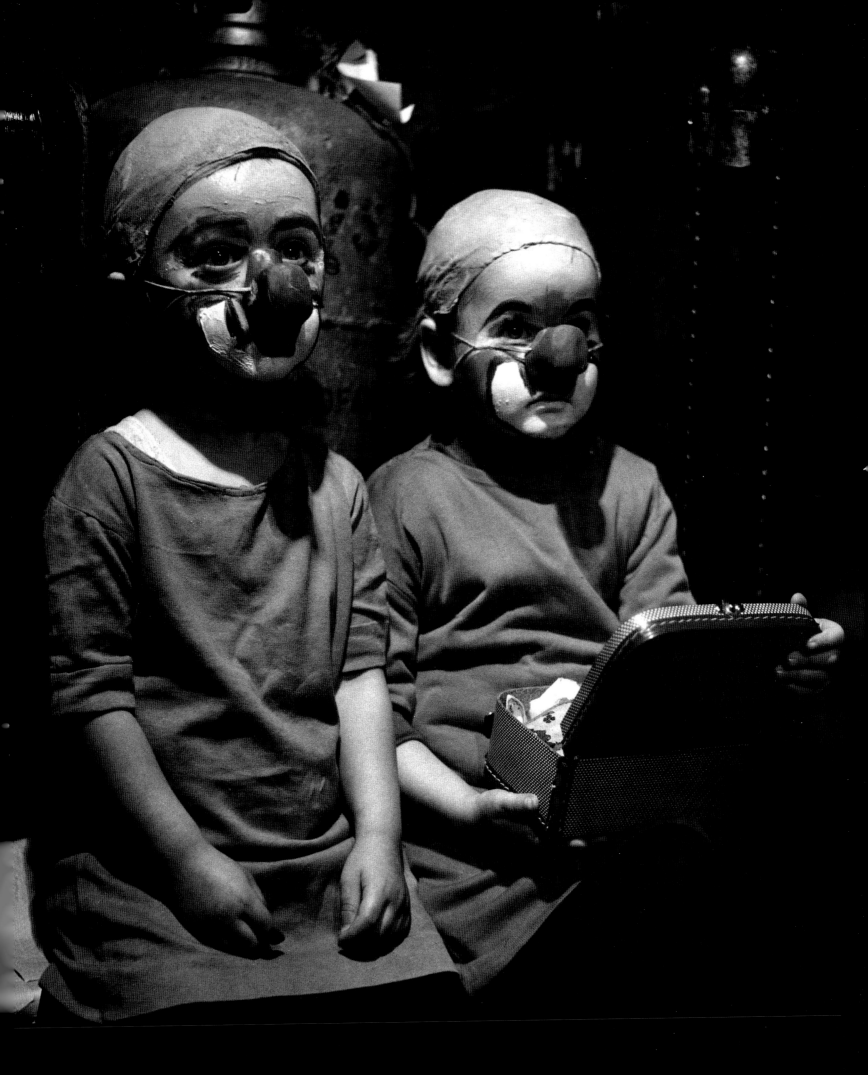

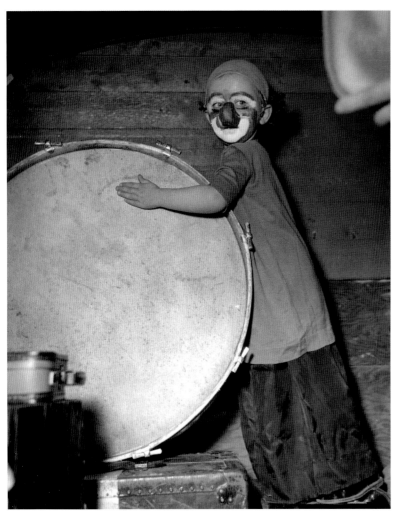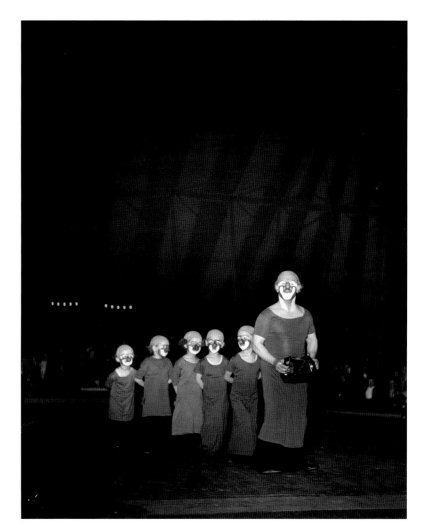

"Laughing in tears", Charlie Rivel, Berlin 1955,
in: *Film und Frau* 26/1955

haps unwittingly, it had connotations with the main character in the 1950 motion picture *Schwarzwald-mädel*. In the latter role the actress smashed all box office records. "In the movies of the 1950s, [Sonja Ziemann] was usually perceived as the incarnation of the good but poor girl who is looking for her prince and will eventually find him," writes Katja Aschke.[8] The apparently private therefore is the most famous of her images.

Gundlach's portrait shots of the young Romy Schneider taken in 1961 are true masterpieces of such corresponding portraits. Even though they were shot in rapid succession, the photographs of the actress seem to be years apart. The extreme close-up of the second portrait, which turns her face into a landscape, almost seems to anticipate the shattering events the wonderful performer was about to experience. Like a hint of what was about to come a virtual shadow is cast across the portrait; stronger than the visible shadow that lightly models the face. For the

glimpse of a moment, we see the star portrait's shiny surface crack.

Such a close-up, which except for the contours of the face leaves out all details but for a lock of hair in the top left corner, tells us of the photographer's affinity with daring aesthetic experiments. He varied a significant feature of the photographic avant-garde – Umbo, Raoul Hausmann and Helmar Lerski had pointed him the right way. The contact sheet from which the close-up has been taken contains a series of shots taken from an even more intimate distance. Some years later, an image depicting the prematurely deceased Martin Kippenberger was likewise reduced to the smallest possible facial section. Gundlach employed such extreme close-up continuously, albeit sparingly.

At this time, Gundlach tended to publish his photographs increasingly in magazines devoted exclusively to the subject of popular movies. This is particularly true of *Film-Revue*. Last but not least, annual audience

awards such as the "Bambi" served to underpin the significance of the glossy magazines. To some extent, the movie magazines used the advertising material from the distributing companies, in addition they also made use of Gundlach's own material or they commissioned him, for instance, with the production of so-called 'home stories', which, composed of photographs and text, related the living conditions of famous movie stars. These snapshots of celebrities' private lives were intended to narrow the gap between the actors on screen and the people in the movie theatres and to get audiences to identify with their idols in turn. Words and pictures served to get the Germans to commit to the civil virtue of good conduct, which would pay off in a modest degree of prosperity.

Since as early as the 1930s, there was a trend in international cinema "to bring the stars back down to earth".[9] "Put differently: These idealized characters were placed in what could be termed realistic surroundings – realism not in the sense that they identify with reality, rather, that particular elements of reality interact with one another, something that allows the audience to assess what they have seen as true."[10] In the movie world, realism is a construct that is composed of symptomatic particles and signals from the realm of reality.

F.C. Gundlach conquered the pages of the elegant magazine *Film und Frau* with his feature on French screen hero Jean Marais and the houseboat the idolized actor and friend of Cocteau inhabited. It was a turning point in his successful career. *Film und Frau* addressed a readership middle-class in background and who aspired to improve their status in society. Therefore cinema and fashion encountered one another upon an elevated social platform and with the morale of the "juste milieu". The magazine sought to restore the reputation of bourgeois morality that had been severely tarnished during the Nazi regime by employing precious rotogravure and using a generous layout. For this reason, at times, the tone adopted

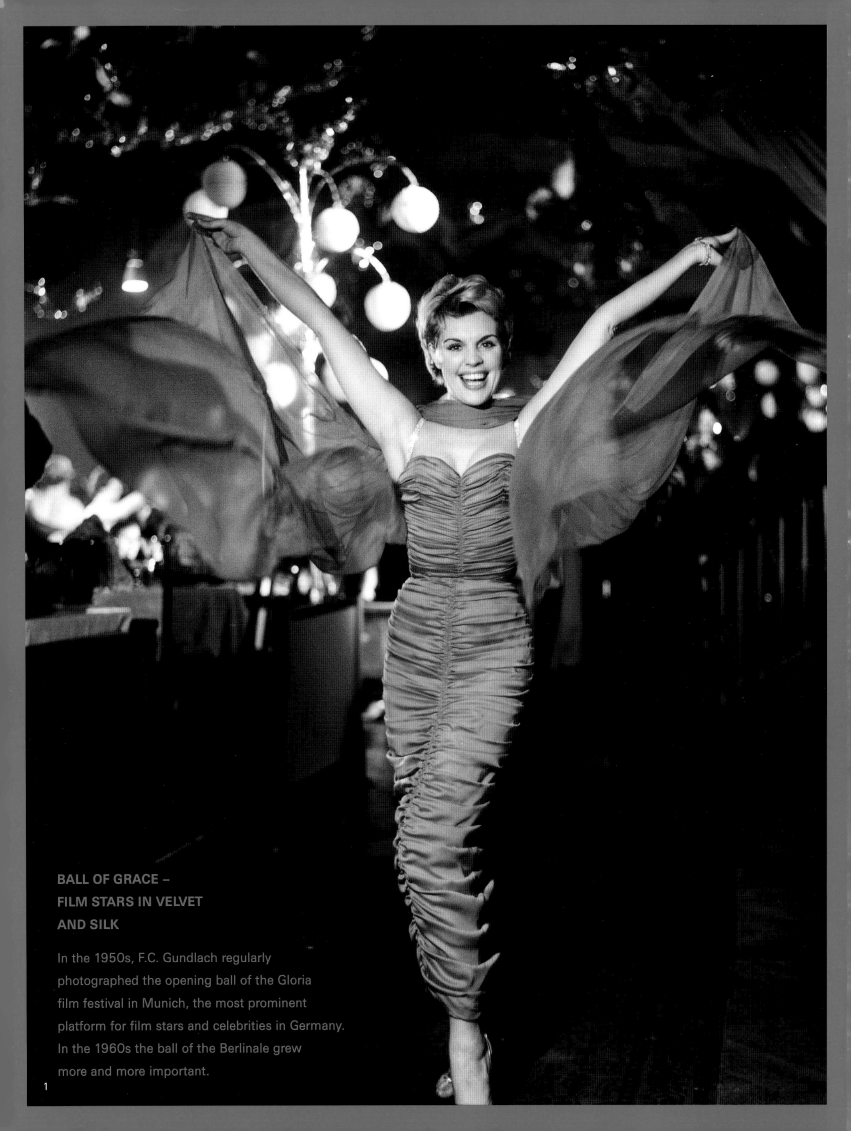

**BALL OF GRACE –
FILM STARS IN VELVET
AND SILK**

In the 1950s, F.C. Gundlach regularly
photographed the opening ball of the Gloria
film festival in Munich, the most prominent
platform for film stars and celebrities in Germany.
In the 1960s the ball of the Berlinale grew
more and more important.

1

23

24

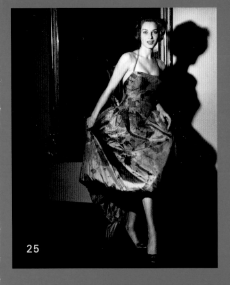

25

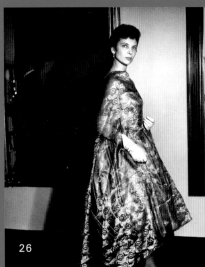

26

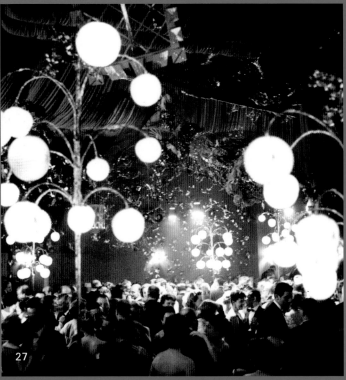

27

28

29

30

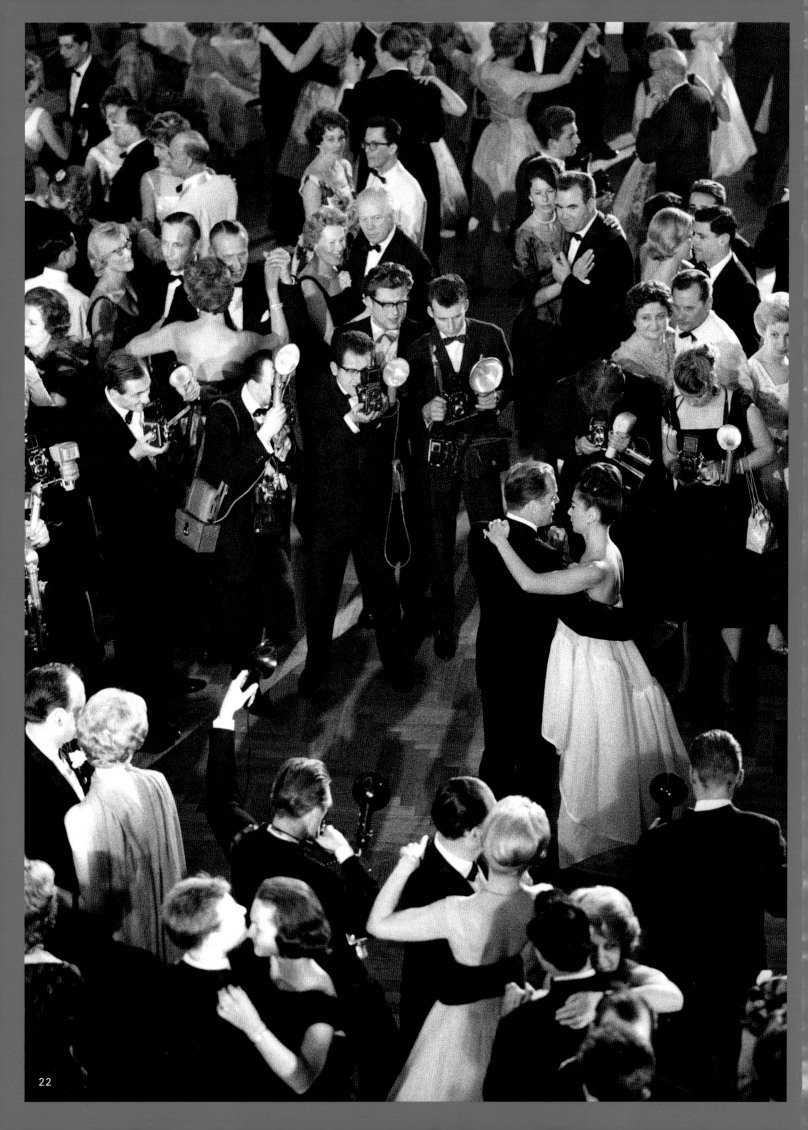

2

3

4

5

7

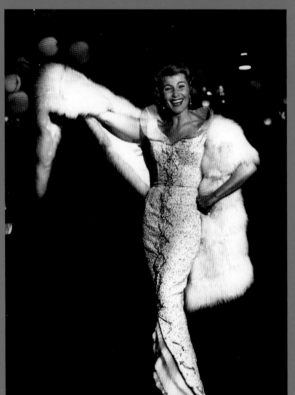

6

8

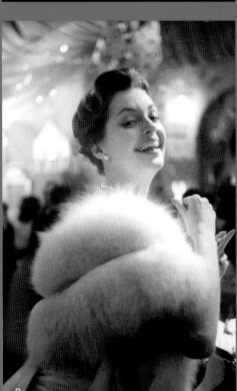

9

10

11

12

13

14

15

16

17

18

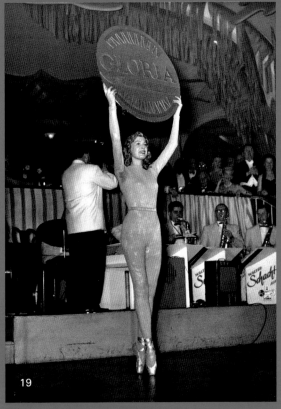

19

20

21

31

32

33

34

35

36

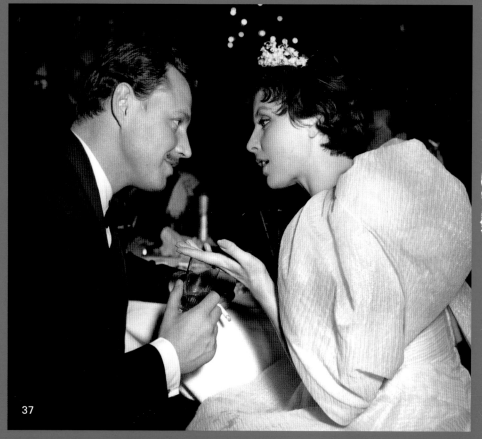

37

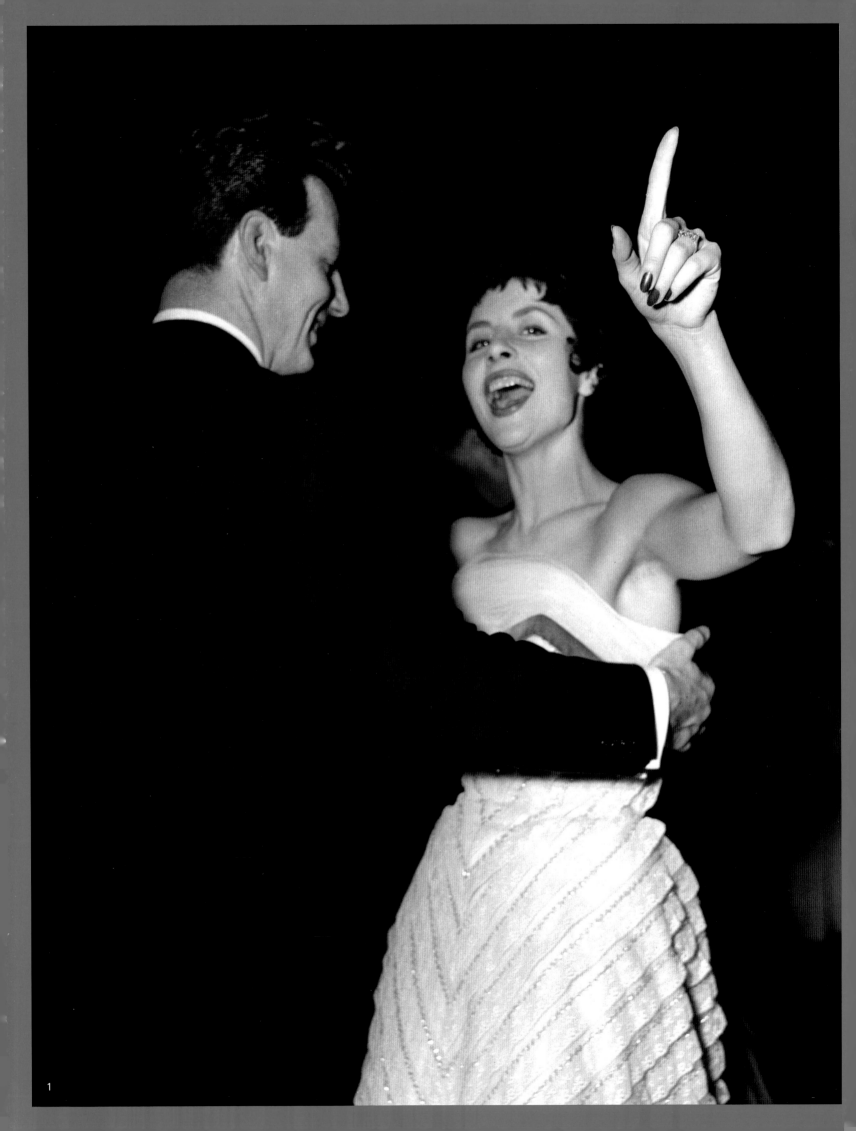

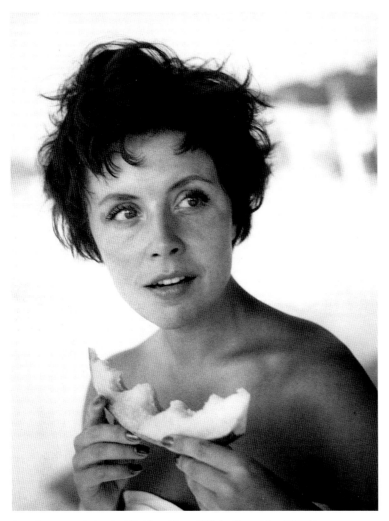

Sonja Ziemann on the beach of Phaleron, Athens 1955, in: *Film und Frau* 24/1955

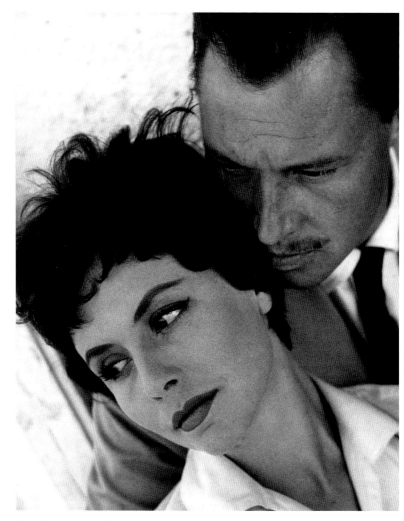

Sonja Ziemann and Ivan Desny while shooting "Mädchen ohne Grenzen" (directed by Géza von Radvanyi), Athens 1955, in: *Film und Frau* 24/1955

in addressing the female readership personally also came across as rather schoolmarmish.[11]

Gundlach's photographic interest had settled on a sphere that alluded less to the visible consistency of everyday reality than to the universe of collective imagination, wishes, dreams – and hidden fears; a fragile web of subliminal currents and sentiments manifested only indirectly in images. Genre movies – more reliably than the works from a kind of advanced art – supplied the patterns and receptacles, the looks, gestures, body languages, types, lighting and utensils in order to emphasize the brittle conflict situations of some evasive phenomena. It is perhaps the reason why West German post-war cinema's bad reputation is undiminished, even if with distance judgment tends to be more differentiated than immediately following the experience.[12]

The Oberhausen Manifesto of February 28, 1962 bid farewell to "Granddad's cinema", proclaimed a "new German cinema" (Neuer Deutscher Film) and

did its utmost to condemn the immediate past lock, stock, and barrel. However, directors such as Helmut Käutner, Wolfgang Staudte, who initially made his movies in the GDR, Harald Braun, Kurt Hoffmann, as well as the younger generation including Rudolf Jugert, Rolf Thiele, Victor Vicas and Georg Tressler overcame (albeit not always successfully) this widespread mediocrity by creating movies of a certain aesthetic standard. They reflected the mood of the country and its people by producing more relatively faithful, and therefore conformist, images. Actors such as Curd Jürgens and Maria Schell became international stars. The fact that many other actors' talents outstripped general expectations was demonstrated by the intense movies of Rainer Werner Fassbinder some twenty years later. As a matter of fact, the old hands of German cinema, who had learned their trade during the 'Third Reich' and obscured the view to reality with their light entertainment movies even at the time, had only little use for their actors. It

"Laughing in tears", Charlie Rivel, Berlin 1955, in: *Film und Frau* 26/1955

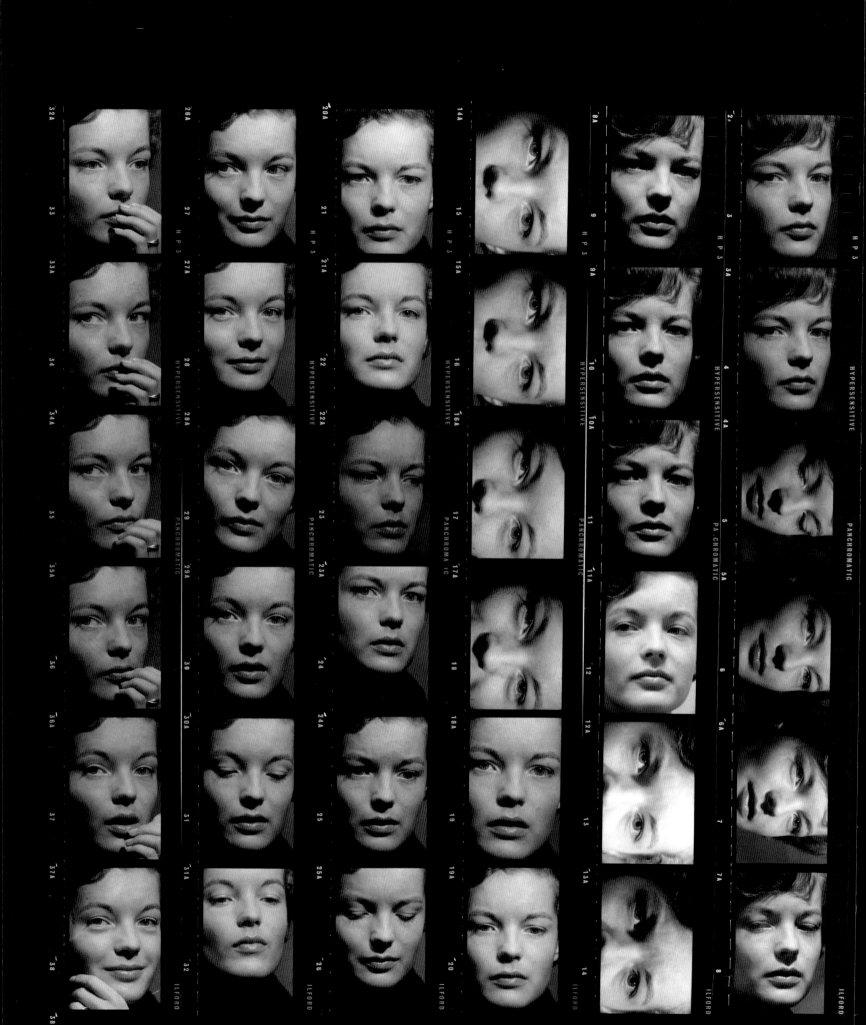

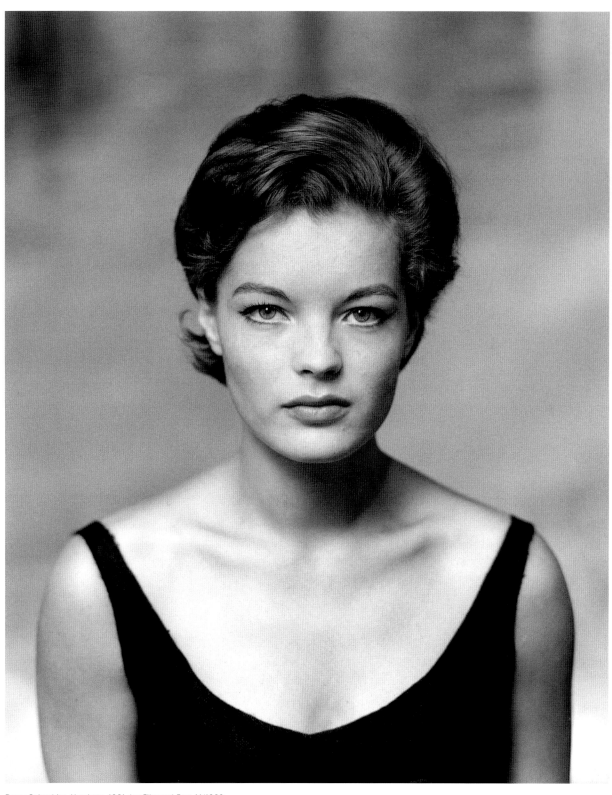

Romy Schneider, Hamburg 1961, in: *Film und Frau* 11/1962

is therefore not surprising that the likes of Nadja Tiller, Liselotte Pulver and Karlheinz Böhm were never as captivating and formidable as when they played movies directed by Roberto Rossellini, Gilles Grangier, Billy Wilder and Pressburger & Powell. Also Romy Schneider celebrated her biggest triumphs in France.

F.C. Gundlach photographed them all, albeit for very different reasons. His images helped present the whole gamut of the illustrated "Who's Who" of the German post-war cinematic era. He composed remarkable images of Helmut Käutner, Dieter Borsche (the star of the first hour), Bernhard Wicki, Curd Jürgens, Maria Schell and Lil Dagover; either in the studio before a neutral background or on location with very few props. His choice of dispensing with any illuminating attributes is immediately notice-

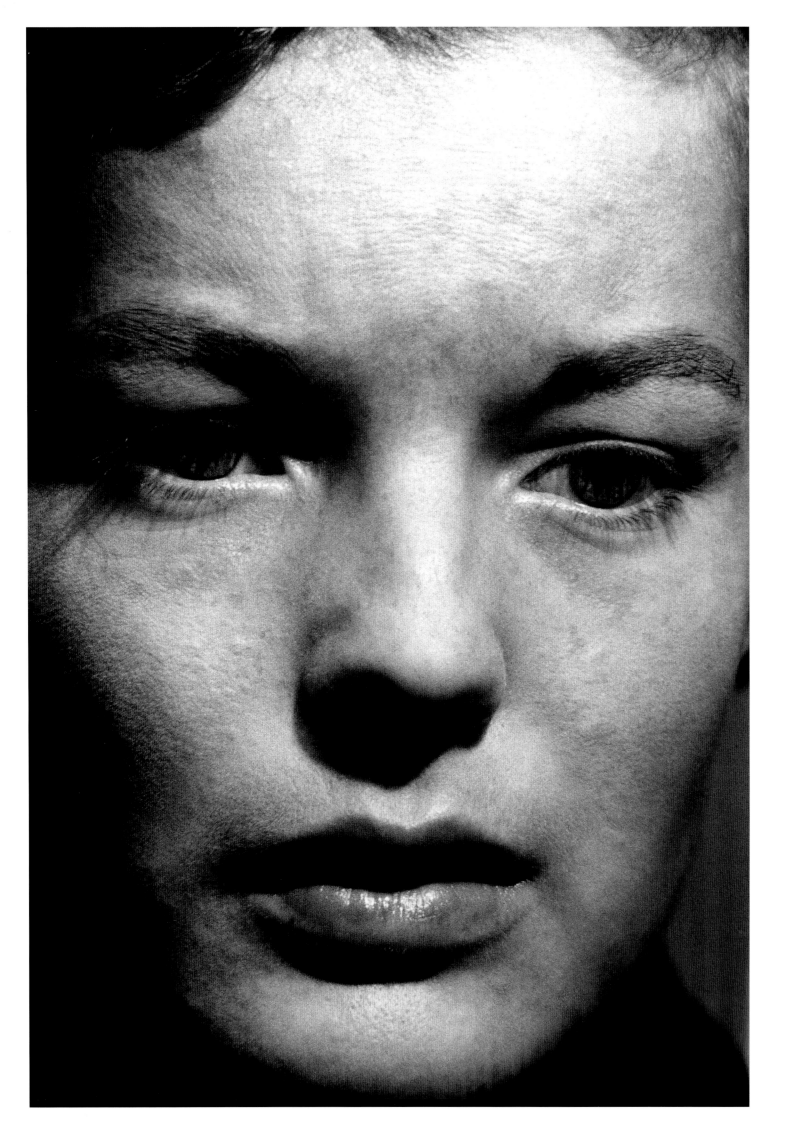

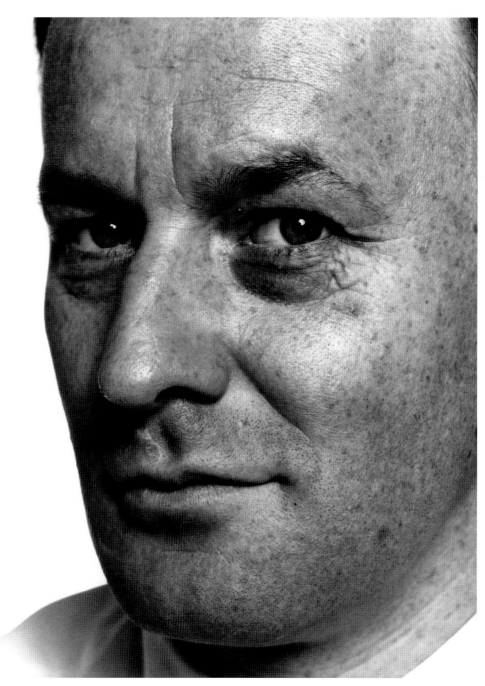

Martin Kippenberger opening the exhibition "D.E.d.A", *PPS. Gallery F.C. Gundlach*, Hamburg 1989

able. Directors and actors play their roles as models for the camera and also slip into the role of models. Gundlach gave them the opportunity simply to play themselves. The light he directed at his models puts them in the limelight, but does not dramatize them. The ample space that surrounds them helps them unfold their personalities without feeling at his mercy. The relationship between the void and a physical presence is in perfect balance. Model and photographer are on a par. The unusual portrait of Jean-Luc Godard captured before and atop a white studio roll emphasizes the photographic situation; even if camera and lamps remain invisible. The cinema rebel and

analyst is sitting on a chair with his legs crossed, his hands clasped on his left knee, in front of an unrolled reel of light paper that is suspended from the studio wall and rolled up again before his feet. The uncompromising film author's eyes are concealed beneath his trademark – his sunglasses. Any attempt of a psychological interpretation was from the outset doomed to failure by his jet black shades. The mirror to the soul – as the eyes are readily apostrophised – is clouded. His body language too leaves no doubt: Godard is shutting himself off. Nonetheless, the image by F.C. Gundlach is one of the most striking portraits of all times of the French-Swiss filmmaker. The

Romy Schneider, Hamburg 1961, in: *twen* 7/1961

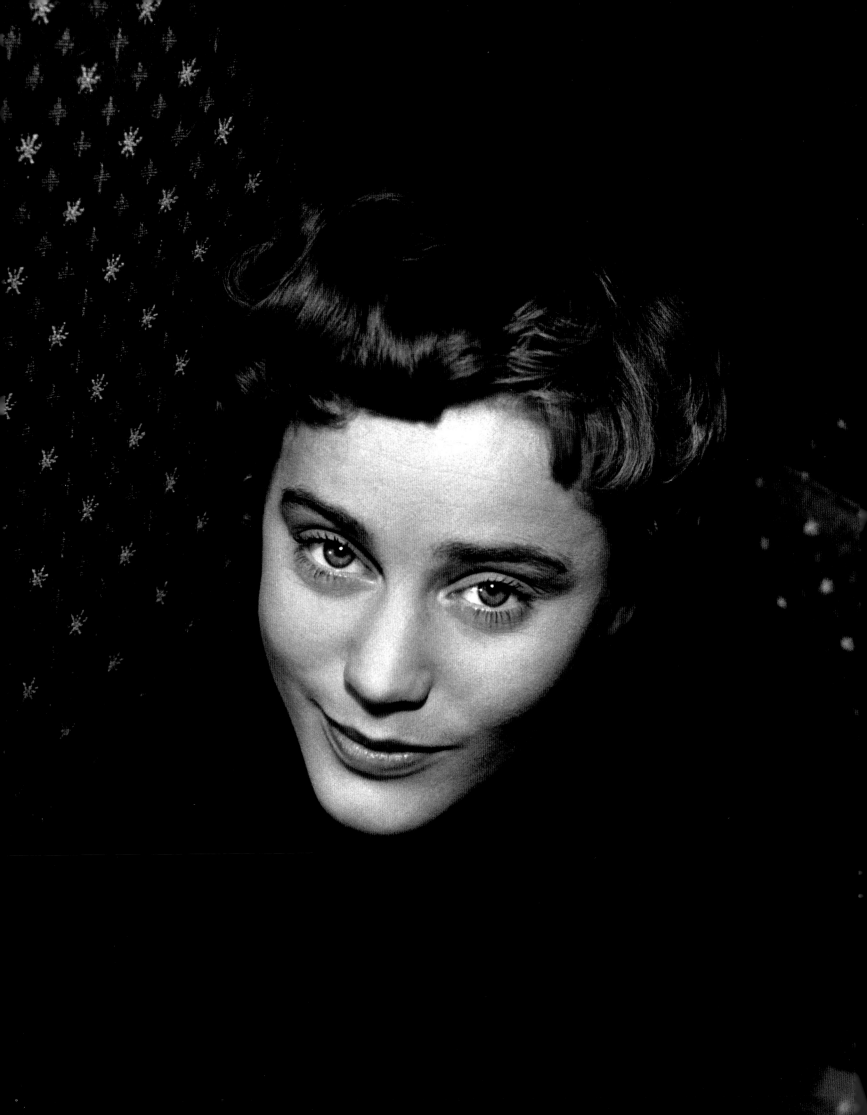

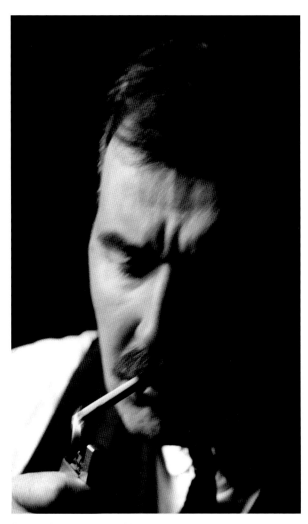

Bernhard Wicki, XI. Berlinale 1961,
in: *Film und Frau* 16/1961

conditions in the photo studio laid bare; some of the photographic means used in the shoot optically accentuated; the rigid, insightful and almost minimalist composition – featuring a right triangle (Godard) placed before a bright vertical rectangle on a darker background that gets repeated in the outer contours of the photograph – in short, by choosing to break with potential illusionary impulses the photographer has nailed his model's specific attitude more clearly than any conventionally composed portrait ever could. Photographs like these somewhat anticipate the oversized head shots by Thomas Ruff. In his best images, it is not sympathy that Gundlach demands from his audience. Instead, his work requires an approach combining analytical skills and empathy.

The studio portraits of Käutner, Wicki or the team comprising Paul Hubschmid and Marianne Koch are certainly of no lesser artistic substance. In each of the shots, the background is neutral and the pictorial space is diffuse. As if the models were caught in a sphere where optical conditions were not clearly defined. The platform is merely insinuated by reflecting light – the only possible spatial structure is a manifestation of our imagination.

Gundlach, unlike Irving Penn, does not push his models into a studio corner in order to force a response, elicit a story from them. Rather, he allows them to be themselves, while devoting his full attention to the formal relationships between the person and their surroundings, between subjectivity and representation. The cool images that calmly and confidently negotiate between the structural requirements of the image and the autonomy of the photographed persons easily bear the comparison with the famous portrait shots by Penn. The ambivalence conferred upon fashion by Roland Barthes, "displaying nudity at the very moment it hides it"[13], can also be applied in a figurative sense to Gundlach's portraits as they open our eyes to look into the models' psyche, capturing their momentary mood only to blur this im-

Maria Schell while shooting "Der träumende Mund" (directed by Josef von Baky), Hamburg 1953

next spread: Helmut Käutner, X. Berlinale 1960, in: *Film und Frau* fall/winter 1960/61

Jean-Luc Godard presents "À Bout de Souffle", XI. Berlinale 1961, in: *Film und Frau* 16/1961

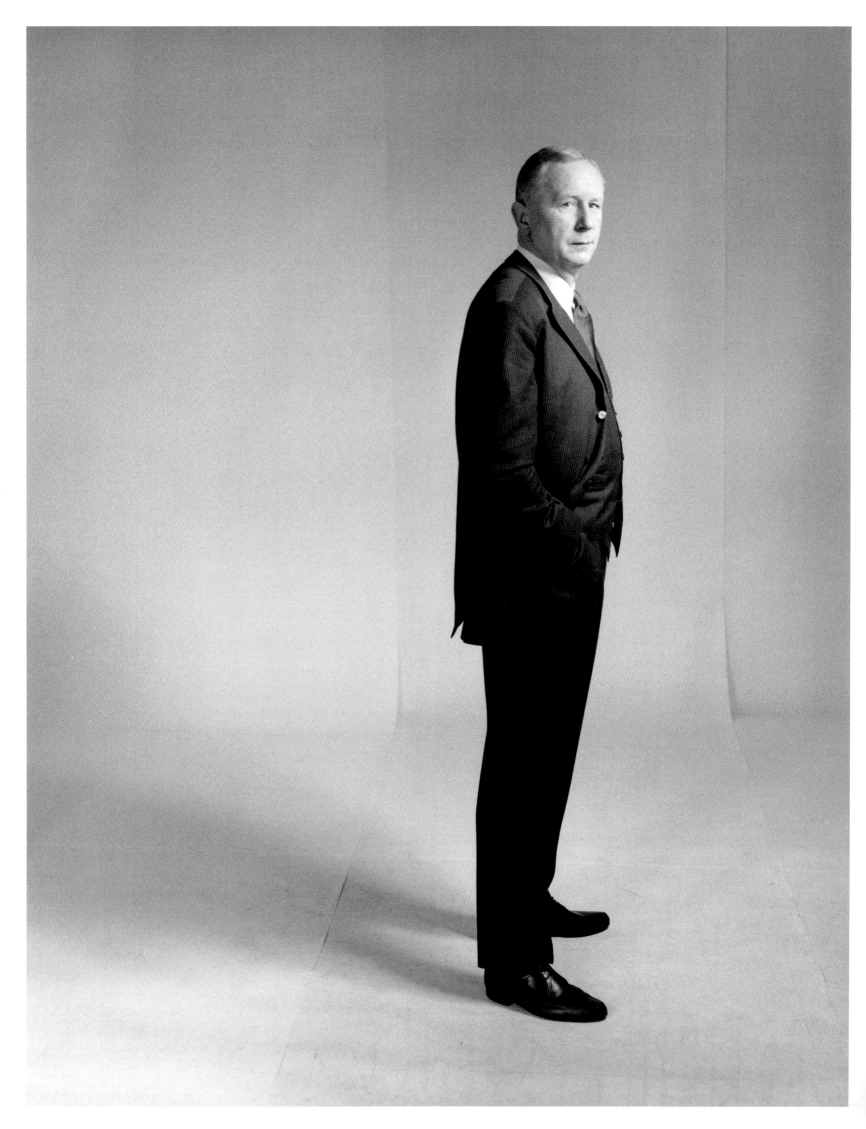

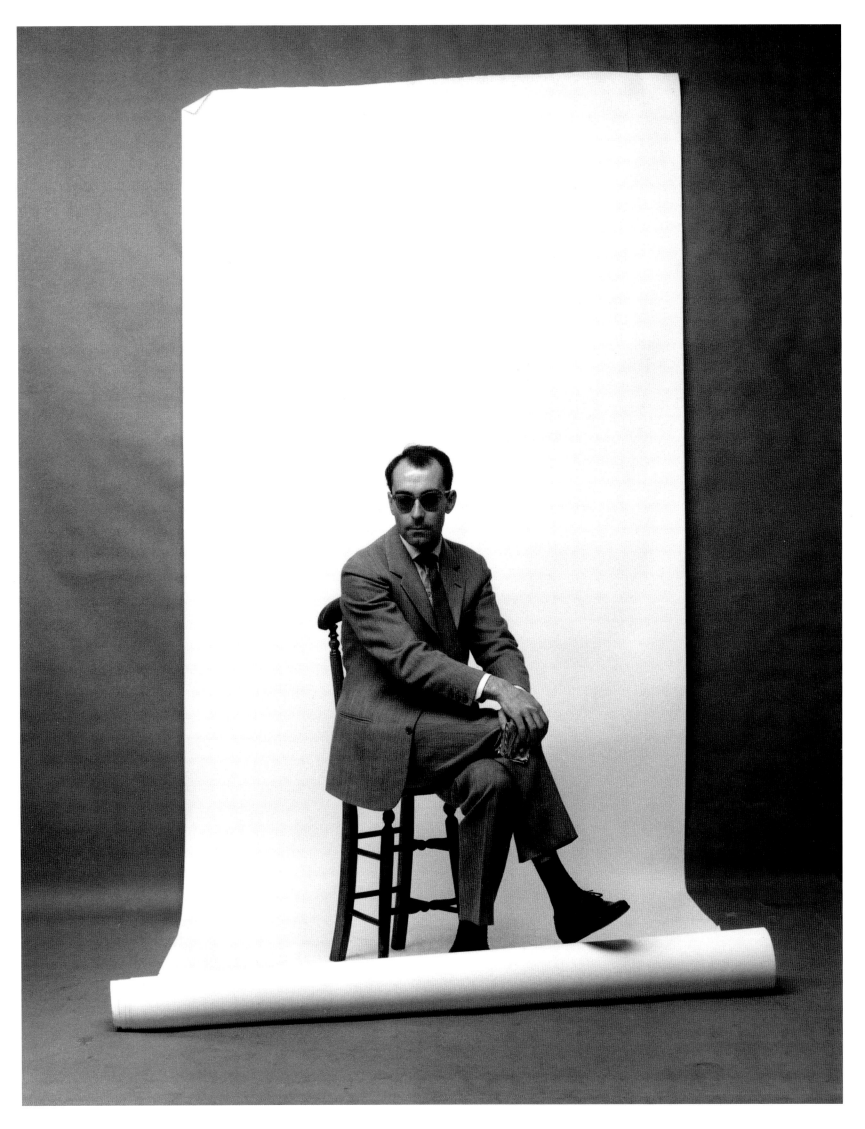

Bernhard Wicki, XI. Berlinale 1961,
in: *Film und Frau* 9/1962

pression instantly at a blink of the eye. As a fashion photographer, F.C. Gundlach adopted the same sensitive approach when working with his models. Within a single genre, he loved to explore things by pushing the image area to its very limits – the close-up of Romy Schneider vis-à-vis the distance to Käutner. Very close or very far: his oeuvre is composed of corresponding extremes.

On October 7, 1950, the photographer for the very first time crossed the border to France. He used his holidays to go to Paris. In those days, not every German person wishing to travel from what until recently was enemy territory was granted an entry permit. A carefully guarded border ran between France and the Federal Republic of Germany, drawn up only in the previous year. Still, Paris was the place where every young German longed to be, striving to escape the claustrophobic conditions at home, looking for a new direction in dealing with existential questions, discovering that the rhythms of jazz perfectly ex-

pressed how they felt about their lives. In any case, they were curious to witness the latest trends in art, literature, movies and fashion. Paris, gradually recovering from the days of the German occupation, was considered the cultural centre of the world, even if New York was doing its best to outstrip the French capital. On June 1, 1950, Janet Flanner noted in her diary for the *New Yorker*: "Paris is currently experiencing its cultural heyday. For anyone living here, there is so much to see and hear – a hotpot of intellectual delights and honky-tonk entertainment. The hotels – down to the bathtubs – are overspilling with tourists from every corner of the world, who have the ready cash to check out everything Paris has to offer, ranging from Furtwängler's wonderful but expensive concerts […] through to Folies-Bergère and her cocoa-skinned Peters Sisters from the United States […]."[14] Simone de Beauvoir had just published her controversial book *The Second Sex*[15], the Socialist Party had overthrown the sixth government from the

Ingrid Andree while shooting "O du lieber Fridolin" (directed by Peter Hamel),
Bendestorf 1952, in: *Film und Frau* 21/1952

Fourth Republic, and the influential politician Robert Schuman had made proposals for a United Western Europe, to be founded upon coal and steel. France, a country periodically rattled by severe strike action and massive social conflicts, was at war with Indochina in its fourth year. On the horizon, in Korea, the possibility of a third world war was looming. The French Parliament discussed plans of rearmament for West Germany. "Many Frenchmen well remembered what Hitler's working battalions, who had received theoretical training only using spades, managed to do to France back in 1940, and thus they were perplexed at the idea that France could possibly hand any German as much as a toy gun [...]."[16]

Gundlach would often return to Paris and shortly thereafter for a number of clients in Germany and Switzerland he would attend the glamorous fashion trails in the spring and in the fall, to observe and to take pictures. Armed with several letters of recommendation, he was initially trying to establish

contacts for himself. This is how he met the highly dynamic film critic Alexandre Alexandre, who also worked for broadcasting stations in West Germany, a German agent couple living in exile and with connections to the fashion scene, as well as F.A. Koebner – founder of *Elegante Welt* published from 1912 and the most successful periodical during the Weimar Republic, *Das Magazin*, launched in 1924 – a legendary figure from the world of German journalism who, though chronically short of cash, was always busy flitting around and pulling strings in the French capital.[17]

Numerous night shots in the style of Brassaïs and the Poetic Realism by Marcel Carnés, Julien Duviviers and the somewhat underrated French version of the "film noir" are testament to the fact that the photographic portfolio of all-round talent F.C. Gundlach had been enriched atmospherically: the images exude the air of Paris. When asked what potentially inspired him, the photographer replied that Paris

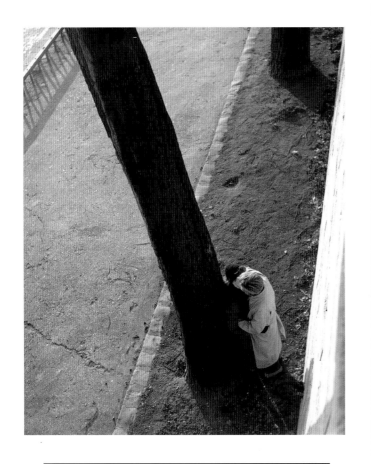

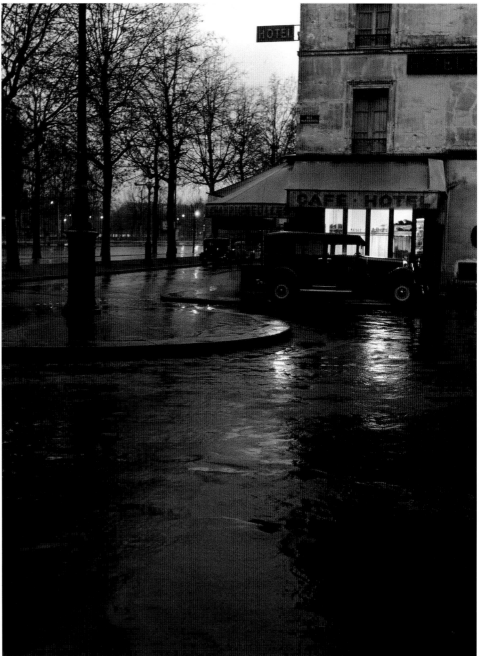

"Young love on the banks of the Seine", Paris 1951
"The small bistro at the corner", Paris 1951, in: *aspekte 60*
44 "Under the bridges of Paris", Paris 1951
"Death in the Seine", Paris 1953
"Foggy day", Paris 1951

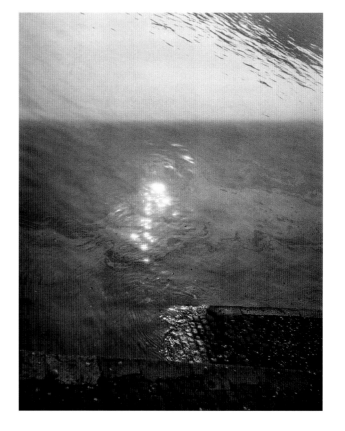

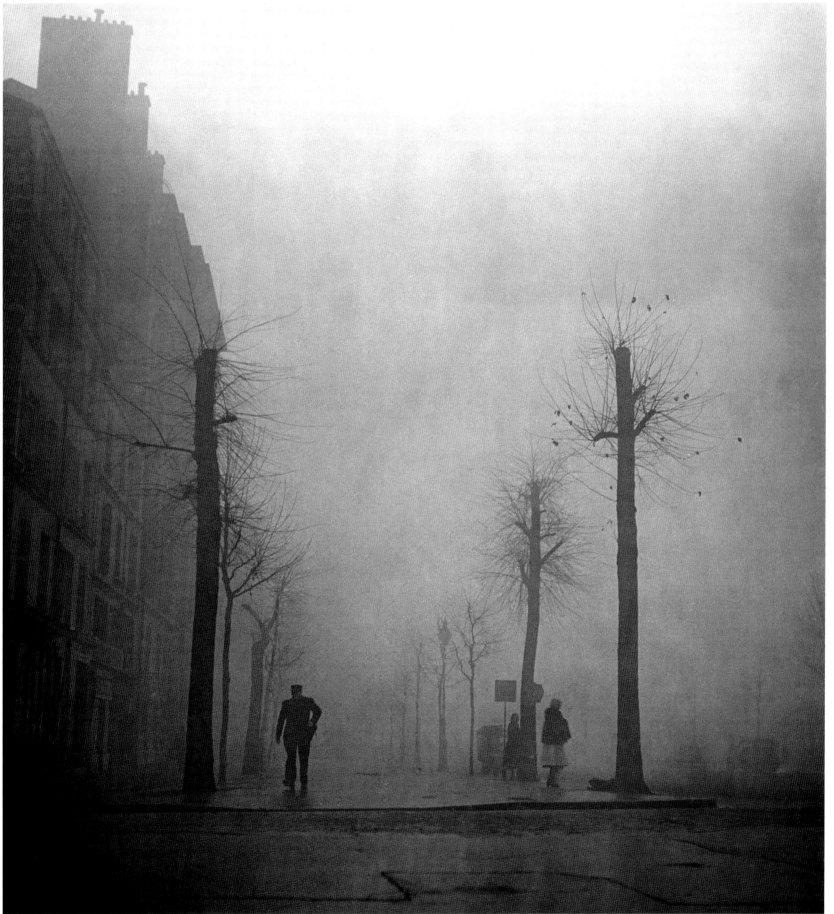

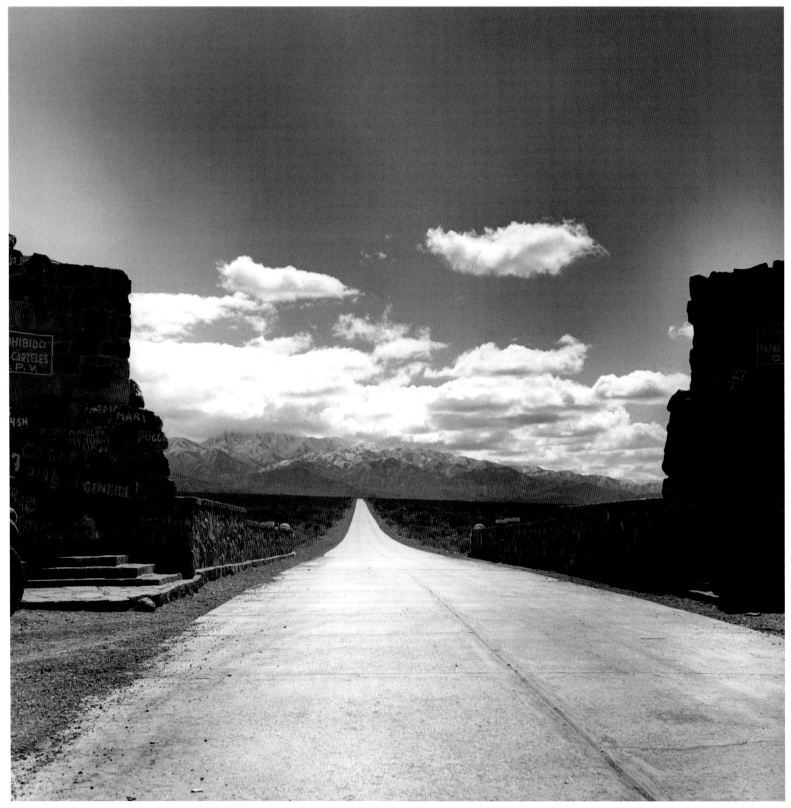

Carretera Pan-Americana, Argentina 1956

simply took a picture of itself.[18] The bistro basked in twilight – this could be where the sandwiches were collected for Inspector Maigret who used to order some before any final interrogation in his office on Quai des Orfèvres. Or the lonely walker, enveloped by morning fog on the wide boulevard – could he perhaps be a young man on his way home from a rendezvous in one of the smoky jazz clubs at Quartier Latin? The lovers perched in a shy embrace underneath a slanting tree that protrudes into the picture; a shot snatched from above, a melancholic Paris picture *par excellence*, taken in the bold birds-eye fashion of the New Vision. Presumably Gundlach went through the same experiences as Nicolaus Sombart,

"The Schah-In-Schah", Isfahan/Persia 1960, in: *Film und Frau* 8/1960

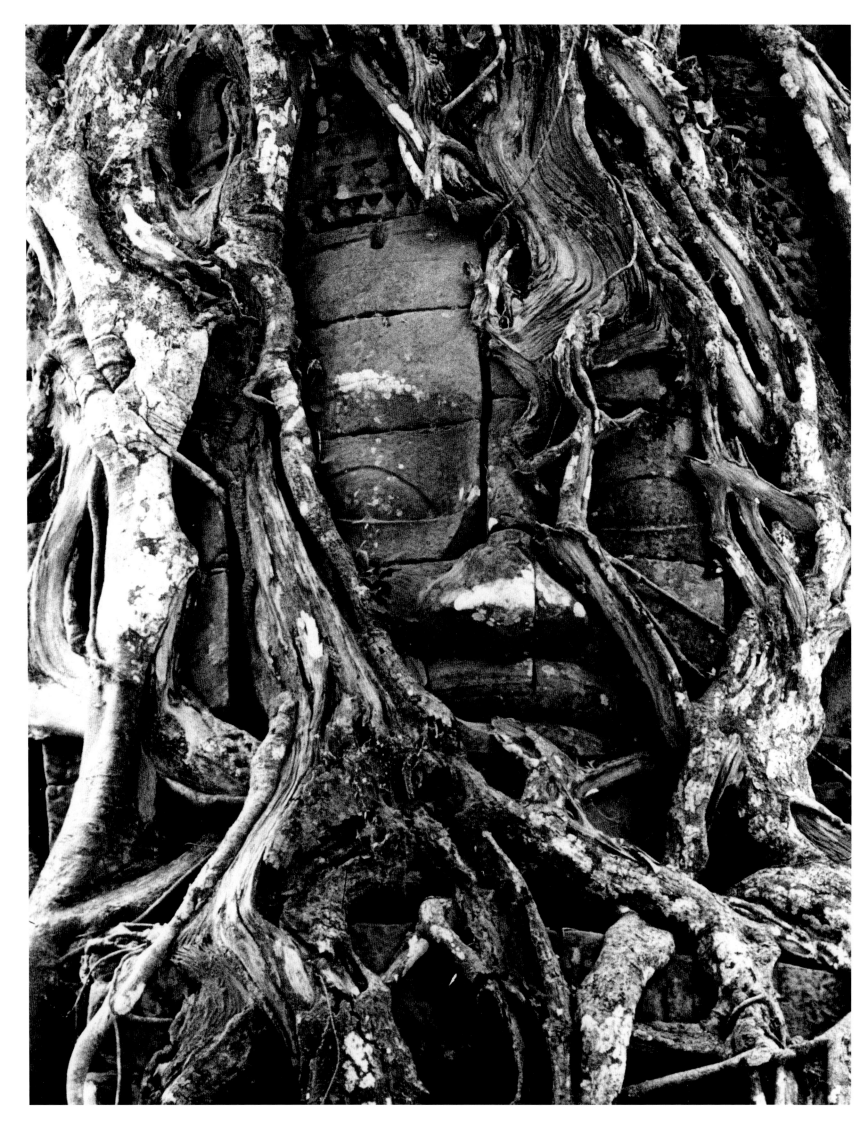

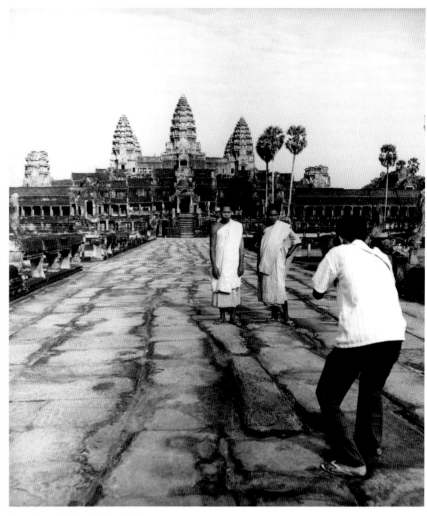

The main temple, Angkor Wat 1961

who came to the French metropolis in the following year: "This was Paris, the Paris inside myself, before I even got to know Paris. A longing arose in me that was not so much geared towards the discovery of something new but rather at retrieving something I vaguely remembered."[19] Even though Gundlach, who originally was from the German state of Hesse, was taken to a POW camp in France as an air force assistant, he came to know the real Paris only through his pictures. In the photograph with the light reflecting from a wet pavement the notions of Subjective Photography and Poetic Realism seem to have formed a perfect marriage.[20]

The metaphor of travelling best characterises the life and work of F.C. Gundlach. Paris was only the beginning – in 1956, he travelled to New York and around the United States. Followed by Egypt and the Middle East and, soon after, Persia, Thailand, Cambodia, Japan, Hong Kong, Central and Latin America… He flew to Angkor Vat at a time when the temple

complex was threatened to be swallowed up not by modern day mass tourism but in fact by the jungle. A feature on Hong Kong provided a pointed portrait of the British colonial city on the Chinese coast in times of change. A clever deal with Lufthansa, which, since the Allies lifted the flying ban in 1955, was ready for take-off again with its brand new Convair and a four-engine Lockheed L-1049 G "Super Constellation", allowed the photographer almost unlimited mobility. He had declined an offer from the company to work for them as a photographer under contract. Instead he had suggested that he provide visual documentation of all opening flights on the new routes – not in return for payment, but for first-class flight tickets. No other master of his trade has travelled the globe as extensively as F.C. Gundlach. This prompted *Film und Frau* – the magazine had counted him among its "aspiring new talents" in 1953 – to end an editorial with the announcement that the "talented young man from Stuttgart was going to continue with his

Buddha overgrown with kapok tree, Ta Prohm 1961

next spread: King Bhumibol leaving his palace, Bangkok 1961

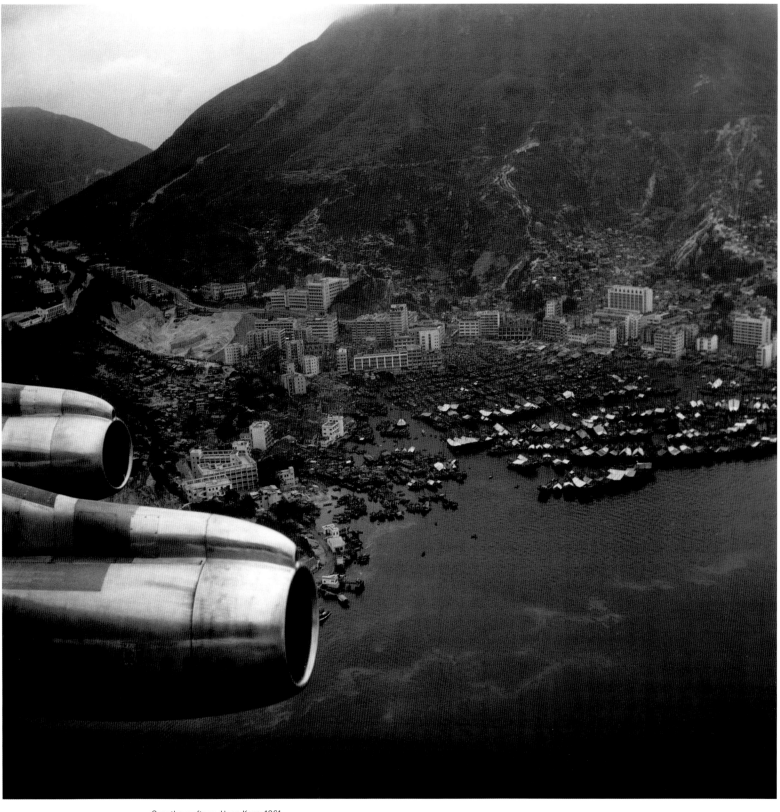

Over the rooftops, Hong Kong 1961

entertaining and vividly portrayed travel accounts also in the future."[21]

The field of fashion at the time was still in the hands of some established photographers. Except for Willy Maywald, who had left Germany following Hitler's accession to the chancellorship and now headed the editorial team, they had all carried out their pro-

fession successfully during the 'Third Reich': first and foremost Hubs Flöter, who had joined the Party in time; Charlotte Rohrbach, personal photographer of the Führer's favorite sculptors Thorak and Breker; as well as Norbert Leonard who, being half Jewish, was caught on the basis of his counterfeit ID papers, deported to Auschwitz and only escaped the concentra-

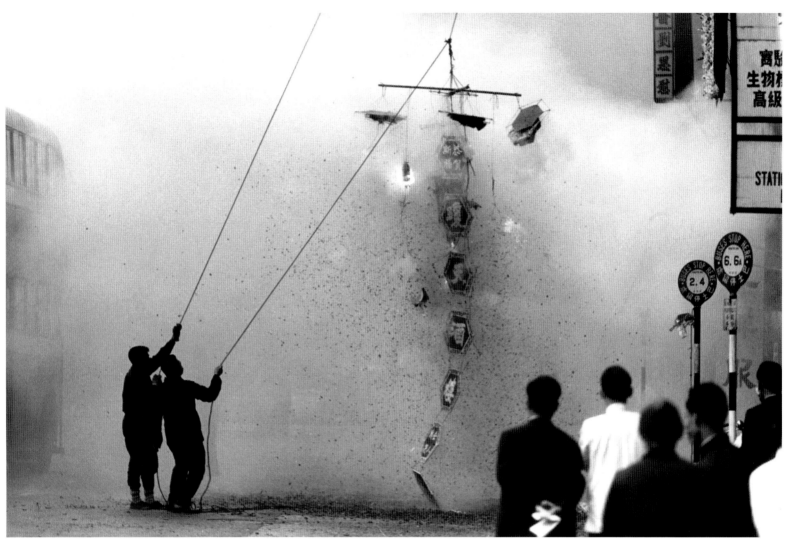

New Year fireworks, Hong Kong 1961, in: *Film und Frau* 14/1961

tion camp alive because his technical training made him indispensable as a forger of British pound notes, and, finally, Regi Relang, who had settled abroad but was forced to return to Nazi Germany as her husband was stateless. Within a very short time, Gundlach assumed Maywald's position.

Like the German post-war film, German fashion photography of that time was not held in high regard, but simply ignored by the international literature on photography. All efforts, including those of the collector, curator and publisher of many books on the subject, F.C. Gundlach, were in vain. One possible reason for this disregard is that the contemporary visual culture of the time was firmly in the grip of Anglo-American idiom. After World War II, US culture, with its commercial dynamics, became a role model in the world of film, art, photography, television and print media.[22] It was the Americans who set the aesthetic standards in fashion photography, most

of all Irving Penn and Richard Avedon, while the fashion editors of the prestigious magazines *Vogue* and *Harper's Bazaar* became the leading authorities for anything that concerned "good taste".

Moreover, fashion photography had taken a hairpin turn by shifting the focus away from the studio and out onto the streets. The Hungarian photographer Martin Munkacsi,[23] an emigrant from Germany (1934), had pioneered the way for this new drive behind fashion photography before the War. Gundlach was among the earliest collectors of his soon to be forgotten pictures. Now Avedon, himself an avid admirer of Munkasci, on leaving the US Navy and signing up for *Harper's Bazaar*, stated to chase his models through the streets of Paris wearing the latest creations from exclusive fashion houses. He made them pose in bars and photographed them in front of casino game tables. A fresh realism swept through the realm of advanced fashion photography, making

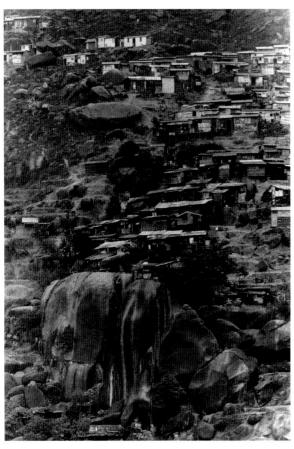

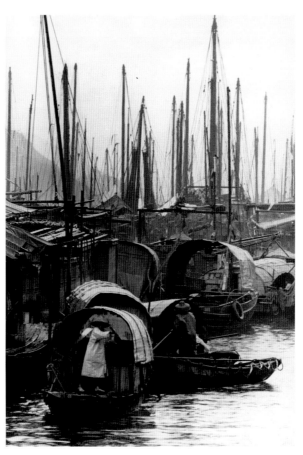

Slum, Hong Kong 1961,
in: *Film und Frau* 14/1961

"Aberdeen, city of junks and sampans", Hong Kong 1961,
in: *Film und Frau* 14/1961

the conventional version of elaborated studio shots suddenly look frumpy.

However, German fashion photography of this time was not nearly as insignificant as its reputation suggested. Flöter, together with his talented wife Ilse, as well as Sonja Georgi, Regi Relang and Leonard had their own idiosyncratic style. They also used – and varied – the formal repertoire that was originally introduced to fashion photography by Yva (whose real name was Else Neuländer-Simon), one of the most innovative photographers during Berlin's Roaring Twenties. Yva had continued to work as a photographer until she was banned from the profession by the Nazis. She was murdered at an undisclosed location, presumably Majdanek concentration camp. Her immense influence on German fashion photography persisted even after the war.[24] Moreover, the ambitions of some influential Nazi officials to succeed Paris as a fashion centre prevented the provincial blood and ground attitude inherent in racial-nationalist ideologies from lodging in the realm of fashion photography. This ambition produced an aesthetic mix of originality and conservative style. Following

the collapse of the Nazi regime, German fashion photography – like German film and German journalism – merged tendencies of continuity and of a new beginning. Paradoxically, the maxim in fashion photography was "no experiments" – long before the party of Germany's first chancellor, Konrad Adenauer, turned this statement into a resounding slogan for their election campaign.

F.C. Gundlach heralded a generation change. He specialized in 1954. It took somewhat longer before his formal-structural, quasi architectural-photographic view came to prevail in fashion photography. This process was furthermore accelerated by changes in the fashion industry: from tailor-made fashion items to regular sizes, from haute couture to ready-to-wear clothing. Even though Gundlach had yet to explore what was for him the unfamiliar territory of fashion photography, he certainly knew a thing or two about fashion. This is because film and fashion merge on many different levels. The medium of moving pictures tends to pick up on fashion trends, often exposing the latest pranks. Film is a catalyst of fashion; it establishes fashion trends in our customs and hab-

Traffic policeman, Hong Kong 1961, in: *Film und Frau* 14/1961; Market Street, Hong Kong 1961,
in: *Film und Frau* 14/1961; Games, Hong Kong 1961, in: *Film und Frau* 14/1961

next spread: New Year fireworks, Hong Kong 1961, in: *Film und Frau* 14/1961

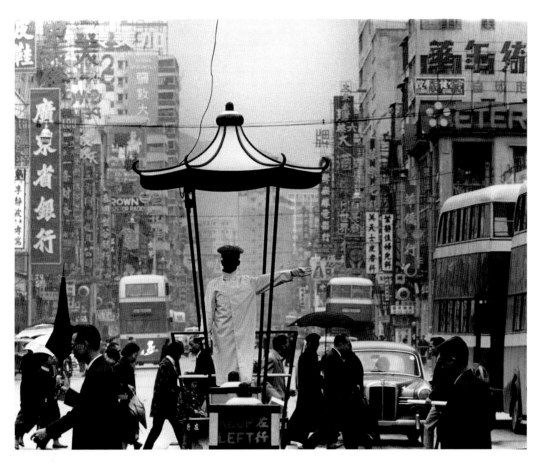
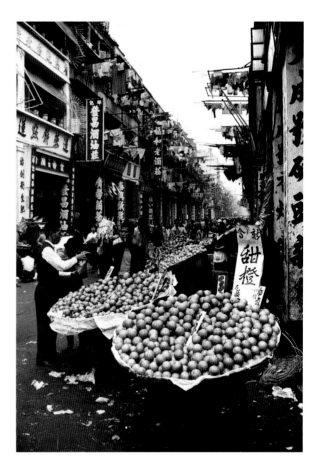
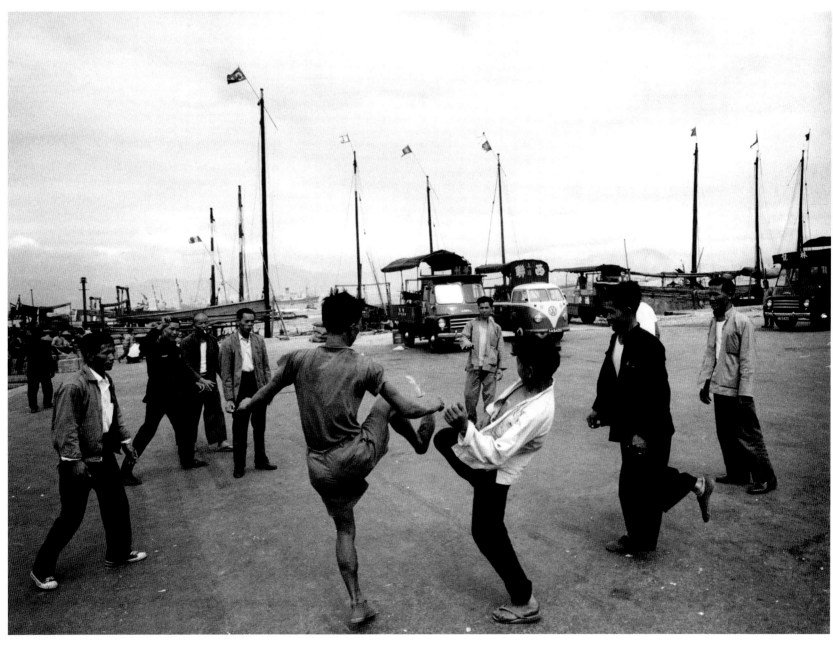

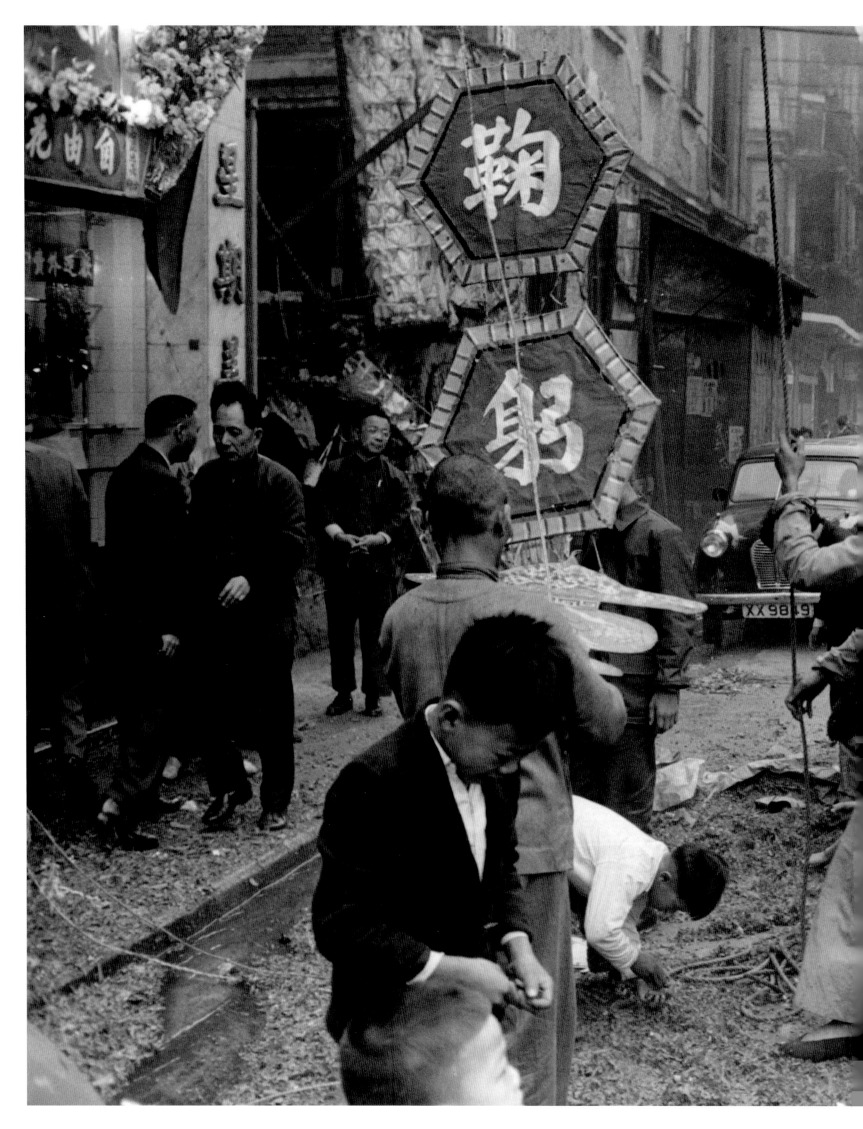

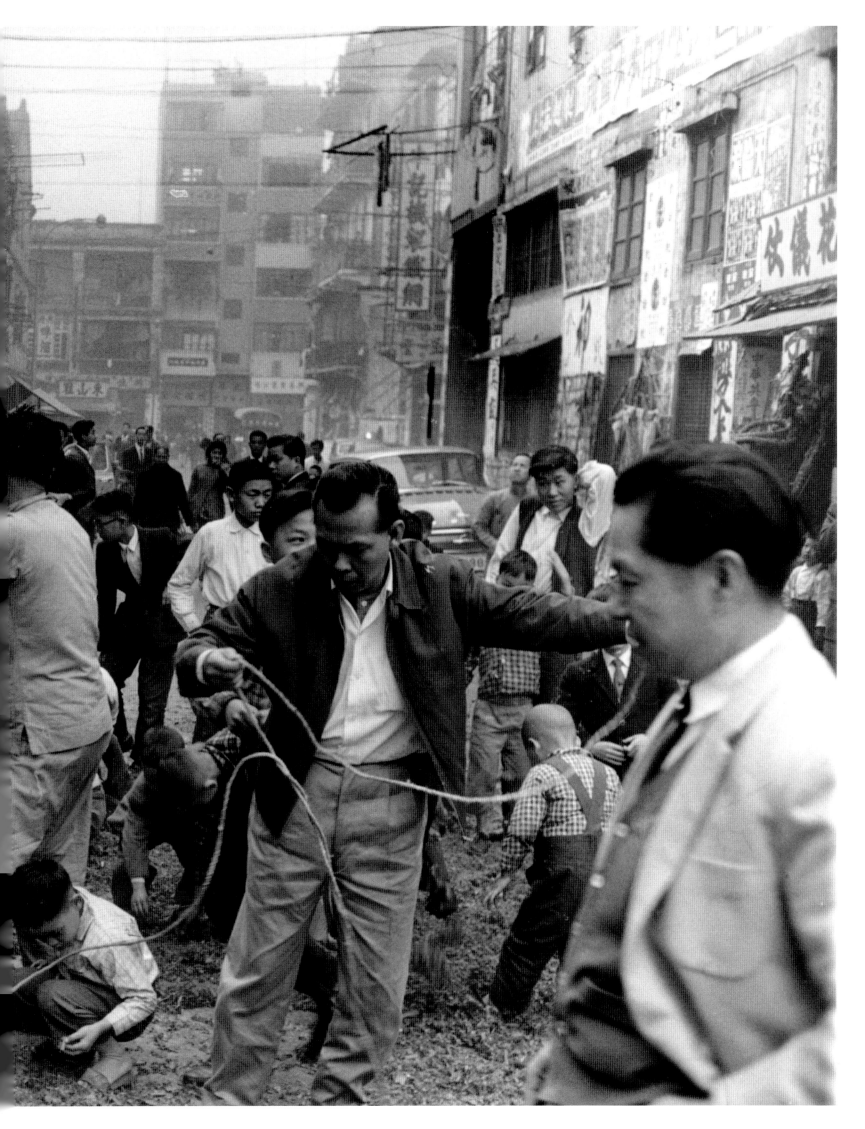

its, shapes our behaviour patterns and outer appearances, and, as a mass medium, constitutes a fiercely intense vehicle for communication. For the proliferation of particular fashion statements in clothing (which is only one aspect of the vast phenomenon of fashion), film carried the same significance as fashion magazines well into the 1980s. Gundlach was at home in film. It is certainly no coincidence that he spotted Austrian actress Nadja Tiller's modelling talent following her first steps as an actress, and subsequently gave her the role of fashion model. With her he went on a "Modebummel" (fashion stroll) to compile a brochure for Heinzelmann, a company advised by Marianne Grund. In September 1952, the article was also published in *Elegante Welt*. Particularly striking about this session is the typological sequence that shows the actress in a number of different poses. It comes across as a visual lexicon on fashion performance in photography, with a step-by-step presentation of effective poses. Moreover, it provides an insight not only in the immanent mechanisms of fashion, but also in the immanent relationships inherent in photography.

We can assume that Grundlach's ever more frequent trips to Paris both heightened his awareness and sharpened his view of the glittering world of fashion. It showed in his assignments for German illustrated magazines. Already in October 1952, *Elegante Welt* published an article entitled "Dior in Paris" featuring photographs by Gundlach. Paris announced its return to the fashion stage on February 12, 1947. On a cold and gray winter's day the doors of a beautiful town house on Avenue de Montaigne opened and the excited and impatiently waiting crowd shocked. Maywald, who at the time witnessed the spectacle, remembers: "When we were finally admitted, they had the most incredible surprise in store for us. Right there, in the middle of the bare Paris, where there was nothing left to buy, not even a scrap of fabric, we stepped into a world of sheer incredible luxury."[25] Still a nobody at the time, Christian Dior presented his first collection – and shot to international fame. "The dresses from this collection – outrageous in style – were lavishly made from the most precious fabrics."[26] The designer named his creation "Ligne Corolle", and the legendary Carmel Snow was quick to come up with a matching label: New Look. Gundlach would photograph her in 1958 at a fashion show in the New York Plaza Hotel; in the twilight of her fairy tale career and in a desolate state. "Haute couture" had at once wiped out the harsh post-war female fashion era with its plain military-style cuts, flat shapes and padded shoulders. Notwithstanding the most hostile attacks: There was no escaping from the New Look elegant cuts, rounded shoulders, wasp waists and long bouffant skirts. Haute couture put an end to the asceticism of war. Even though Dior sent his models on the catwalk in more contemporary silhouettes, the times, with a society that was becoming more homogeneous yet hungry for change, had already surpassed the high fashion trend. Nevertheless, for the next ten years, the New Look cleared the stage for the most glamorous era ever witnessed in the fashion circus.

Reflecting on seductive magic of this fashion, the economic importance it had for France should not be neglected. According to authors D. I. Miller and M. B. Picken, two out of five French workers made a living from the fashion industry, including suppliers such as the textile, accessories and needle industry.[27] Notwithstanding haute couture's claim to exclusivity, many designs were intended for reproduction from the outset. "An authentic model handcrafted in the Dior workshops in Paris was precious and expensive. The immensely successful 1947 daywear dress 'Elle' illustrates the pricing scheme: A private customer was charged 32.000 French Francs, while a professional buyer had to pay 45.000 French Francs for the

"Black Nadja", Stuttgart 1952, in: *Deutsche Illustrierte* 39/1952

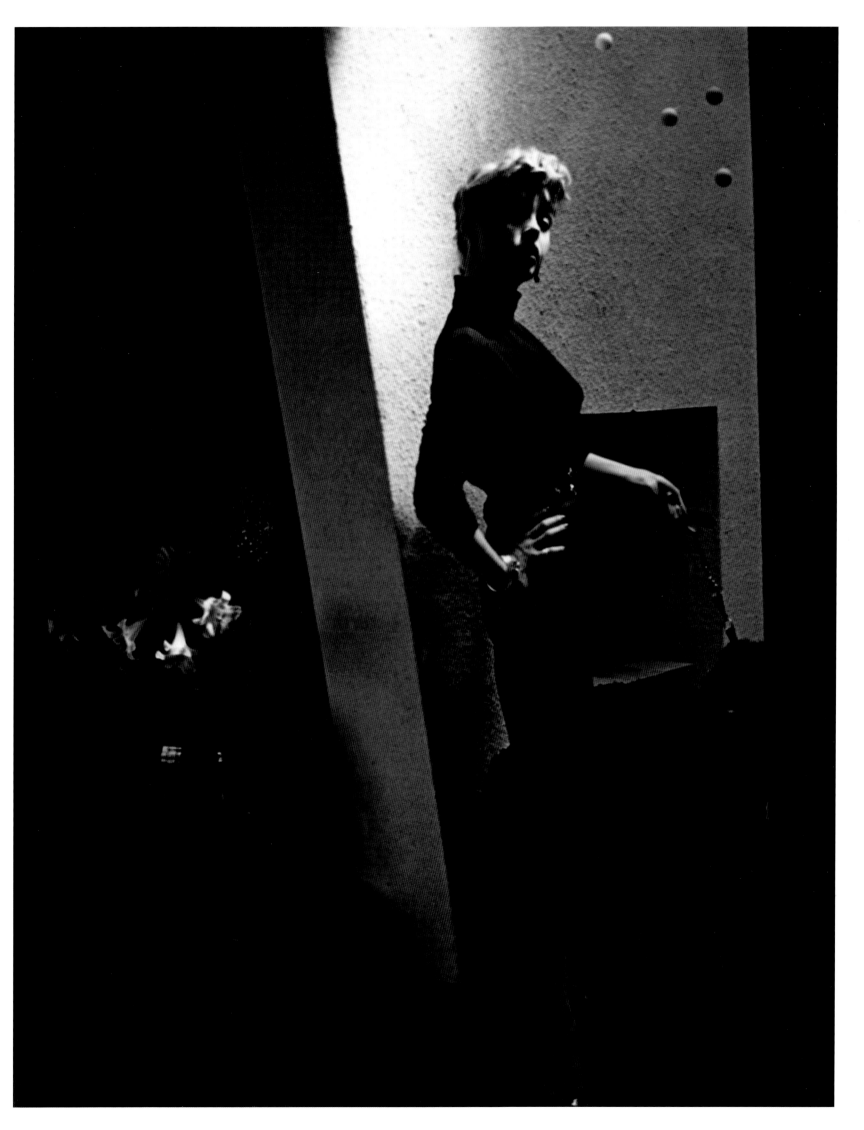

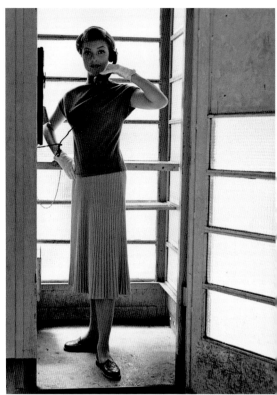

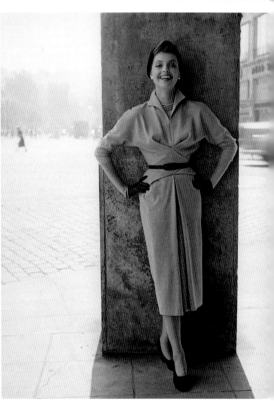

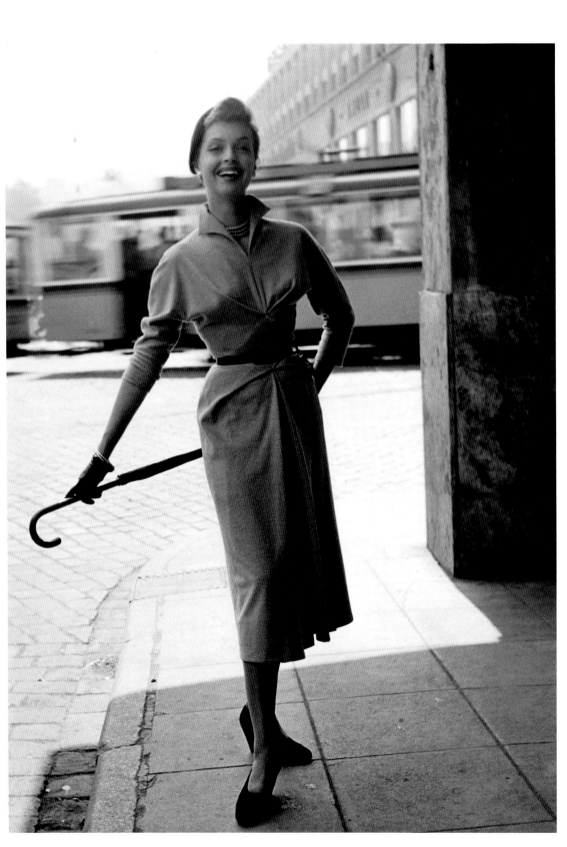

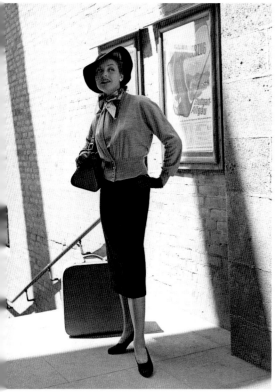

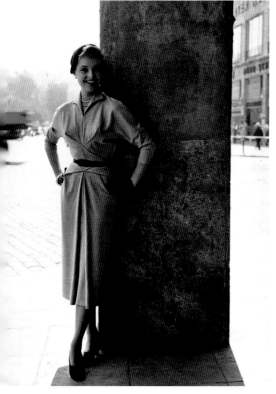

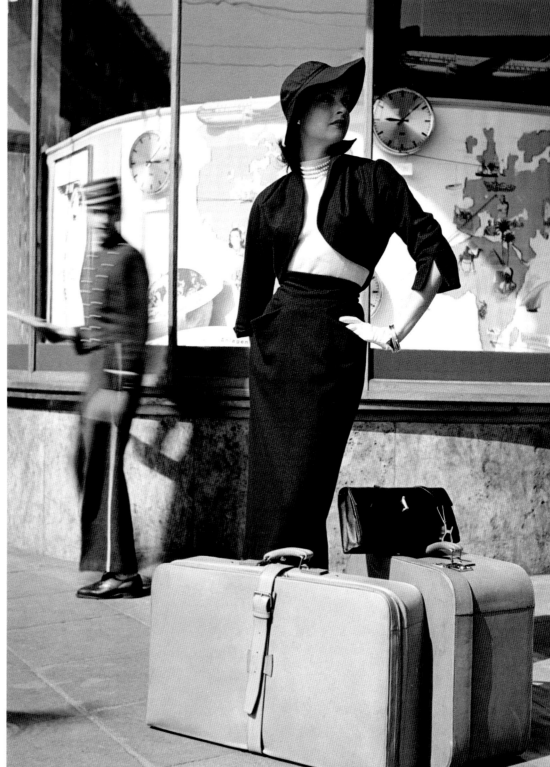

Nadja Tiller for Heinzelmann en Vogue, Stuttgart 1952, in: *Elegante Welt* 9/1952

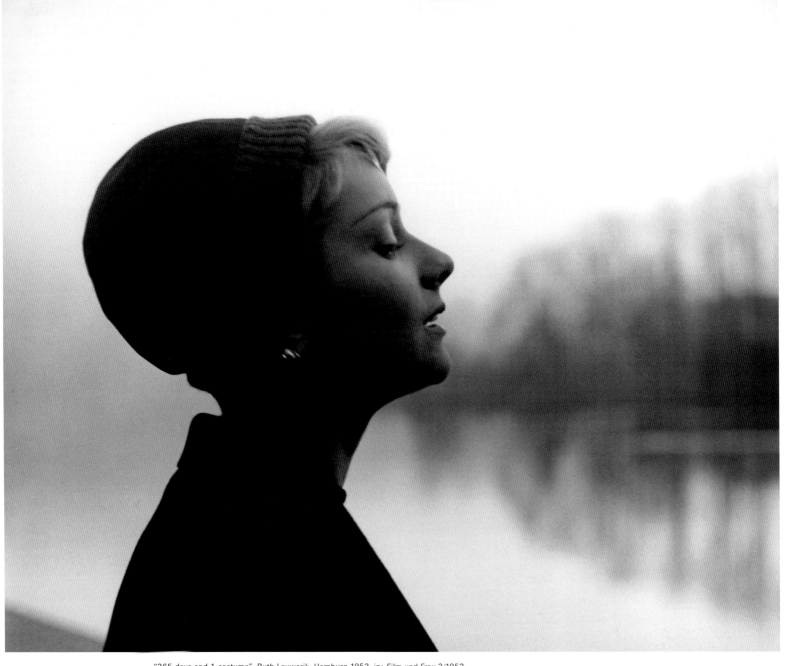

"365 days and 1 costume", Ruth Leuwerik, Hamburg 1953, in: *Film und Frau* 3/1953

same model, including reproduction rights. A paper-cut pattern of the design cost 10.000 French Francs for professional visitors – the price of the admission fee. Prices for couture dresses shot up rapidly: In 1954, the average price for a daywear dress by Dior had already risen to 125.000 French Francs."[28] The buyers, namely the representatives of Americas most prestigious fashion stores, soon came to be crucial players in the game, thanks to their enormous supply needs and large budgets. The US fashion press was equally influential. With breathtaking photographs and superbly written articles, they sparked the curiosity of the most well-healed clientele at the time for the latest creations from the Paris fashion design-ers. "No fashion event could begin until the editors of 'Vogue' and 'Harper's Bazaar' had arrived at the show. The best sofas were reserved for them at all times. Only when photographers Louise Dahl-Wolfe and Richard Avedon, Carmel Snow – the empress of the American fashion press and directrice of 'Harp-er's Bazaar' – and her French assistant Marie-Louise Bousquet had taken their seats could the spectacle begin."[29] The rules of the game required that only buyers and representatives of the fashion press were admitted to the initial shows. This was followed by a three-month moratorium during which all they had

seen was strictly confidential. The intention was to make sufficient time for the industry to reproduce the purchased styles so that they would be available in department stores in time for the official "enthronement" of the latest fashion.

Having turned his professional attention to the glittering phenomenon of fashion, F.C. Gundlach was not only one of its most avid, but also most brilliant illuminists. Only photography can provide the glamour fashion requires. Gundlach swiftly adapted the established repertoire of fashion photography and added to it the aesthetic moments which young American photographers had used to pep up the genre. However, he allowed less room for manoeuvre than fashion photographers from overseas. Material resources were more scant and the aesthetic ideas of his clients more conventional. Yet literature on fashion photography overrates this. For on the one hand, Avedon, Dahl-Wolfe, Penn & co. worked for elitist magazines with well-established traditions, comparatively low print runs and an exclusive readership, while Germans worked for magazines with a clientele that was by no means sure of its social position. The female readers of American magazines came from a socially established upper class. This class also supplied the buyers of the original models in the fashion houses. That which was at best tailored to good taste was simply not acceptable for the elitist *Harper's Bazaar* and *Vogue*. On the other hand, international monographs on fashion photography contain only the top achievements of British and American photographers. Moreover, their authors strive for a primarily aesthetic, artistic perspective. Yet the most popular photographs neither reflect the current standard of the magazine nor are representative of its writers' work. And neither do they give the faintest hint of the internal conflicts between photographers, editors and advertisers which even occasionally blew up at *Harper's Bazaar* and *Vogue*. Some unusual photographs disappeared into a drawer and only advanced into incunables much later.

Fashion is a complex system[30] of conflicting vectors on a plane that has by no means a fixed outline. Fashion photography is no exception. As Roland Barthes noted: "Fashion, like all fashions, depends on a disparity of two consciousnesses, each foreign to the other. In order to blunt the buyer's calculating consciousness, a veil must be drawn around the object – a veil of images, of reasons, of meanings; a mediate substance of an aperitive order must be elaborated; in short, a simulacrum of the real object must be created, substituting for the slow time of wear a sovereign time free to destroy itself by an act of annual potlatch."[31] Fashion journalism gives fashion a meaning, a significance, through which the above-mentioned potlatch, the suicide owing to the inevitable emergence of a new fashion, understandably becomes necessary.

Fashion photography is a discipline that constantly has to navigate its way between the Scylla of the existing conditions of a job and the Charybdis of subjective, aesthetic ambitions. Like Odysseus, F.C. Gundlach steered his pictures through the cliffs with a rare sense of the existing possibilities. Even his most artistic pictures satisfy the key requirements in terms of the elementary characteristics of fashionable clothing, namely the cut, quality of fabric, wearability and details. Nonetheless, there is no lack of aesthetic sophistication. And in terms of demonstrating a sense of release and elegance, they certainly bear comparison with Penn's eminent fashion photos. Be it the 1950 fashion portrait of the supernaturally beautiful Simone d'Aillencourt, with shining eyes and wearing a dyed beaver fur coat, her arm gracefully resting on the cool metal of a convertible car; be it the breathtaking shot of Lo, taken in 1954, with her face tilted slightly upwards, in a wide-cut ocelot coat that drapes behind her in a diagonal line in front of the rear contours of

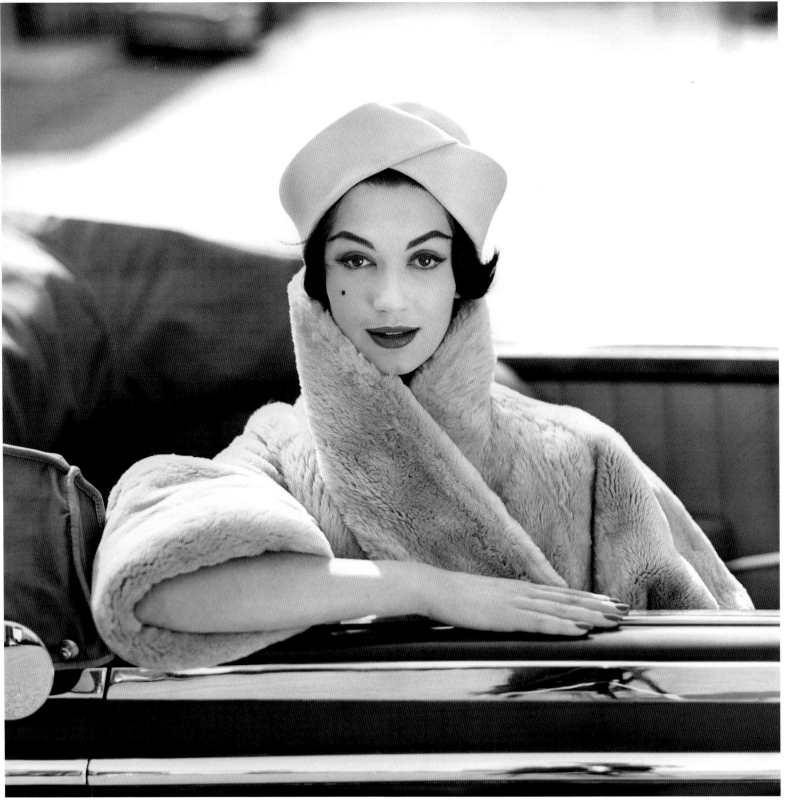

Simone d'Aillencourt, light beaver coat by Pelz-Maier, Frankfurt on the Main 1950

a black limousine. They radiate lightness, a sense of naturalness and stylistic originality; a striking sense of security in working with the models; an amazing ability to help them dominate the shot; a feel for casual performance and a memorable and yet discriminating visual rhetoric. Both these photographs demonstrate a tension between the clear, constructive arrangement and the different textures of the details. Gundlach knew like few others how to appeal to the observer's sense of touch in his pictures. He is as brilliant at depicting fur coats in his fashion photographs as the painter Frans Hals was at reproducing lace from Brussels. Fur must not be too shiny, so that it won't look trashy, the photographer explains.[32]

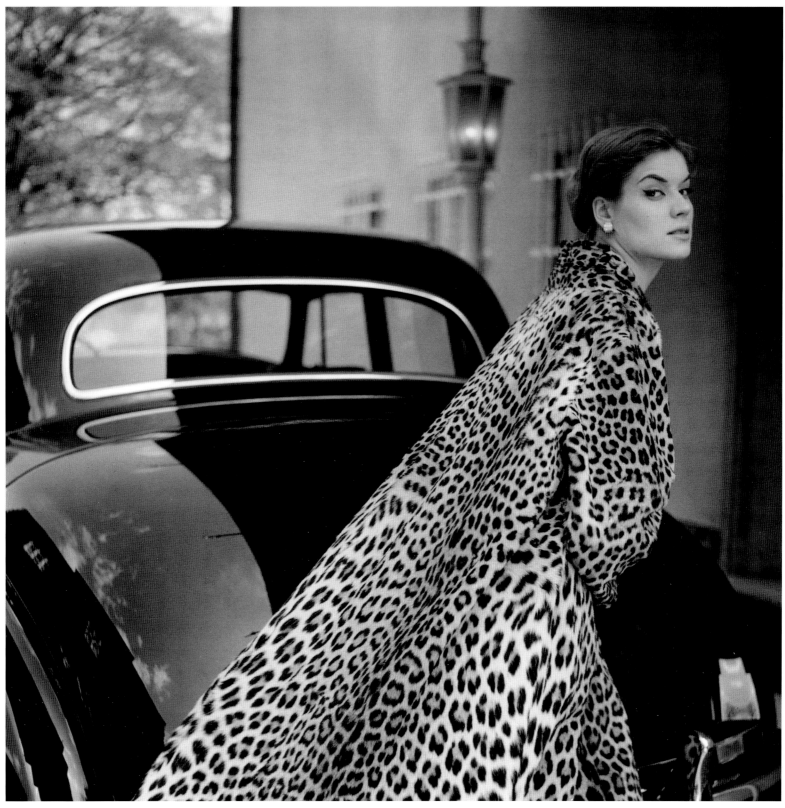

Lo Olschner, ocelot coat by Berger, Hamburg 1954

Gundlach often used distorting means such as zoom lenses or, even before it became common practice, wide-angle lenses. In general he experimented incessantly with the possibilities of photographic technology and the formal organization of images. Symptomatic of his unconventional style are distorted proportions, for example, the giant model in front of the tiny Pyramids or, vice versa, the thumb-sized model next to the colossal body of a jet. Likewise, he understood the established conventions of the medium's genres and methods as an opportunity to explore unknown territory. Portrait, landscape, journalistic and documentary photography all merge into one. Moreover, he often varied visual effects used in painting.

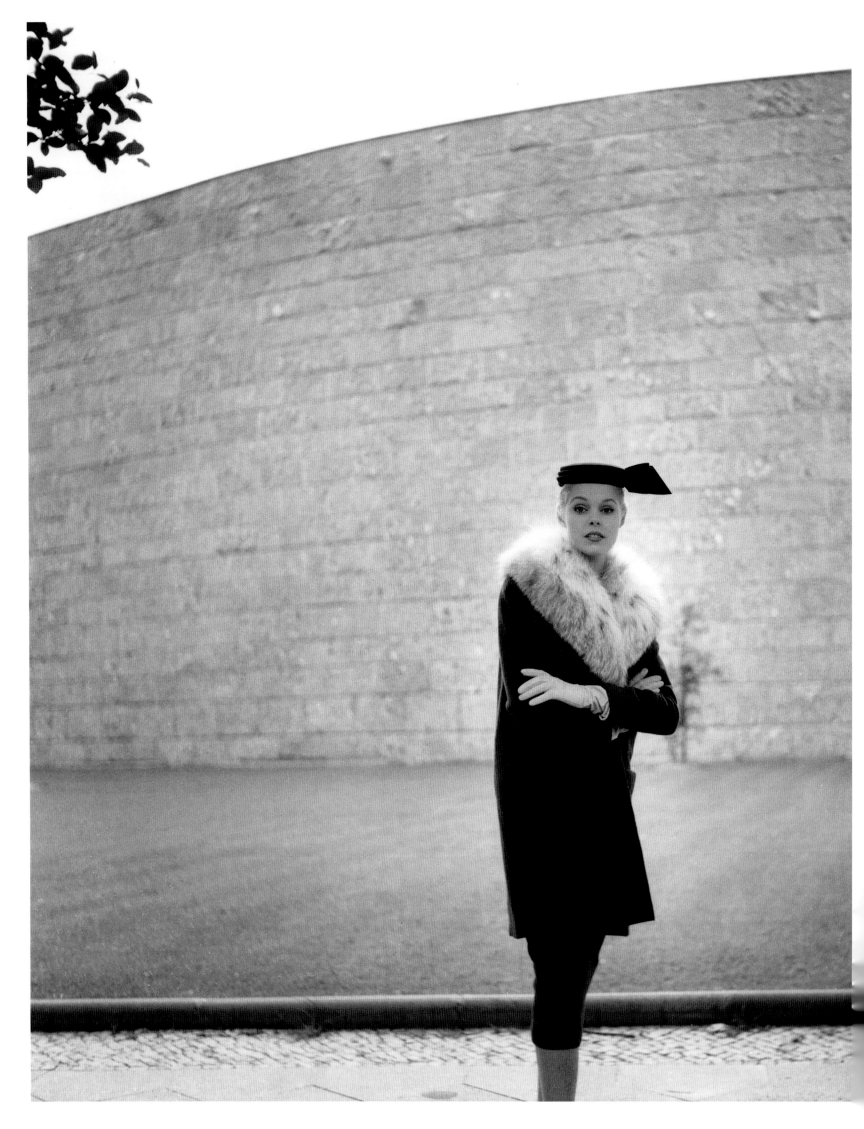

With an ironic nod, the 1955 photograph "Regen-wetter aufgeheitert" (rainy weather brightened up) references Gustave Caillebotte's magnificent painting "La Place de l'Europe, temps de plui, 1877". Wearing stylish hats and raincoats, three beautiful women are posing under their striped umbrellas in front of a cityscape in Berlin that is fading away in the gray; the one in the middle is facing the photographer, while the two on the left and right are taken in profile, striding out ahead. They are acting on a fragmented, intricate pavement that is glittering with rain. The realism of the setting provides a stark contrast to the models' elaborated poses. Despite the evidently bad weather bad, the shot with its silhouetted figures conveys a cheerful and relaxed atmosphere. In contrast to this, the 1963 photograph of Gitta Schilling, depicting her in front of a pram, openly alludes to attitudes of journalistic photography by combining a fashion pose with a snapshot situation.

While he worked as a photographer, F.C. Gundlach observed, followed and portrayed a dramatic change in the image of women. This change was not restricted to the Western hemisphere; rather, it assumed global dimensions and is by no means over yet. In the 1950s, the fashion scene tended to be dominated by the image of the distinguished lady who was reserved, elegant, slightly stiff, young, yet a far cry from being youthful, feminine, erotic or overly body-conscious. Following the end of the war, however, young women became increasingly vibrant, down-to-earth and attractive, adventurous, and high-spirited. Aware of her sex appeal, they certainly knew how to flaunt it. This image, which had originally emerged in the U.S., now swept across to the European continent. These new women had more sex appeal than her movie counterparts, who assumed the role of "best pal". They were less sterile than the "pin-up girls", but not as lascivious as the "nymphs", to name some other examples of the role patterns in contemporary cinema.[33]

The new model was an independent figure of fashion photography. She paved the way for the high status of her successors who became super and mega stars. She changed her "type" according to her fashion outfits she and thus usually slipped into the role of another person. She was pretty, casual and also cut a fine figure in an evening gown. However, it was her body language that set her apart from her predecessors. Models such as Suzy Parker or Elise Danials alias Dovima, who filled Acedon's fashion pictures with their vibrant radiance, pointed the way. In fact, models also became younger-looking with every new decade. The photographer David Seidner found the perfect words to describe this new type of model: "What comes across in her photographs is her great openness, her casual, trusting character, her spontaneity and her highly intelligent expression. And a deep understanding of what we might refer to as the art of the unfinished movement that only very few models master – this pausing like in a freeze frame, a split second before the action is completed, which allows viewers to complete the photographs for themselves, to finish the story that is hinted at, to read the picture on different levels."[34] Although Seidner's words were meant for Lisa Fonssagrives, a model from Blumenfeld, Horst P. Horst and Penn (whom she married), they are universally valid. Actresses should have the above-mentioned skill for professional reasons. However, Gundlach denies this: "[…] it is difficult to produce fashion photographs with actresses for they are used to continuous acting. It is a model's skill to move in sequences, in intervals, almost like in a cartoon."[35] Regardless of whether it was the models or the fashion world that provoked these changes – both are merely the visible embodiment of profound social upheaval.

Against the backdrop of the so-called "Cold War" Western societies achieved economic prosperity unprecedented in their history. The inner-European

Grit Hübscher, ensemble by Staebe-Seger, Berlin 1954

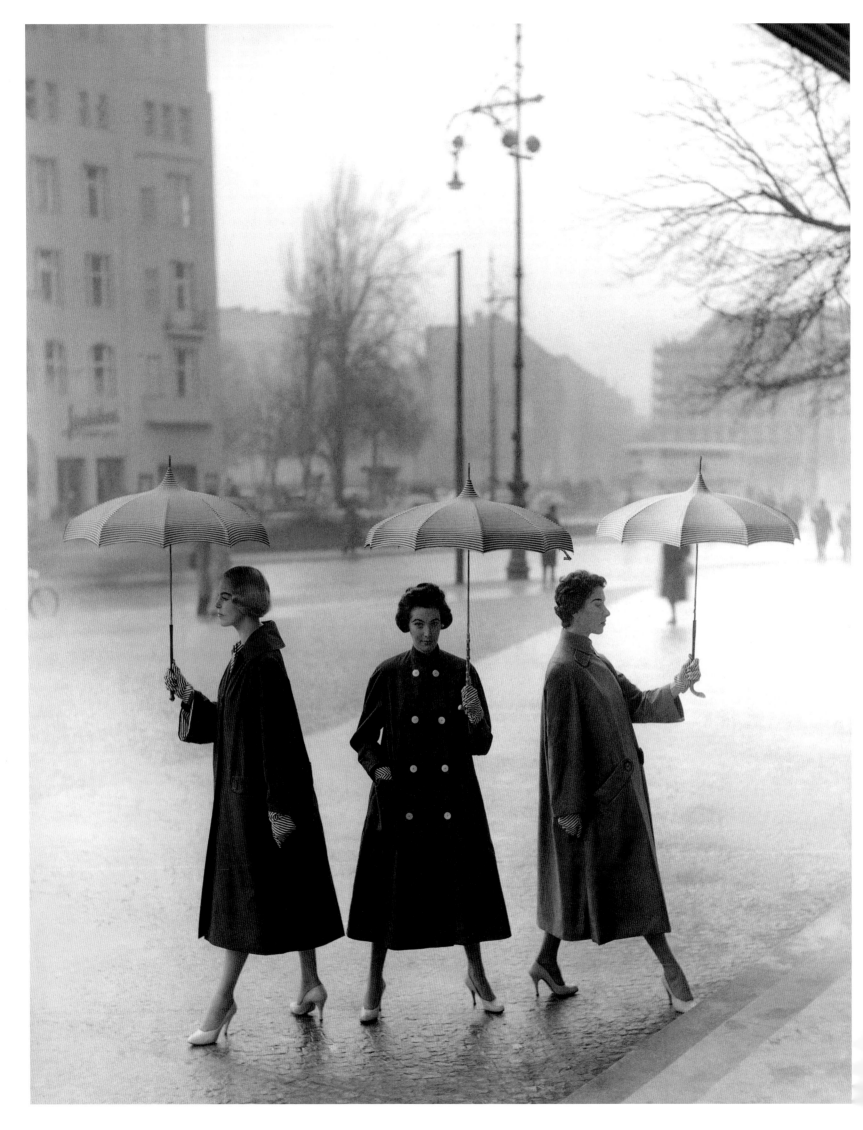

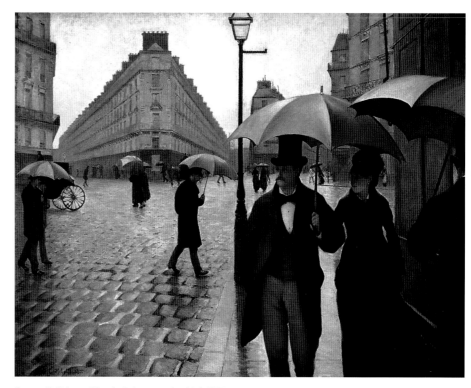

Gustave Caillebotte: "Rue de Paris, temps de pluie" 1877

borders began to open up and the continent grew together economically, politically and culturally. However, the "Cold War" also had its hot phases and prosperity developed at a different pace in different countries. Scarcity societies became welfare societies. This resulted in the erosion of traditional social bonds, forced individualism including the constant wish for self-realization and, so to speak, as a mirror image trend, the loss of self-driven personality development, giving way to the multifaceted masks and role play witnessed in late modernism.

Social developments became manifest in fashion only subliminally. Fashion crystallized into a self-referential system like art or economics, a self-referential game. Moreover, fashion provided a range of instruments that cleverly channelled the challenges posed by the real world – or, more precisely, that turned them into emblematic surrogates of social processes. For example, it assimilated the mass protest of the young generation – which manifested itself at first in popular music and, with some delay, in the streets of the metropolises in the form of raging battles with the institutional law enforcement agencies – with the real as well as virtual rejuvenation of the models.[36] This was combined with a strong youth culture and the adoption and commercializa-

tion of significant elements of both the fashion and mentality of protest. It was also accompanied by an acceleration of living conditions with a stark increase in factory clothing production, in mass-produced, cheap ready-to-wear clothing, and a sudden acceleration of changing outfits, for example, with mini, midi and maxi skirts following the rhythm of the seasons. Simultaneously, the European textile industry shrunk as the manufacture of clothing was transferred to so-called low-wage countries. For the same reason, changes in mass-produced fashion at the beginning of the new millennium were limited to details and nuances.

Even though F.C. Gundlach's photographs communicate these profound social changes merely by way of mediation, the extent to which they are characterised by the atmosphere of the era is nonetheless astonishing. This atmosphere is the result of carefully staged fashion, models, setting and central image elements image. Irrespective of the fact that the fashion is the key motif, the photographer pays just as much attention to those factors. In this combination of coordinated image elements this fluent sphere of ideas, emotions and yearnings objectifies itself. Usually covered up by factual events, they nevertheless shape our psychological connection with the world.

"Rainy day made bright and gay", coats and umbrellas by Staebe-Seger, Berlin 1955, in: *Film und Frau* spring/summer 1955

This sphere becomes evident in the topic of travelling. The vehicles and destinations of a journey reoccur in Gundlach's shots in chronological order as early companions of mass tourism. Railroad, bus and car (symbol of individual independence), ship and airplane; Paris, Italy, New York, the Canary Islands, Africa, the Middle and Far East, the Caribbean and South America. Fashion and mobility are closely linked. "It is, first and foremost, a movement of today's society", sociologist René König analyses, "which encourages a considerably accelerated development of fashion, in other words, the movement we call 'social mobility' today. Social mobility means more or less a solubilisation of society, which [...] has been undergoing extraordinary change both internally and externally."[37] Travelling enables people to liberate themselves from traditional social bonds and get to know the unknown. Desire is its driving force and like fashion it is a key factor within the social "wish-fulfilling machine". Motion and emotion correspond to each other, motion and moving. "Being on vacation is a transition from collectivity to individuality; [...] this means that the subject positions himself autonomously in its social world or landscape. The self-positioning is simply a symbol of modernism [...] People, even if by no means everyone, are gradually developing from *homo faber* (man as a 'maker') to *homo ludens* (man as 'player') by seeking the most suitable form of self-realization (significantly, 'Homo ludens' by Huizinga was published in 1955). [...] In the 1960s, the breakthrough of leisure time as a significant source of life and identity building followed on a broad basis."[38]

The changes in the models' performance, the obvious permissiveness and relaxed demeanour that became evident in their body language and had resulted from the increasing liberalization of customs are as conspicuous. When Penn and Gundlach explain independently from each other that fashion photographs are a mirror of collective dreams this is not entirely conclusive. For the dreams they conveyed could actually be fulfilled by the increasing prosperity. It was rather about yearnings that had a chance of becoming true, about products of the imagination. "[...] it is not the object but the name that creates desire; it is not the dream but the meaning that sells."[39]

Gundlach was a master of constructing things that conveyed such a meaning. His ability to connect the photographed fashion in terms of content and form with the manifold appearances of the setting becomes evident in many outdoor shots. Occasionally, the model's pose is a paraphrase of the peculiar form of a building in the background of the picture or of the specific atmospheric circumstances; at times the road traffic, at others a jazz club, disco, casino or race track.

On the other hand, the photographer strives for a sometimes openly conceptual approach towards his subject by including the material preconditions of a construction in the picture, the lamps, wires and struts of the studio, the film reel, or he makes abundantly clear that he has worked with photo wallpaper, back projection or indoor mounting. Even if his use of what is randomly available at times seems to be owed, above all, to time pressure and other forces, it is actually constitutive of the photographer's aesthetic approach. Thus Gundlach accentuates fashion as an artificial phenomenon. Since the late 1960s, fashion has become a game that in itself functions as a game, in short: a game playing a game. And Gundlach plays along, also in a playful way. Therefore, many of his published pictures turn out to be sensitive exercises of a "perceptive seeing" (Max Imdahl).[40]

To show one example, this is the great series of the first spring collection by Courrèges in the style of the mini (1965). Here, the photographer's and designer's intentions and the accurate poses of the models seem to comment on and intensify each another with the

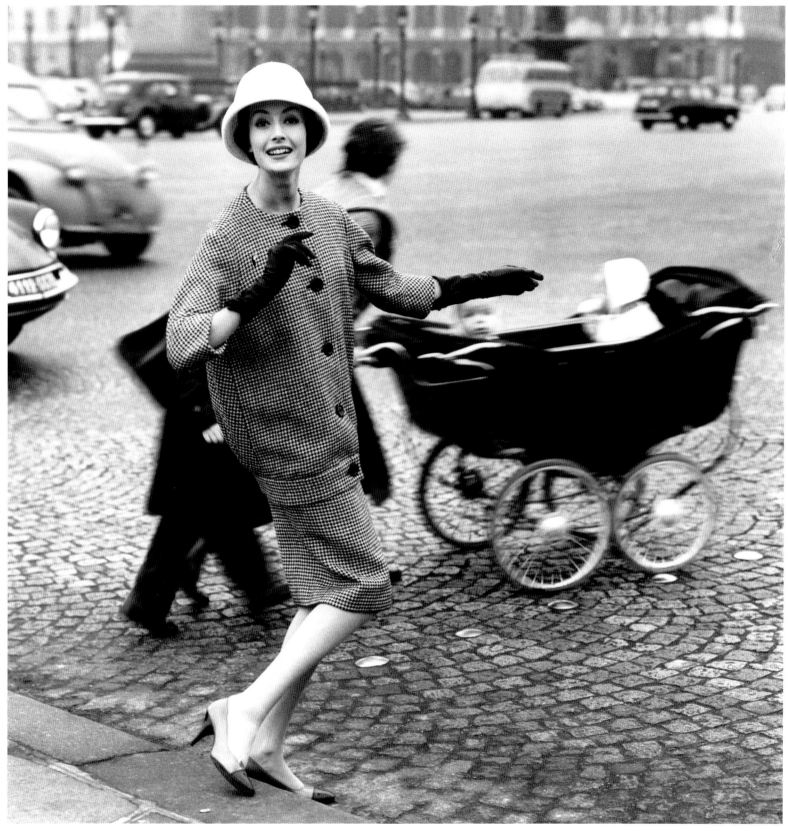

Gitta Schilling in a cardigan, Paris 1962

language of form. The orchestration is in fact real-
ized in the clothes alone. The orchestration over-
rules their function. In these high-spirited shots, in
front of a neutral background, the models are acting
like characters in a comic strip but without losing
their human charisma. The fact that Gundlach was

a professional photographer makes this evident aes-
thetic, artistic attitude all the more astonishing. He
carried out commissioned work and never lost touch
with his responsibility of photographing fashion in a
way that made its crucial features immediately rec-
ognizable. In 1965, F.C. Gundlach had signed a pre-

contract with *Brigitte* magazine. Due to changes the publisher had made to the editorial staff his relations to *Film und Frau* Magazine had cooled off. His work in advertising and for other glossy magazines did not influence his commitment. He even created many of his "most liberated" pictures, the occasion for which has by now become irrelevant, for the companies Falke and Pelze Berger. Nine years before, he had moved from Stuttgart to Hamburg, where the biggest publishing houses had set up their headquarters and Germany's most important tabloid was also edited. *Brigitte* did not only open a new chapter in the photographer's career – the magazine's success story coincided with a turning point in the history of fashion. Its most striking symptom: "Young people in the Western world have by now become the top leaders of fashion and role models of society *par excellence*"[41], something that did not change in the following 50 years. As the selection of his models[42] shows, Gundlach had adapted to this fact.

A colour picture from the myth-enshrouded year of 1968 depicting the model Beschka condenses in her face the transition from ladylike haute couture to a young and natural trend in fashion photography. The young woman became a role model for a whole generation that had freed itself from the constraints of long outdated social norms.

With his pictures intended for publication in *Brigitte* the photographer addressed a different clientele than in *Film und Frau*. Regular surveys carried out by the publishing house provided a "profile" of its readership. "Overall, the 'typologies of women' show that there are different types of women who read 'Brigitte' [...] However, regarding personality traits, a particularly high number belonged in the categories of 'independent' and 'young and active' women, while fewer readers could be assigned to the other four types: 'self-sufficient', 'discontent', 'easy to please' and 'undistinguished'.[43] The self-advertising char-

acterized the readers as interested in many things, adventurous, rather emancipated, curious about trying out new recipes, slightly narcissistic, in any case "women who [were] more critical, self-confident and free-spending than the average".[44]

The characteristics assigned to the *Brigitte* readership could be equally those of the models who in Gundlach's inspirational shots are flitting all over the world; young, attractive, rascally or dreamy, depending on whether pop, flower power or elegance was in fashion. The photographer, who filled the better part of the magazine's fashion features, many of them almost single-handedly, virtually threw himself into a flush of creativity. 1966 was an extremely fruitful year and he produced an abundance of magnificent pictures.

While F.C. Gundlach and his crew travelled from continent to continent, in 1966, West Germany's two largest parties formed the first Grand Coalition since the war and thereby sealed the true end of the Adenauer era. The representational figure of the "economic miracle", Ludwig Erhard, had failed politically as his successor and the curve of the economic upturn had momentarily dipped. The Vietnam War in the Far East escalated; there was growing unrest among university students in the Western hemisphere; the Cultural Revolution was raging in China. Herbert Marcuse published his *Repressive Tolerance*, the perfect manual to analyze the real conditions under capitalism which fashion had obviously helped cover up.

We would not be exaggerating if we said that a whole generation of young women in the German-speaking world got to witness the world of fashion through Gundlach's pictures (and a mirror-image of themselves). In 1985, *Brigitte* was Germany's top-selling women's magazine; professional surveys estimated the number of women who exclusively read *Brigitte* at 2.88 million. Gundlach was the magazine's

"Summer in furs", Deborah Dixon, broadtail poncho by SWA, Beirut/Lebanon 1963, in: *Quick* 3/1963

next spread: "The line of fashion", Püppi Döhler, ensemble by Staebe-Seger, Berlin 1956, in: *Film und Frau* spring/summer 1956

Simone d'Aillencourt, costume by Lindenstaedt & Brettschneider, Berlin 1957, in: *Film und Frau* spring/summer 1957

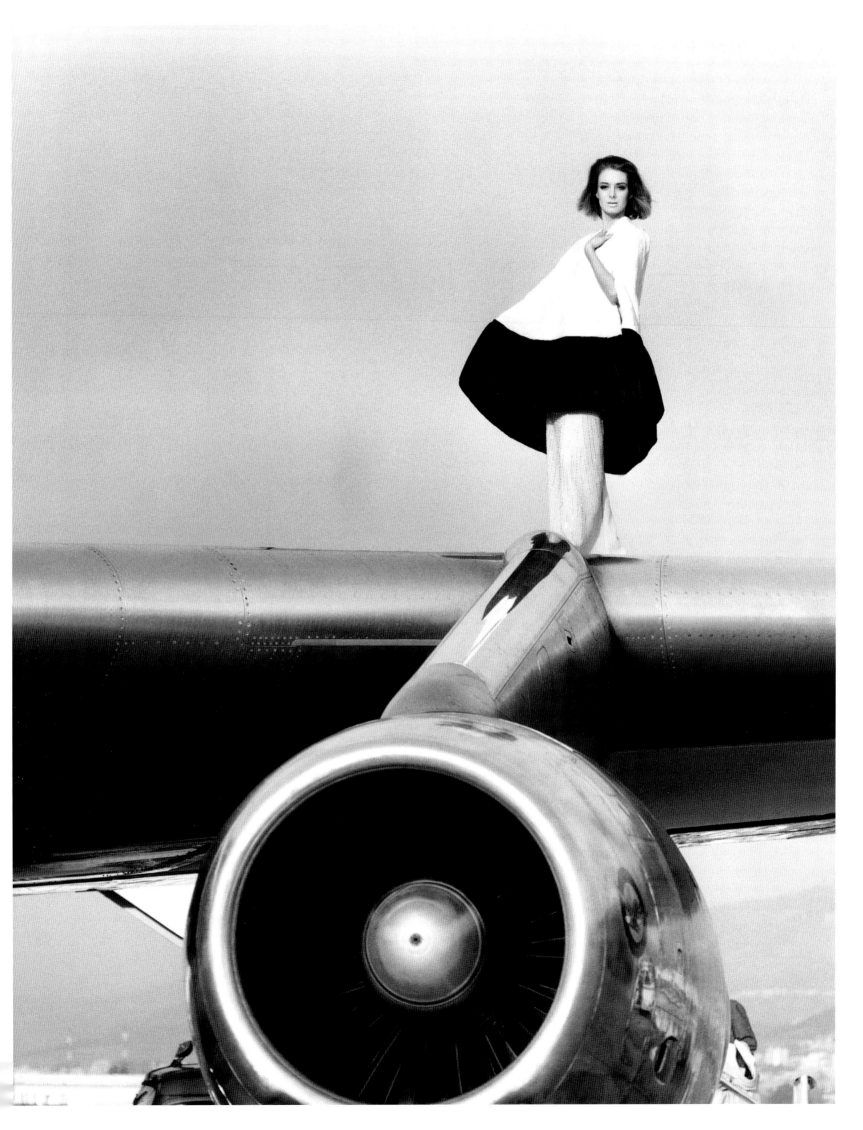

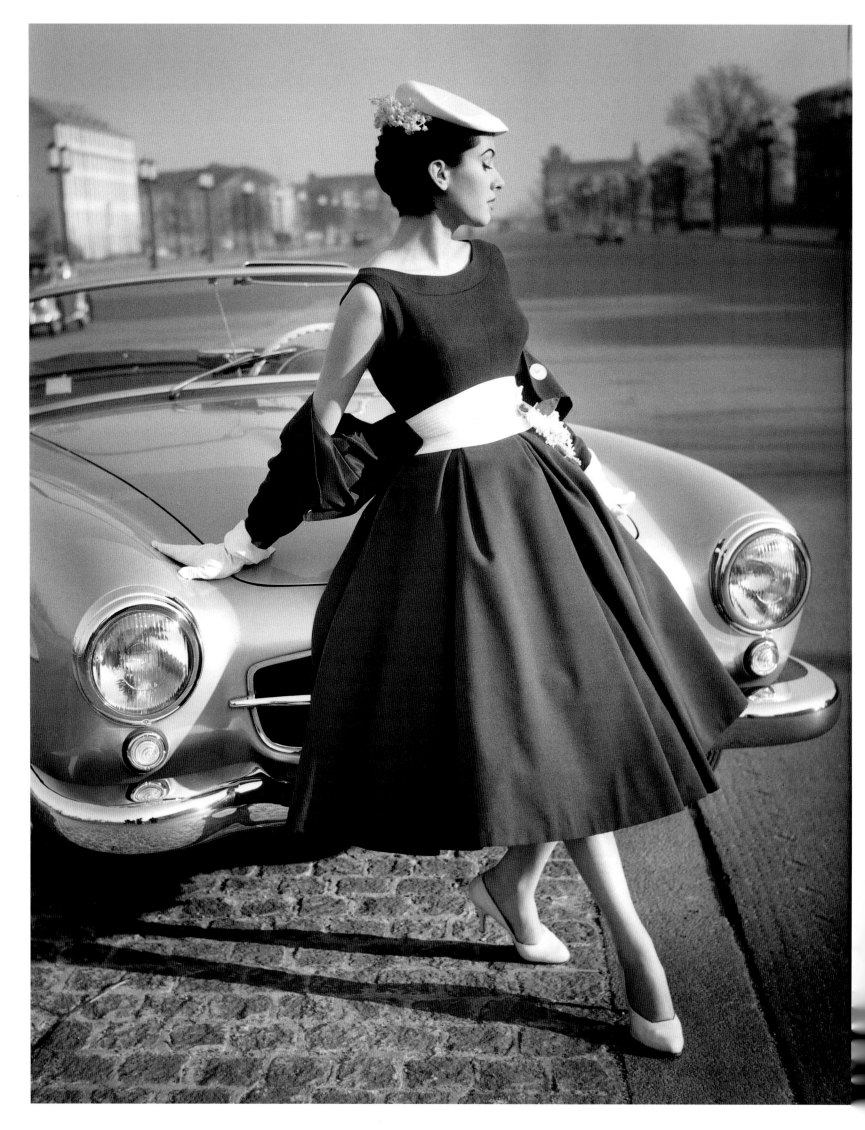

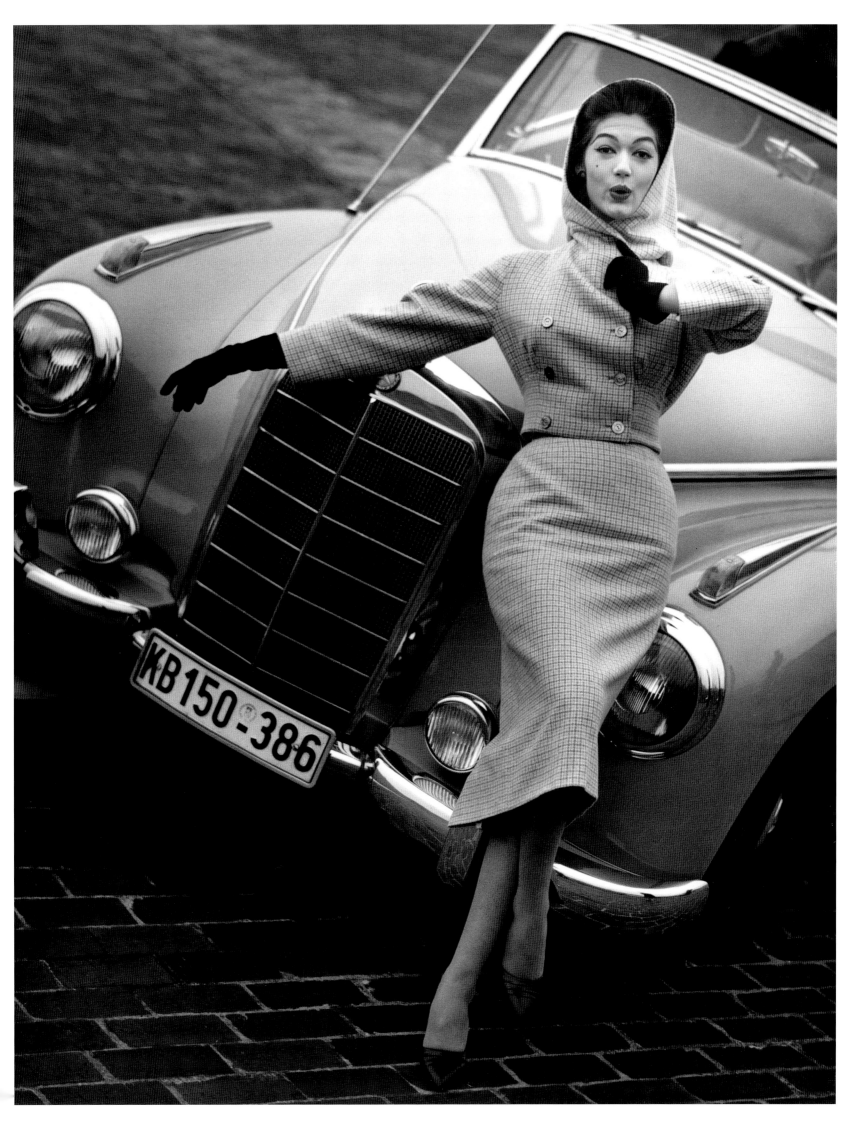

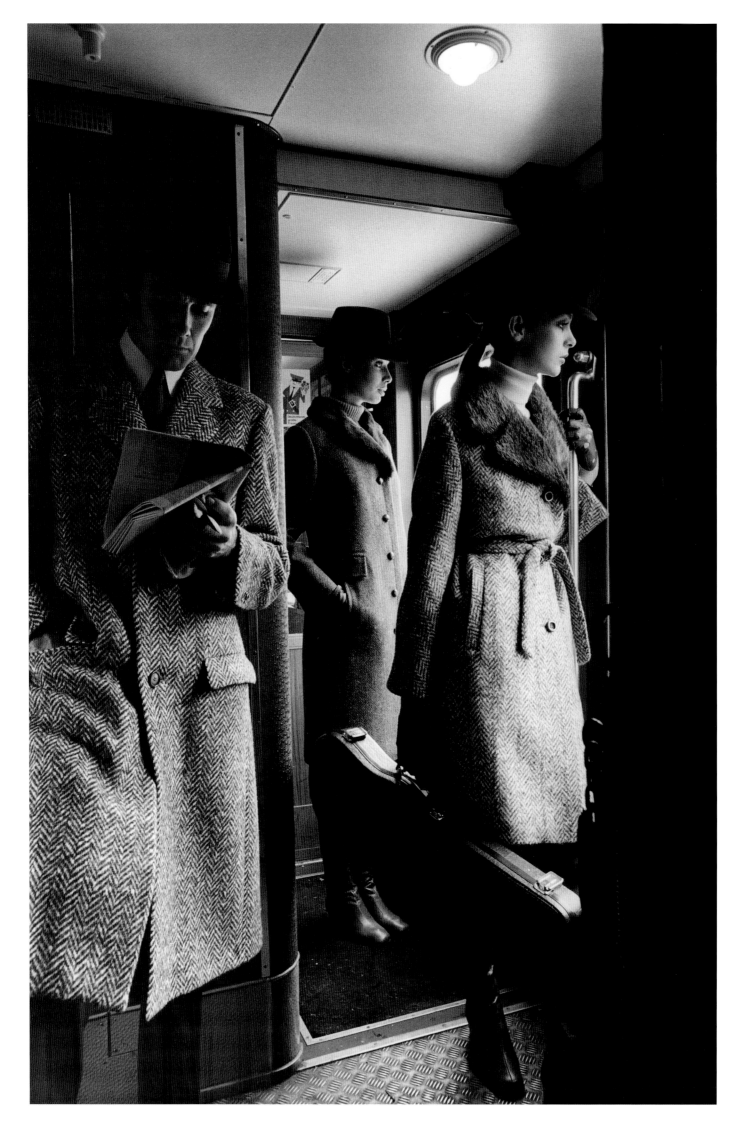

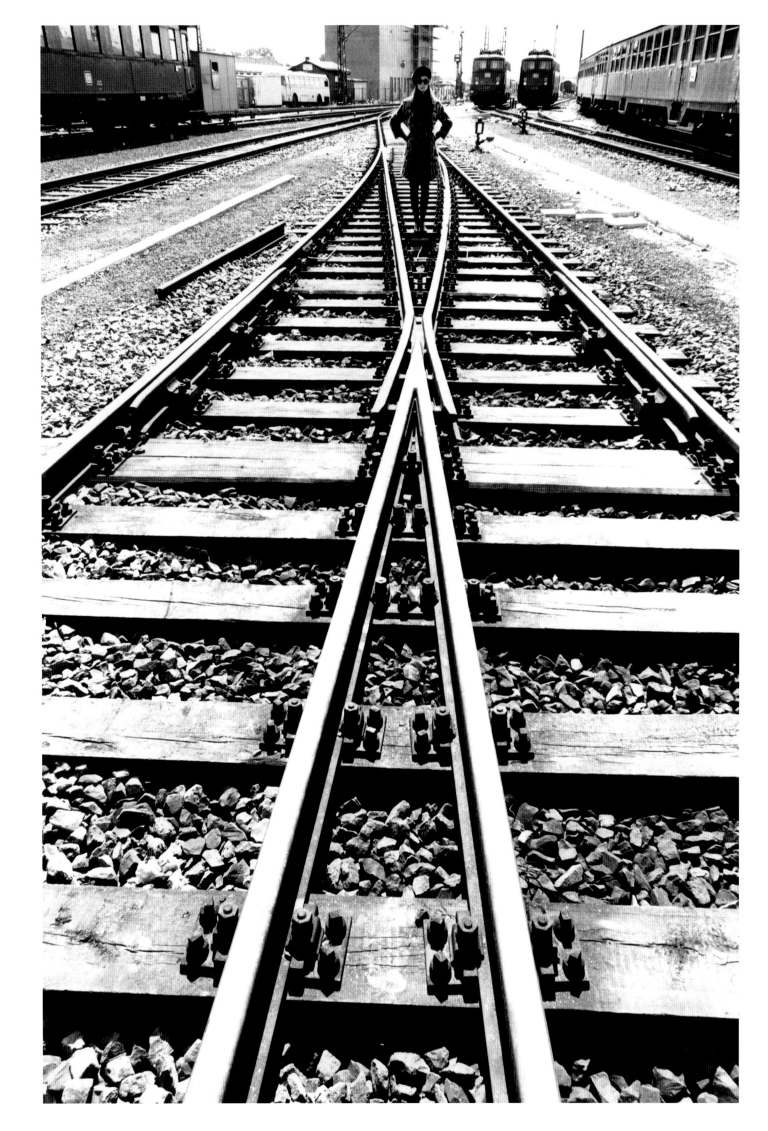

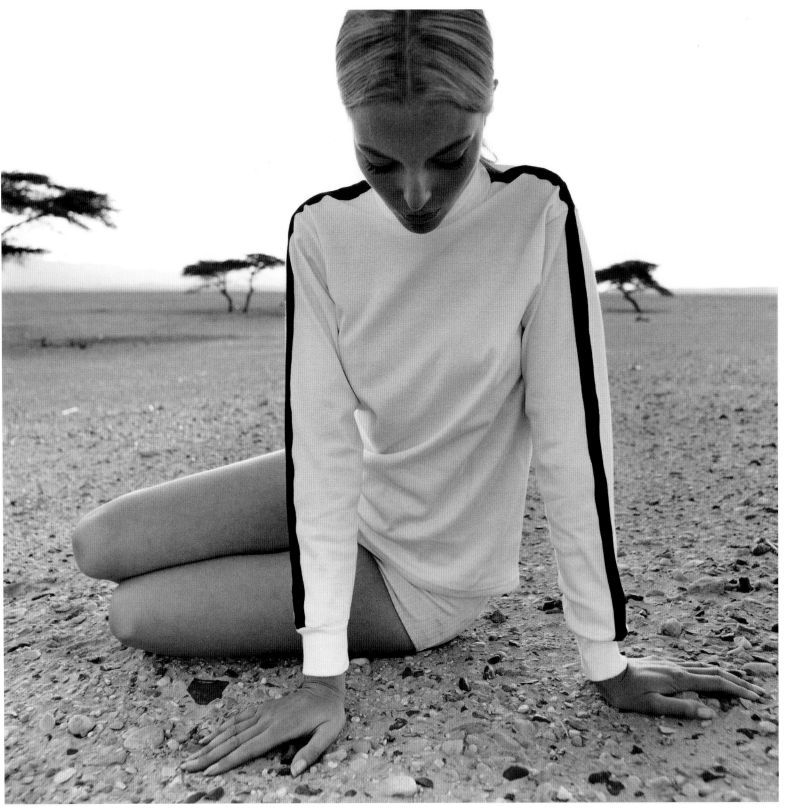

Ann Zoreff, pullover by Heinzelmann, Kenya 1966, in: *Brigitte* 8/1966
previous spread: Birgitta, Gloria and Patrick, Hamburg 1970
"On the tracks", Hamburg 1968

leading photographer and his pictures certainly increased the magazine's circulation.

Undeniably, the wide circulation also caused pressure resulting from high expectations that were adverse to experiments and flamboyances. Gundlach

was not spared conflicts, even if they rarely broke out. A production for swimwear in Egypt provoked the objection of Peter Brasch, Editor-in-Chief of many years, for being too ambitious. However, one of the shots, taken in 1966, ranks among the photog-

"The Cheops pyramids", Karin Mossberg and Micky Zenati in Op Art-Fashion, Gizeh/Egypt 1966, in: *Brigitte* 8/1966

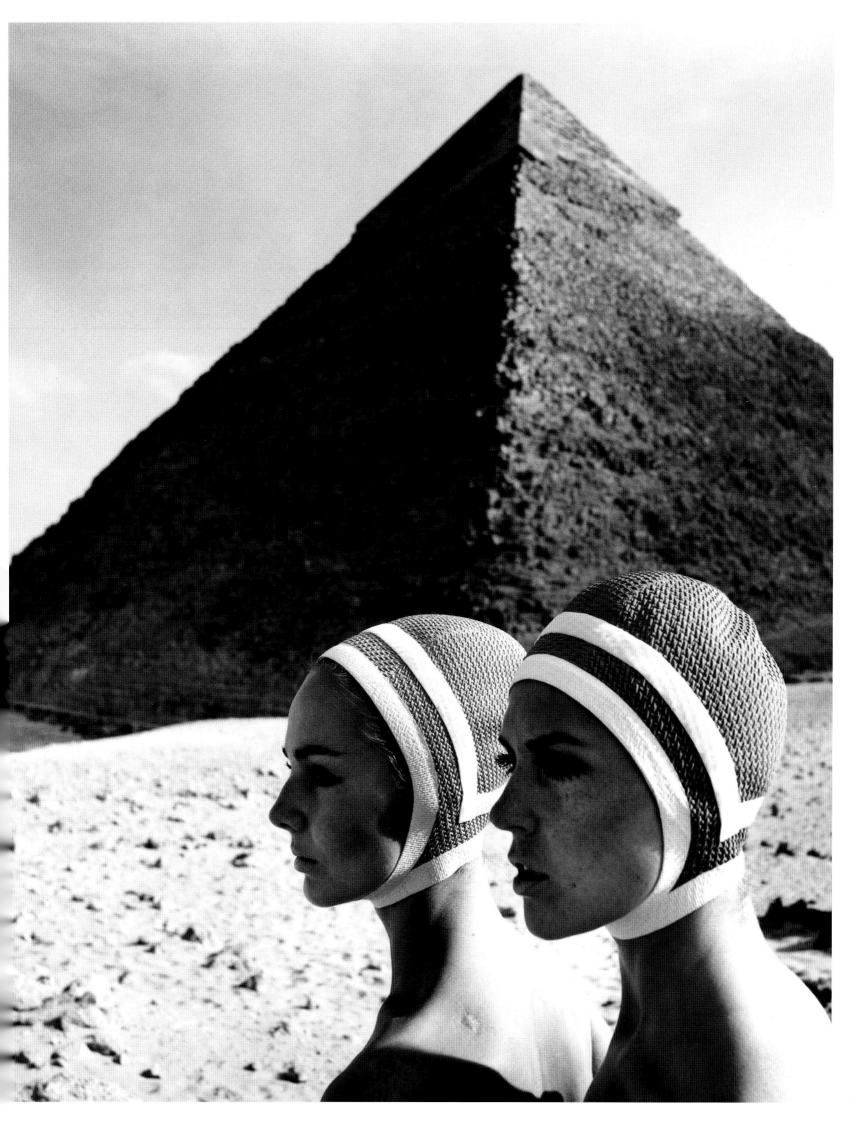

rapher's absolute masterpieces. It shows two heads in profile with identical bathing caps in the lower right half of the picture, in front of a looming pyramid – two round heads and a pointed one, as it were. Complexity and conciseness, the crucial ingredients of any picture, are beautifully combined in this shot. Gundlach achieved effects of extreme simplicity and refinement, his images are perfect as regards the distribution of forms, lines and masses. Thanks to Barbara Buffa's power of persuasion the pictures of this lavish production came to be published after all. The compromise was made in the title: Spending a day on the beach (!).

"Stylish and easy-to-wear" was the fashion editors' motto. In terms of fashion, they steered a middle course.[45] Likewise *Brigitte* refused to promote the aggressive "exploitation of the flesh" (a phrase coined by Thomas Wagner), its vulnerability and the morbid invocation of the abnormal that advanced fashion photographers such as Newton, Bailey and Guy Bourdin in France, England and Italy had been insisting upon since the 1970s. Fashion photography branched out in two ways: While fashion focused primarily on changes in the detail, the naked female body became the preferred object of fashionable change, emphasising its bright and its dark alike. Raw sexuality replaced the erotic aura. The naked skin replaced the clothing material: life-style photography instead of classic fashion photography.

F.C. Gundlach kept to his structural style that still maintained a certain distance. He made reductions whenever it was possible and achieved an expression of utmost refinement in his pictures. His 1966 image "Ann Sorev im hellen Oberteil, Kenia" fills the frame, the top half of her head cut off, she is sitting on the desert soil, twisting towards the left and looking at the countless little stones on the ground. The model is propped up on her hands. Her legs are bent. The aforesaid top drapes gently and smoothly around the

hardly modulated upper part of her body. A thin, dark stripe runs down from each shoulder to the armbands. Like a modern painter, the photographer uses them as additional broad contours. Thus, a tense relationship between concrete and abstract representation arises, which feeds into a textured contrast. The top's fabric, the model's skin and hair and the karstic ground, each in themselves representing another, a different tactile sensuousness and the latent, erotic tension between covering up and revealing are the elements of which the image is composed. The wind-tousled trees in front of a diffusely white sky highlight the subtle melody of this formidable black-and-white picture.

Gundlach also took a similar approach as regards the use of colour, which gradually conquered the world of fashion photography. Never shrill, they reveal his extremely subtle sense of colour. The clear shining light which seems to fill the pictures from the inside and which the observer seems to feel on his or her own skin is another aesthetic feature of his art. The light appears to be almost corporeal. In these pictures, the models take on the role of distinctive identities, neither mutating into coat stands nor personalities who, according to Barthes, in art are always composed from several characteristics.[46] His impressive portraits of the models ranging from the wonderfully seductive Wilhelmina to the fresh, austerely melancholic Karin Mossberg all the way to the nymph-like unknown model put the rule to the test. Also in fashion photography F.C. Gundlach is a most sensitive portraitist – of individuals and of society. Well into the 1970s, the photographer "documented" the change of clothes in fashion and varied his repertoire often and in an original way. He built a successful business, opened a gallery and bookshop, started assembling an extraordinary photography collection and taught photography as a university lecturer in Berlin. His most influential

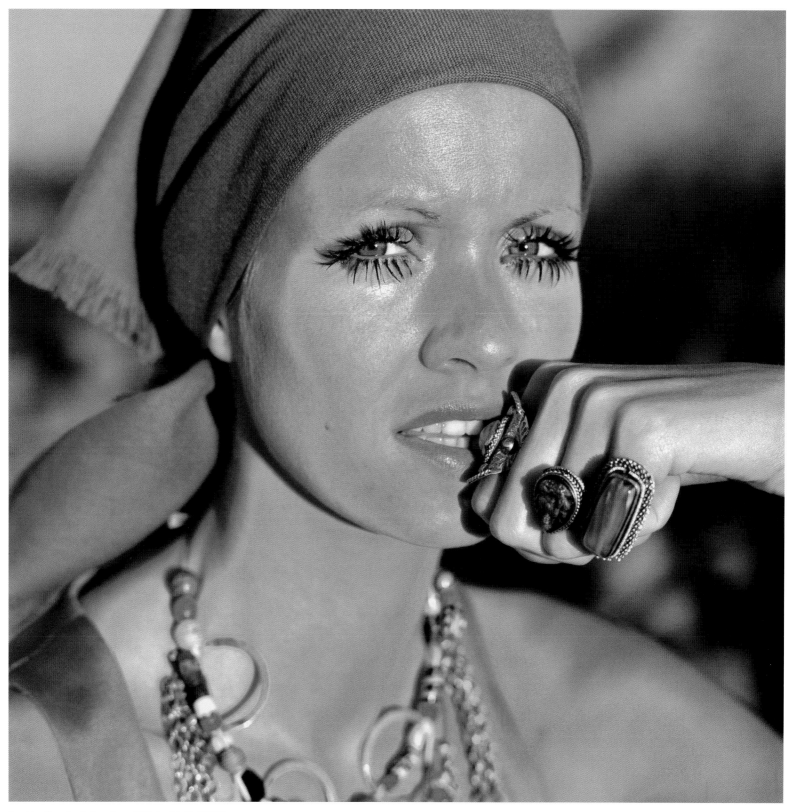

Beschka, Gipsy-Look, Cape Town 1969, in: *Brigitte* 9/1969

contribution to the aesthetics and history of fashion photography, however, is the structural-functional visual language: a visual architecture which despite all endeavours to achieve an aesthetic effect with a picture does justice to the motif. Form and content do not drift apart. Therefore, his shots have survived the perpetual potlatch of fashion in superior style and have, to the same extent that the objective motifs in his pictures have faded, transgressed into the realm of art.

ENDNOTES

1 Maurice Bessy: *Erich von Stroheim. Eine Bildmonographie.* München 1985, p. 10.

2 *Im Zauber des Lichts,* ed. by Walther Heering. Harzburg 1940.

3 Eric Borchert: *Mein Objektiv sieht Europa.* A Zeiss Tessar book. Halle 1938.

4 Peter Reichel: "Der nationalistische Staat im Bild," in: *Deutsche Fotografie. Macht eines Mediums 1870–1970,* ed. by Kunst- und Ausstellungshalle der Bundesrepublik Deutschland in cooperation with Klaus Honnef, Rolf Sachsse and Karin Thomas. Exhibition Catalogue (exhibition from May 7 to Aug. 24, 1997). Cologne 1997, p. 103.

5 Willi Baumeister: *Das Unbekannte in der Kunst.* Stuttgart 1947.

6 See *Aus den Trümmern. Kunst und Kultur im Rheinland und Westfalen 1945–1952. Neubeginn und Kontinuität,* ed. by Klaus Honnef and Hans M. Schmidt. Exhibition catalogue (exhibition: Rheinische Landesmuseum Bonn, Kunstmuseum Düsseldorf, Museum Bochum). Cologne, Bonn 1985.

7 *Das gute Leben. Der Deutsche Werkbund nach 1945,* ed. by Gerda Breuer. Tübingen 2007.

8 Katja Aschke: "Die geliehene Identität. Film und Mode in Berlin 1900–1990. Betrachtung einer medialen Symbiose," in: *Berlin en vogue. Berliner Mode in der Photographie,* ed. by F.C. Gundlach, Uli Richter, texts and editorial revision Katja Aschke, Enno Kaufhold, Gretel Wagner Exhibition catalogue (exhibition: Berlinische Galerie, Museum für Moderne Kunst, Photographie und Architektur, Martin-Gropius-Bau, Berlin, from Jan. 15 to Feb. 21, 1993; Münchner Stadtmuseum, Fotomuseum, Munich, from March 8 to April 4, 1993; Museum für Kunst und Gewerbe, Hamburg, from Sept. 10 to Oct. 31,1993). Tübingen, Berlin 1993, p. 262.

9 Margaret Thorp, quoted in Dieter Prokop: *Materialien zur Theorie des Films. Ästhetik, Soziologie,Politik.* Munich 1971, p. 439.

10 Dieter Prokop (see note 9), p. 439.

11 Annette Brauerhoch: "Moral in Golddruck. Illustrierte Film und Frau," in: *Frauen und Film. Die Fünfziger Jahre,* No. 35, Basle, Frankfurt/M., October 1983, pp. 48–57.

12 Joe Hembus: *Der deutsche Film kann gar nicht besser sein.* Bremen 1961.

13 Roland Barthes: *The fashion system.* Translated from French by Matthew Ward and Richard Howard. Los Angeles, CA, London 1983, p. 19.

14 Janet Flanner: *Pariser Tagebuch. 1945–1965.* Translated from American English by Dr. Gerhard Vorkamp. Hamburg, Düsseldorf 1967, p. 95.

15 Simone de Beauvoir: *Le Deuxième Sexe,* (1949).

16 Janet Flanner (see note 14), p. 102.

17 "Der wundersame Tintenfisch," in: *Das Magazin,* anniverary edition, 1924–2004, Berlin, March 2004, p. 11.

18 F.C. Gundlach speaking with the author on October 6, 2007.

19 Nicolaus Sombart: *Pariser Lehrjahre 1951–1954. Leçons de Sociologie.* Frankfurt/M. 1996), p. 12.

20 *Résonances I. Photographie après la guerre. France-Allemagne, 1945–1955.* Exhibition by Ute Eskildsen: Jeu de Paume, Hôtel de Sully, Paris, from Dec. 4, 2007 to Feb. 17, 2008.

21 "Unsere Fotografen," in: *Film und Frau,* issue 1/1953, vol. 5, p. 6.

22 Klaus Honnef: *Pop Art,* ed. Uta Grosenick. Cologne 2004.

23 *Martin Munkacsi.* Eds. F.C. Gundlach; Klaus Honnef, Enno Kaufhold. Exhibition by F.C. Gundlach, texts and research by Klaus Honnef and Enno Kaufhold. Exhibition catalogue (exhibition: Haus der Photographie at Deichtorhallen Hamburg, from Apr. 14 to July 24, 2005; Martin-Gropius-Bau, Berlin, from Aug. 5 to Nov. 6, 2006). Göttingen 2005.

24 Johannes Christop Moderegger: *Modefotografie in Deutschland 1929–1955.* Norderstedt 2000. The author has the great merit of having described the contexts, complexity and background of German fashion photography with respect to important players, history and the media.

25 Willy Maywald: *Die Splitter des Spiegels. Eine illustrierte Autobiographie in Zusammenarbeit mit Patrick Brissard.* Munich 1985, pp. 206–207.

26 Willy Maywald, see note 25, p. 207.

27 Alexandra Palmer: "Inside Paris Haute Couture," in: *The Golden Age Of Couture. Paris and London 1947–57,* ed. by Claire Wilcox. Exhibition catalogue (exhibition: Victoria and Albert Museum, from Sept. 22, 2007 to Jan. 06, 2008). London 2007, p. 80.

28 *Christian Dior und Deutschland 1947 bis 1957,* ed. by Adelheid Rasche in cooperation with Christina Thomson with a greeting by Claude Martin. Exhibition catalogue (exhibition: Kulturforum Potsdamer Platz, Kunstbibliothek, from Feb. 13 to May 28, 2007). Berlin, Stuttgart 2007, pp. 40 ff.

29 Willy Maywald (see note 25), p. 234.

30 Martin Harrison: "Lisa Fonssagrives-Penn," in: *Lisa Fonssagrives. Drei Jahrzehnte klassischer Modephotographie,* ed., illustration and preface by David Seidner, with a text by Martin Harrison, ed. Diane Edkins. Munich, Paris, London 1996, pp. 25–42.

31 Roland Barthes (see note 13), pp. Xi–xii

32 F.C. Gundlach in one of the numerous conversations with the author.

33 Enno Patalas: *Sozialgeschichte der Stars.* Hamburg 1963.

34 David Seidner: "Statischer Tanz," in: *Lisa Fonssagrives* (see note 30), p. 12.

35 "Interview. Mit F.C. Gundlach sprachen Gabriele Honnef-Harling und Klaus Honnef," in: *ModeWelten. F.C. Gundlach. Photographien 1950 bis heute,* ed. by Klaus Honnef. Berlin 1985, p. 25.

36 F.C. Gundlach: *Die Pose als Körpersprache,* with an essay by Klaus Honnef. Exhibition catalogue (exhibition: Staatliche Museen zu Berlin, Kunstbibliothek, from May 29 to July 29, 2001). Cologne 2001.

37 René König: *Menschheit auf dem Laufsteg. Die Mode im Zivilisationsprozeß.* Munich, Vienna 1985, p. 238.

38 Karlheinz Wöhler: "Endlich wieder urlauben. Urlaub in den fünfziger Jahren als ein Phänomen der Moderne," in: *Die Kultur der 50er Jahre,* ed. by Werner Faulstich. Munich 2002, pp. 264–265.

39 Roland Barthes (see note 13), p. xii.

40 Max Imdahl: "Ikonik. Bilder und ihre Anschauung," in: *Was ist ein Bild?,* ed. by Gottfried Boehm. Munich 1994, pp. 300–324.

41 Gertrud Lehnert: *Geschichte der Mode des 20. Jahrhunderts.* Cologne 2000, p. 56.

42 F.C. Gundlach: *Die Pose als Körpersprache* (see note 36).

43 Sylvia Lott-Almstadt: *Brigitte 1886–1986. Die ersten hundert Jahre. Chronik einer Frauen-Zeitschrift.* Hamburg 1986, p. 233.

44 Ibid., p. 234.

45 Barbara Buffa, in: Gespräch mit Barbara Buffa. Ein Interview des Fotohistorikers Johannes Christoph Moderegger mit der Mode-Chefredakteurin der *Brigitte,* Barbara Buffa. Conducted on Nov. 27, 1996 in Hamburg, unpublished manuscript, p. 4.

46 Roland Barthes (see note 13).

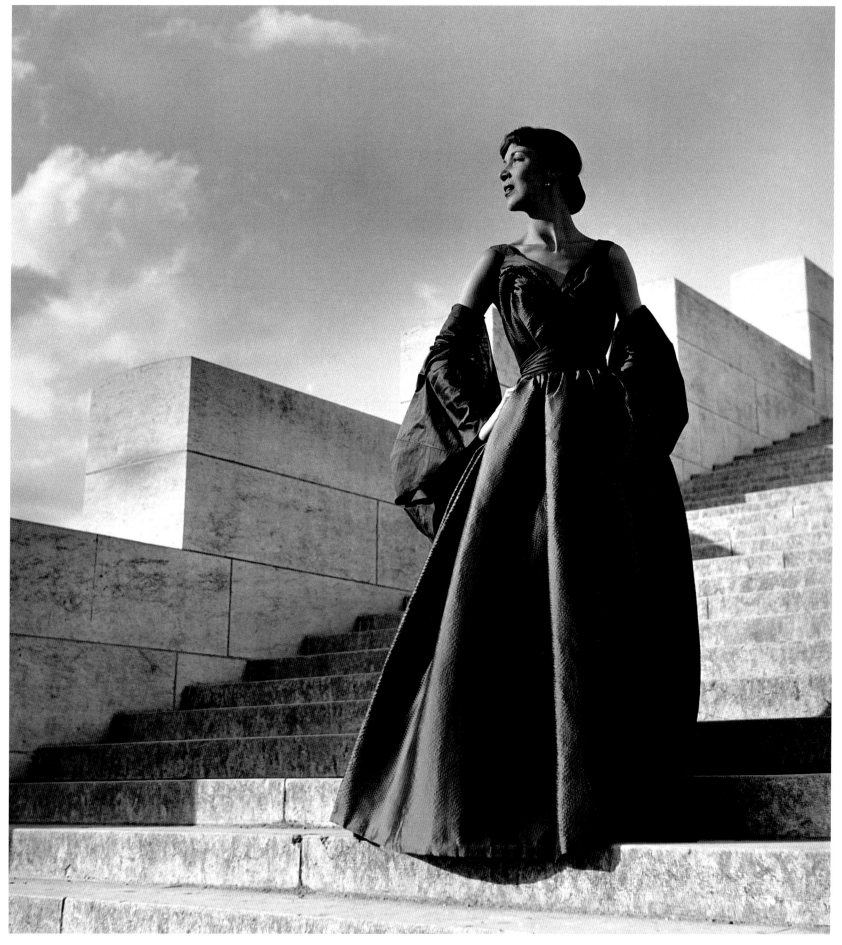

Evening dress by Manguin, Paris 1952

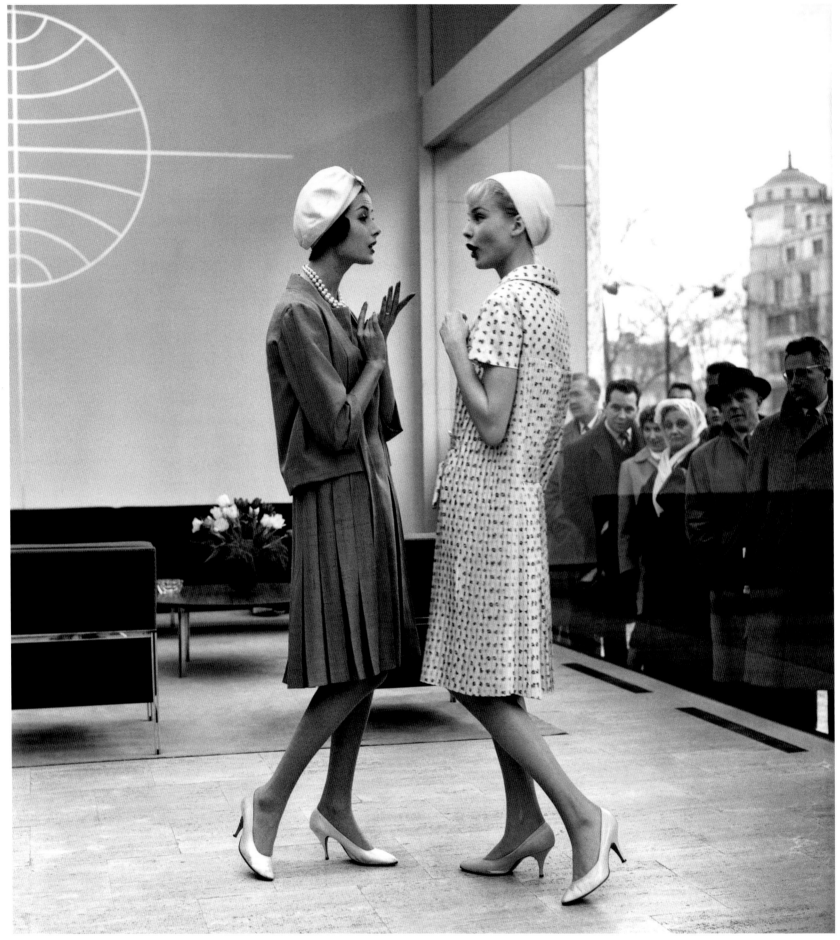

"Summer-Fashion-Theater", Gitta Schilling and Christa Vogel in ensembles by Guy Laroche, Paris 1958, in: *Stern* 9/1958

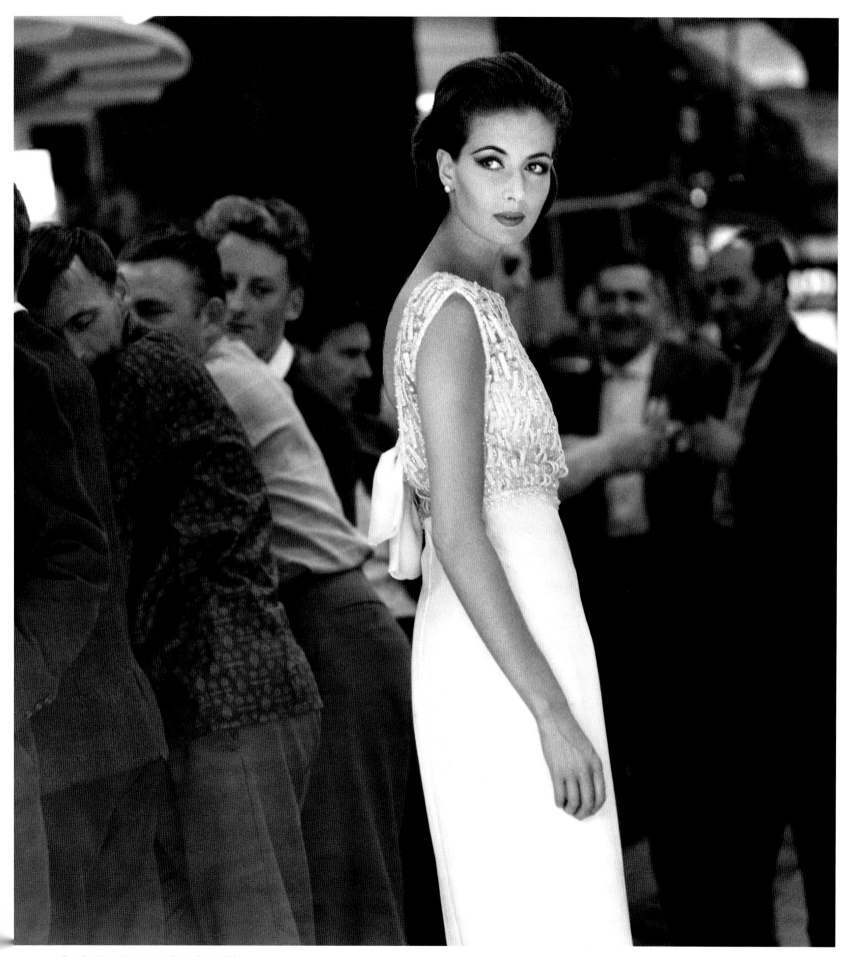

Gitta Schilling, dress by Jean Patou, Paris 1962
next spread: Gitta Schilling, ensemble by Pierre Balmain, Paris 1962
Siv Benno and Pierre Hogard, cocktail dress by Pierre Cardin, Paris 1962, in: *Quick* 9/1962

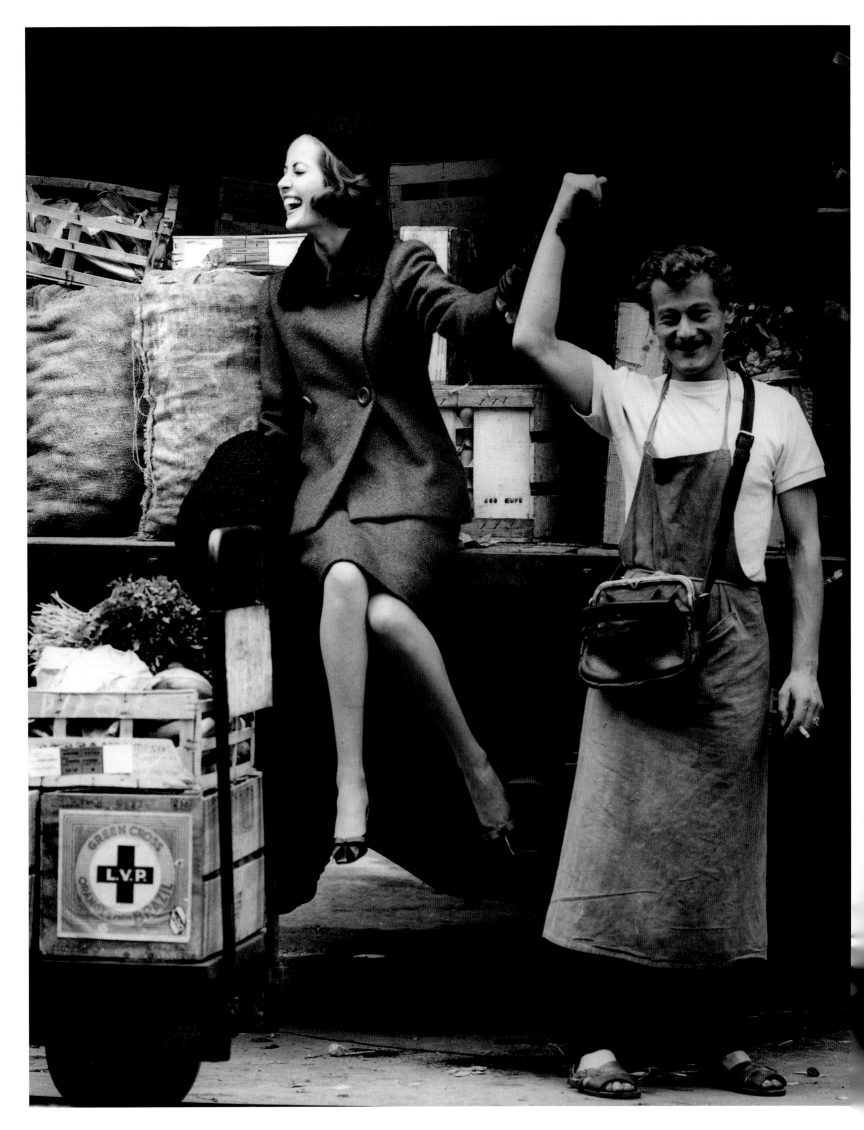

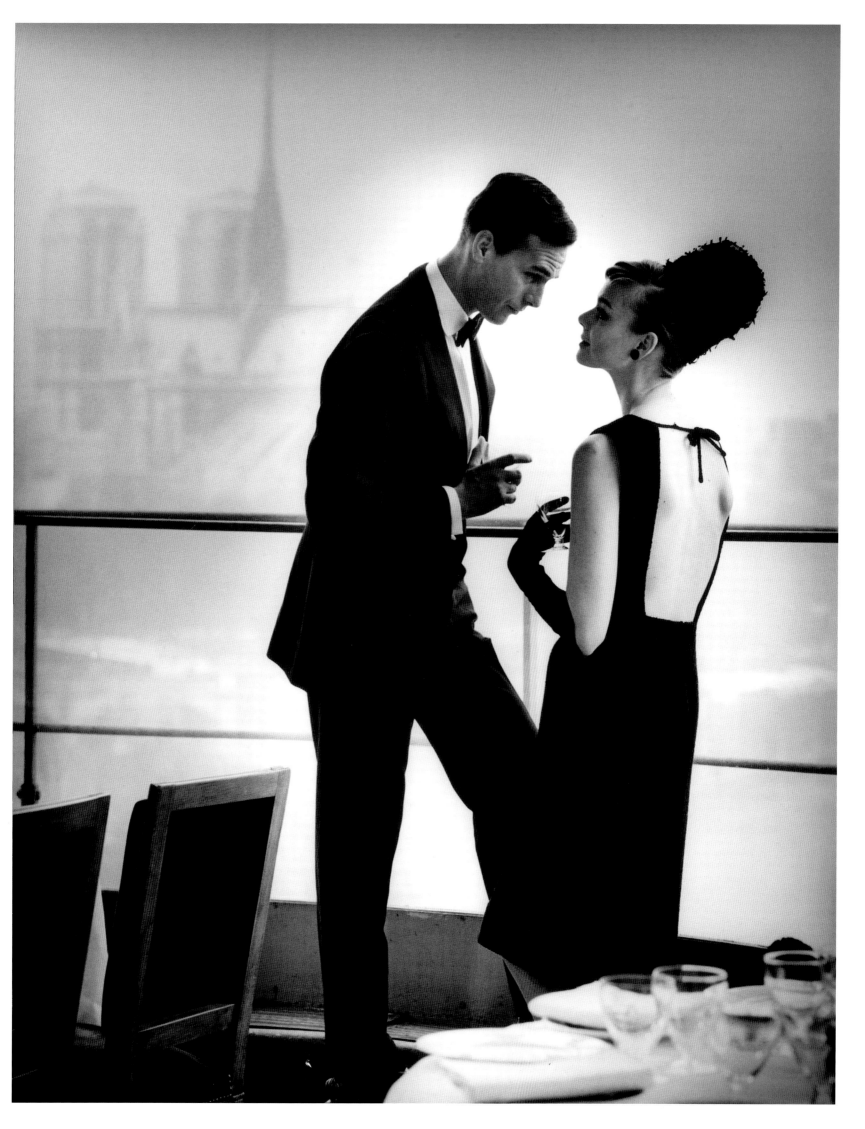

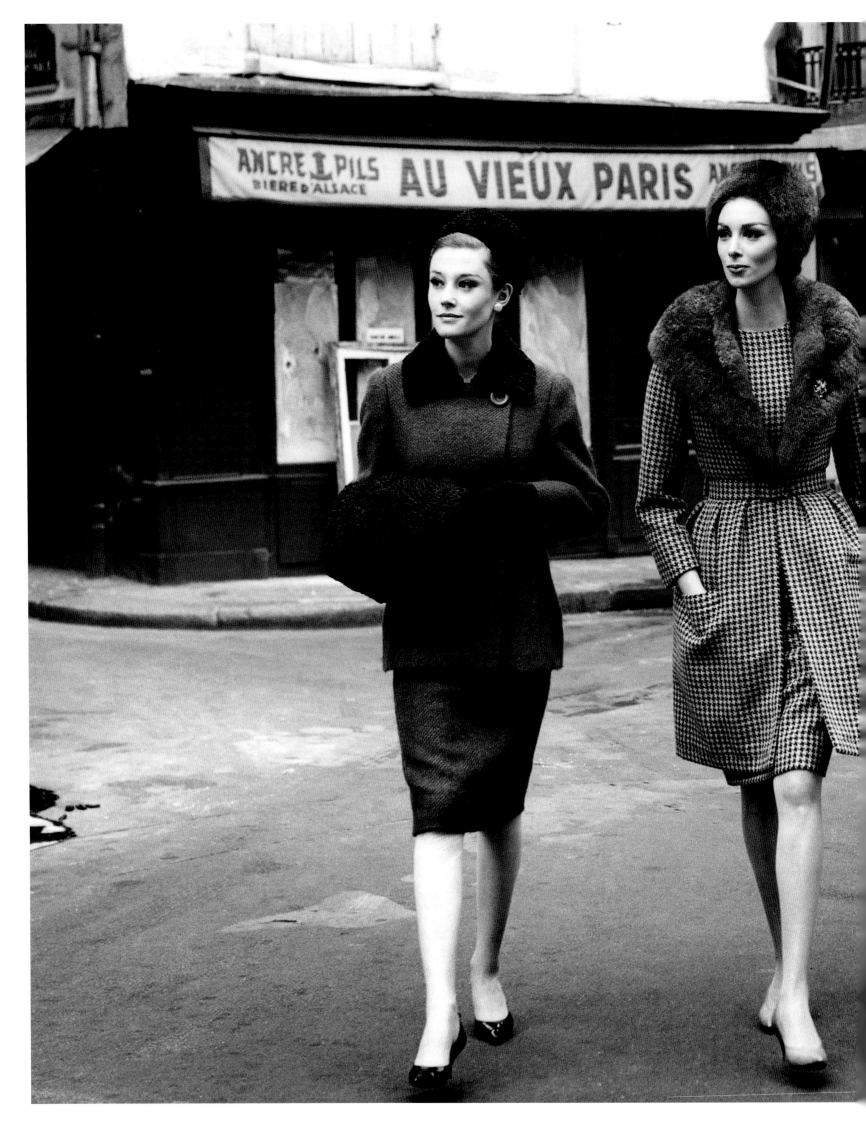

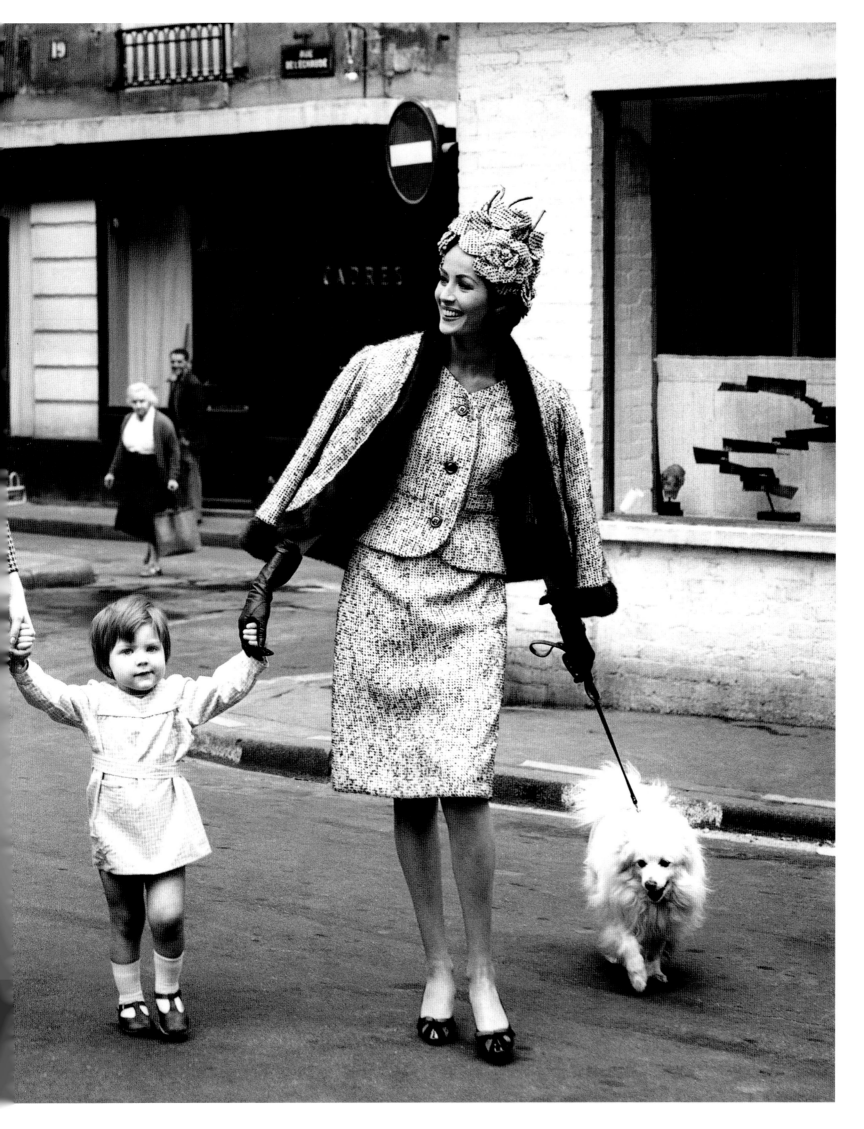

Cocktail dress by Dior, Paris 1962

previous spread: Gitta, Wilhelmina and Ingeborg, ensembles by Pierre Balmain,
Nina Ricci and Lanvin-Castillo, Paris St.-Germain-des-Prés 1966, in: *Quick* 35/1962

next two spreads: "Paris Collections", Wilhelmina, Paris 1963
"Paris Collections", Antonia, Paris 1964
"Op Art-silhouette", coat by Lend, Paris 1966, in: *Brigitte* 4/1966
Pantsuit by André Courrèges, Paris 1965, in: *Constanze* spring/summer 1965

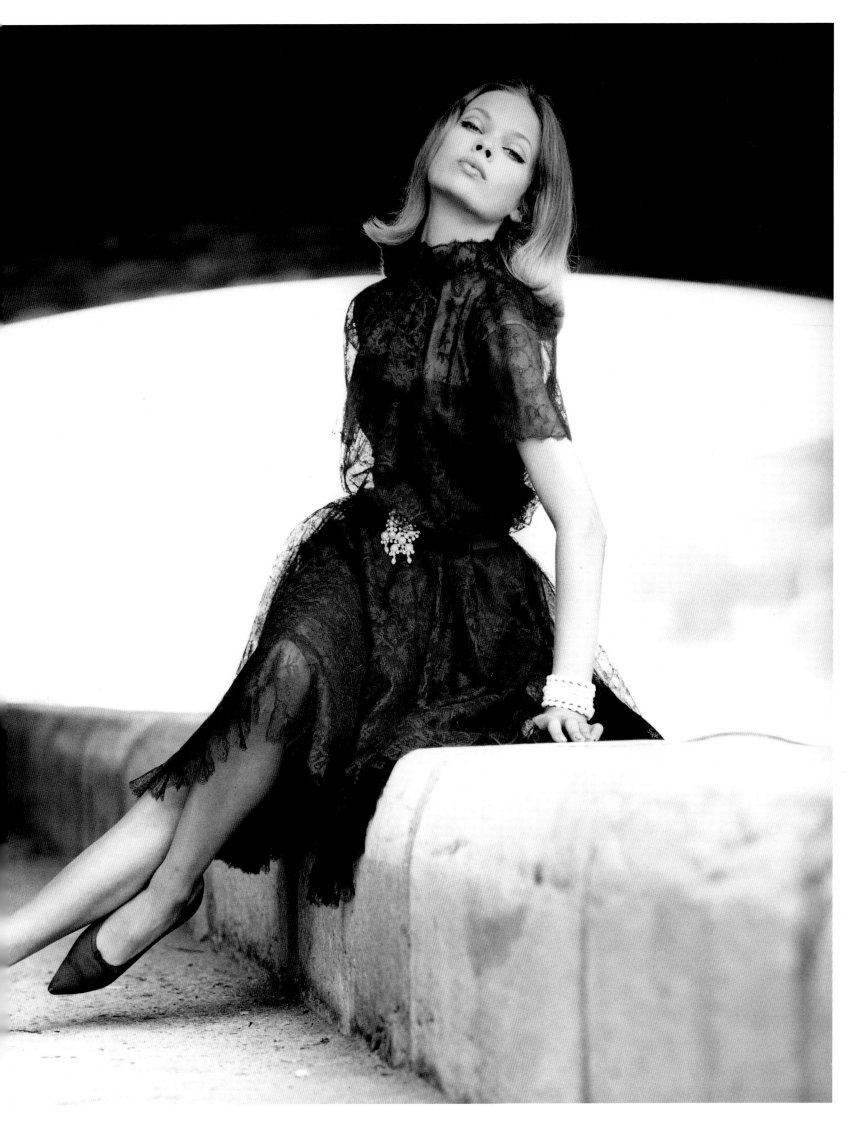

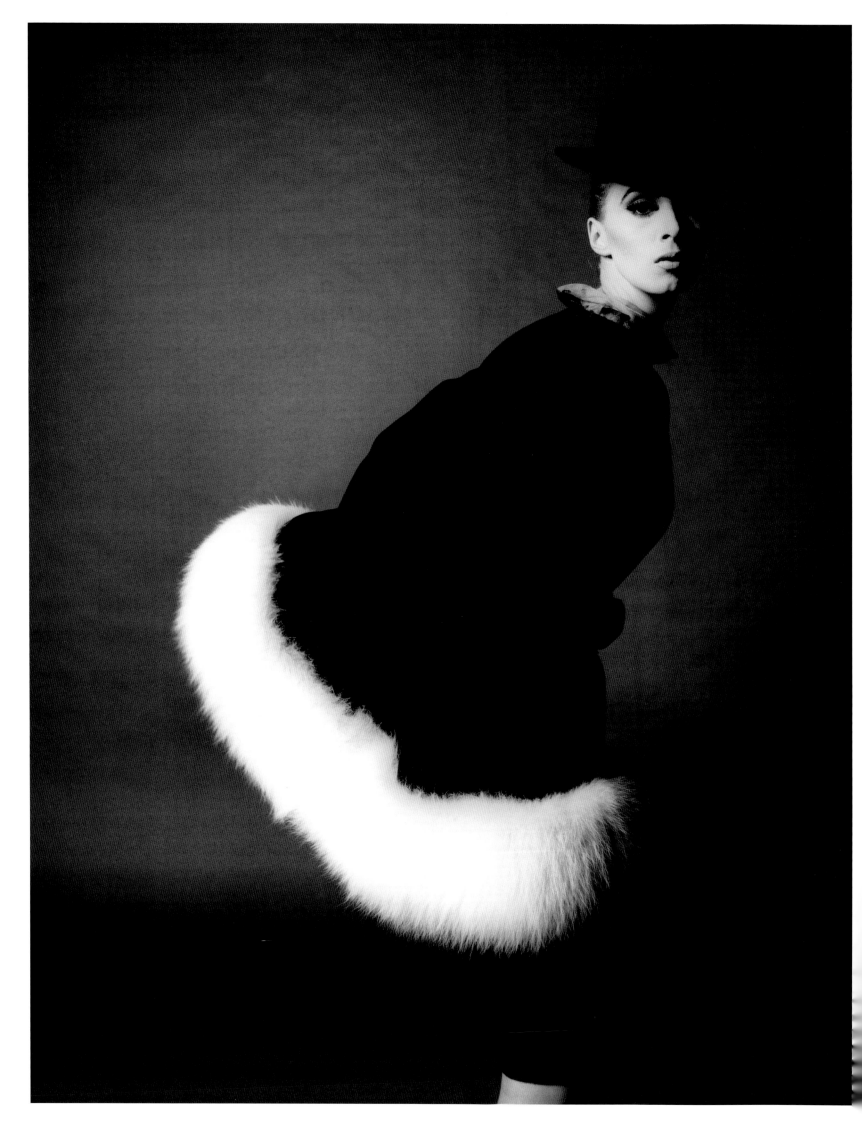

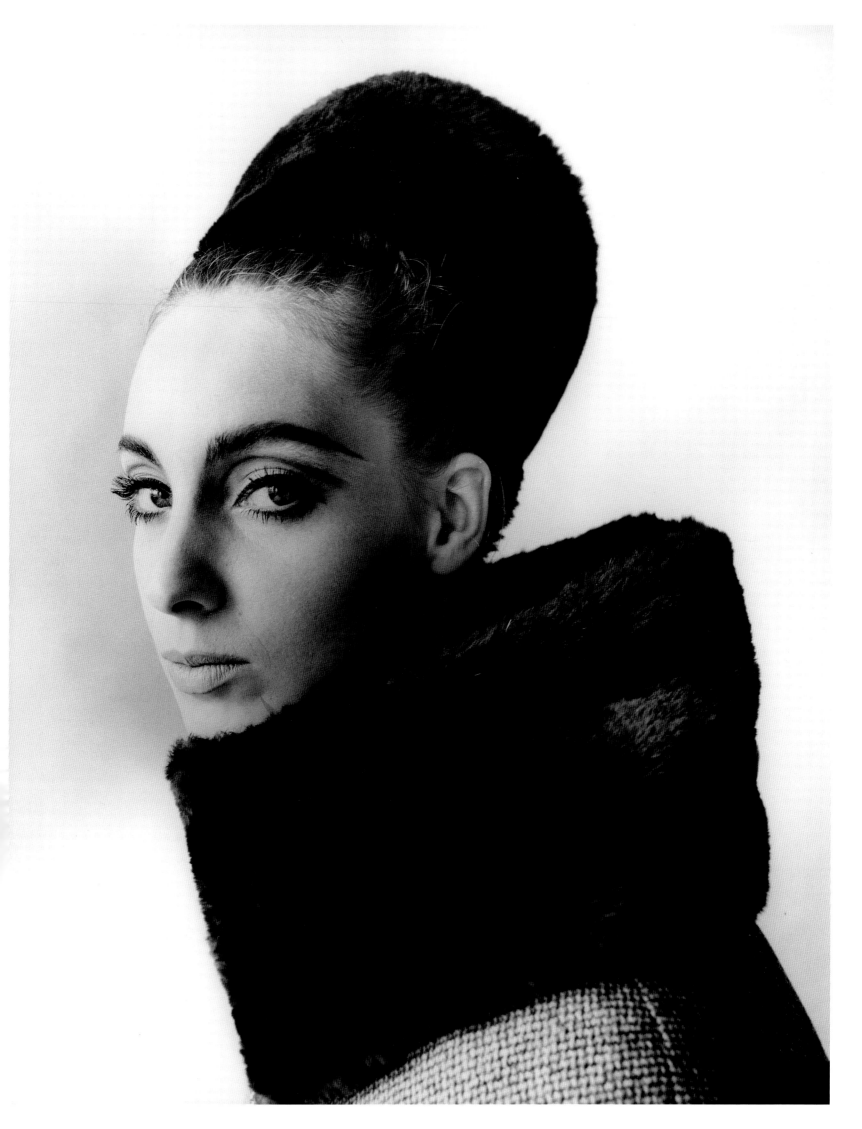

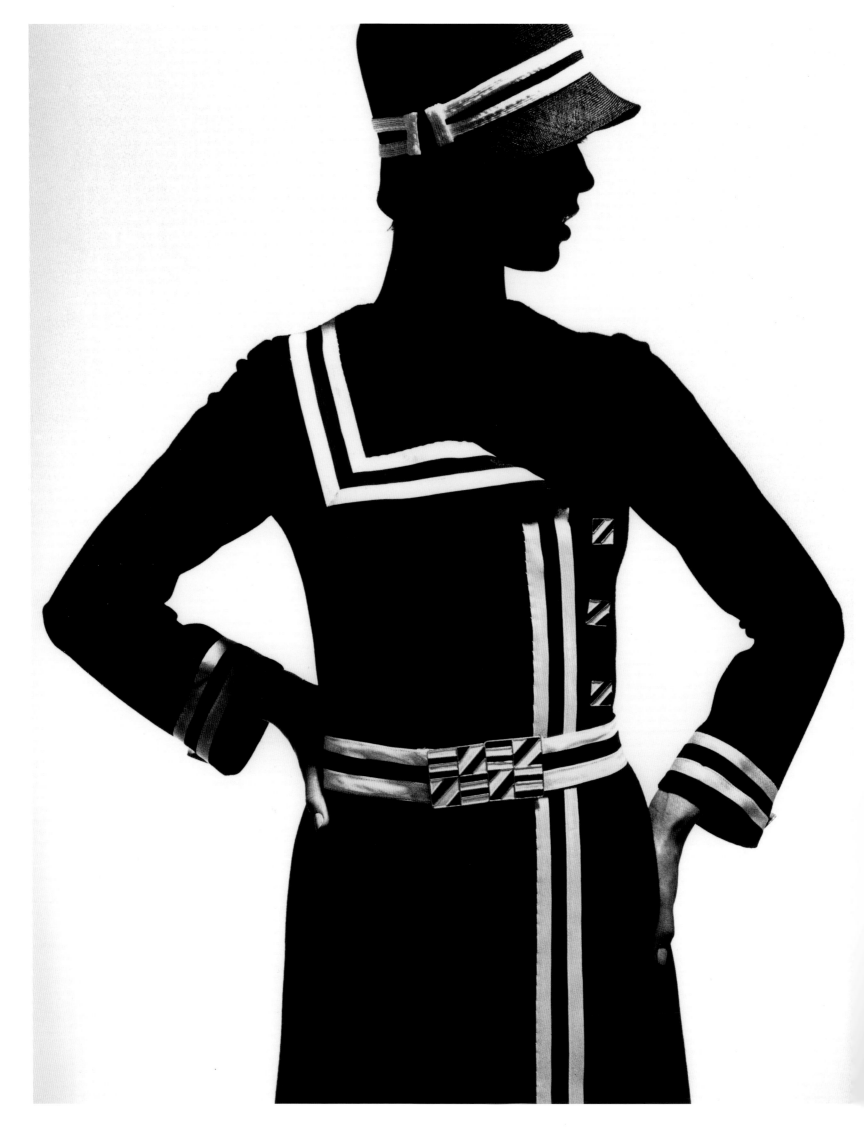

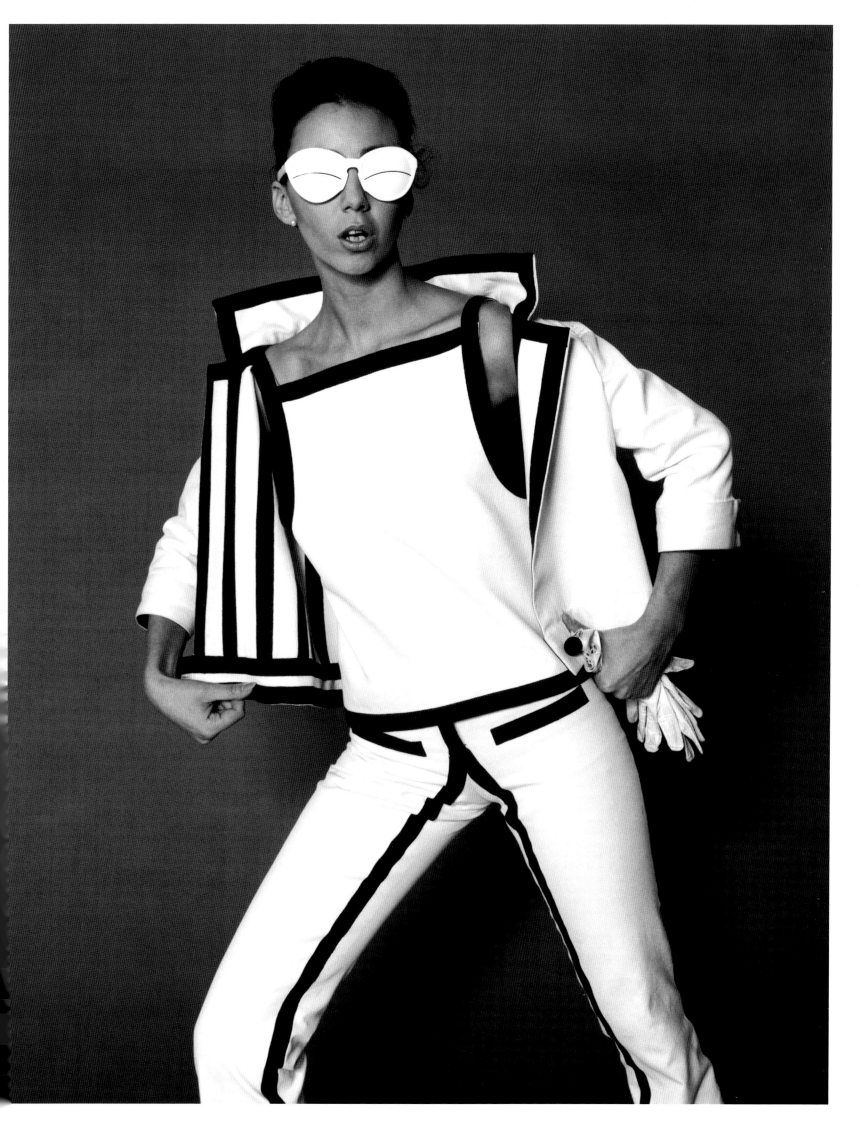

INVENTING A PHOTOGRAPHIC STYLE

Sebastian Lux

In his individual photographic language F.C. Gundlach re-presented the changes both in fashion and society over a period of more than four decades, while his forward-looking studies in style influenced the fashion of tomorrow. Gundlach's photographic oeuvre – sparing in its use of photographic tools, expressive in its graphic design, and masterful in its combination of photo model and background – is characterised by a timeless elegance and lightness. At the same time the photographs express the photographer's bond to the actual moment of the take. For this commercial photographer, the end product was the image in the printed magazine. F.C. Gundlach described his aesthetic aspiration in the 1959 photography yearbook *Das Deutsche Lichtbild* as follows: the aim of his fashion reportages was "not to simply photograph clothes, but to interpret the line of a new fashion by representing it in images".[1]

In his portraits, F.C. Gundlach relied on a consistent verism. His concrete and yet sensitive photographs of German and international film stars broke with the established idiom of glamorous Ufa star portraits. As he said later, "I had dared to portray the stars without a soft focus lens and not as heroic."

By being published in fashion and society magazines ranging from the *Deutsche Illustrierte* to *Stern* to *Twen*, and from *Elegante Welt* to *Film und Frau* to *Brigitte*, F.C. Gundlach not only wrote fashion photography history, he also had a decisive influence on the image of women in Germany, from the yearning for beauty in the post-war era to the new naturalness of the 1980s.

Today, F.C. Gundlach's photography has long since departed from the context in which it emerged. Starting with the first solo exhibition at the Librairie Jean Robert in 1951,[2] his photographs have established

"Everything glitters", Inger, mini by Betty Barclay, Hamburg 1966, in: *Brigitte* 25/1966

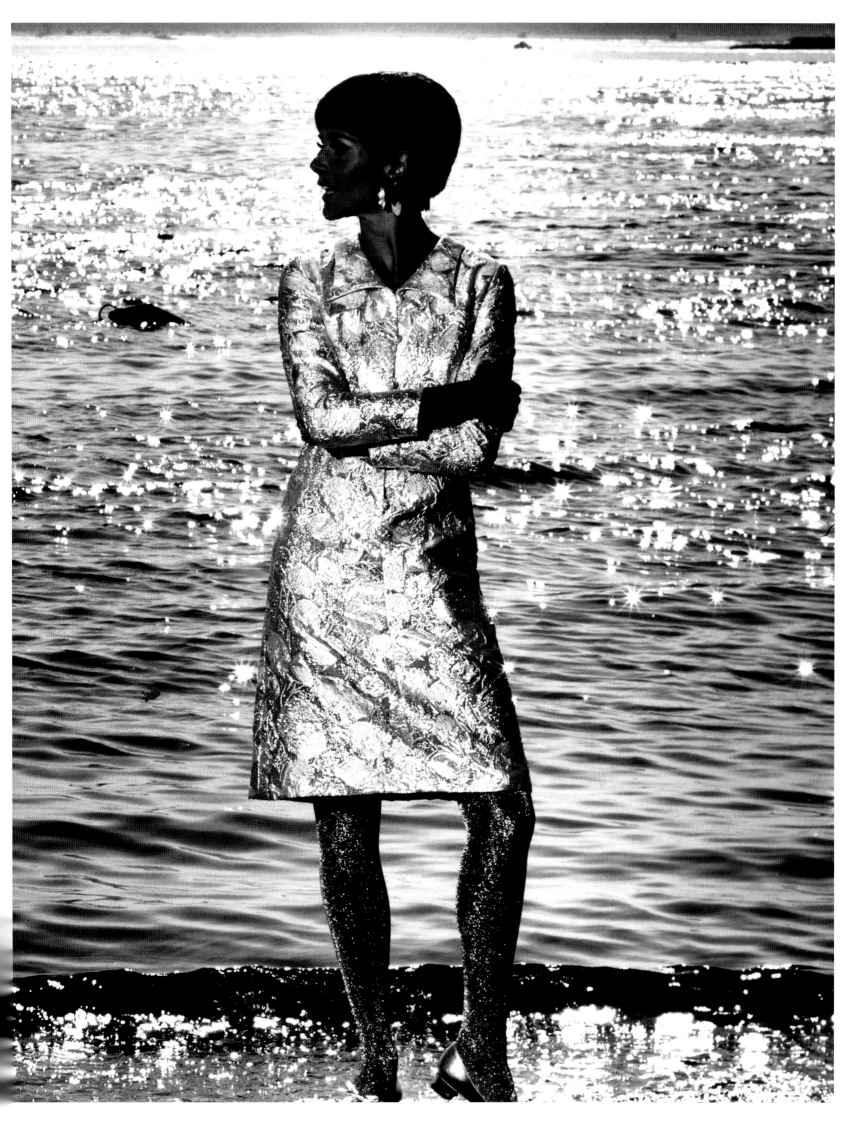

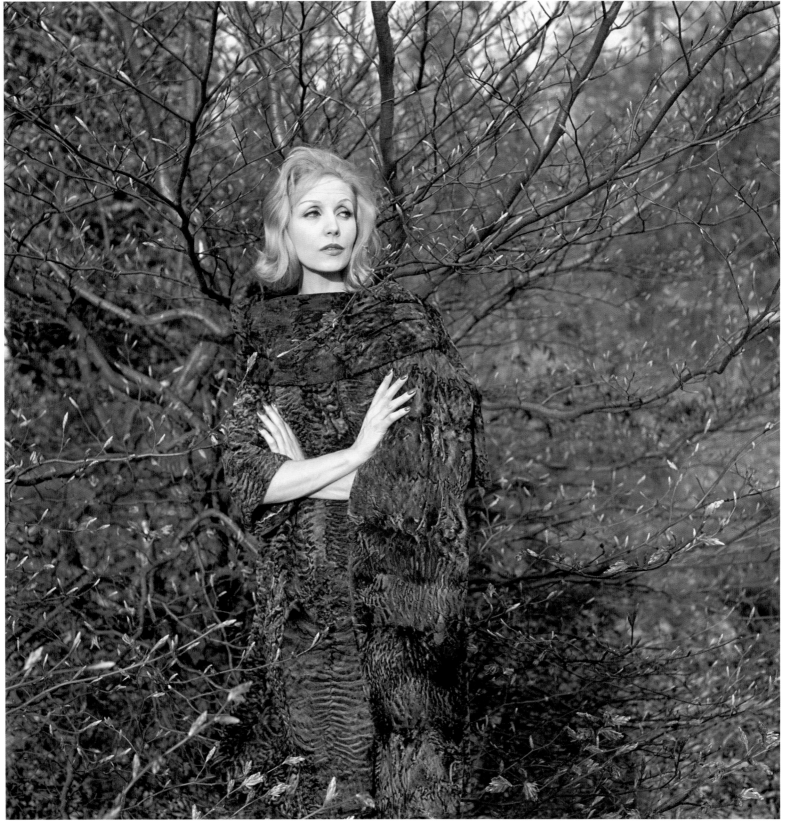

Denise Sarrault, broadtail coat by Berger, Frankfurt on the Main 1956

themselves in the art collections of galleries and museums as icons of German portrait and fashion photography.

F.C. Gundlach's photographic style is restrained and takes account of the function of fashion photography as a projection screen for dreams and long-ings. "I feel like a packager of modern fairytales," is how Gundlach referred to this aspect of his work in 1961.[3] His pictorial composition is clear and rigorously thought through, the studio arrangements and aptly chosen locations are none too opulent, but do provide a graphic texture. He imbues fashion design

and photographic venue with an aesthetic tension through his "unique sense for the stylistic expressiveness of textile design".[4] The contour and structure both of the fashion item and the background, the pattern and texture of the fabrics and furs become "autonomous graphic signals",[5] intertwining elements of his genuinely photographic understanding of form. "My fashion images are [...] a synthesis of the image of the woman, the dress and the background, whereby the emphases of the individual pictorial elements are composed differently in each picture," Gundlach himself says of his compositional approach.[6] Without being mathematical or modular, he uses these elements to create a game of forms which can ultimately be ascribed to one of two extreme positions:

Fashion designs characterized by the detailed visual structure of fabric, print and pattern are treated by Gundlach according to an 'all-over' principle. Denise Sarrault in a brownish-red Persian lamb coat almost merges with the brownish-red of the branches and buds in spring. The vegetal background repeats the curls and coloration of the fur, while the model's hair is a much brighter shade of red, her arms and face stand out in their pallor and, as a contrast, heighten the all-over impression of the rest of the pictorial plane. The contre-jour photograph of a dress with a metallic glint against a background of rippling water is designed in a similar way. Gundlach avails himself of natural and artificial light sources to heighten light reflections on both the fabric of the dress and the water; their complementary structure induces a decorative design on the whole of the image area.

Fashion designs whose appearance is determined by the outline are treated differently. Gundlach reduces these to the outlines and a few internal details and arranges them in relation to geometrical backgrounds. To this end he conscripts architecture, means of transportation and accessories as pure forms, to say nothing of backdrop papers and scene painting.

The series "Triumph des Imprimés" (Triumph of the Print)[7] taken in 1956 for *Film und Frau* and the Op-Art swimsuit photographed in Athens in 1966 clearly illustrate this second approach. Be it a garage door in Berlin or the roof of a futuristic beach pavilion in Vouliagmeni – in these images architecture is reduced to abstract line and plane and made to correspond to contour and internal detail of the fashion design. In the first case, the strictly vertical line of the garage door contrasts and accentuates the S-shaped line of the model's pose; in the second, the curved outlines of the strongly contrasting planes of the roof and the sky in the Greek sun repeat the Op-Art design of the swimsuit. The whole is segmented; the detail becomes abstract: F.C. Gundlach uses architecture as an artistic cliché to create a montage by photographic means.

The temples of Angkor Wat swamped in jungle vegetation or Oscar Niemeyer's hypermodern drawing-board city Brasilia, the Campanile in Venice or the sensational spiral staircase in the New York Guggenheim Museum were chosen by F.C. Gundlach as settings whose symbolic force adds further levels of meaning to his photographs. He also availed himself of different means of transport, such as cars, planes, and boats, as structural elements and as pointers to social mindset. The car positioned at a slight angle in a high-key photograph taken during the 1958 Fur Fair in Frankfurt divides the pictorial plane and sets the mood of the scene in which Denise Sarrault turns away provocatively from the viewer, while at the same time luring him into the image by glancing over her shoulder as she takes a side step. At the graphic level, Gundlach interweaves the lines formed by the leg and pose of the model, the diagonal of the car, the seams of the collar, cape and skirt, and even the seams of the tiles on the ground, to create a taut network that supports the dark form of the fur outfit. Location, model and pictorial compo-

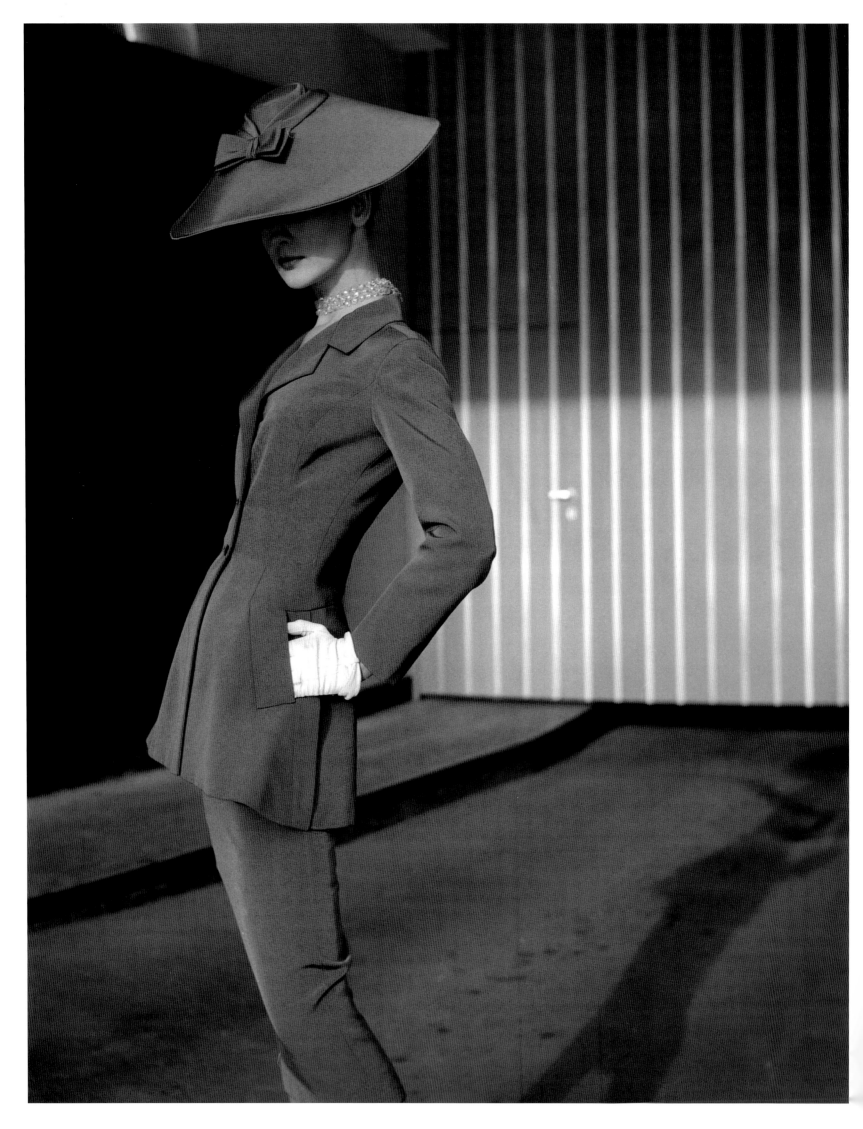

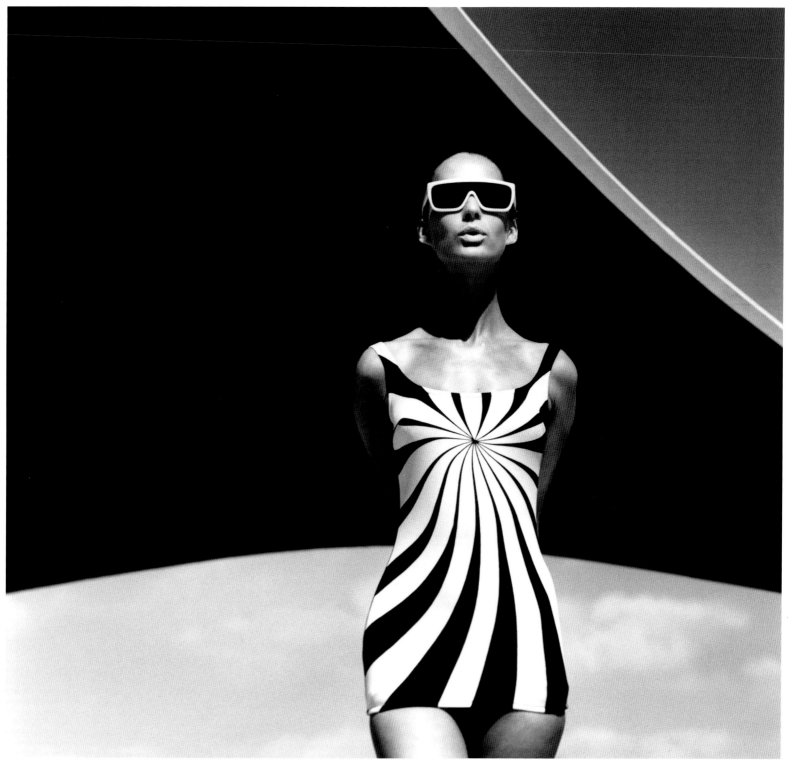

Brigitte Bauer, Op Art-swimsuit by Sinz, Vouliagmeni/Greece 1966

sition combine to present a fur coat in an altogether modern way.

The shaping of the relationship between pictorial plane and fashion item is particularly extreme in one of Gundlach's earliest photographs for *Brigitte* in 1963. The shimmering surface of the aircraft's rump and wing occupies more than three quarters of the pictorial plane. Due to the low perspective lines, the photo model is drawn far back into the pictorial

space, while also being supported and emphasised in the vanishing point and at the top of the steps. The prominent Pan Am logo points to a way of life – a flight to a faraway place has become a status symbol.

The revolutionary expansion of international air traffic in the late 1950s also fundamentally altered Gundlach's photography. As the summer collection has to be photographed in winter, the winter collection in summer, he was one of the first fashion

Bambi, ensemble by Gehringer & Glupp, Berlin 1956

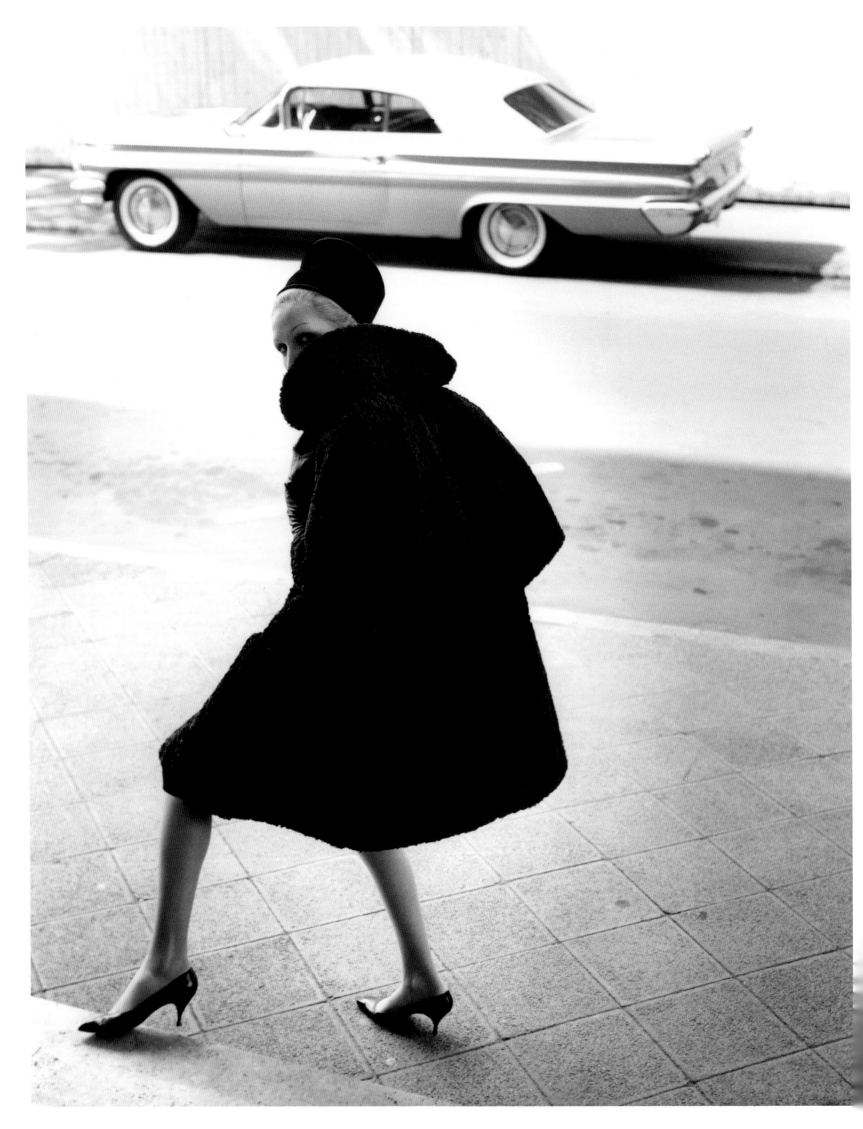

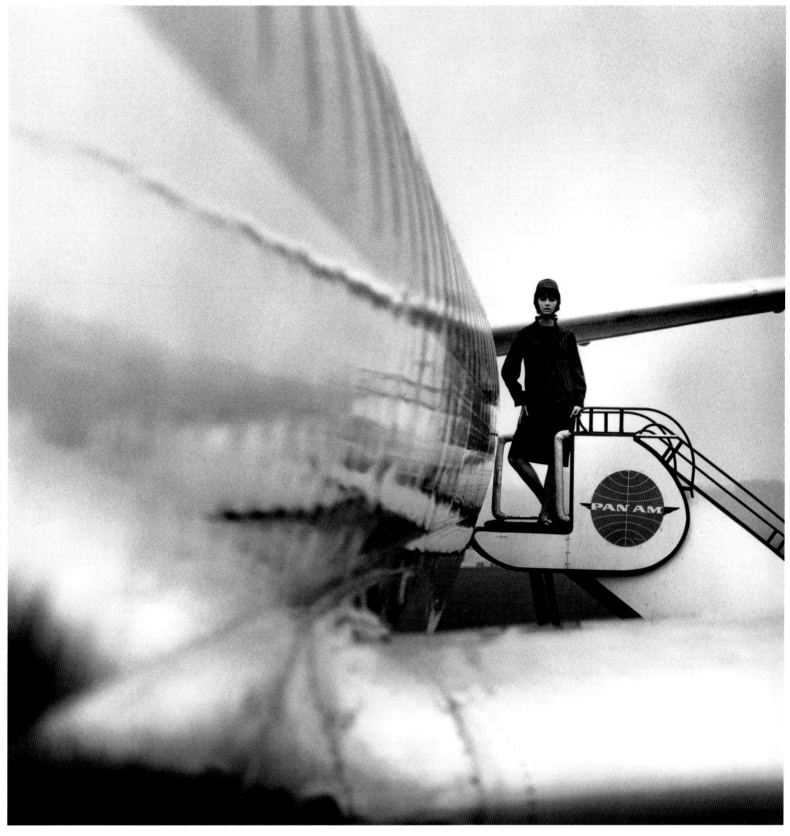

"Jet-Age", Gunel Person, Hamburg 1963, in: *Brigitte* 17/1963

photographers in Germany to opt for 'fashion trips', flying to Africa in winter and to Lapland in summer, where temperatures and vegetation suited the fashion being photographed.

The world's deserts, coasts, jungles and mountains presented the photographer with multi-coloured or patterned backdrops which he could relate to the colour themes of the respective fashion designs in his photographs. This way Gundlach transported fundamental aspects of his pictorial idiom into colour photography. It is this aspect of his work that is discussed in the report by the *East African Standard* on one of

Denise Sarrault, cape coat made of Persian lamb, Frankfurt on the Main 1958

next spread: Gitta Schilling, Place de la Concorde, Paris 1958, in: *Stern* 9/1958

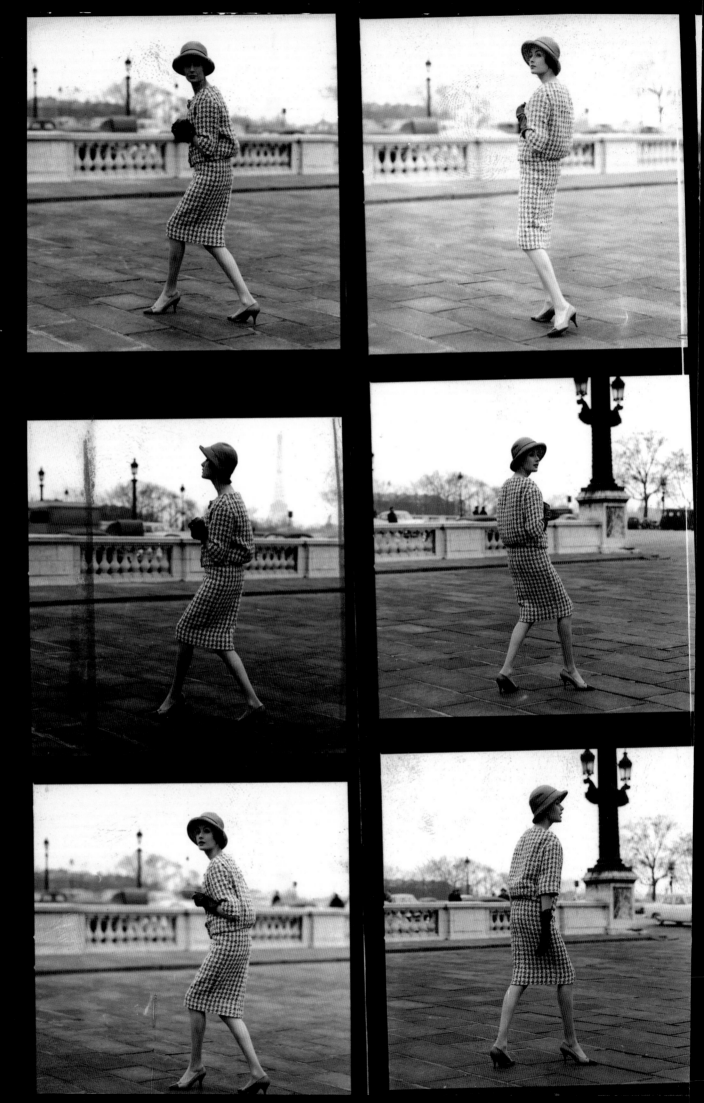

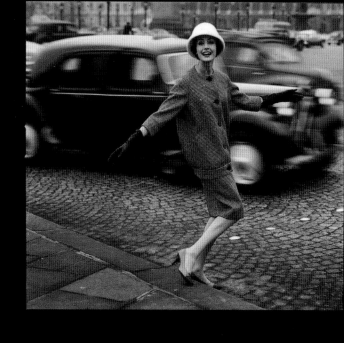
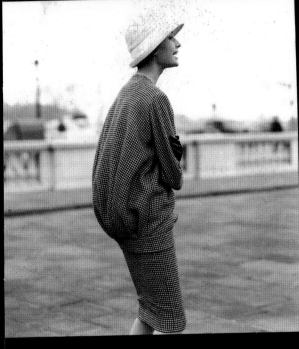
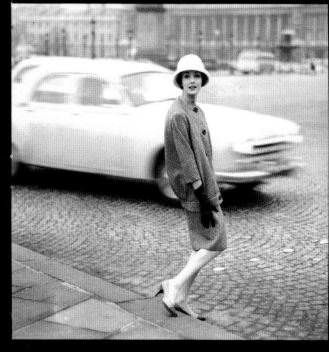
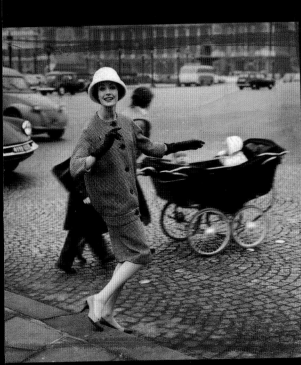
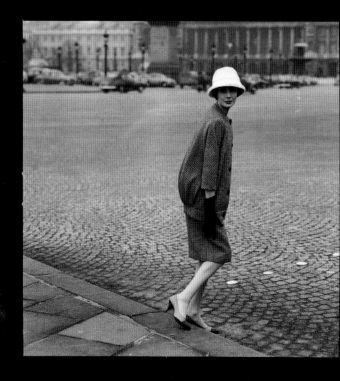

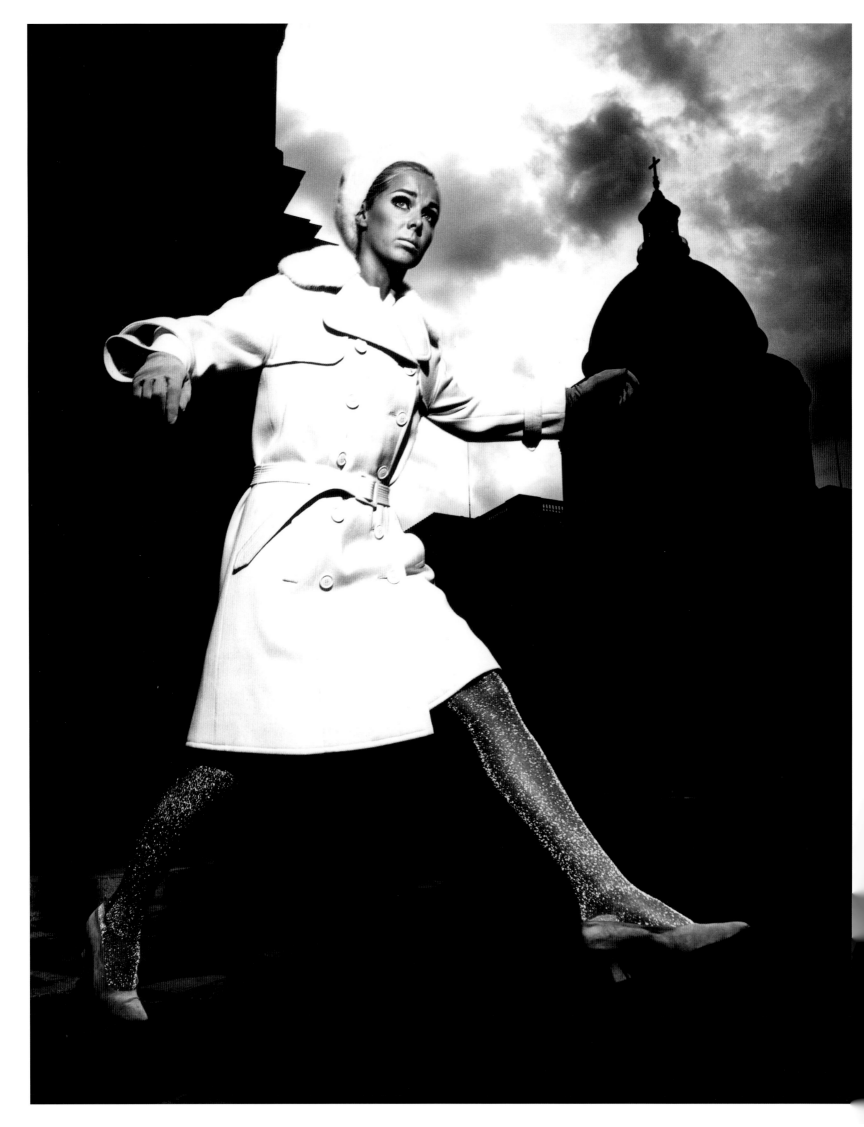

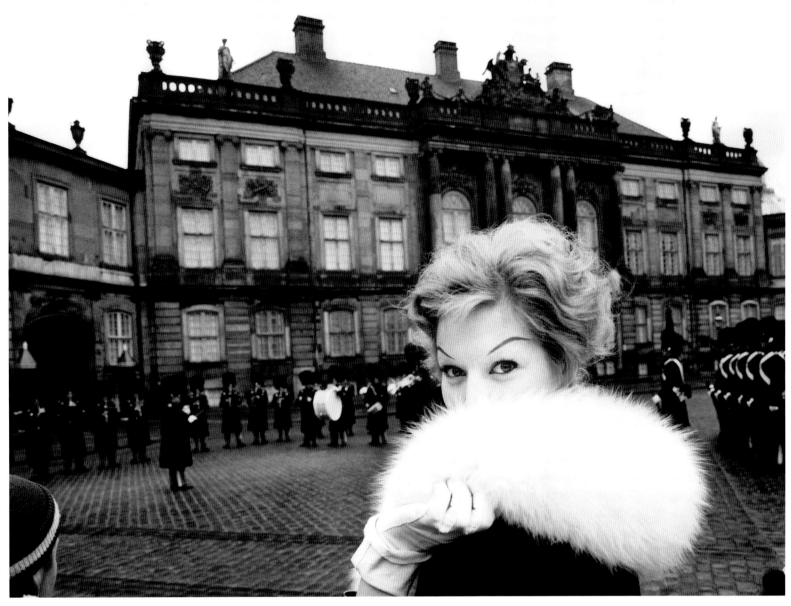

Lo Olschner, coat with fox-collar by Heinz Oestergaard, Copenhagen 1959, in: *Stern* 51/1957

Gundlach's fashion trips to Kenya: "The kaleidoscope of colour continues to unfold with snappy outfits pictured against the deep sweeping blue-grey vista of the Ngong Hills. There are blue and gold effects from the Coast and the different colouring of hills and water at Lake Naivasha. 'The red soil areas proved a wonderful foil for outfits in deep tan shades and altogether the colour combinations we have found here have been ideal,' Mr. Gundlach said."[8]

His intuitive handling of locations and his swift grasp of situations are something Gundlach retained from his time as a photo-journalist in Stuttgart and Paris: "As a photo-journalist [...] it was only natural that I was soon doing the outdoor shots not with the standard Rollei but with a Leica, because I was faster

with it and could stage my fashion photos in a more reportage like way."[9] The contact sheet of a photo series in Paris shows that for this particular purpose he sometimes deliberately left things to chance. It would seem as if photographer and photo model Gitta Schilling were simply waiting on the Place de la Concorde in Paris for something to drive by: a black car – too ordinary; a white car – too lacking in contrast; a child's pram – just right. Gundlach also acquired his ability to re-tell a story in a sequence of images during his time as a free-lance supplier of reportages and "star at home" stories. This enabled him to produce fashion reportages with a high level of spontaneity and with narrative elements, like in the photographs of Ellinor and Charlie Rivel. As the

Karin Mossberg, short coat by Nina Ricci, Paris 1966, in: *Moderne Frau* 21/1966

next spread: "Summer furs", Gloria Friedrich for SWA, Baalbek/Lebanon 1964

Janni in front of Ramses statues, evening dress by Uli Richter, Luxor/Egypt 1961, in: *Film und Frau* 4/1962

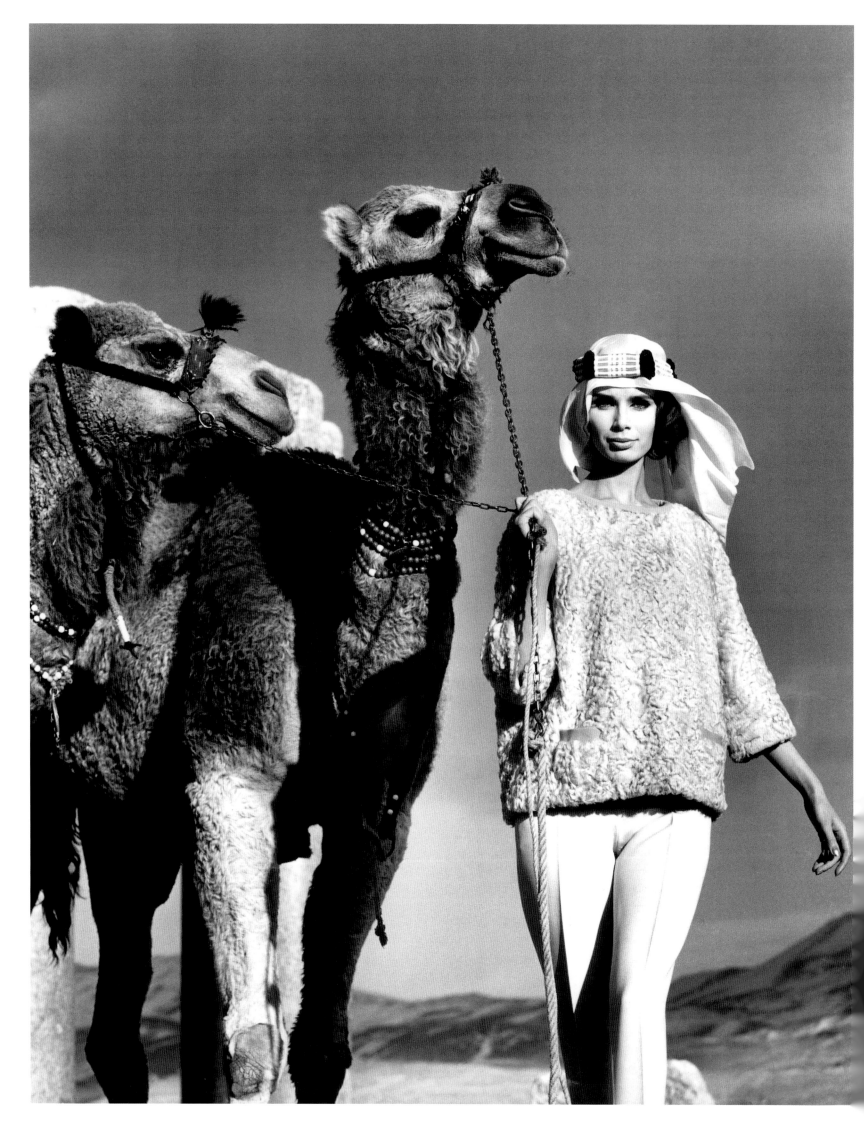

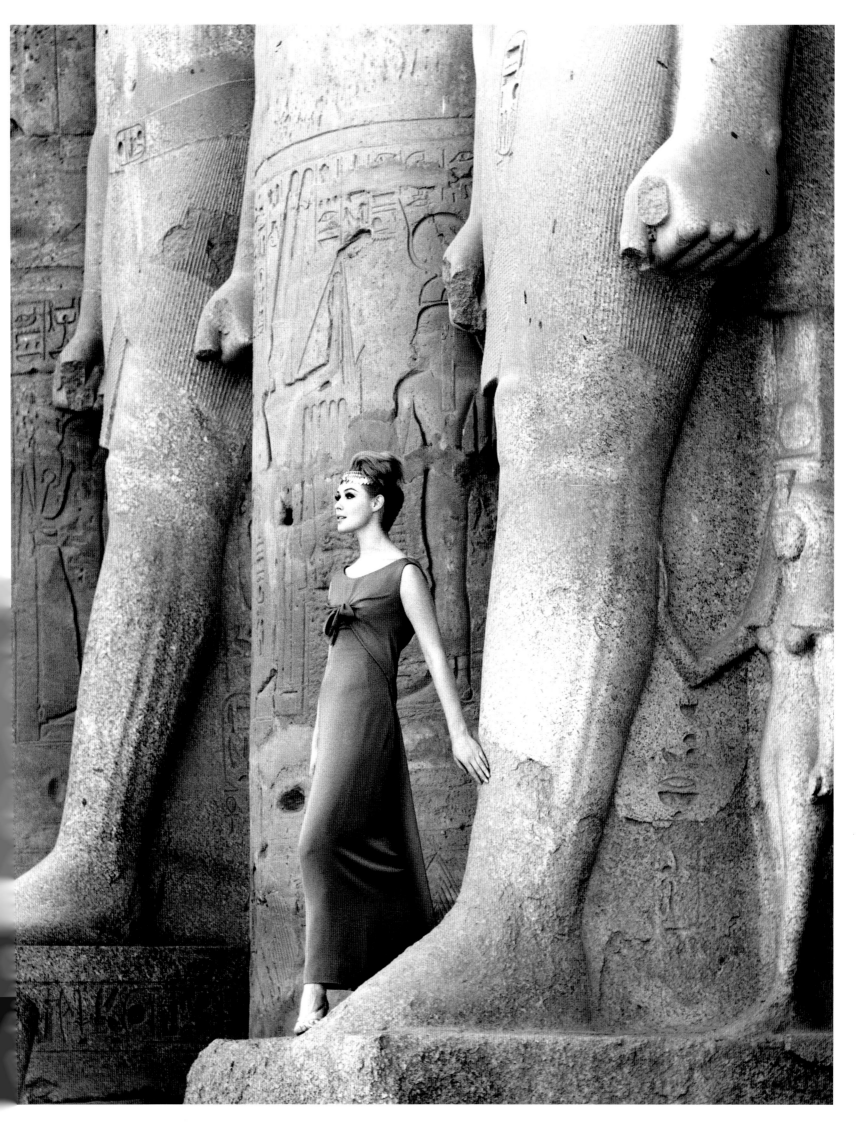

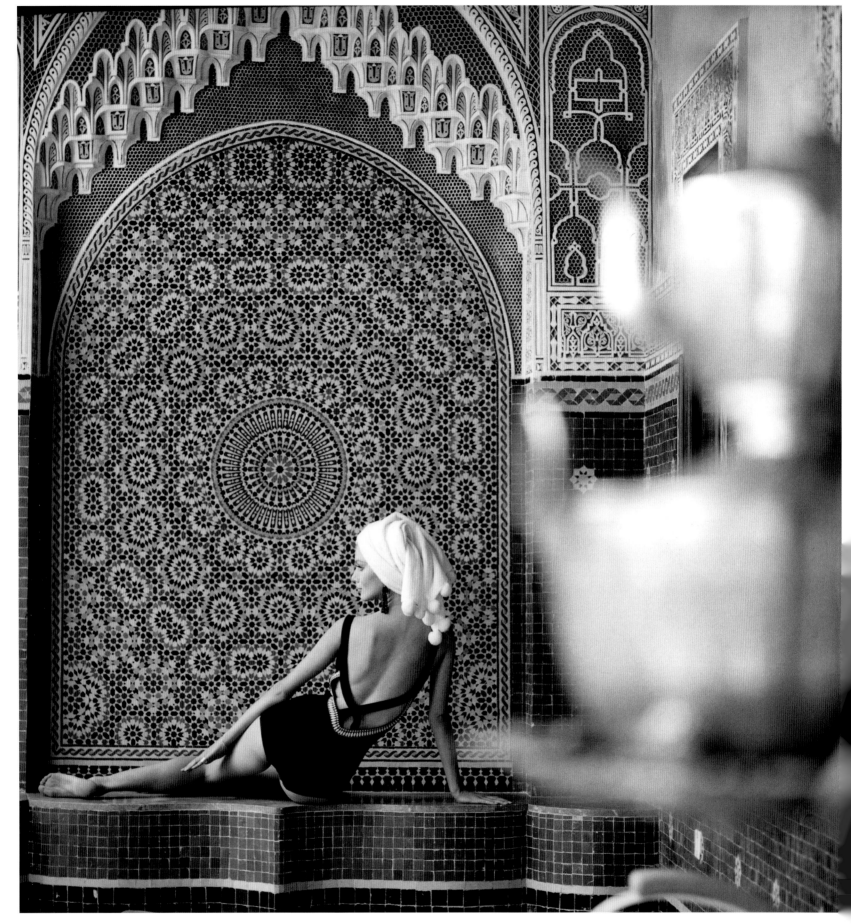

Lissy Schaper for Triumph, Tanger/Marocco 1964

110

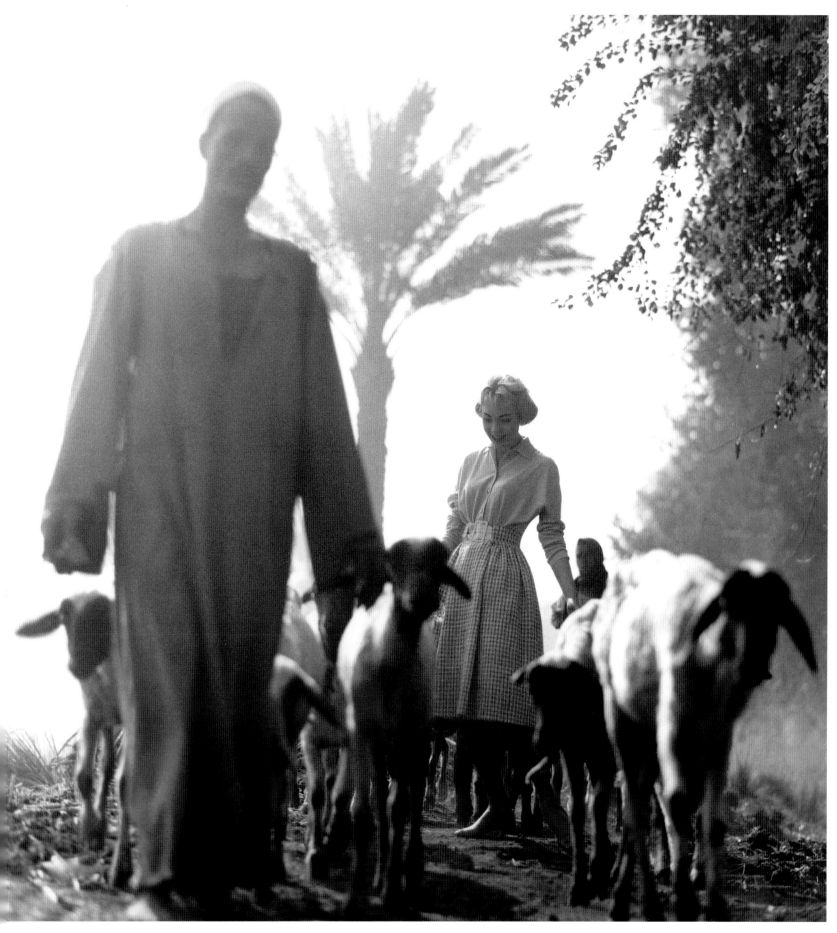

"The fellahs", Christa Reimer, Egypt 1959

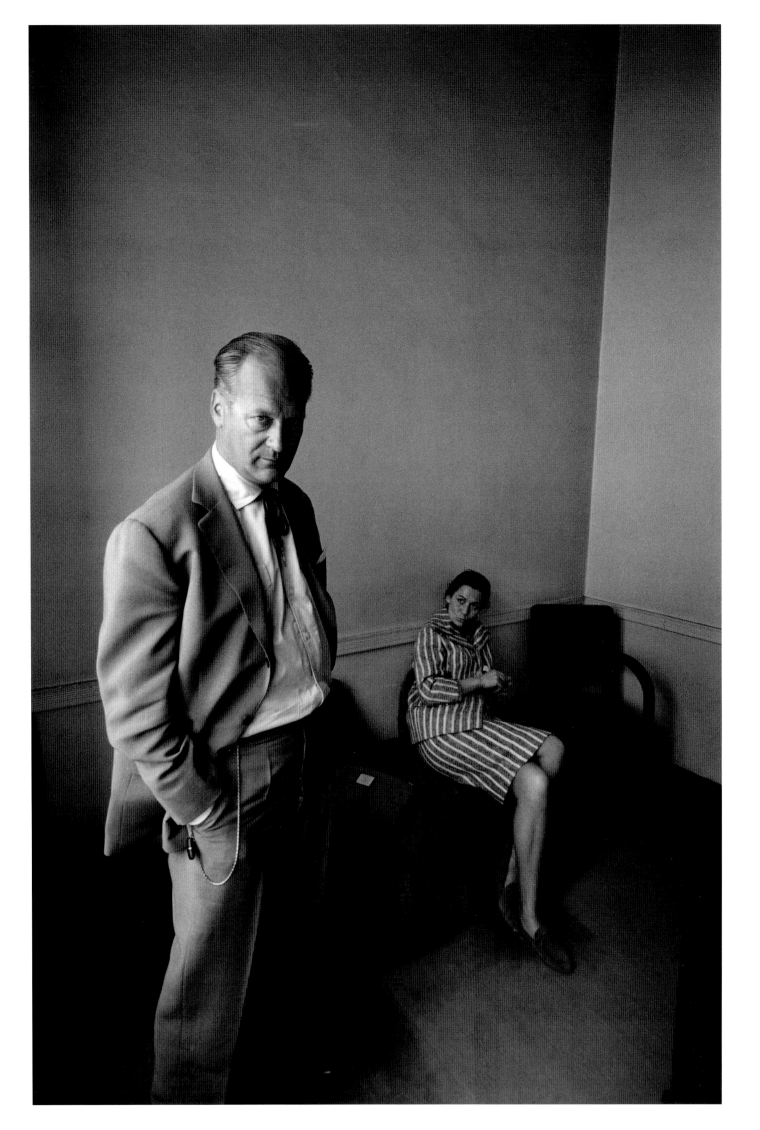

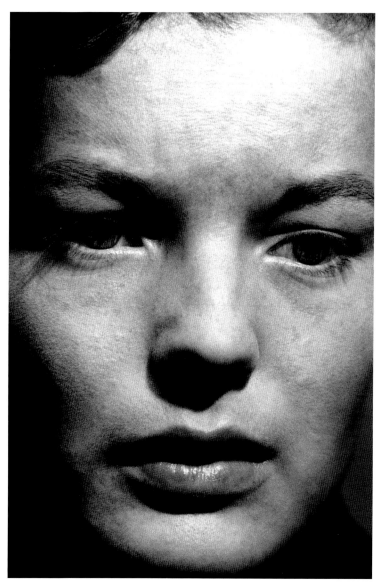

Romy Schneider, Hamburg 1961, in: *twen* 7/1961

photographer's accomplice, the clown charms and amuses the model, while Gundlach captures the situations he requires.

It was above all the wide-angle lens that enabled him to vary perspective and composition: "My favourite focal length was 28 millimetres! Because you could get closer with it, have steeper perspectives and greater depth of focus, even with several pictorial levels," Gundlach says today.[10] He used this lens for the fashion reportage on Nino raincoats in the port of Hamburg, and also for the portrait of Curd Jürgens. The by-standers were not aware of the potential of the 'wide angle' and thought they were outside the camera's range. As a result, it captured the sceptical-looking dock worker and the wonderfully sardonic expression of Jürgens' wife watching her husband posing. By contrast, Gundlach took the portrait of

Romy Schneider using a telephoto lens with a focal length of 400 mm and a triple extension, tailor-made for him by Kilfitt in Munich. He was thus able to take photographs of great immediacy without having to hold the camera directly in front of the sitter's face.

Despite all his experiments with contour and structure, with symbol-laden settings and reportage techniques, F.C. Gundlach never lost sight of the fashion design. "For me, the fashion outfits were always the heart and soul of every picture, they were the occasion for the pictures, and I would say that a sophisticated cut, a fold, could certainly be the subject of a picture."[11] This is wonderfully expressed in his commentary on his very compelling shot of a simple fashion creation by Lanvin: "This photograph is important for me: the essence of fashion with extremely reduced means, and just one source of light."[12] The

Simone and Curd Jürgens, carnival in Estoril 1960

next two spreads: "Am Baumwall", coat by Nino, Hamburg 1958; Bernadette, dress by Lanvin, Paris 1966, in: *Annabelle* 8/1966

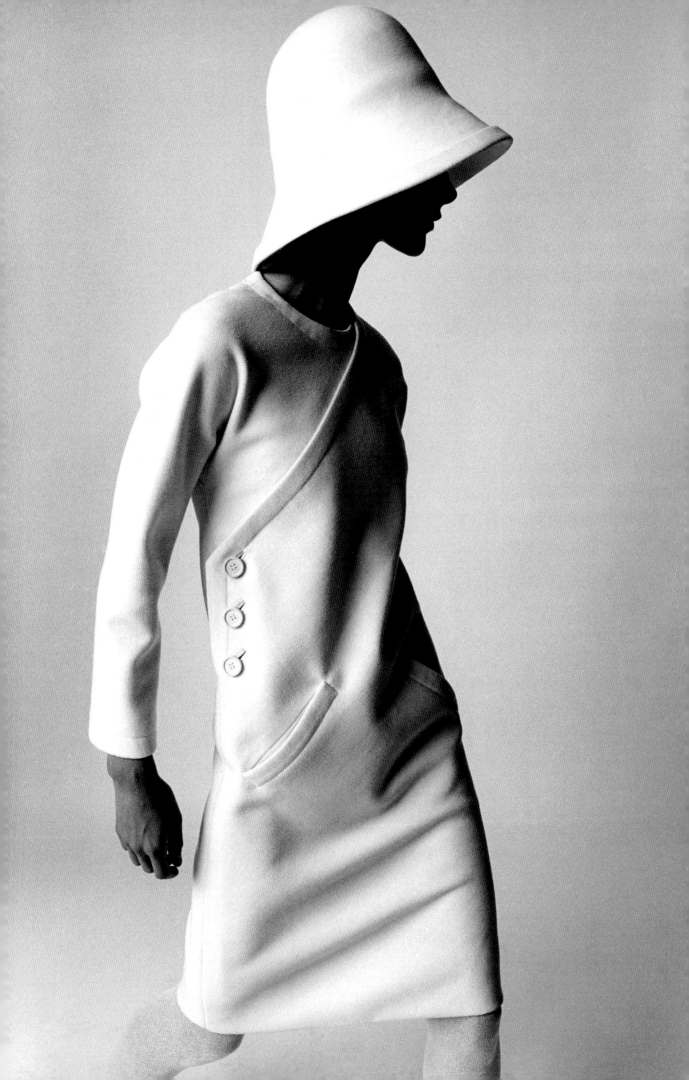

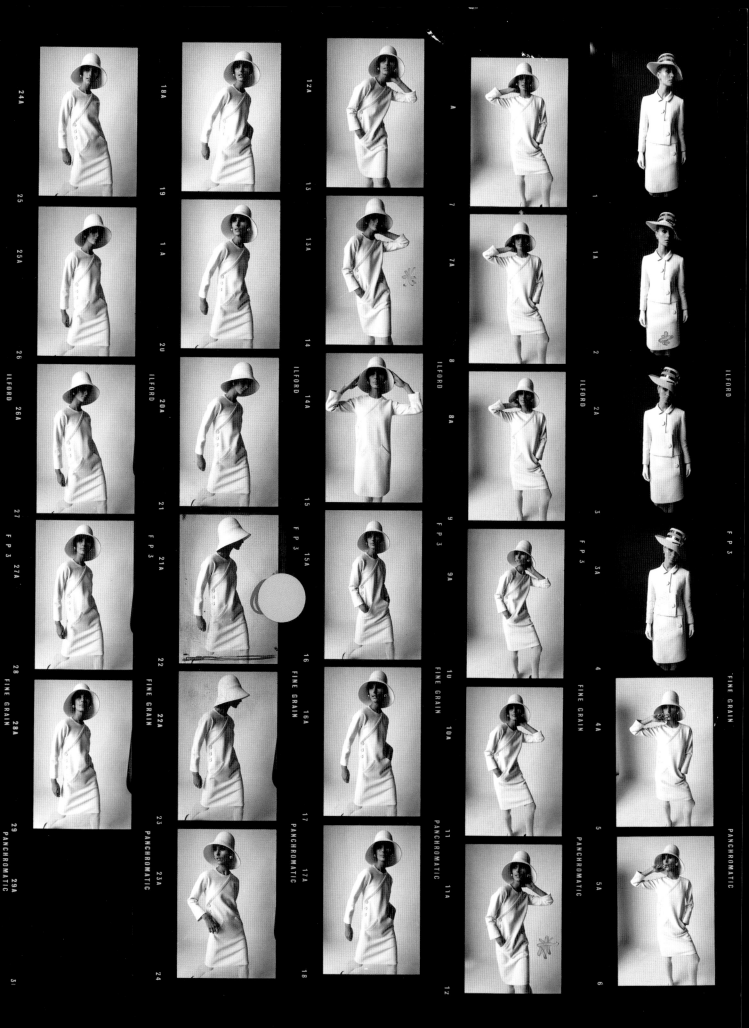

"Winter landscape", Heinebach 1943 "Light and shadow", Heinebach 1943

dress is difficult to photograph: it is monochrome, not figured, and not opulent as regards the fabric. It is mainly defined by a diagonal seam and three buttons on a side lapel. In finely graded shades of grey, ranging from light to an even lighter grey, Gundlach emphasizes the line of the seam and the pocket, which is also repeated in the brim of the hat. The wide angle shifts the view to the advantage of the head, producing a slightly mannered visual sensation.

F.C. Gundlach's pictorial composition attests to a wide graphic repertoire and a spontaneous, creative response to fashion, photo model and location. Besides this he achieves a personal photographic style without slavishly adhering to any creative grid system. The key to his diversity *and at the same time* his stylistic solidity lies in Gundlach's photographic development. When he received his first camera, an Agfa Box, in 1938, his first photographs were already mises-en-scène: he arranged his little brother and a friend on a stepladder, pressed the self-timer and sat himself down on the lowest step. "Up to the age of 16, I was zealously taking snapshots, I would almost say obsessively […]. My working models were mostly postcards of film stars, and I tried to imitate their

handling of light," he says about this stage in his career.[13] In the subsequent years, two trends emerge in his independent work: pictorialism with its deliberate highlights and blurs, which played an important role mainly in portrait photography until well into the 1930s; then quite obviously the style of New Vision, to be found in many of the photographs Gundlach took even while studying in Kassel.

In the fall of 1933, the Propaganda Ministry of National Socialist Germany defined the essential task of amateur photography as 'to photograph the homeland' such as to provide an idyllic image of Germany that would distract from the reality. This feature is visible in Gundlach's peasant folklore from the area around the village of his birth, Heinebach in Hesse, and includes his portrait of his mother as a peasant, a 'Madonna in a Pinafore', presumably his earliest published work dating from 1943.[14]

After the war, while studying under Rolf Werner Nehrdich at the Private Lehranstalt für Moderne Lichtbildkunst in Kassel, Gundlach learnt all about photographic technique. He mainly recalls from this particular period the high-contrast theatre photographs by his teacher's father, Max Nehrdich.

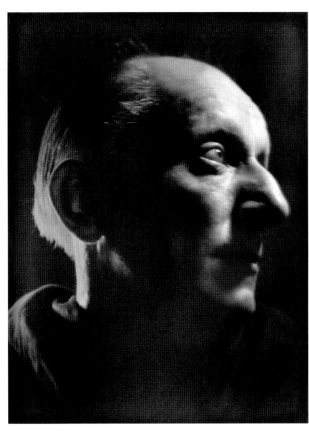
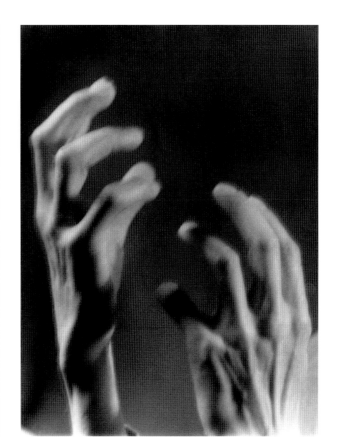

Portrait, Heinebach 1947
Hands, Heinebach 1947
"Madonna", Heinebach 1943

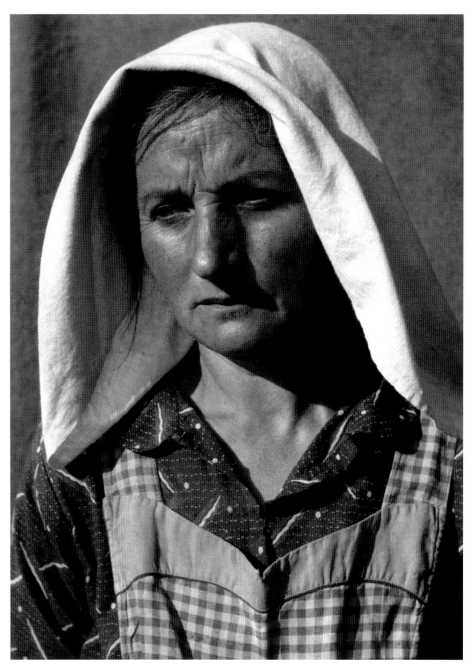

"Lights in the night", Stuttgart 1950

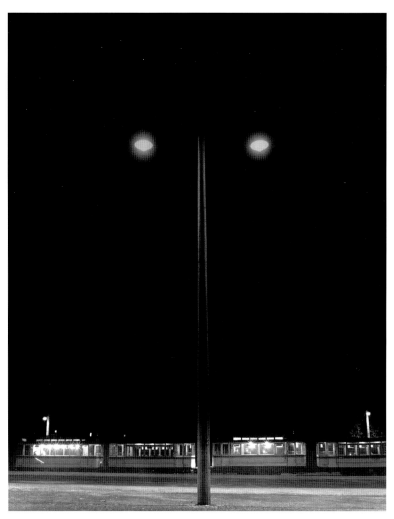

"The last train", Deutsche Gartenschau auf dem Killesberg, Stuttgart 1950

In Kassel and during his first years in Wiesbaden, Stuttgart and Paris, Gundlach absorbed many and varied photo-aesthetic impressions. His first job, as an 'Operateur' in the Hollywood Studio in Wiesbaden, again confronted him with the style of the glamorous Ufa portrait. The customers having their portraits taken were mainly American soldiers of occupation and their girlfriends, and with the help of lighting and a soft-focus lens Gundlach made film stars of them.

Seeking a new challenge, he went to the exhibitions by the fotoform group, which had been propagating its distinctive subjective grasp of reality and the autonomy of the photographic image since 1949. Their influence on Gundlach is evident in his independent work: chance finds are considered worthy of being photographed, objects are trimmed and rendered abstract, the composition becomes planar, the image's grey tones are reduced to just a few, the perspective is unclear.

Gundlach came into closer contact with fashion photography as assistant to Ingeborg Hoppe in Stutt-

gart. Today he assesses that episode as follows: "Her photographs were static, and extremely sharp. What I learnt from her was precision!"[15] Of greater influence on Gundlach's style at that time however, were the works of Erwin Blumenfeld and Irving Penn, Martin Munkacsi, Richard Avedon and Edward Steichen in *Harper's Bazaar* and *Vogue*: "Those are the images that stuck in my mind from my visits to the Amerika Haus in Stuttgart! [...] What impressed me about Blumenfeld's photographs was the ingenious coloration, the playfully elegant pictorial compositions influenced by Surrealism. In Penn it was the clarity, the almost ascetic reduction of the pictorial design to the essential. I tried to integrate all of that."[16] These studies in style influenced F.C. Gundlach's photography, and it was between these positions that he later unfurled the entire repertoire of his fashion photography.

"Then I fledged my wings, extended the range of my activities. While working for Mrs. Hoppe I spent

"The Third Man", Stuttgart 1951

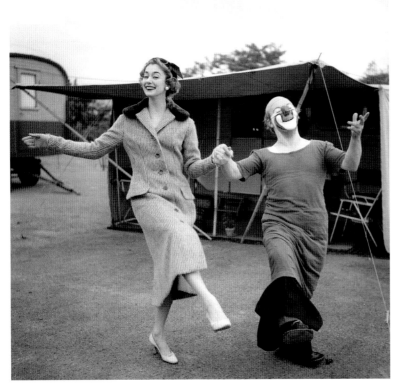

Ellinor and Charlie Rivel, dress by Staebe-Seger, Berlin 1955, in: *Film und Frau* 17/1955

my holidays in Paris – taking photographs. Paris was a completely different world!"[17] The photographer's first entry into France is stamped in his passport as 7 October 1950. Gundlach's modern approach was enhanced by the French existentialism of St. Germain des Prés and French cinema. He photographed Raymond Hermantier and Brigitte Auber during the filming of "Sous le ciel de Paris" (director: Julien Duvivier 1951), and Gérard Philipe during "Fanfan La Tulipe" (director: Christian-Jacque 1952) at the Paris-Billancourt film studios.

In the independent photographs he took in Paris the dominant elements are dismal, deserted street scenes, wet cobblestones at dawn, and off-centre figures. His reportages and portraits have persuasively unusual perspectives, reduced light and surrealistic arrangements. The high angle portrait of Jean Marais climbing up the ladder of his houseboat or the "slightly surreal" portrait of Dieter Borsche with the heads of two wooden dolls are typical of the star-portraits Gundlach created at that time with a view to the print medium. The swift portraits for the *Süddeutsche Rundfunk* and for radio and television guides,[18] and his star portraits for the film distributers Gloria, Union and Schorcht-Film had awakened

in him the ambition to distinguish himself from set photography and role portraits. As he emphasises today: "What emerged had to be my image."[19]

"As a young photographer, of course, you want to be published!"[20] This explicit agenda meant the end of Gundlach's experimental photography done without a commission, and at the same time is the point of departure of his development into a much-published fashion photographer. At that time, Gundlach was photographing stylistically confident fashion sequences for *Elegante Welt*, such as the report on the 1951 Dior Collection. In issue 9/1952, editor F. W. Koebner also published parts of Gundlach's first fashion reportage featuring an actress: his "Modebummel mit Nadja"[21] for Heinzelmann en vogue set the example for the series "Film Stars in Fashion" he would later be publishing in *Film und Frau*. In Paris he met editor-in-chief Curt Waldenburger who won him over definitively to fashion photography with the publication opportunities in *Film und Frau*. By that time, Gundlach already had a photographic repertoire which he was then able to display in a variety of published fashion photographs: as the youngest photographer in the *Film und Frau* team he had to assert himself against, and distinguish himself from established colleagues

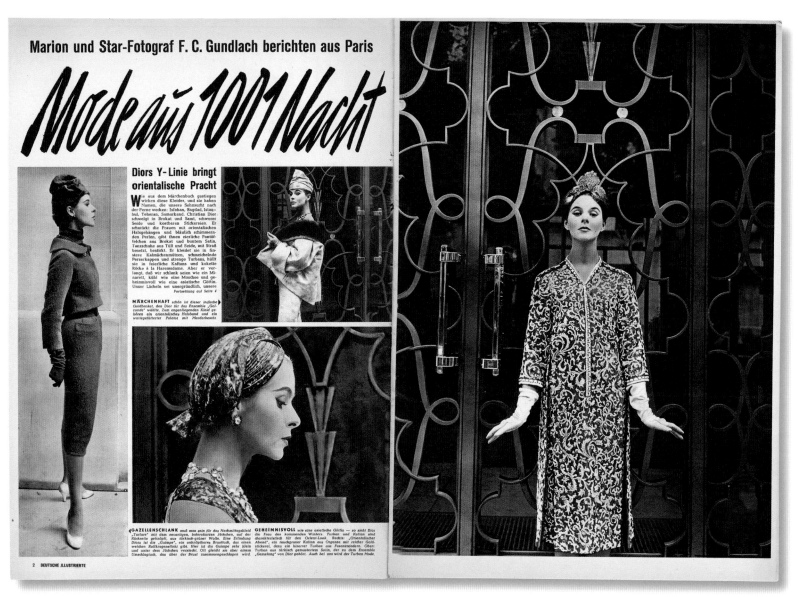

Marion und Star-Fotograf F. C. Gundlach berichtet aus Paris

Mode aus 1001 Nacht

Diors Y-Linie bringt orientalische Pracht

Wie aus dem Märchenbuch gestiegen wirken diese Kleider, und sie haben Namen, die unsere Sehnsucht nach der Ferne wecken: Isfahan, Bagdad, Istanbul, Teheran, Samarkand. Christian Dior schwelgt in Brokat und Samt, schwerer Seide und kostbaren Stickereien. Er schmückt die Frauen mit orientalischen Halsgehängen und bläulich schimmernden Perlen, gibt ihnen zierliche Pantöffelchen aus Brokat und buntem Satin, Tanzschuhe aus Tüll und Seide, mit Straß besetzt. Er kleidet sie in finstere Kalmückenmützen, schmeichelnde Perserkappen und strenge Turbans, hüllt sie in feierliche Kaftans und kokette Röcke à la Haremsdame. Aber er verlangt, daß wir schlank seien wie ein Minarett, kühl wie eine Moschee und geheimnisvoll wie eine asiatische Göttin. Unser Lächeln sei unergründlich, unsere *Fortsetzung auf Seite 4*

MÄRCHENHAFT schön ist dieser indische Goldbrokat, den Dior für das Ensemble "Golconde" wählte. Zum enganliegenden Kleid gehören ein orientalisches Halsband und ein weitgefütterter Paletot mit Marderbesatz.

GAZELLENSCHLANK muß man sein für das Nachmittagskleid "Torino" mit dem neuartigen, bolerokurzen Jäckchen, auf der Rückseite geknöpft, aus türkisch-grüner Wolle. Eine Erfindung Diors ist die "Guimpe", ein anknöpfbares Brusttuch, das einen weichen Rollkragenersatz gibt. Hier ist die Guimpe unter dem kleinen Jäckchen versteckt. Oft gleicht sie aber einem Ensemble Umschlagtuch, das über der Brust zusammengeschlagen wird.

GEHEIMNISVOLL wie eine asiatische Göttin — so sieht Dior die Frau des kommenden Winters. Turban und Kaftan sind charakteristisch für den Orient-Look. Rechts: "Orientalischer Abend", ein rauchgrauer Kaftan aus Organza mit reicher Goldstickerei, dazu ein binarrer Turban aus Fasanenfedern. Oben: Turban aus türkisch pensaieriem Satin, der zu dem Ensemble "Gmmelong" von Dior gehört. Auch bei uns wird der Turban Mode.

2 DEUTSCHE ILLUSTRIERTE

"Marion and star-photographer F.C. Gundlach report from Paris: Fashion of 1001 Nights", *Deutsche Illustrierte* 36/1955

like Hubs Flöter, Regina Relang, Sonja Georgi and Charlotte Rohrbach. Gundlach rose to the challenge. He employed his wide range of pictorial means with unerring accuracy and reacted flexibly to the outfits, the models and the situations in fashion shootings. He thus developed the "cool, glamorous black-and-white realism" with which he placed himself fully at the service of fashion.[22] Clear pictorial compositions, expressive poses and varied perspectives set the scene for the fashion designs and emphasise details – a fold, an elegant cut, a precious fabric. This soon brought him to people's attention. In a letter to Gundlach dated 5 September 1953, editor-in-chief Curt Waldenburger writes: "Sonja Georgi rang today and, with amazement and admiration, took note of the work of her young colleague F.C. Gundlach."[23]

F.C. Gundlach took fashion photographs for maga-

zines and journals over a course of thirty years. This time period saw not only enormous social changes, but also the various influences exerted by the international photography and publishing scene, the fine arts, and indeed fashion itself. This is evident in both Gundlach's pictorial idiom and composition. In the early 1950s, formal scenes in elegant interiors conveyed the dream of open luxury; in the late 1950s fashion photographed abroad mirrored the yearning for distant places. In the 1960s, self-confident poses testify to a new physicality and emancipation while, in the 1970s, fashion photography seemed to free itself from all the constraints of mise-en-scène, without which, however, it cannot even occur.

One example of Gundlach's response to these developments is the obvious influence of Op Art and Pop Art. The fashion designs of the time also ex-

124

Shorts by André Courrèges, Paris 1965
next spread: Pantsuit by André Courrèges, Paris 1965, in: *Constanze* spring/summer 1965
Astrid Schiller, mini by André Courrèges, Paris 1967, in: *Constanze* 2/1967

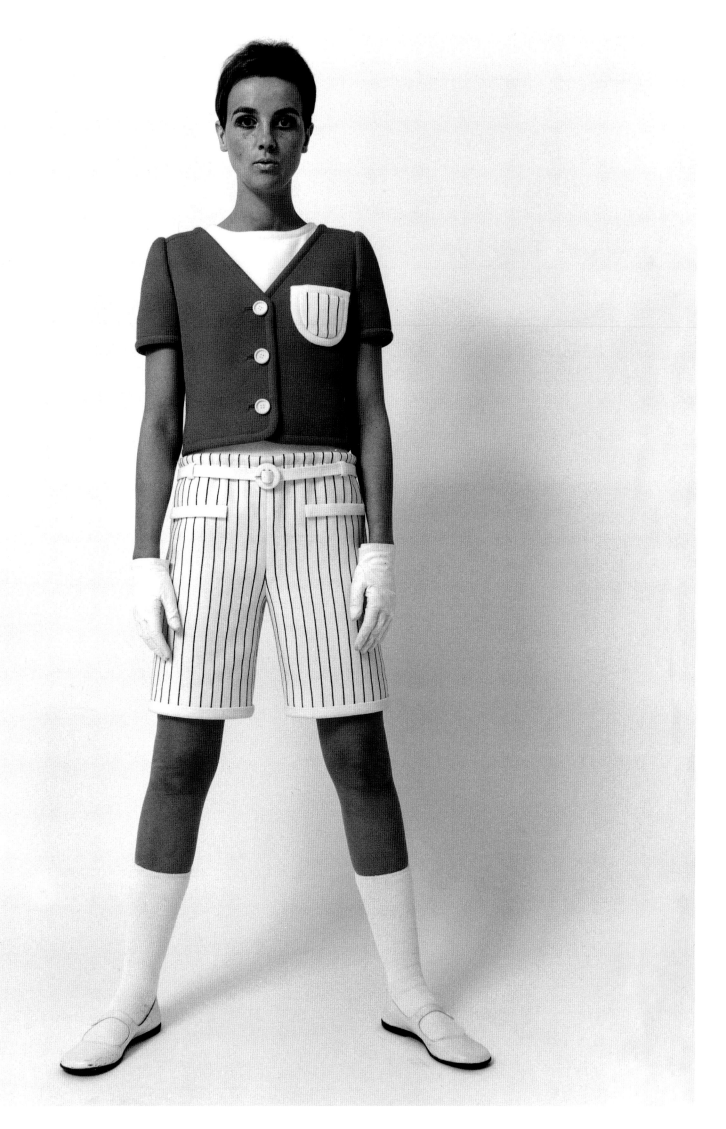

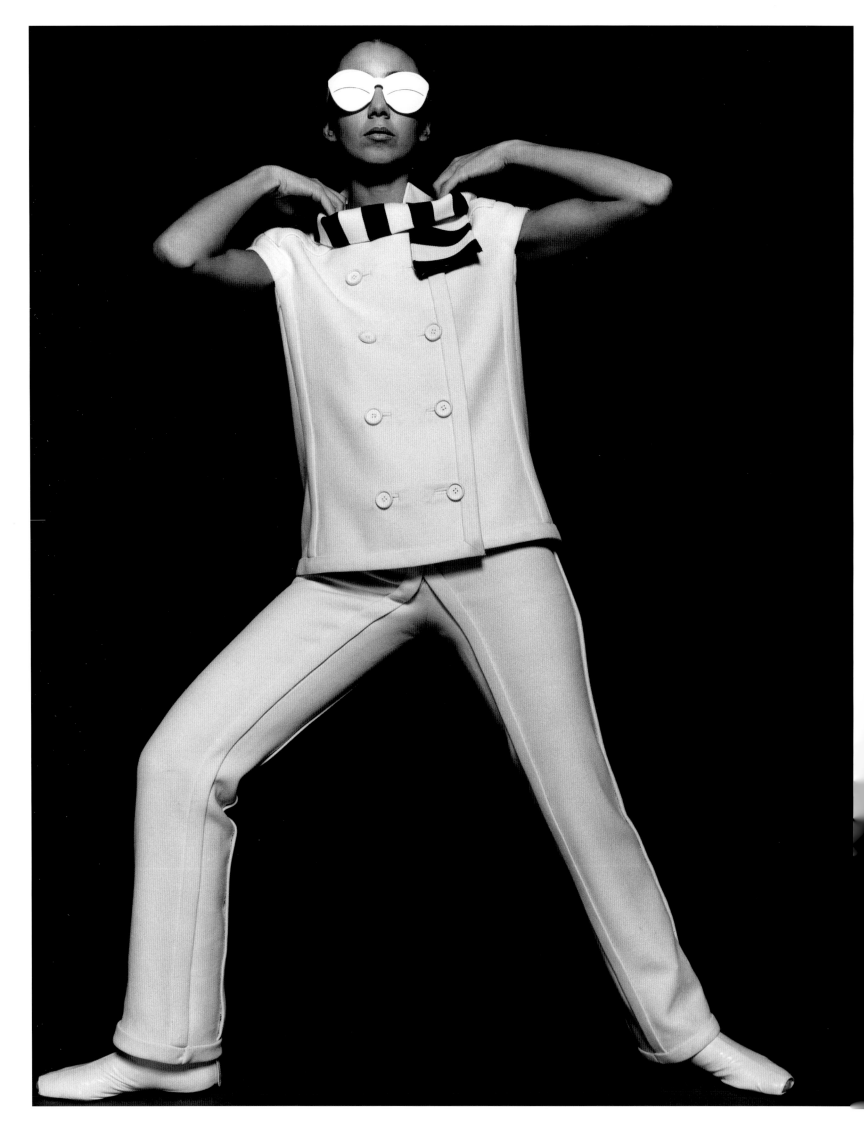

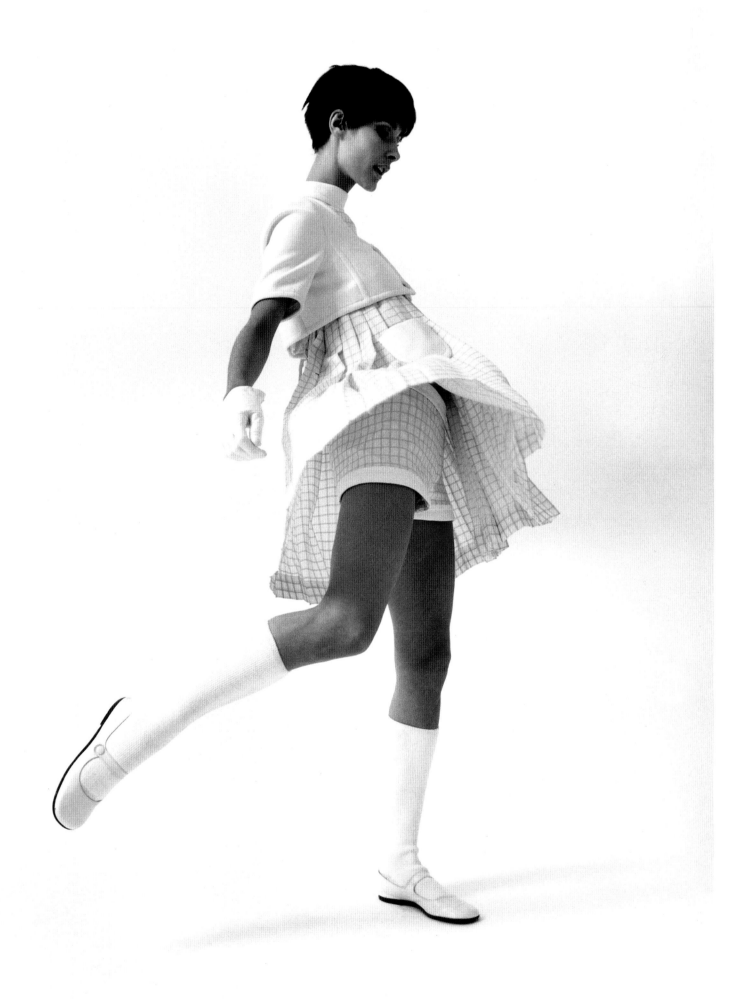

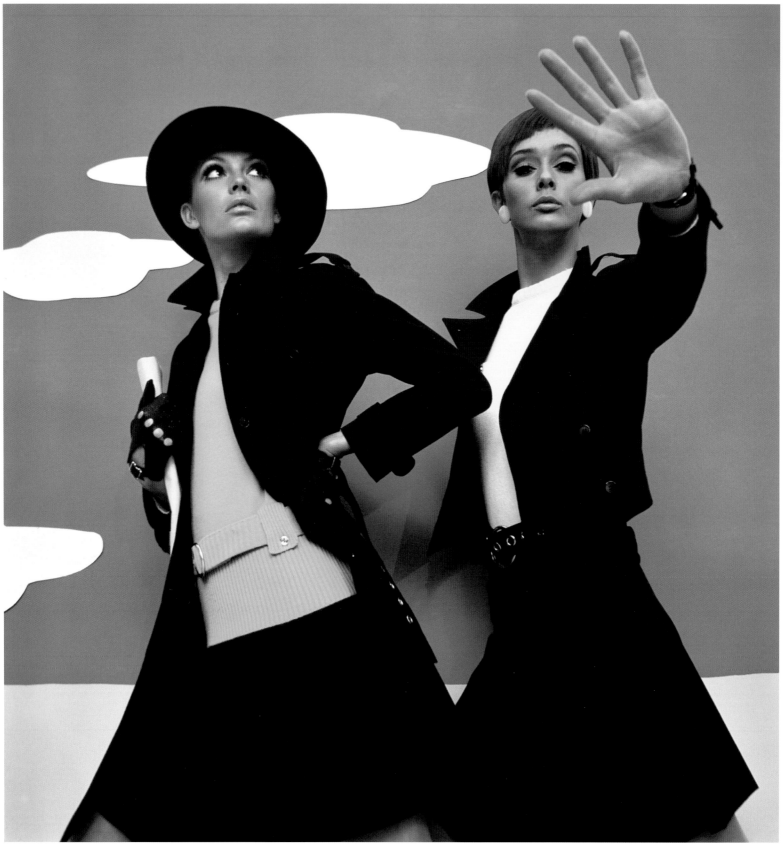

"Pop Art-Fashion", Birgit Larssen and Ina Balke, Hamburg 1967, in: *Brigitte* 18/1967

pressed current art trends, even more strongly than before: fabric patterns and cuts reflected the brash colours, the extreme contrasts, the optically illusory line. Gundlach used a visually similar formal idiom for his pictorial compositions and photographed the strictly geometrical fashion designs by André Cour-règes, Lend, Missoni and Daniel Hechter in front of equally strict black-and-white or trendily colourful backgrounds. He had elaborate settings à la Lichten-stein made, and he used back projections of Hockney

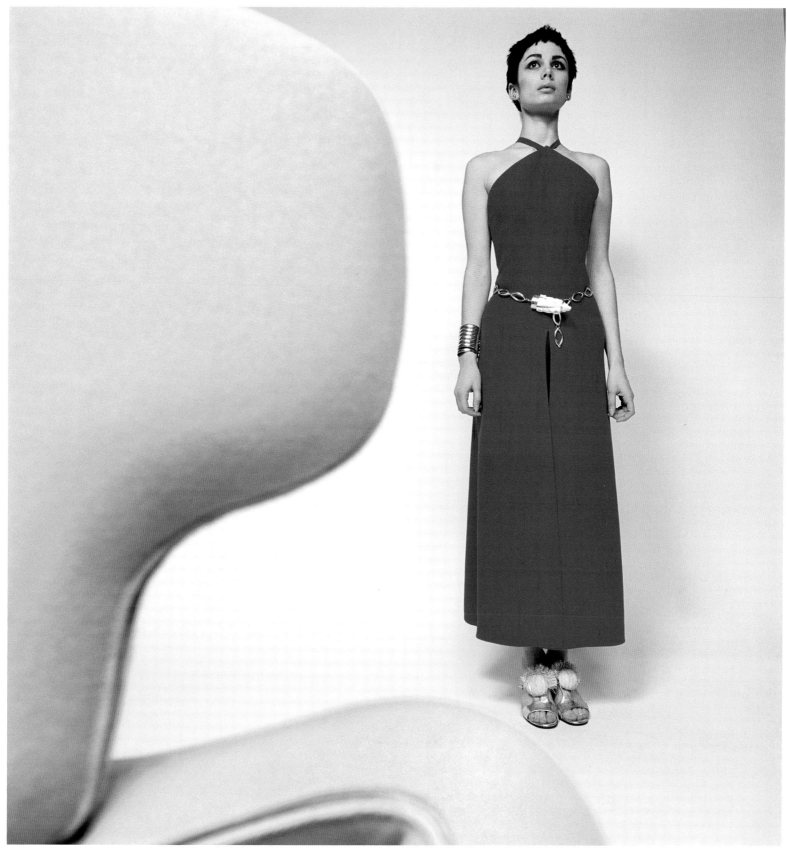

Mickey Belverger, evening dress by Christian Dior, chair by Airborne International, Paris 1967, in: *Annabelle* 1967

and Meckseper motifs as backdrops for his photographs. Realizing the inestimable value of time-bound poses offered to him by a Grace Coddington or an Ann Zoreff, he allowed his photo models much more freedom of movement than ten years previously.

According to social philosopher Gilles Lipovetzky, the task of the fashion photographer is "to illustrate the work of renowned fashion designers and bring out the becomingness and originality of clothing by means of flattering poses and situations".[24]

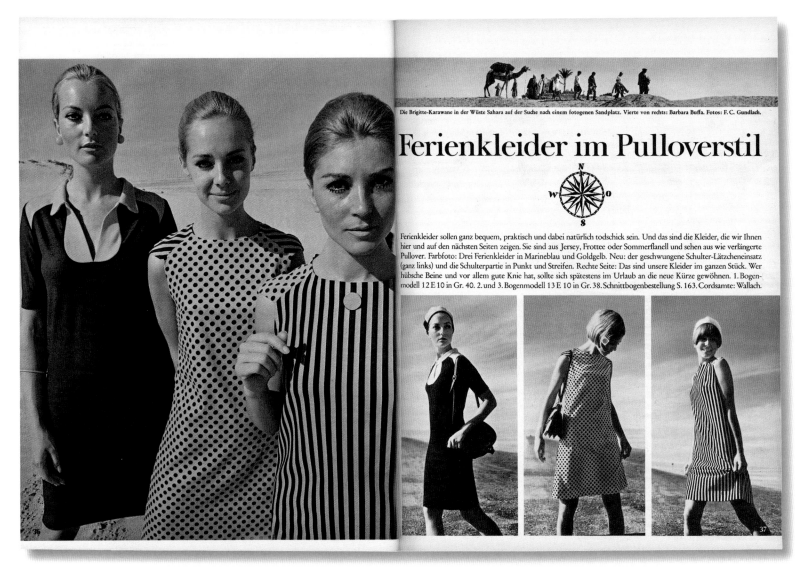

Die Brigitte-Karawane in der Wüste Sahara auf der Suche nach einem fotogenen Sandplatz. Vierte von rechts: Barbara Buffa. Fotos: F. C. Gundlach.

Ferienkleider im Pulloverstil

Ferienkleider sollen ganz bequem, praktisch und dabei natürlich todschick sein. Und das sind die Kleider, die wir Ihnen hier und auf den nächsten Seiten zeigen. Sie sind aus Jersey, Frottee oder Sommerflanell und sehen aus wie verlängerte Pullover. Farbfoto: Drei Ferienkleider in Marineblau und Goldgelb. Neu: der geschwungene Schulter-Lätzcheneinsatz (ganz links) und die Schulterpartie in Punkt und Streifen. Rechte Seite: Das sind unsere Kleider im ganzen Stück. Wer hübsche Beine und vor allem gute Knie hat, sollte sich spätestens im Urlaub an die neue Kürze gewöhnen. 1. Bogenmodell 12 E 10 in Gr. 40. 2. und 3. Bogenmodell 13 E 10 in Gr. 38. Schnittbogenbestellung S. 163. Cordsamte: Wallach.

"Holiday dresses like pullovers", *Brigitte* 10/1966

Admired for their aesthetics and their creative pictorial form, at least since the second half of the 20th century individual fashion shots have separated out of their production context to become part of the art business – represented by galleries, exhibited at museums, published (again) in catalogues. Thus fashion photography hovers between its illustrative function on the one hand and its own creative aspiration, indeed its artistic value, on the other. The art of fashion photography consists of realising one's own ambitions within the framework of the commission, and furnishing the fashion design with an artistic interpretation. Often the external circumstances of the commission are catalysts for the creative process, anchor points used by the photographer, and friction surfaces on which a fireworks of pictorial ideas is kindled. "I never took photographs against the fashion."[25] With this fundamental statement, Gundlach

not only places his photography at the disposal of fashion, he also accepts the consequences which the fashion styles have for his pictorial idiom.

When Gundlach took up fashion photography in 1951, developments in that sector were determined by Haute Couture in Paris.[26] Starting with the "New Look" which had been introduced by Christian Dior at his salon on Avenue Montaigne in 1947, the fashion designer "in a lean post-war era accommodated women's longings and dreams, their craving for luxury, in the opulent folds of fabric and the constant emphasis on extremely slim waistlines".[27] From then on, the image of fashion changed from season to season. The waistline changed, the hemline rose or fell – from the A to the H to the Y line, it was the contour that characterised each fashion. Fashion photography too had to conform to this guideline in its pictorial composition. Attendance at the Paris fashion shows

F.C. Gundlach in his studio, Barbara Buffa in the background, Hamburg 1966

was handled very restrictively by the Chambre Syndical de la Couture Parisienne, and taking photographs was strictly prohibited. Only a single version of each design was presented, tailor-made for the house mannequin. As a result, photographers for numerous magazines from all over the world queued up for each dress, and each one of them got no more than a few dresses in front of their camera, each of them only for a few minutes. In this narrow time-frame, the most a photographer could do was go outside the fashion house with the mannequin, something that was complicated by the fact that all the designs had to be hidden from the public, kept under 'wraps' until the photo shoot. F.C. Gundlach was also restricted in his creative work by these givens. Thus the shots of Dior's 1955 Y-line were taken in front of the entrance to the house right next to Dior's salon in Paris. Nevertheless, Gundlach used his photographic means to successfully incorporate the fashion information in an aesthetically top-class motif.

"The product of my work was always the printed image, the publication," says Gundlach, thus defining himself as a photographer with the dual task of merging the visions of the fashion designer with the ideas of the editors of the distributing medium, or fashion magazine.[28]

At the magazine *Film und Frau*, fashion editor and designer in personal union Helga Waldenburger, allowed her photographer Gundlach free rein. The one thing he had to do was position the style of his photographs somewhere between "bourgeois" and "elegant". By contrast, Barbara Buffa, fashion editor with *Brigitte*, had very clear ideas about the fashion sequences to be photographed. She selected all the fashion designs, decided on the theme and style of the takes, and frequently even accompanied the photographer on his

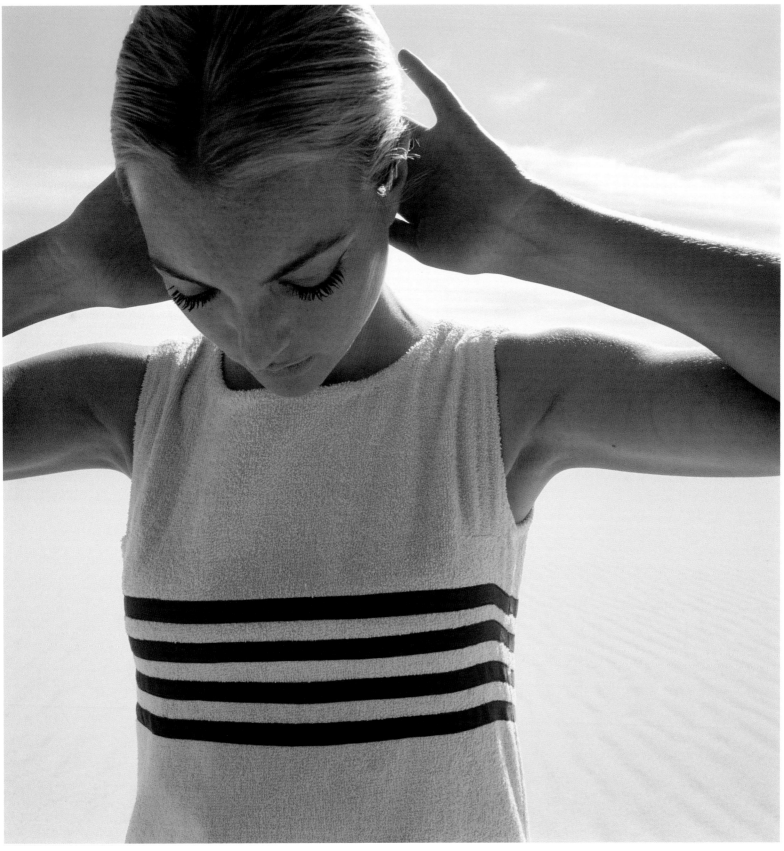

"All day at the beach", Karin Mossberg, Gizeh/Egypt 1966, in: *Brigitte* 8/1966

fashion trips. One story about a fashion sequence taken in Africa shows the narrow limits which the innovative photographer Gundlach was subjected to by the editor-in-chief: His wide-angle photographs of swimming and leisure wear taken in front of the pyramids of Giza and in the Ngong hills in Kenya were initially rejected as too avant-garde by the *Brigitte* editors. Only after enormous protests was it agreed to publish the series – under the absurd title "Den ganzen Tag am Strand" (The whole day on the beach). Gundlach com-

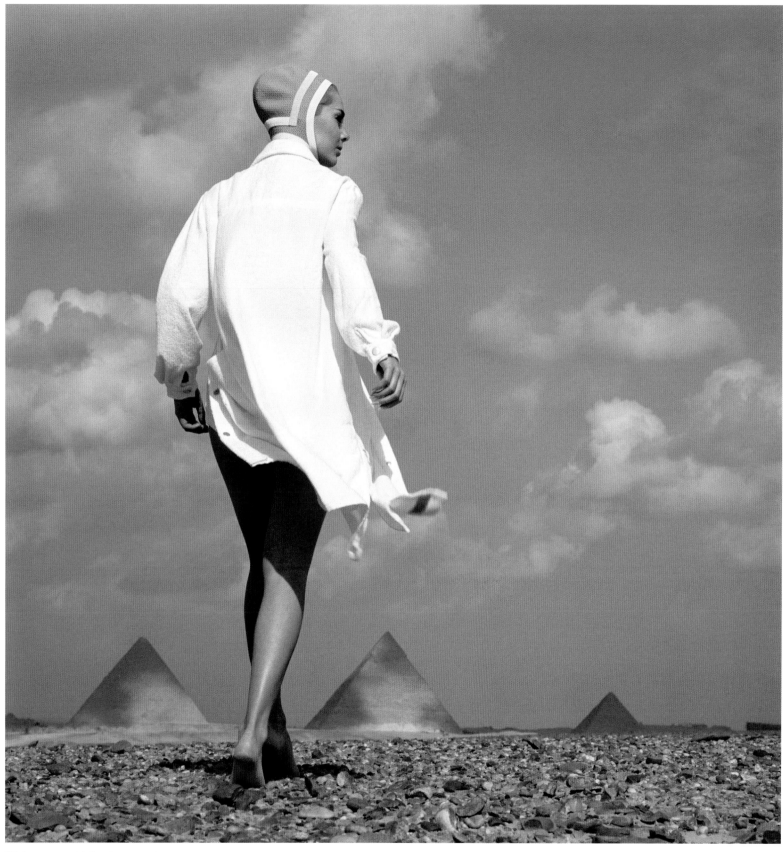

"All day at the beach", Karin Mossberg, Gizeh/Egypt 1966, in: *Brigitte* 8/1966

mented regretfully on this conservative attitude: "They did want innovation – but with the hand-break on."[29] Yet because the photographer was aware of the external constraints, he could confront them as a challenge to his photographic skills and, within the confines of

the commission, still achieve motifs that went far beyond the mere depiction of "fashionable clothing for the purposes of advertising and sale".

One of Gundlach's repeated strategies in dealing with the constraints of the commission was offen-

Beach suit by Guitare, Gizeh/Egypt 1966, in: *Brigitte* 8/1966

sively address the production conditions: he raises inappropriateness to the level of a manifesto and emphasises the artificial aspect of staged fashion photography by integrating everyday equipment, such as cables, spotlights and ladders, into his motifs and even regarding backdrop paper as an object worthy of being photographed as such.

The poses adopted by the photo models play an important role in this context. "Anyone who poses wants to be photographed in a position that is nei-

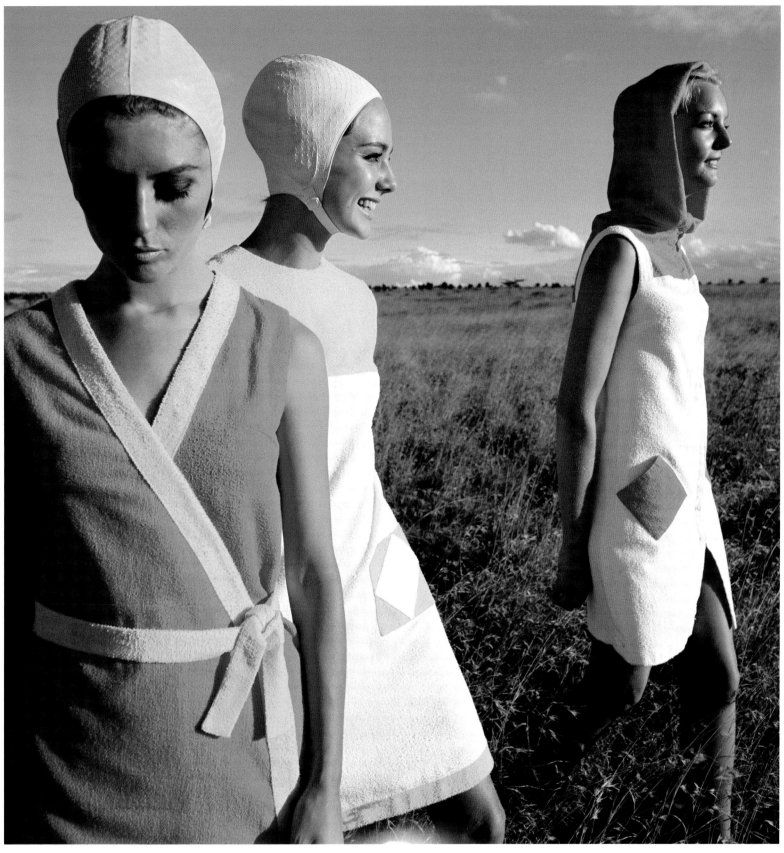

"Op Art-Fashion at the beach", Micky, Karin and Ann, Kenya 1966

ther natural, nor intended to be natural," ascertains Pierre Bourdieu.[30] And the poses taken up by Gundlach's models are often extreme. This obvious staging in all its artificially creates distance, yet does not compromise credibility. Rather, the initial irritation caused by the self-referential motif heightens the impact of the fashion photos.

Gundlach thus touches on a basic function of fashion photography: the situation staged for the fashion shot is "freed of all naturalism"; as an "abstract institu-

next spread: Bambi, dress by Horn, Berlin 1957, in: *Film und Frau* spring/summer 1957
Simone d'Aillencourt, dress by Horn, Berlin 1957, in: *Film und Frau* spring/summer 1957

tion" whose "formal generality" is initially free of individual attributes, the photo model becomes a means of transportation for design creations by being dressed in fashionable clothing.[31] This blend of apparent objectivity and emphasised staging enables the viewer to grasp the potential of the depicted fashion and relate it to individual wishes and ideas. One could say, like Robert Castel: "Because photography depicts the object as absent, it can become a vehicle for dreams".[32]

When Gundlach hung up his camera in the late 1980s, deliberate arrangement had been replaced by a new naturalism: sporty photo models supposedly comporting themselves as in real life. Gundlach had also turned this 'fashion in fashion photography' into convincing photographs. His most important period however, extends from the first fashion reportages for *Elegante Welt* and the early portraits from Paris to the Hippie era, when he photographed knitwear and bell-bottom trousers for *Brigitte*. During that era, his fine antenna picked up stylistic influences from fashion, fashion photography, art and design and made them part of his concise photographic hallmark.

ENDNOTES

1 Steinert, Otto and Wolf Strache (eds.): *Das Deutsche Lichtbild 1960*. Stuttgart 1959, p. 52.

2 The text on the invitation card: "Jean Robert présente dans sa Librairie, 32, Rue Jacob des œuvres photographiques de F.C. Gundlach du 27.10. au 27.11.1951."

3 Susa Ackermann: *Couture in Deutschland*. Munich 1961, p. 118.

4 Christel Heybrock: *Mode schafft sich ihren Raum. Körper und Kleidung als Lebens-Inszenierung in den Fotografien von F.C. Gundlach.* <http://hometown.aol.de/__121b_BWLpHS6uzHRnlpqiTPMatDrhqhOQlxqHvJpglaYhu6g> (visited on: January 10, 2008).

5 Neumann, Nicolaus: *Gestatten: Mister Fotografie*. In: *Art* issue 4/2002, p. 67.

6 Frecot, Janos and Helmut Geisert (eds.): *Aufbaujahre*. Berlin 1985, p. 31.

7 *Film und Frau* fashion magazine, Spring/Summer 1956, p. 30.

8 *East African Standard*, January 1966, no day, no page number.

9 Frecot, Janos and Helmut Geisert (eds.): *Aufbaujahre*. Berlin 1985, p. 31.

10 F.C. Gundlach in conversation with the author, Hamburg, November 2007.

11 Berger, Beate: *Die Bilderwelt der Mode.* <http://www.wdr5.de/sendungen/featureserie/manuskript/mode171004.pdf> (visited on January 10, 2008).

12 *Szene Hamburg*, issue 11/1991, p. 30.

13 *Leica World*, issue 1/2002, p. 25.

14 In a letter to F.C. Gundlach dated 26 May 1943, the office of the 'Reichsbauernführers' (Ministry of Agriculture) confirmed receipt of three photographs which, according to the photographer, appeared in a magazine published by that institution.

15 F.C. Gundlach in conversation with the author, Hamburg, November 2007.

16 F.C. Gundlach in conversation with Jörn Rohwer: *Romy Schneider war ein transparentes Medium*. In: *Berliner Zeitung*, 17/18.8.1996, p. 47.

17 F.C. Gundlach in conversation with the author, Hamburg, November 2007.

18 Staff identification *Funk-Illustrierte* 1951: "The holder of this card, Franz Christian Gundlach, is a permanent employee of the *Funk-Illustrierten*".

19 F.C. Gundlach in conversation with the author, Hamburg, November 2007.

20 Ibid.

21 Heinzelmann en vogue: *Modebummel mit Nadja* (engl.: A fashion stroll with Nadja). Photographs from this series are also in *Film und Frau*, issue 24/1952, p. 14, and *Elegante Welt*, issue 9/1952, pp. 36–37.

22 F.C. Gundlach in conversation with Ilka Piepgras: *Wie haben Sie den Stil der Deutschen geprägt?* In: *Die Zeit* no. 40, 29.9.2005.

23 Curt Waldenburger to F.C. Gundlach in a letter dated 5.91953.

24 Lipovetsky, Gilles: "Modischer als die Mode", in: Lehmann, Ulrich and Jessica Morgan: *Chicclicks*. Ostfildern 2002, p. T8.

25 F.C. Gundlach in conversation with the author, Hamburg, November 2007.

26 Cf. Baudot, François: *Die Mode im 20. Jahrhundert*. Munich 1999, p. 12.

27 Link-Heer, Ursula: *Die Mode im Museum oder Manier und Stil*. In: *Mode, Weiblichkeit und Modernität*, ed. by Gertrud Lehnert. Dortmund 1998, p. 142.

28 F.C. Gundlach in conversation with the author, Hamburg, November 2007.

29 F.C. Gundlach in conversation with the author, Hamburg, November 2007.

30 Bourdieu, Pierre: *Die gesellschaftliche Definition der Fotografie*. In: *Eine illegitime Kunst*, ed. by Pierre Bourdieu and Luc Boltanski. Frankfurt/M. 1981, p. 92.

31 Barthes, Roland: *Die Sprache der Mode*. Frankfurt/M. 1985, p. 265 and 313.

32 Castel, Robert: "Bilder und Phantasiebilder", in: *Eine illegitime Kunst*, ed. by Pierre Bourdieu and Luc Boltanski. Frankfurt/M. 1981, p. 238.

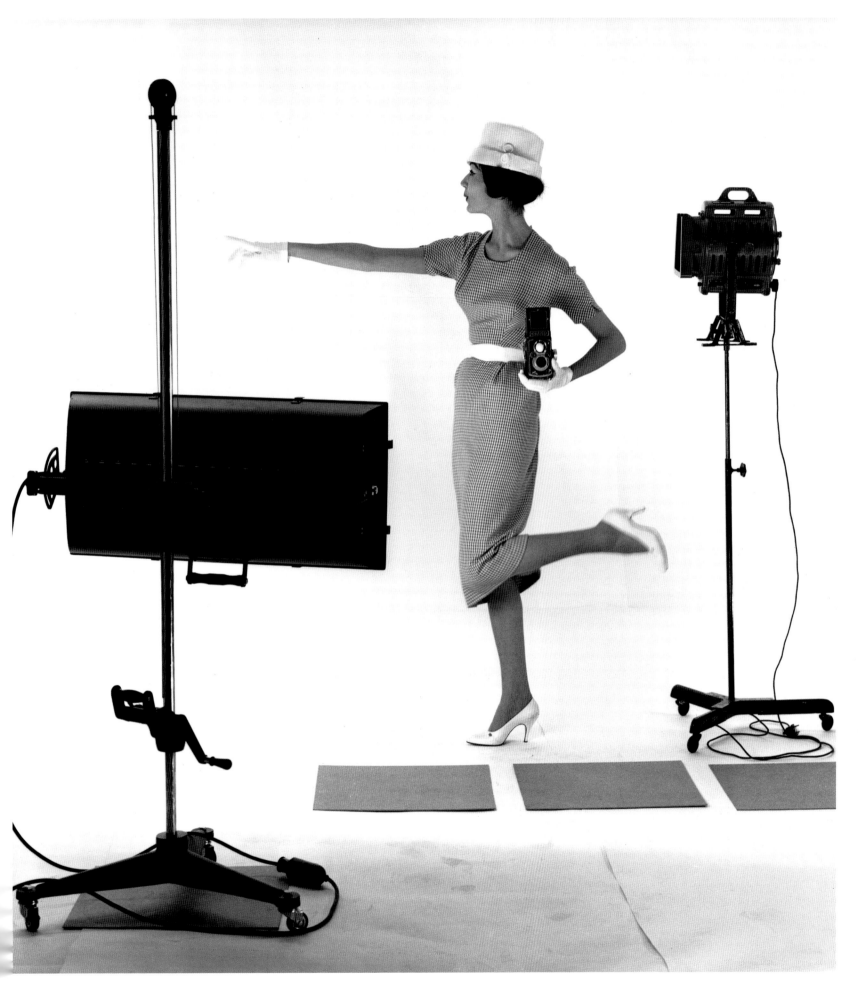

Simone d'Aillencourt, dress by Gehringer & Glupp, Berlin 1957, in: *Film und Frau* spring/summer 1957

next spreads: Inge Schönthal-Feltrinelli, Hamburg, Elbchaussee 1955
Horst Bucholz while shooting "Himmel ohne Sterne" (directed by Helmut Käutner), Munich 1955
Gérard Philipe while shooting "Fanfan la Tulipe" (directed by Christian Jaque), Paris 1951
"Cary Grant. A star at the ball", Berlin 1960, in: *Film und Frau* 16/1960

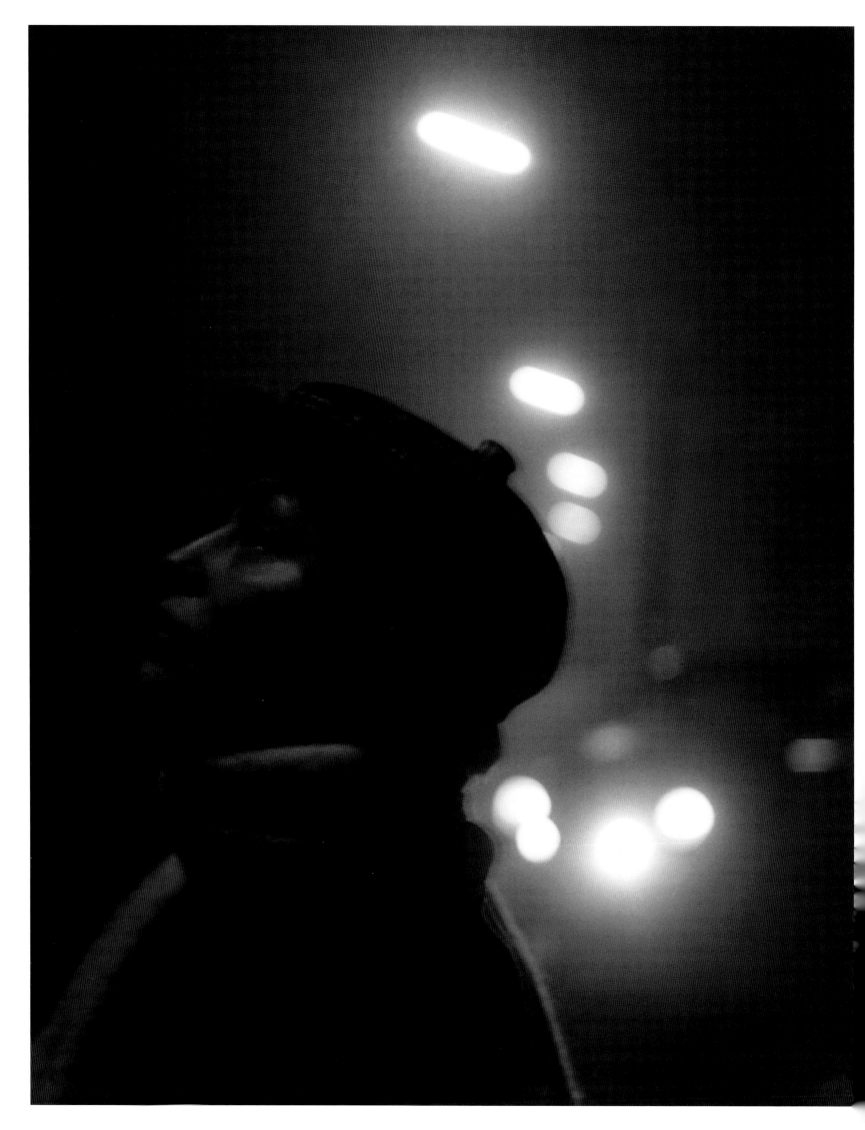

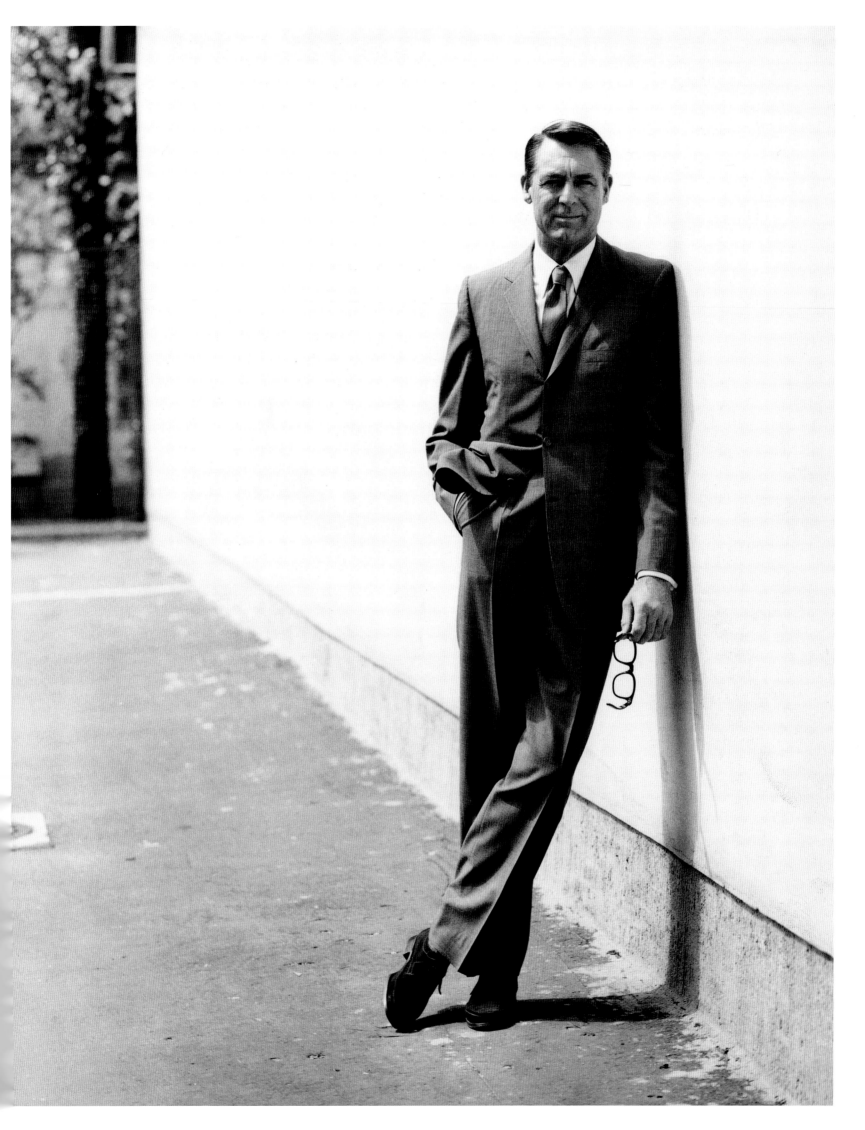

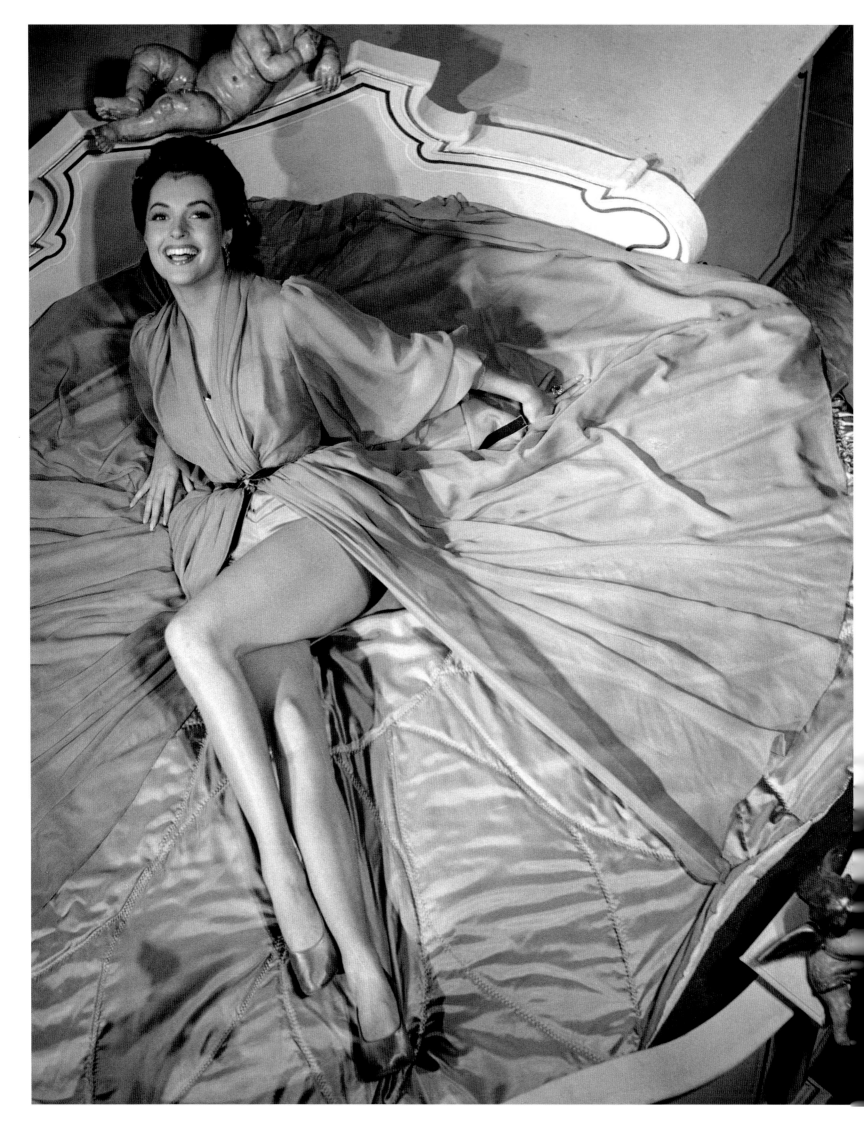

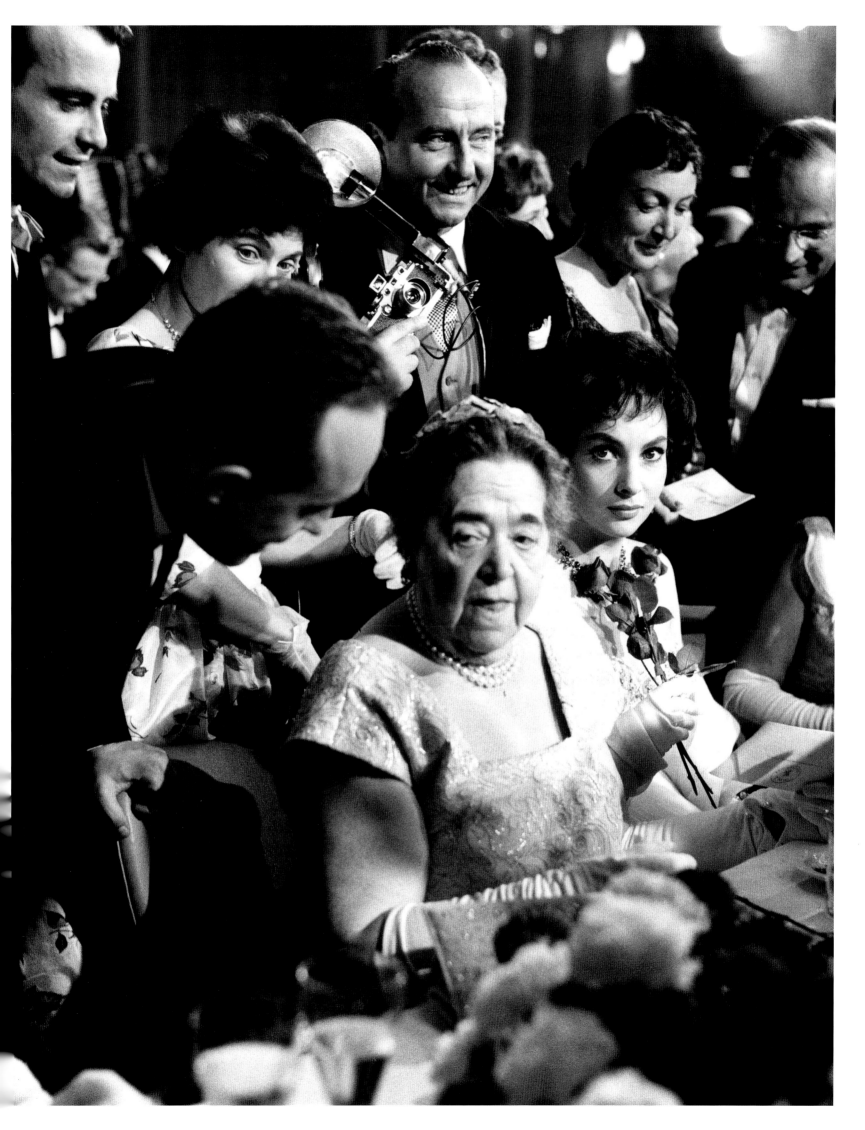

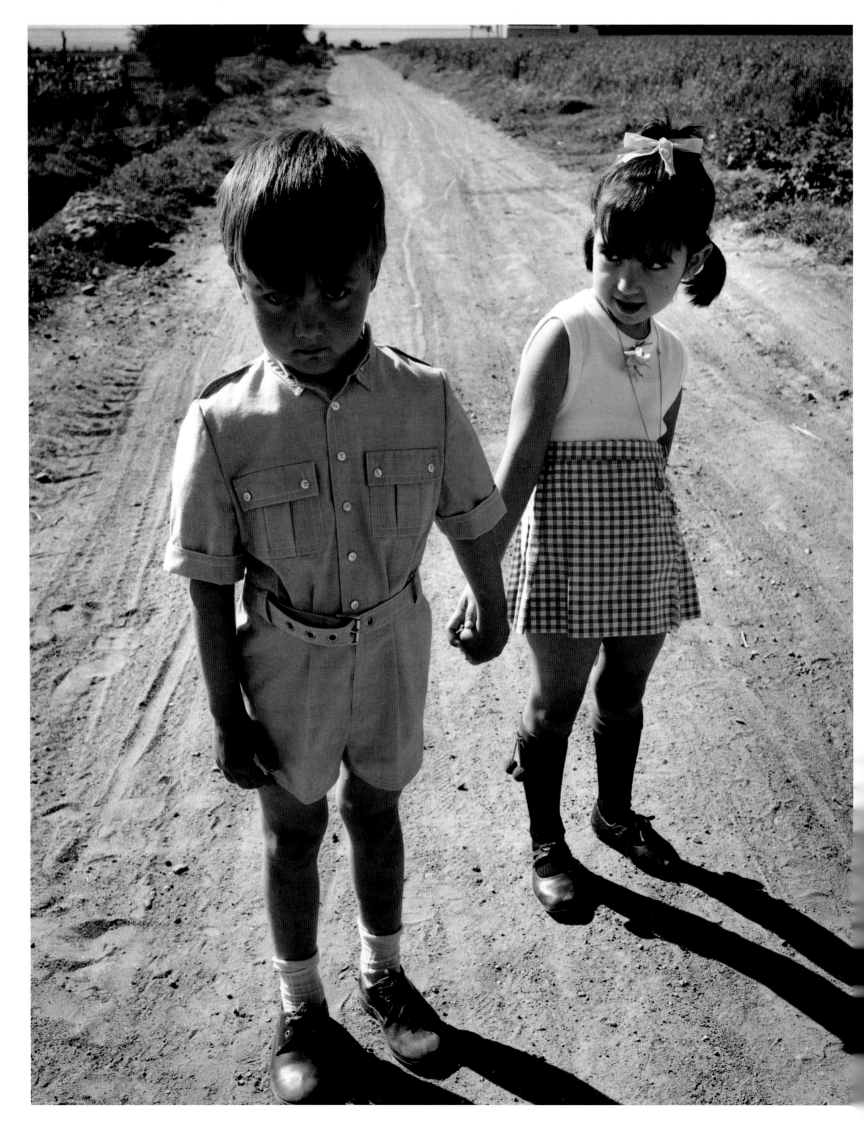

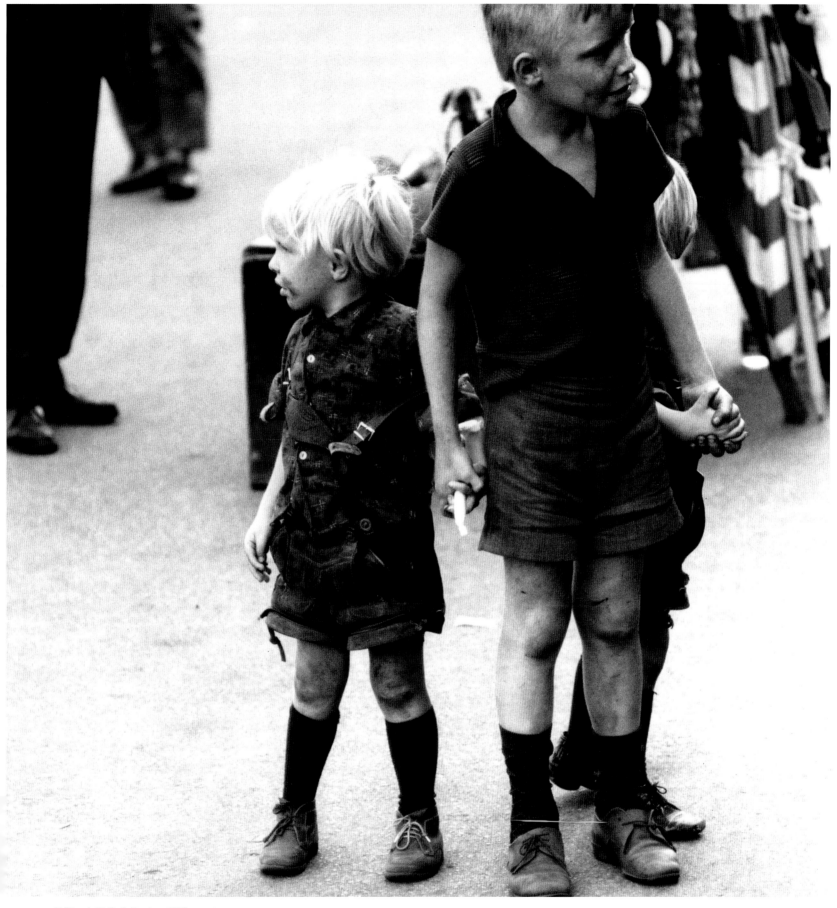

Children in St. Pauli, Hamburg 1970

left page: "Summer holidays", Costa del Sol 1967, in: *Brigitte* 13/1967

previous spread: Nadja Tiller while shooting "Ein tolles Früchtchen" (directed by Franz Antel), Graz 1953

Elsa Maxwell and Gina Lollobrigida, X. Berlinale 1960, in: *Film und Frau* 16/1960

"The last labyrinth", Kowloon,
Hong Kong 1961, in: *Film und Frau* 14/1961

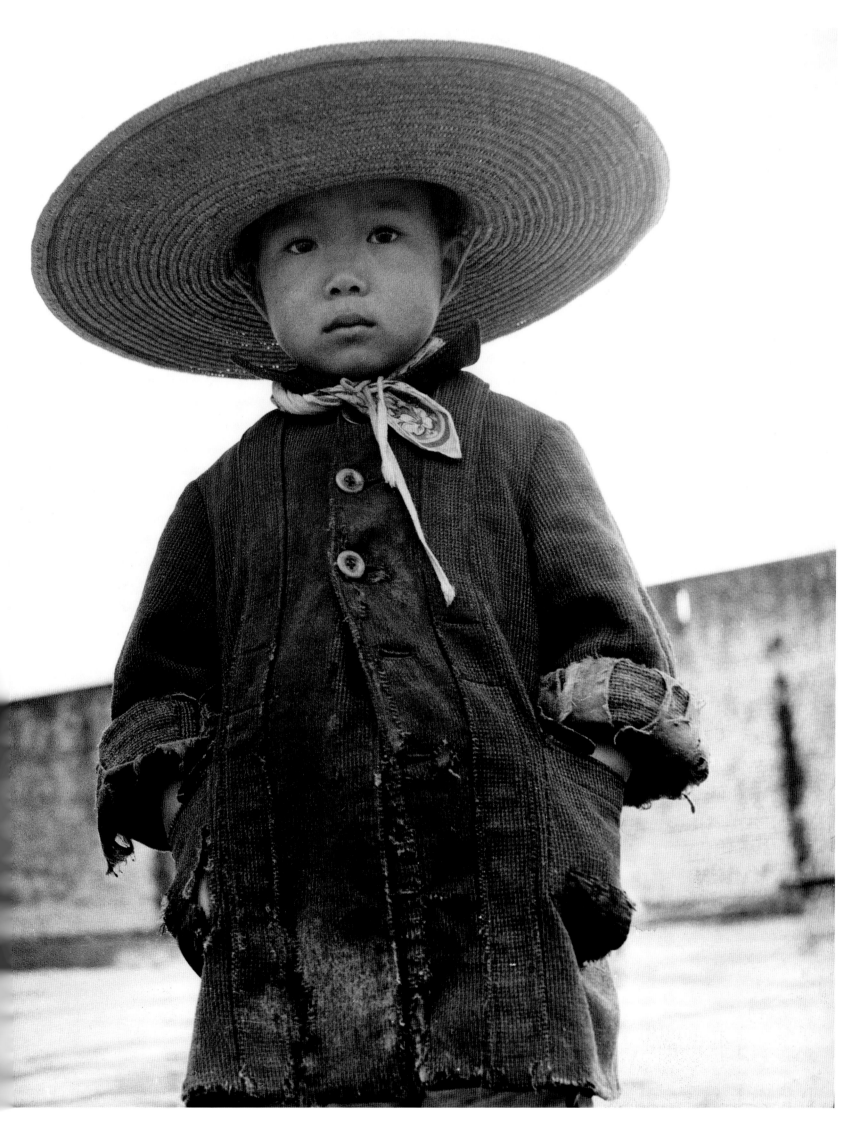

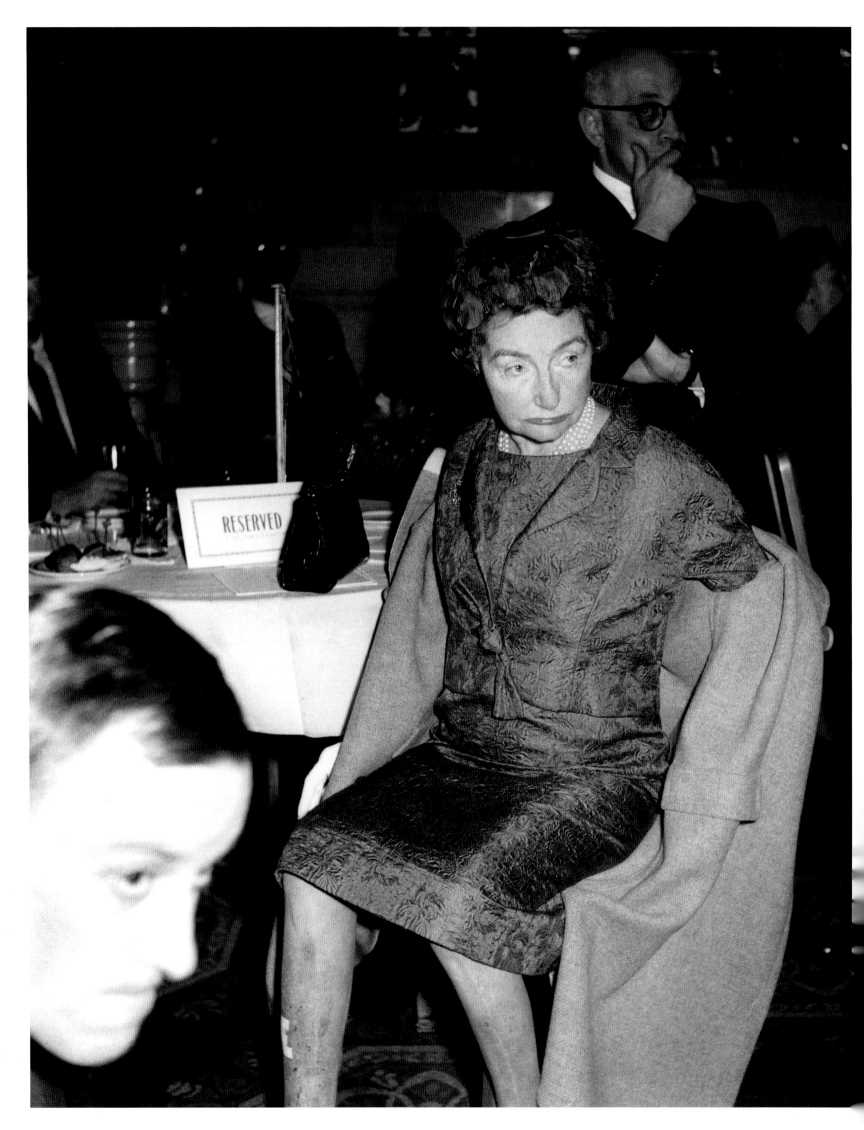

COMMISSIONED AESTHETICS

F.C. GUNDLACH
AND THE PRINTED PAGE

Hans-Michael Koetzle

The image is one of his lesser-known works and at a first, fleeting glance it could be read as a (self) ironical if not cynical commentary on a photographic oeuvre that at heart is committed to that notion of beautiful appearances called fashion. It was probably in the fall of 1958 that F.C. Gundlach photographed on the floor of the New York Plaza *en passant* a visibly aged Carmel Snow, already suffering from alcohol abuse, whose efforts to retain a sense of poise get quite literally caught in her coat. Readers today will need to be introduced to Carmel Snow: In the world of fashion from the 1930s to the 1950s Snow was one of the most powerful names in the field of fashion journalism, a synonym for elegance on paper, and indeed *Stern* in 1958 felt it appropriate to portray her to its readers as the "recognised fashion queen of America,"[1] although she had long since been dethroned, for she had lost her job and, in line with an old ritual, had attended the New York fashion show as a private individual.

Editor-in-chief since 1932, Snow had made *Harper's Bazaar* already before World War II into the most important fashion magazine – alongside *Vogue* – and ensured it was the best in terms of graphics and photography. The latter was above all the result of the brilliant cooperation of Alexey Brodovitch, who had been working for the Hearst group's flagship ever since 1934 and is considered by many to have been one of the most innovative designers of the 20th century. He has even been called the "greatest art director of all time".[2] Hollywood has at least once created a filmic monument to the duo of Snow/Brodovitch, whereby in particular Kay Thompson ("Funny Face") offers a perfect performance and idea of what it may have meant to have Carmel Snow fronting things.[3]

Gundlach's portrait of a wasted Carmel Snow ran counter one would imagine to his customary oeuvre, with its focus on perfectly presented elegance. But the first impression deceives. In actual fact, the

Carmel Snow at the show "Fashion made in Germany", Plaza Hotel, New York 1958, in: *Stern* 49/1958

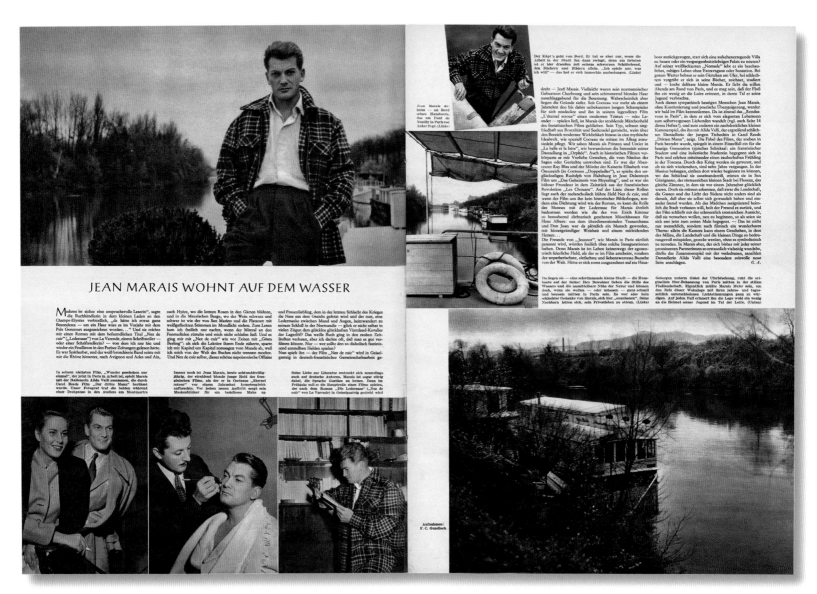

black-and-white square image takes us straight to the heart of the cosmos of a photographer who always wanted his professional impact in the world of fashion photography to be seen in a broader context. First of all, Gundlach, with his roots in photo-journalism, repeatedly sought to use elements of reportage fruitfully in his fashion interpretations. And second, he came up with a definition of the genre at an early date that insisted fashion photos should not solely promote sales of the clothes. Good fashion photography, Susan Sontag once said, was more than just photographing fashion.[4] And Richard Avedon is quoted as having said that "fashion photography must be about something."[5] Precisely Avedon showed how information and a joy for the eyes could be combined in fashion photography suggests Martin Harrison, who also feels that Avedon's best fashion images have a subtext: "The per-

formances he directed are informed by his empathy for the 'complex nature of what is to be dressed up, the vulnerability, the anxiety, the isolation of being a beauty'."[6] Put differently, over and above all haute couture or women's or men's wear, good fashion images, i.e., those that point beyond the day and place of their publication, address basic questions of the human conditions, reflect on dreams of beauty, eroticism, appeal, and likewise on those moments when people fear that those fantasies are lost forever. Moreover, in the best of cases they give us information on an age, a culture, a civilization or a moment in history. While this may not be part of a fashion photographer's brief, it is definitely on the agenda of those who wish with their work to make a mark.

F.C. Gundlach's fashion photography, and he produced it in the course of about four decades, quite

"Impressions", Paris 1951

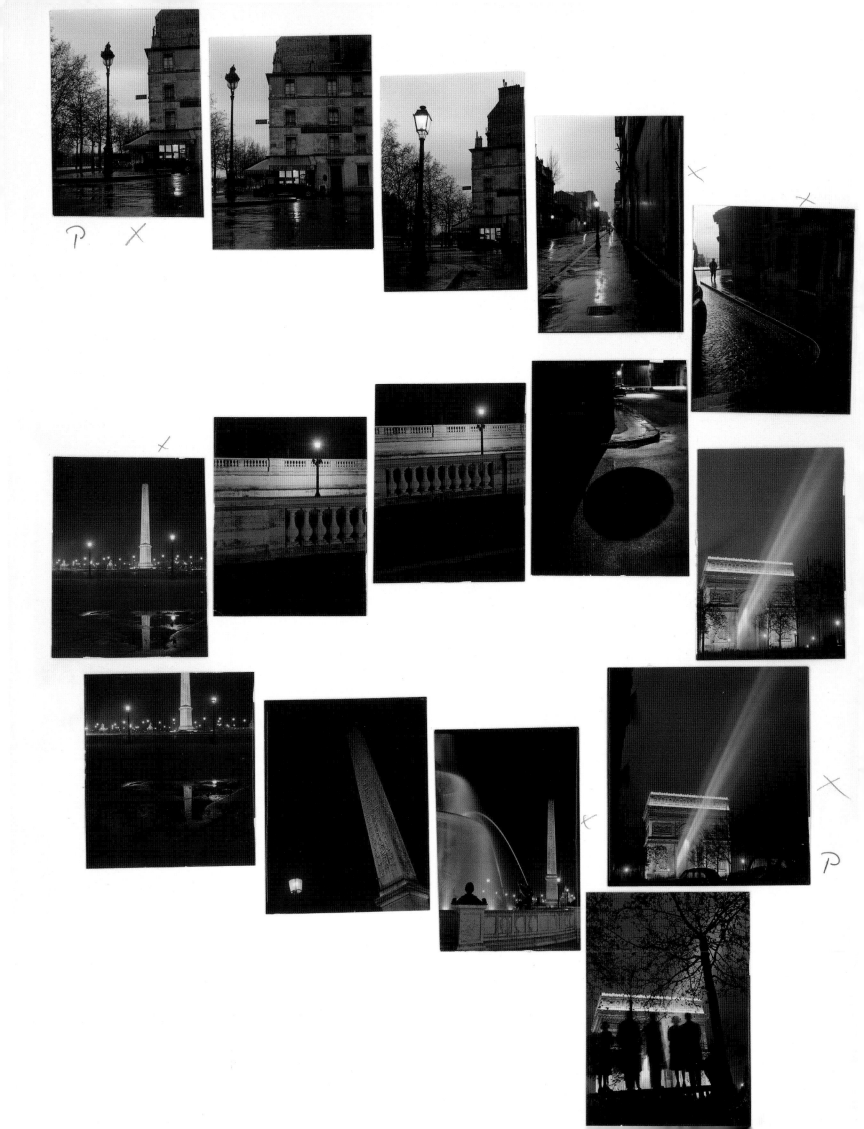

"Carmencita Franco", *Deutsche Illustrierte* 36/1953

unmistakably bears his very own signature. His pictures, be they black-and-white or colour, have a careful composition and are highly artificial complex aesthetic structures that even when considered outside their media context (newspapers or magazines) can hold their own, be it on the wall in a museum or a gallery. One could likewise talk of a "commissioned aesthetics," presented consciously and self-confidently, and from today's viewpoint one could speculate whether for F.C. Gundlach, who has always been interested in formal/aesthetic issues, a career in "art" would not have been just as conceivable. Quite apart from the fact that in West Germany in the 1950s and 1960s there was no such thing as a career track for artists working in photography (even the experiments of the "subjectivists" were the product of staff photographers working in their free time), F.C.

Gundlach himself chose the path of working under commission at an early date and throughout his life has considered it a creative challenge. While others, such as Robert Frank, may have suffered under the conditions of producing fashion photographs for an editorial desk, others, such as William Klein, primarily used their editorial work as a way of financing their own free projects. But for F.C. Gundlach fashion photography, i.e., working in a team, under time pressures and to a clear briefing, was never a burden and instead always a stimulus, less a constraint and more an invitation to be more imaginative and inventive,[7] and here he can be compared to Helmut Newton, who once confessed: "I seem to need this kind of discipline and a definite framework in which to work […] I find the editorial page acts for me as a kind of 'think tank' or laboratory to try out new ideas."[8]

next spread: "Nippon's clocks tick faster", *Frankfurter Illustrierte* 19/1961

Funk-Illustrierte

Radio-spiegel

NUMMER 47

Erwartung, Spannung und viel, viel Vorfreude
Am Spieltisch besinders P. C. Gundlach

WOCHE VOM 18. BIS 24. DEZEMBER 1949 · STUTTGART · 17. JAHRGANG

30 Pf.

48

REVUE

GREGOR VON REZZORI

HIER WIRD MODE ZUR KUNST

NEUER ROMAN:

DIE VERSUCHUNG

FILM UND MODE Revue

NR. 23 · JAHRGANG 6
PREIS 50 PFENNIG

Dreiteiliges Bildreportage:
Adrian Hoven - privat
Außerdem heute:
Großes Preisausschreiben!

Josefin Kipper

Münchner Illustrierte

NR. 25 · MÜNCHEN, 19. JUNI 1954 · 30 PFENNIG

Alle finden sie bezaubernd
Die dreiundzwanzigjährige Filmschauspielerin, Tänzerin und Sängerin Nadja Tiller aus Wien.

funk und familie

NR. 46 / 5. JAHRG. SENDEWOCHE VOM 9. BIS 15. NOVEMBER 1952 PREIS 30 PF.

Deutsche film Illustrierte

NADJA TILLER, österreichische Schönheitskönigin des Jahres 1949, erschien in dieser reizvollen Verkleidung in dem Film "Ich hab mich so an Dich gewöhnt" und spielte anschließend "Wer werden das Kind schon schaukeln".

40 PFG

5. JAHRGANG · HEFT NR. 30
DÜSSELDORF, DEN 22. JULI 1952

FILM UND MODE Revue

NR. 21 · JAHRGANG 6
PREIS 50 PFENNIG

NUMMER 21

Ingrid Andree
spielt die weibliche Hauptrolle im Farbspielfilm der "FILM und Mode-REVUE" in den neun romantischen Lustspielfilm "O du liebe Friseße".

Gong die radiowelt

EDITH PAPST aus Düsseldorf war die einzige Preisträgerin im Italien-Wettbewerb der deutschen Rundfunks, die keine Vorurteile hatte.

ILLUSTRIERTE FUNKWELT · 25.-31. MAI 1952 · HEFT 22

SÜDWEST-AUSGABE

35 Plg

Nr. 18 Heute: Letzte Folge unseres großen Preisausschreibens auf Seite 5

Die Frau im Spiegel

Margit Saad kann lachen

35 PFG

Sylvester Wöhler berichtet aus Japan

Nippons Uhren schlagen schneller

Weltprobleme im Spiegel des japanischen Alltags — ein Inselreich zwischen den Stühlen von historischer Tradition und hemmungslosem Amerikanismus — der Samurai stirbt in Jazzorgien

Auch in Japan steigen die Preise. Sie steigen so rapide, daß sie den zwar gleichzeitig ansteigenden Löhnen und Gehältern gefährlich davonlaufen. Angesichts dieser Entwicklung geht zum ersten Male die bisher so bescheidene Butterfly, vor allem die japanische Hausfrau, als wahlberechtigte Bürgerin aus ihrer potentiellen Reserve heraus. Seit jeher war es gefährlich, wenn Frauen auf die Barrikaden gingen. Wenn aber Nippons Töchter, bisher in aller Welt eben wegen ihrer Bescheidenheit und liebenswürdigen Behutsamkeit gepriesen, in die Politik eingreifen, dann wird es für die Regierung in Tokio besonders kitzlig. Gerade diese rechte Regierung des Ministerpräsidenten Ikeda verdankt trotz dem Fernsehmord des Sozialistenführers Asanuma und den anschließenden Studentenkrawallen gegen das Bündnis zwischen Japan und den USA ihre gefährdete Zweidrittelmehrheit im

Parlament den japanischen Wählerinnen, wahrscheinlich nach einem schon häufiger gebrauchten konservativen Schlagwort: Nur keine Experimente.

Aber das Aufmucken der Frauen durch die Sprecherinnen ihrer Verbände ist nur eines der Zeichen dafür: Japans Uhren schlagen schneller!

Noch am 4. September 1856 standen sie nahezu still. An jenem Morgen hißte der amerikanische Generalkonsul namens Townsend Harris – als der erste geduldete Repräsentant eines fremden Landes überhaupt – nach seiner Landung am Ufer des kleinen Hafens Schimoda das Sternenbanner und vermerkte im Tagebuch die prophetischen Worte: „Ist es wirklich ein Glück für Japan?" Bis dahin hatte der feudal regierte, einen lebenden Gottkaiser anbetende Inselstaat Japan jede Verbindung mit der übrigen Welt bei

(Bitte lesen Sie weiter auf Seite 56)

„Also um sechs im Teehaus!" Wie lange noch wird man solche bunten Kimono-Schmetterlinge in Tokio bewundern können? Die kleine Geisha, die hier durch eines der brandroten, öffentlichen Telefone mitten auf dem Bürgersteig ihre Verabredung trifft, wird bald nur noch in exklusiven Nachtklubs zu sehen sein. Ihre drollige, häufig benutzte Atemschutzmaske ist eine Ausgeburt japanischer Furcht vor Erkältungen in kühler Jahreszeit.

Ein Musterbeispiel ideenreicher Verkehrs- und Stadtplanung lieferte Tokio mit dieser Autobahn mitten durch das Geschäftszentrum der Innenstadt, die über die Dächer der Läden und Büros hinweg selbst die Ginza, etwa den Kurfürstendamm dieser Millionenstadt, kreuzt. Hier in der Fassadensachlichkeit von Stahl und Glas und im Feuerwerk der abendlichen Lichtreklame findet man außer den seltsamen Schriftzeichen kaum noch fernöstliche Eigenart.

Fotos Gundlach **7**

DIE KRONKOLONIE
IHRER MAJESTÄT

港香

HONGKONG

"The Crown Colony of Her Majesty the Queen", *Film und Frau* 14/1961

Magazines are the destination of photographed fashion. Fashion shots were first dreamed up and made for illustrated magazines, whereby the term "illustrated" refers to print products that "as mass-distributed periodicals with full-page contents and secondary topicality are to be classified as coming between newspapers and magazines, and as having images as their main component."[9] Franz Christian Gundlach (whom his school friends and family called Christl) was no doubt in his mid-20s when he first encountered transatlantic magazines such *Vogue* or *Harper's Bazaar* in the Amerika-Haus in Stuttgart and it was a shock, as Gundlach concedes looking back, and we cannot exclude that the encounter influenced Gundlach's further path in life, even if he had long since taken the decision to try and make a name for himself in photography. As a school pupil, Gundlach

had already been fascinated by a medium that prom-ised both elegance (in portraits of stars) and the big wide world (in reportages), and before he even turned 18, while assigned to an anti-aircraft battery he pro-duced his first portrait jobs, even if they were techni-cally far from accomplished. This was followed by a period as a POW and convalescence from a serious illness, and two years as a student in Kassel, working for Rolf W. Nehrdich, who had been active until 1945 in Berlin and had relocated there with his "Private College for Modern Photographic Art".[10] For a few weeks Gundlach was employed in a portrait studio in Wiesbaden that preferentially served members of the US Army, before moving at the end of 1949 to Stutt-gart, equipped with three letters of recommendation from his teacher in Kassel, who stated that "along-side an exceptional talent, he has his own ideas, great

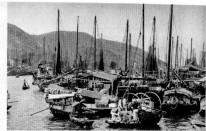
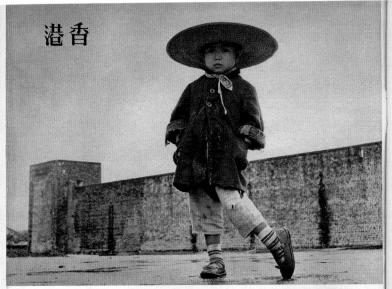

energy and ambition".[11] Despite the appalling World War II air raids on Stuttgart, the main railway station and its striking architecture, the brainchild of Paul Bonatz, had largely survived unscathed and the inner city belt of small and medium-sized industrial enterprises that shaped the city's face seems to have got back into rhythm faster than elsewhere. And Stuttgart, with its radio station, famous printing companies such as Belser, the *Stuttgarter* and *Schwäbische Illustrierte* newspapers, and Willi Baumeister's endeavours at the Academy, was something of a city of the arts and media. And if something started to come to the surface in F.C. Gundlach in the years around 1950 then it was an emphatic and growing interest in the media, in publishing, and in the printed image.

While still a pupil he occasionally treated himself to a copy of the *Berliner Illustrirte* (as of 1941 *Illustri-erte*) *Zeitung*, and a little later he started to find his bearings with volumes containing illustrated plates, such as *Berlin* by Mario von Bucovich[12] or application-focused books such as *Das goldene Buch der Rolleiflex* by Dr. Walther Heering.[13] Above all the book *Mein Objektiv sieht Europa*[14] brought out in 1938 by the later PK (= propaganda company under National Socialism) photographer Eric Borchert[15], with 80 illustrations and precise instructions on techniques and image design evidently left its mark. It was the first time he had come across the possibility of staging photos. In a nutshell: It was the media world of printed images, it was magazines and books that from the very beginning captured the amateur's attention and in retrospect F.C. Gundlach's path into the printed world seems only logical. Incidentally, he emphasizes that industrial or object photography

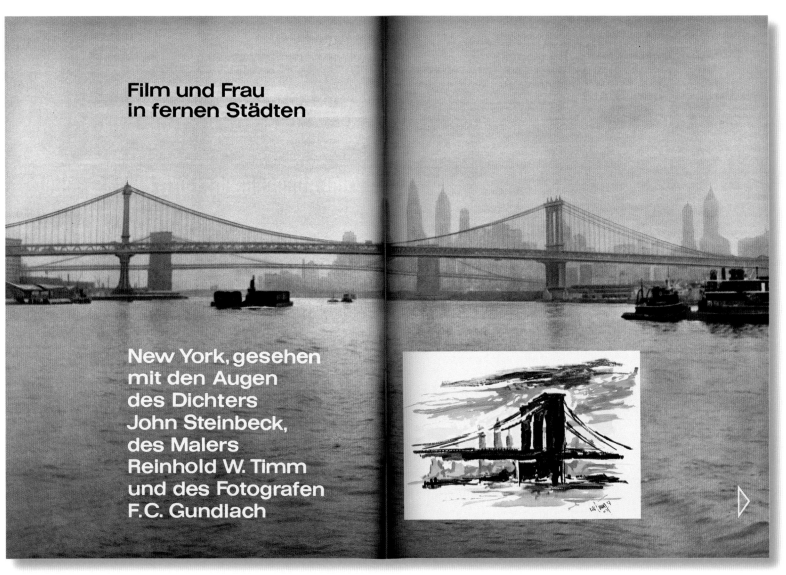

Film und Frau
in fernen Städten

New York, gesehen
mit den Augen
des Dichters
John Steinbeck,
des Malers
Reinhold W. Timm
und des Fotografen
F.C. Gundlach

"Film und Frau in distant cities", *Film und Frau* 18/1963

never interested him, which is why there was never any question of signing on, for example, with Adolf Lazi, who in the 1950s ran a truly legendary photo studio in Stuttgart.[16] Gundlach finally got a job as assistant to Ingeborg Hoppe, who was admittedly a product of the 'Lazi School' and therefore preferred "very static" and "very precise" images,[17] but with her clients from the still highly profitable Swabian textile industry (such as Bleyle or Schachenmayr) was already touching on topics that must have more or more appealed to Gundlach.

From January to December 1950, the young photographer earned his spurs in Ingeborg Hoppe's company, prominently located in a villa at Heidehofstrasse 4, and it was there, on the lower ground floor that F.C. Gundlach also had his first lodgings. He earned less than 200 marks a month, reflecting

the tough times that were a far cry from the 'economic miracle' as it was later described.[18] The magazine world of the times was, following the German currency reform and the annulment of the obligation to license the publication with the military occupying forces, very varied, but quite modest in terms of the number of pages, the paper and the print quality, and the output was by no means on a par with pre-War magazines such as *Die Dame* or *die neue linie*. One needs to have seen what West German magazines of the early 1950s looked like in order to understand the impression that US fashion magazines such as *Harper's Bazaar* and *Vogue* left on F.C. Gundlach at the time. Today, he still specifically remembers Erwin Blumenfeld, whose fashion images were honed of Dada and Surrealist models and particularly fascinated him. This was no doubt another early school of

Film und Frau

HEFT 2/VI · 60 PF.

IN OESTERREICH S 4.50
IN DER SCHWEIZ Fr —.70

DIE PIKANTEN JAHRE EINER FRAU *

UNSERE FREUNDLICHE KLEINE WOHNUNG

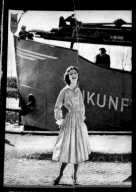

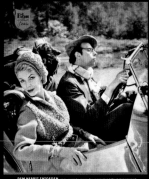
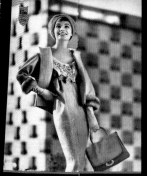
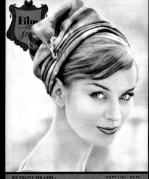
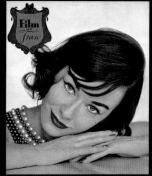
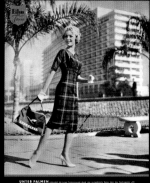

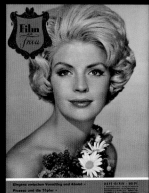
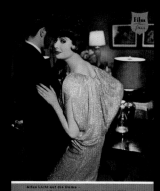
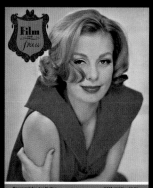
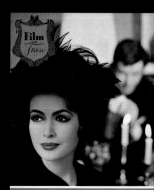

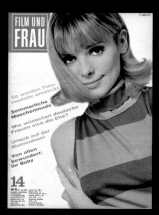

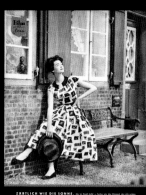

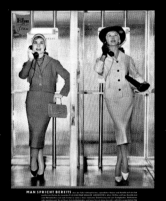
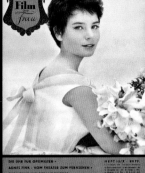
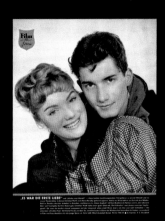
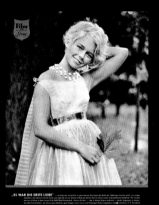

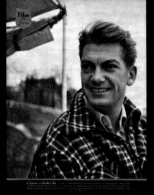

Gatien erblickt ihn

Die ersten Augen

Rumer ist Dich der beste Medizin

Ein Pappkarton und eine Goethe-Büste

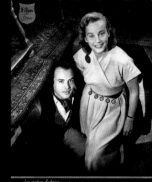

Ein steiler Aufstieg

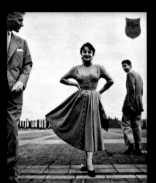

IM KREUZFEUER BEWUNDERNDER BLICKE

BESUCH AN BORD

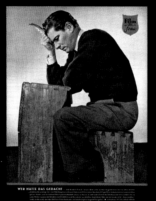

WER HATTE DAS GEDACHT

MOSELFAHRT AUS LIEBESKUMMER ·
AUF DER TRAUMINSEL · TELEVISION 1875

HEFT 25/V · 60 PF.

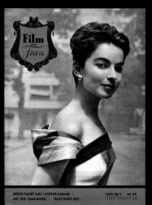

ALLES, WAS MADAME INTERESSIERT ·
SOLL MAN IHM ALLES SAGEN?

HEFT XXIV · 60 PF.

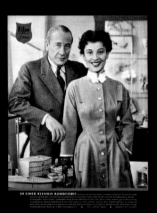

IN EINER KLEINEN KONDITOREI

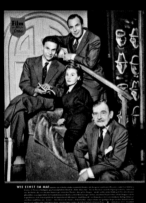

WIE EINST IM MAI

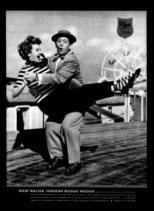

NICHT WALZER, SONDERN BOOGIE WOOGIE

EIN INTERESSANTES GESICHT

MÄRCHENHELD IN ZIVIL

DIE NEUE MODE — ANMUTIG UND KLEIDSAM ·
ZUR MANDELBLÜTE NACH MALLORCA ·
NEUER ROMAN: SIND WIR DÖHN WIRKLICH SO?

HEFT 8/VII · 70 PF.

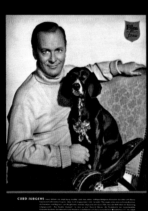

CURD JÜRGENS

FRÜHLING AN DER COSTA BRAVA ·
HEIRATET MAN SEINEN TYP? ·
EIN TAG MIT ERNEST HEMINGWAY

HEFT 10/VII · 70 PF.

AUFTAKT DER HERBSTSAISON

DER TORERO KAM ZURÜCK ·
HAUS UND HOBBIES EINES HERRN ·
MODE AM STEUER

HEFT 24/VII · 70 PF.

DER MANN MIT DEM GOLDENEN ARM ·
KLEINES HAUS MIT GROSSEM KOMFORT ·
NEUER ROMAN: GUTEN MORGEN, MISS FINK

HEFT 5/VIII · 70 PF.

WETTBEWERB DES LUCHOWER REISENS, REISEKILOMETER
IM GESAMTWERT VON 50 000 DM ZU GEWINNEN

HEFT 7/VIII · 70 PF.

FILM: UNVOLLENDETE LIEBE
UND: FERNES HAUS AM MITTELMEER
FRAU: SOMMERLICHE MODE-MELODIEN

HEFT 11/VII · 70PF.

GLÜCKLICHE EHEPAARE SAGEN JA ·
JAGD AUF FORELLEN ·
UNTERM STROHDACH WOHLGEBORGEN

HEFT 12/VIII · 70 PF.

DER GROSSE AUFTRITT

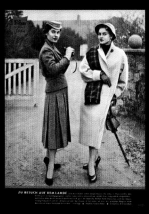

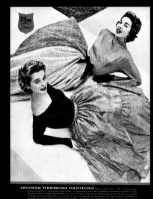

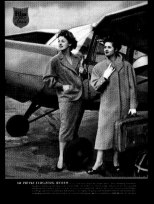

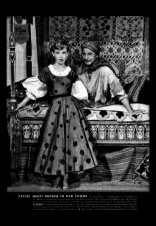

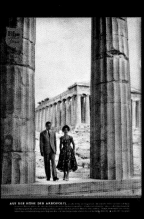

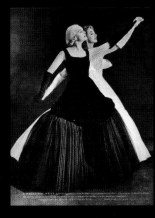

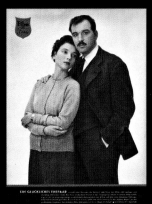

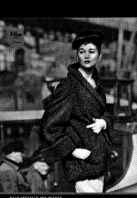

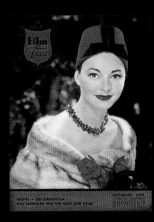

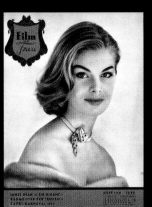

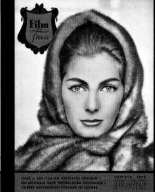

MODEHEFT

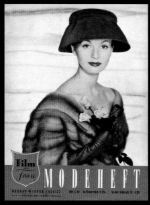

MODEHEFT

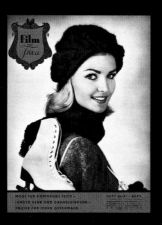

ZU HAUSE IN ZWEI KONTINENTEN

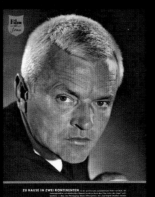

BALL DER ANMUT

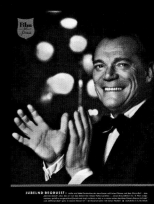

JUBELND BEGRÜSST

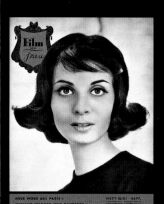

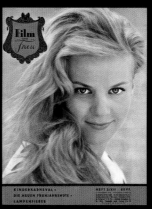

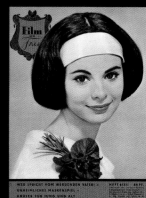

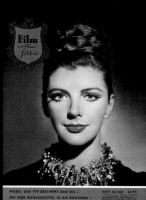

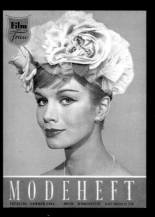

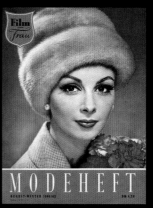

MODEHEFT

MODEHEFT

Pelze im Lande der Mitternachtssonne

moderne FRAU

So werden wir morgen wohnen

Ein Seitensprung ist kein Scheidungsgrund

Die schicken neuen Pelze

moderne FRAU

Das Geheimnis einer Schönheits-Farm

Künstler-Porträt: Alexander Kerst

Krebs muss nicht Schicksal sein

Luftige bunte Maschen Mode

moderne FRAU

Schön an einem Sommerabend: Festliche Mode Zärtliche Frisuren

Die Männer, die nicht nein sagen können

moderne FRAU

Curd und Simone Jürgens: Warum wir uns noch immer lieben

Bekannte Fotomodelle verraten das Geheimnis ihrer Schönheit

Vergnügte Mode – auch wenn's mal regnet

moderne FRAU

Mode: Schick von 9 bis 5 Uhr

Schönheit: Frisuren, die Sie kaufen können

Serie: Lisa della Casa: Warum wir uns noch immer lieben

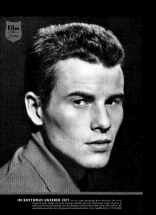

IM RHYTHMUS UNSERER ZEIT

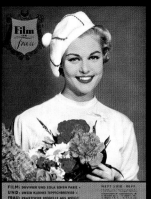

FILM: DUVIVIER UND ZOLA SEHEN PARIS •
UND: UNSER KLEINES TEPPICHBREVIER •
FRAU: PRAKTISCHE MODELLE AUS WOLLE

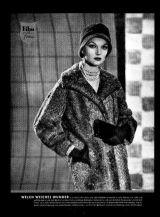

NETT UND ADREET UNTERWEGS UND ZU HAUS •
KLEINWOHNUNG MIT ALLEM DRUM UND DRAN •
DAS WÄRE EIN VORBILD FÜR MANAGER

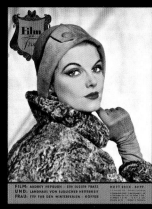

WELCH WEICHES WUNDER

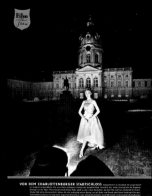

FILM: AUDREY HEPBURN — EIN SÜSSER FRATZ
UND: LANDHAUS VON SÜDLICHER HEITERKEIT •
FRAU: TYP FÜR DEN WINTERFERIEN — KOPFER

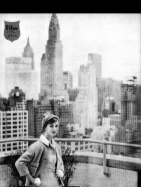

VOR DEN WOLKENKRATZERN IN NEW YORK

NEUES AUS PARIS: NATÜRLICHKEIT •
UNSER ROMAN: VERRAT IM SPIEGEL!

Film und Frau: RICHTUNGWEISEND FÜR MODE •
VORBILD FÜR MODERNES WOHNEN •
INTERESSANT FÜR DEN HERRN

WELTTHEATER IN EINER KLEINEN STADT •
KARL HOFER — MALER UND SEHER •
JAGDHÜTTE FÜRS WOCHENEND

VOR DEM CHARLOTTENBURGER STADTSCHLOSS

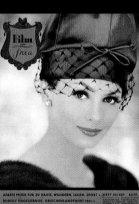

APARTE MODE FÜR ZU HAUSE, WANDERN, JAGEN, SPORT • HEFT 20/XII •
RUDOLF NAGELSTANGE: GRIECHENLANDFAHRT 1961 •
AKADEMIE DER KÜNSTE IN WESTBERLIN

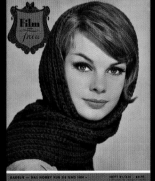

BADELIE — DAS HOBBY FÜR SIE UND IHN •
GEFÄHRLICHE LIEBSCHAFTEN •
400 JAHRE ALTES BAUERNHAUS MODERN EINGERICHTET

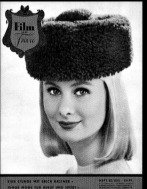

EINE STUNDE MIT ERICH KÄSTNER •
JUNGE MODE FÜR BERUF UND SPORT •
EIN PROBLEM: DAS RECHT AUF GLÜCK

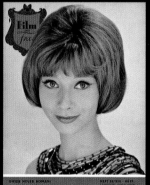

UNSER NEUES ROMAN:
DIE NACHT, IN DER ICH ABSCHIED NAHM •
HAZIENDA AN DER ISAR

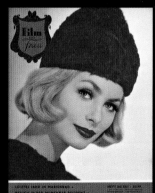

LETZTES JAHR IM MARIENBAD •
BESUCH IN DER MÜNCHNER RESIDENZ •
BERÜHMTE HUNDE BERÜHMTER FRAUEN

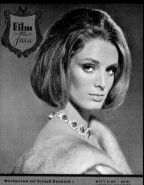

WOCHENEND AUF SCHLOSS DENBECK •
PARADIESE DIESER ERDE ...? •
INTERESSANTE THEMEN FÜR DEN HERREN

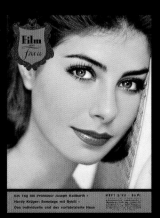

Ein Tag bei Professor Joseph Keilberth •
HARDY KRÜGER: SONNTAGE MIT SYBILL •
Das individuelle und das vorfabrizierte Haus

Fliegende nach Fernost •
Frühlingsmode aus Florenz und Berlin •
Neuer Roman: Meilenstein 344

Porto: Spiel mit der Mode •
Der Ritter vom silbernen Turm •
Eine Stunde mit Heinrich Böll

Grand Wallon: Freudö mit Katka •
Liebe will gelernt sein •
Nicht an Kalorien vorbeischauen!

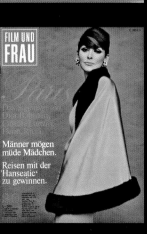

FILM UND FRAU

Männer mögen
müde Mädchen.

Reisen mit der
'Hanseatic'
zu gewinnen.

FILM UND FRAU

Was
jede Frau
sich
heimlich
wünscht

Liz Taylor:
Scheiden
tut weh

moderne FRAU

Unser Krimi:
Jan Veenstra
und der
blutrote Rock

Mode: Pullis,
Röcke und Hosen

Königin Sirikit:
Es macht mir Freude,
meinem Mann
zu gehorchen!

moderne FRAU

Zauberhaft
wie nie:
Mode aus
der Boutique

Unser Krimi:
Jan Veenstra
und die
junge Witwe

Wie sie lebt
und wie sie liebt:
Die Italienerin

Entdecken Sie
die richtigen
Farben für Ihre
Wohnung!

moderne FRAU

Allein um die
Welt in 40 Tagen

Das große Abenteuer der Denise de Boutique

romantische Party

JUBELND BEGRÜSST — stellte sich Eddie Constantine, der Amerikaner mit Pariser Charme, auf dem Gloria-Ball — dem „Ball der Anmut", über den wir auf den Seiten 2 bis 5 dieses Heftes berichten — seinen Bewunderern vor. In Wien aufgewachsen, spricht er ausgezeichnet Deutsch und singt und boxt, so daß er in seinen ersten deutschen Filmen „Gauner im Frack" und „Millionendieb" ganz in seinem Element ist — als Herzensbrecher mit harten Fäusten! ● Aufnahme: F. C. Gundlach

Film und Frau

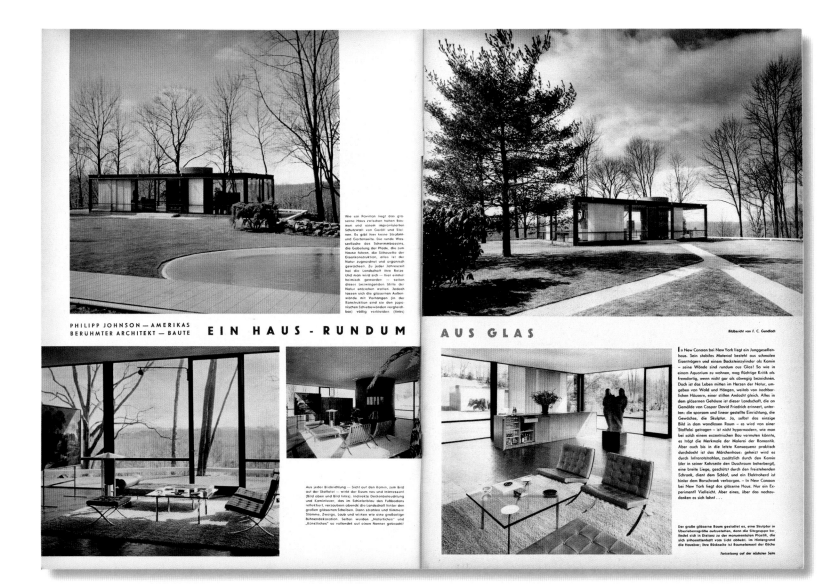

Wie ein Pavillon liegt das gläserne Haus zwischen hohen Bäumen und einem improvisierten Schutzwall von Geröll und Steinen. Es gibt hier keine Straßen- und Gartenseite. Die runde Wasserfläche des Schwimmbassins, die Gabelung der Pfade, die zum Hause führen, die Silhouette der Eisenkonstruktion, alles ist der Natur zugeordnet und organisch gewachsen. Zu jeder Jahreszeit hat die Landschaft ihre Reize. Und man wird sich — hier einmal heimisch geworden — selten dieser bereingenden Stille der Natur entziehen wollen. Jedoch lassen sich die gläsernen Außenwände mit Vorhängen (in der Konstruktion und sie den japanischen Schiebewänden vergleichbar) völlig verkleiden (links).

PHILIPP JOHNSON — AMERIKAS
BERÜHMTER ARCHITEKT — BAUTE
EIN HAUS - RUNDUM

AUS GLAS

Bildbericht von F. C. Gundlach

In New Canaan bei New York liegt ein Junggesellenhaus. Sein stabiles Material besteht aus schmalen Eisenträgern und einem Backsteinzylinder als Kamin — seine Wände sind rundum aus Glas! So wie in einem Aquarium zu wohnen, mag flüchtige Kritik als fremdartig, wenn nicht gar als abwegig bezeichnen. Doch ist das Leben mitten im Herzen der Natur, umgeben von Wald und Hängen, weitab von nachbarlichen Häusern, einer stillen Andacht gleich. Alles in dem gläsernen Gehäuse ist dieser Landschaft, die an Gemälde von Caspar David Friedrich erinnert, untertan: die sparsam und linear gestellte Einrichtung, die Gewächse, die Skulptur. Ja, selbst das einzige Bild in dem wandlosen Raum — es wird von einer Staffelei getragen — ist nicht hypermodern, wie man bei solch einem exzentrischen Bau vermuten könnte, es trägt die Merkmale der Malerei der Romantik. Aber auch bis in die letzte Konsequenz praktisch durchdacht ist das Märchenhaus: geheizt wird es durch Infrarotstrahlen, zusätzlich durch den Kamin (der in seiner Kehrseite den Duschraum beherbergt), eine breite Liege, geschützt durch den freistehenden Schrank, dient dem Schlaf, und ein Elektroherd ist hinter dem Borschrank verborgen. — In New Canaan bei New York liegt das gläserne Haus. Nur ein Experiment? Vielleicht. Aber eines, über das nachzudenken es sich lohnt . . .

Aus jeder Blickrichtung — Sicht auf den Kamin, zum Bild auf der Staffelei — wirkt der Raum neu und interessant (Bild oben und Bild links). Indirekte Deckenbeleuchtung und Kaminfeuer, das im Schieferblau des Fußbodens reflektiert, verzaubern abends die Landschaft hinter den großen gläsernen Scheiben. Dann strahlen und flimmern Stämme, Zweige, Laub und wirken wie eine großartige Bühnendekoration. Selten wurden "Natürliches" und "Künstliches" so vollendet auf einem Nenner gebracht!

Der große gläserne Raum gestattet es, eine Skulptur in Überlebensgröße auszustellen, denn die Sitzgruppe befindet sich in Distanz zu der monumentalen Plastik, die sich silhouettenhaft vom Licht abhebt. Im Hintergrund die Hausbar; ihre Rückseite ist Raumelement der Küche.

Fortsetzung auf der nächsten Seite

"A house made out of glass", *Film und Frau* 22/1958

seeing that in addition to providing clear sources of inspiration also revealed quite generally the potential magazines offered as a medium.

At an early date during his time in Stuttgart, in part parallel to his employment by Ingeborg Hoppe, F.C. Gundlach started building a business as a freelance photographer. In case this initially involved photographs that he sold to newspapers and magazines as illustrations. His re-encounter with an old school friend from his days in Heinebach, namely Hans-Dieter Schmoll, was a stroke of good fortune and possibly his actual entry into the world of print media: Schmoll had for a time worked as news editor at Süddeutscher Rundfunk and was deputy editor-in-chief of *Funk Illustrierten*,[19] which was brought out by Süddeutscher Zeitschriften-Verlag (Stuttgart). Schmoll continued to have good relations to the world of ra-

dio, knew people at SDR and the organization there, and was also acquainted with any number of artists from the world of serious and popular music. More importantly, in his new position he was able to offer the young F.C. Gundlach more or less weekly opportunities to publish his work. What he needed were illustrating portraits of the then renowned musicians, not to mention cover motifs for the magazine – and Gundlach was able to deliver them by the latest as of the end of 1949.

Another area of work, and it was one that was to impact on his later fashion photography, was film, a medium that was – at least financially – by no means yet in a critical state. What specifically the German production companies needed were star portraits for the press, for posters and for other adverts. Gundlach produced portraits of Margit Saad, Ruth Nie-

next spread: "Master builder of the tropics: Oscar Niemeyer's jungle villa", *Film und Frau* 1/1957

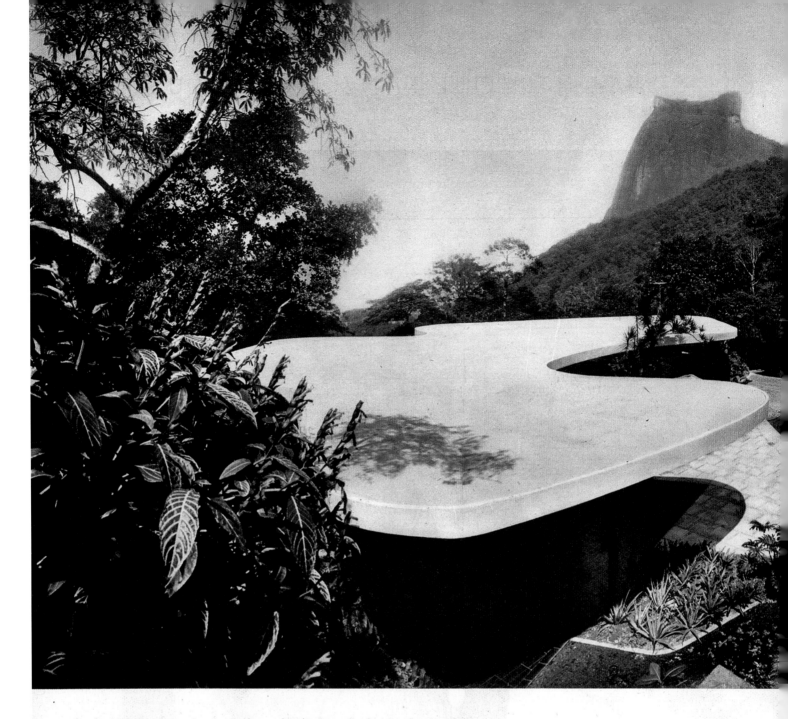

BAUMEISTER DER TROPEN

Oscar Niemeyers „Urwaldvilla"

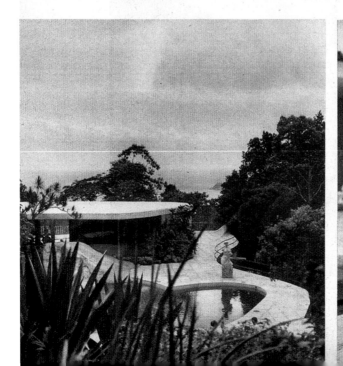

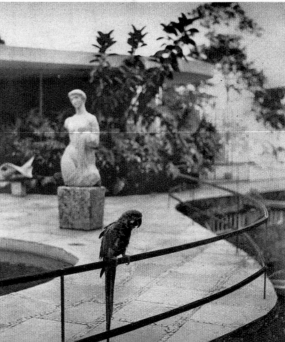

Hoch über der Bucht von Rio liegt das Haus Oskar Niemeyers. Niemeyer, Sproß einer westfälischen Familie, gehört zu den führenden Architekten Brasiliens. Das Märchen-Retiro, das er sich baute, sprengt alle konventionellen Vorstellungen. Unnachahmlich leicht ist die Linie des strahlend weißen Dachs, auf das fremdartige Bäume ihre gefleckten Schatten werfen (Bild oben)

Über das Gewirr der Bäume hinweg sieht man hinab auf den Atlantik (ganz links). Wenn unten in Rio die Hitze brodelt, ist es hier oben in Canaos kühl und erträglich ... Aufn.: Charles Wilp

Zuweilen glaubt man durch ein Zauberreich zu wandern. Auf dem Eisengeländer hockt ein Papagei mit flammendem Gefieder, und vor den wild wuchernden exotischen Gewächsen träumen Skulpturen, klassisch und schön (links)

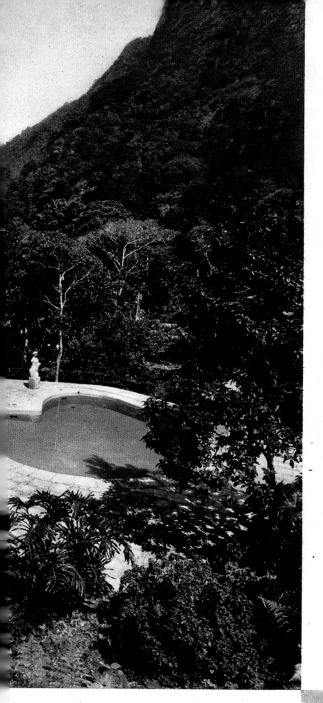

Niemeyers Haus ist frei von der funktionalistischen Starre, die so vielen modernen Bauten anhaftet. Alles ist unglaublich leicht und gelöst: die Linie des Dachs, die Form des Beckens. Ja, selbst der Felsen scheint mit der Hand modelliert

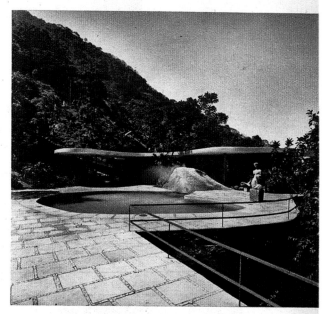

Ein wenig erinnert das Ganze an ein Schiff, das kühl und weiß durch die grüne Flut der tropischen Vegetation steuert. Das schwarze Eisengeländer wird zur Reling und die helle Terrasse zum Deck, auf dem geheimnisvolle Bajaderen nach dem Bade ruhen . . .

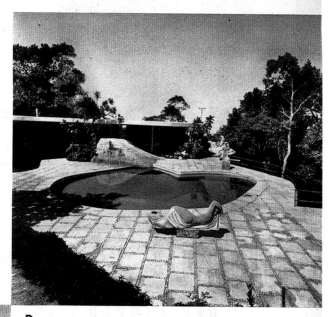

Der Architekt Professor Oscar Niemeyer hat seine Träume und Sehnsüchte beim Bau seines eigenen Hauses, seiner „Urwaldvilla", verwirklicht — einem architektonischen Glaubensbekenntnis, das schon zu einem Wallfahrtsort für die Architekturbeflissenen aus aller Welt geworden ist. Am bergigen Gestade des Ozeans, in die tropische Vegetation des Urwalds hineingebettet, ist dieses Haus tatsächlich die Vollendung der Sehnsüchte eines Architekten. Felsen und Urwaldriesen, Gebirgsbäche und Schlinggewächse sind hier in den Bau einbezogen, machen einen Teil von ihm aus. Ein phantasievoll geschwungenes Dach, von schmalen Stützen gehalten, schmiegt sich in weichen Kurven an den brasilianischen Urwald an, dessen üppige Farbenfreude den Kontrast zu dem fahlen Grau des Baustoffes abgibt. Dem härtesten aller Baustoffe, dem Eisenbeton, ist hier eine graziöse Leichtigkeit abgewonnen worden, die von fern an die Schwerelosigkeit indianischer Zelte erinnert — jener von Bambusstäben getragenen Zeltdächer, deren hochgeschlagene Seitenwände kühlendem Wind Zutritt zum Zeltinneren erlauben. Das ist im ungezügelten, fast ausschweifenden Formenschwung ein glitzernder Traum des 20. Jahrhunderts, aber doch der Traum eines Südamerikaners. →

E
ine halbe Wegstunde von Brasiliens Hauptstadt Rio de Janeiro entfernt liegt das eigenwilligste Wohnhaus Brasiliens. Erbauer und Besitzer ist Prof. O. Niemeyer, Brasiliens berühmter Architekt. Sein Name hat in aller Welt als der eines kühnen Avantgardisten Gewicht und Klang. Das Gefühl neuzeitlichen Wohnens prägt sich in seinem Haus in einmaliger Weise: Die Innenräume verschmelzen mit dem Draußen zur harmonischen Einheit. Die Natur wächst in die Räume hinein, weil die Wohnung keine starren Wände mehr kennt. Glas gibt die Illusion der Weite, aber zugleich begrenzt es auch. Die Felsen der Landschaft wurden nicht gesprengt. Niemeyer ließ sie unbesorgt in die Räume hineinwachsen, deren Wände sich mit wenigen Handgriffen verschieben lassen, um aus zwei Zimmern ein großes, aus der geräumigen Wohnhalle drei kleine Gästezimmer zu gewinnen.

Oscar Niemeyers Vorfahren stammen aus Westfalen. Der Fünfzigjährige spricht allerdings kein Deutsch mehr. Doch wird auch er in Deutschland bauen. Seine Pläne für die Neugestaltung des Hansa-Viertels in Berlin sind in seinem Atelier im 12. Stockwerk eines Appartementhauses in Copa Cabana ausgefeilt worden. Sein Assistent, der deutsche Konstrukteur Biermann, fliegt zwischen Rio de Janeiro und Berlin hin und her, um die Ausführung mit den Ideen des

Fortsetzung auf Seite 16

Willenskraft und Vitalität kennzeichnen die Erscheinung des Fünfzigjährigen. Niemeyer spricht kein Deutsch mehr, obwohl erst sein Vater, ein Berliner Architekt, die alte Heimat verließ, um in einer neuen Welt neue Aufgaben zu finden. Aufnahme: Charles Wilp

Aufnahmen: F. C. Gundlach

Hinter dem Hause steigen die Berge auf, steil und unerreichbar, ein merkwürdiger Gegensatz zu dieser schattigen Idylle, in der ein Vogelkäfig im Geäst eines Baumes hängt, ein Hund auf die Geräusche von draußen lauscht und ein Spielzeugauto auf seinen kleinen Besitzer wartet

"...seen with the eyes of a woman: Minister of State Oskar Stübinger", *Film und Frau* 16/1959

haus, Ingrid Andree, Sonja Ziemann, Will Quadflieg, and Nadja Tiller. The list of the stars of the West German silver screen photographed by the young Stuttgart resident by the mid-1950s is as long as that of the magazines that ensured his images nationwide exposure. Film magazines like *Film und Mode Revue, Deutsche Film Illustrierte, Film, Die Filmwoche* or *Star Revue* were among them, as were the afore-mentioned radio magazines or the genre of classic illustrated magazines that swiftly took off again after the German currency reform of 1948 with publications such as *Quick, Revue, Illustrierte Post, Stuttgarter Illustrierte, Schwäbische Illustrierte, Münchner* or the *Frankfurter Illustrierte.* Gundlach published in *Ihre Freundin,* in *Constanze,* which had a high circulation, and above all as of early 1951 in the fortnightly *Film und Frau,* where his idea of presenting film stars in

(purchasable) fashion designed especially for them established a genre that was not only successful back then. The notion of "film stars in fashion" stands for F.C. Gundlach's growing interest in fashion, and it increasingly became the focus of his work for magazines.

It was likewise during F.C. Gundlach's time in Stuttgart that he first travelled to Paris, which was quite definitely the undisputed world capital of fashion, and more besides. Culturally speaking, Paris was still the centre of the Western world and F.C. Gundlach was not the only German photographer to look to Paris for inspiration in the 1950s – and find it. Otto Steinert visited the city for the first time at the end of the 1940s. However, while Steinert merely used Paris as an excuse for images in the spirit of "subjective" photography that tended towards abstraction,

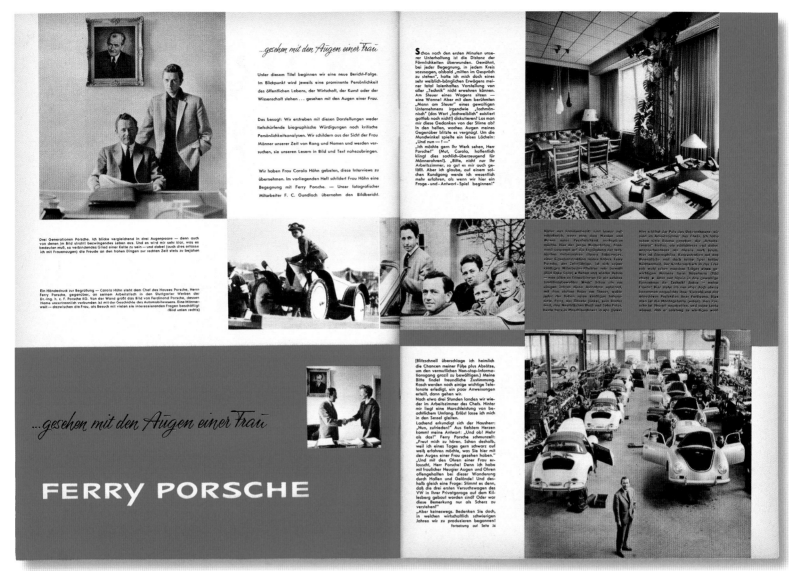

"... seen with the eyes of a woman: Ferry Porsche", *Film und Frau* 11/1959

Gundlach sought out themes, stories, and reports for West German periodicals. It is easy to reconstruct Gundlach's first trips to Paris as the visas he needed document them. He drove there in the second-hand car he had bought himself, lived in a cheap hotel, and from there swiftly made contacts. The young photographer skilfully did what we would today term "networking", made friends in the "scene", and they were subsequently to open many a door for him: Be it to Jean Marais or Jean Cocteau or the young Jean-Louis Barrault and his wife Madeleine Renaud, on whom Gundlach produced his first smaller pieces of photojournalism. The pictures he took in black-and-white with his Rolleiflex Gundlach then printed out as contact sheets, cut the images out and glued them in line with layout ideas in a dark folder. Not only do Gundlach's collection of cartons, and they are slightly smaller than A3 in size, show how over and above the good individual images he was already thinking in terms of contexts, of series and stories. However plain they are from today's perspective, they also show a clear grasp of questions of editing and page design.

F.C. Gundlach's first photo exhibition from Oct. 27 – Nov. 27, 1951 in the (now defunct) Jean Robert book store in Paris is more than just an anecdote. What exactly he put on display at Rue Jacob 32, i.e., on the left bank of the Seine, is no longer known. What has survived is a guest book, and the entries confirm just how large his circle of friends and admirers already was. Exhibiting photographs as if they were prints or panel paintings was still quite unusual at the beginning of the 1950s. Specialised galleries or even museums did not exist and thus F.C. Gundlach

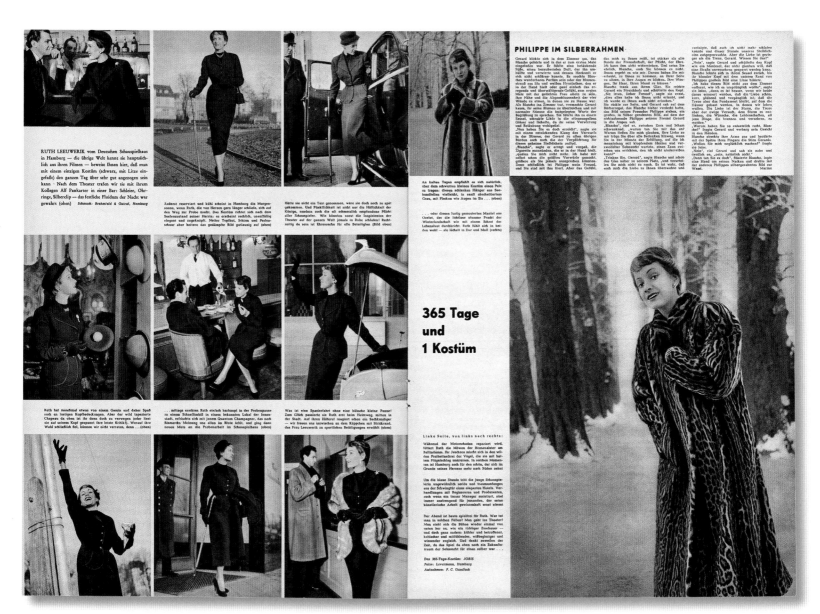

"365 days and 1 costume", *Film und Frau* 3/1953

was not the only person whose images reached an audience via free wall space in a bookstore. What was remarkable about F.C. Gundlach's Paris exhibition was primarily the fact that it showed that from an early date he was already always thinking of a quite different media context for the works. F.C. Gundlach always defined himself as a reliable service provider, as a photographer working for the print media and for whom the museum wall was at best a remote option. Indeed, it seems telling that it was not for another twenty-five years that he had his next major exhibition, "Modewelten".[20] Gundlach never focused on "art", never primarily concerned himself with ensuring his oeuvre a place in museums. Nevertheless, precisely in his "applied" work he set himself high formal standards, repeatedly searched for that one

surprising image, and as a result years and even decades later the images still work, even in completely different context to that of illustrated magazines.

In the 1950s, F.C. Gundlach frequently worked as a reporter for illustrated magazines that (at any rate until the final triumph of TV[21]) continued to function as the "window on the world". A large story he produced for *Deutsche Illustrierten* (no. 32, 1953) on Aristoteles Onassis, who had travelled to Hamburg with his young daughter Christina for the christening of a ship, is documented.[22] Another picture story, running to several instalments, for *Deutsche Illustrierten* appeared in 1953 and was on Carmencita Franco, the Caudillo's daughter.[23] And to name a third example, he also brought out a photo story on the new Japan in *Frankfurter Illustrierte* – it was entitled "Nippons

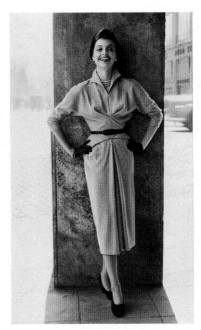

Paris? Ein Modell von Dior? – – –
Nein, ein

Heinzelmann en vogue

Dieses ladylike vornehme Kleid mit der in Bluse und Rock
harmonierenden Faltengestaltung bringt jeder Frau
den Erfolg, den sie sich ersehnt.
Daher nennen wir es nicht Endstation Sehnsucht, sondern

Endstation Glücklich

Bluse: **Corinna** Rock: **Stella**

Modebummel mit Nadja

"A fashion stroll with Nadja", Heinzelmann en Vogue 1952

Uhren schlagen schneller", meaning "time moves at a different pace in Japan".[24] In the late versions of *Film und Frau* F.C. Gundlach repeatedly quit the world of fashion photography in favour of *reportage*, whereby in his case the stories were all on "soft" topics. He focused neither on wars nor on conflicts, neither on the political nor on the social, fields that were the prime ground of young German photographers such as Robert Lebeck, Thomas Höpker or Rolf Gillhausen. What Gundlach provided were photo stories on art and culture, architecture and the everyday world of foreign peoples and cultures, and not often he had taken them parallel to international fashion shootings. Thus, in 1957 he photographed Oscar Niemeyer's private villa in the Tropics for *Film und Frau*.[25] A little later he was admitted into the private home of his prominent US colleague Horst P. Horst.[26] In 1963, F.C. Gundlach reported from as many as three metropolises in the Far East (Hong Kong, Tokyo and Bangkok), again for *Film und Frau*,[27] and that same year also from New York, in which instance the dialog between F.C. Gundlach's photographs and the Reinhold W. Timm's paintings, reproduced in colour, can be considered one of the editors' most striking ideas.[28]

F.C. Gundlach is probably the fashion photographer of his generation in Germany who tended to work most in a journalistic vein, although in the final instance he always emphasised the fashion. Put differently, he was more interested in how he could control, stage and design the shot than in the "found image" or the "decisive moment", which was so in favour since Henri Cartier-Bresson, and which decid-

167

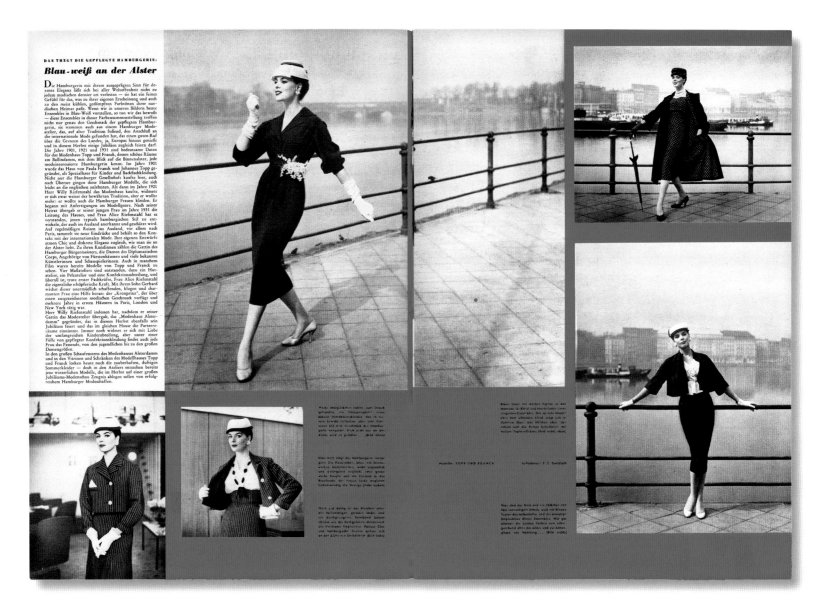

"Blue and white on the Alster", *Film und Frau* 16/1956

"The first cover in color", Curt and Helga Waldenburger, Hamburg 1955

edly influenced the agenda of at least one generation of photographers post-1950. Gundlach was long since both photo journalist and fashion photographer, but with the beginning of his trips to Paris, i.e., as of the early 1950s, his focus started to shift firmly in the direction of fashion. Alongside personal interest, two reasons may have been decisive. Since 1945, Parisian fashion's economic importance has soared and (until the Wall was built in 1961) so had Berlin's – and the high-circulation fashion magazines required an increasing number of photos, fuelled by the interest of international readers who after the War and the trials and tribulations of the immediate post-War era now wanted at least to see and thus vicariously participate in the renaissance of haute couture. The latter was back with a vengeance with Christian Dior and his first collection (in February, 1947).[29] And the high art

of fashion-making managed to regain something of its pre-War significance for a few years before prêt-à-porter won the day.

The fact that the doors of the major houses gradually opened to the young F.C. Gundlach has primarily to do with the afore-mentioned contacts in Paris. The photographer has vague memories of Walter Dickhaut, a German emigrant who had fled the Gestapo and remained in Paris after the War and apparently helped Gundlach with the one or other introduction.[30] We know more about Franz Wolfgang Koebner, who was, as Gundlach insists, at that time a "nationally known celebrity in journalism" and a "real all-rounder" – as the long-standing editor-in-chief of *Elegante Welt*.[31] Koebner had the very best contacts in the Parisian fashion world and it was essentially he who smoothed F.C. Gundlach's path into fashion.

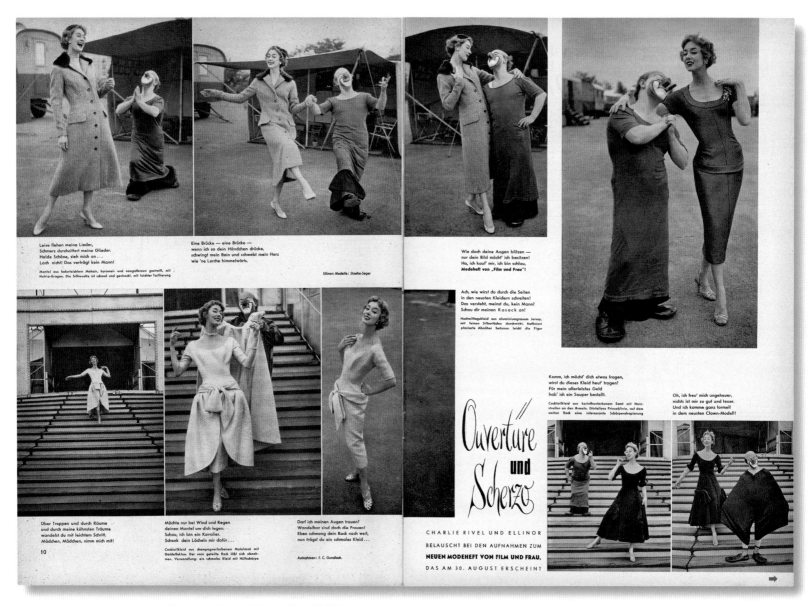

Leise fliehen meine Lieder,
Schmerz durchzittert meine Glieder.
Holde Schöne, sieh mich an...
Loch nicht! Das verträgt kein Mann!

Mantel aus federleichtem Mohair, karamel- und naugatbraun gestreift, mit Nutria-Kragen. Die Silhouette ist schmal und gestreckt, mit leichter Taillierung

Eine Brücke — eine Brücke —
wenn ich so dein Händchen drücke,
schwingt mein Bein und schwebt mein Herz
wie 'ne Lerche himmelwärts.

Ellinors Modelle: Staebe-Seger

Wie doch deine Augen blitzen —
nur dein Bild möcht' ich besitzen!
Ha, ich kauf' mir, ich bin schlau,
Modeheft von „Film und Frau"!

Ach, wie wirst du durch die Seiten
in den neusten Kleidern schreiten!
Das versteht, meinst du, kein Mann?
Schau dir meinen Kasack an!

Nachmittagskleid aus aluminiumgrauem Jersey, mit feinen Silberfäden durchwirkt. Raffiniert placierte Abnäher betonen leicht die Figur

Über Treppen und durch Räume
und durch meine kühnsten Träume
wandelst du mit leichtem Schritt.
Mädchen, Mädchen, nimm mich mit!

Möchte nur bei Wind und Regen
deinen Mantel um dich legen.
Schau, ich bin ein Kavalier.
Schenk' dein Lächeln mir dafür...

Cocktailkleid aus champagnerfarbenem Matelassé mit Goldeffekten. Der vorn geteilte Rock läßt sich abnehmen. Verwandlung: ein schmales Kleid mit Hüftschärpe

Darf ich meinen Augen trauen?
Wandelbar sind doch die Frauen!
Eben schwang dein Rock noch weit,
nun trägst du ein schmales Kleid...

Aufnahmen: F. C. Gundlach.

Komm, ich möcht' dich etwas fragen,
wirst du dieses Kleid heut' tragen?
Für mein allerletztes Geld
hab' ich ein Souper bestellt.

Cocktailkleid aus korinthenfarbenem Sand mit Herzstreifen an den Armeln. Gürtellose Prinzeßlinie, auf dem weiten Rock eine interessante Schärpendrapierung

Oh, ich freu' mich ungeheuer,
nichts ist mir zu gut und teuer.
Und ich komme ganz formell
in dem neusten Clown-Modell!

Ouvertüre und Scherzo

CHARLIE RIVEL UND ELLINOR
BELAUSCHT BEI DEN AUFNAHMEN ZUM
NEUEN MODEHEFT VON FILM UND FRAU,
DAS AM 30. AUGUST ERSCHEINT

10

"Overture and Scherzo", *Film und Frau* 17/1955

Not only by repeatedly publishing his work right into the 1960s, but also by familiarising him with the subtle rules of the industry, including the gifts known as "corruptionals" with which one gained an entry to the press desks of the various couturiers. "He got me in there," F.C. Gundlach recounts, as "Koebner always knew someone in a company."[32]

In this context, a constantly repeated anecdote would have it that F.C. Gundlach's entry into fashion photography took place with his first fashion images published in *Film und Frau*. In actual fact, he had long since published fashion images, and gained experience in the world of fashion, when in February 1953, his first double-spread featuring fashion came out in the magazine Curt and Helga Waldenburger – under the title of "365 Tage und 1 Kostüm" (365

days and a costume).[33] Without doubt, *Film und Frau* was one of the most unconventional new magazines founded in post-War West Germany, and yet a typical product of the 1950s to the extent that its face and content were not shaped by market analyses or reader surveys, but by the publishers' personal vision: In this case, the childless couple Curt and Helga Waldenburger, who from the very outset had placed the fortnightly magazine, which initially came out on a Thursday, later on a Wednesday and as of 1961 every Tuesday at the very centre of their lives. Curt Waldenburger is said to have been an essentially withdrawn man with a clear feel for architecture and art, an aesthete who shied away from Hamburg's social life.[34] Waldenburger collected Impressionists just as he did Gothic Madonnas. In private letters, he was now and

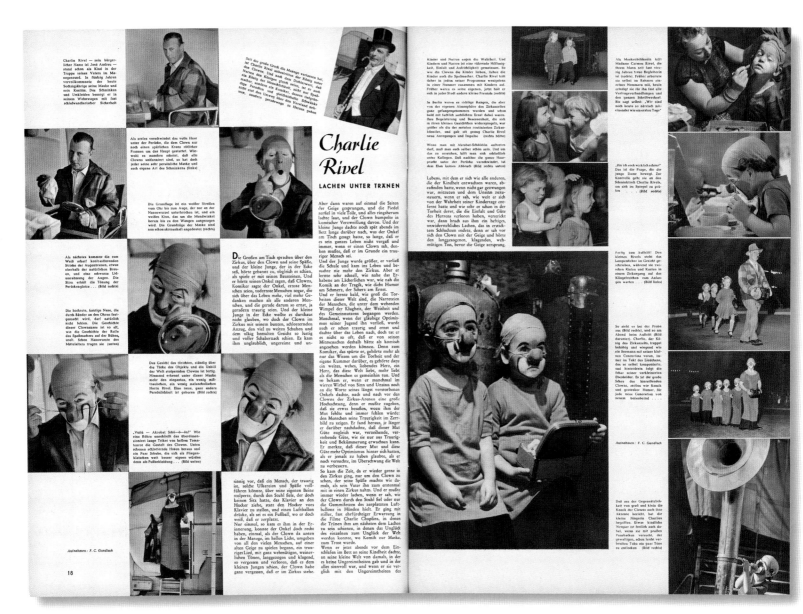

"Charly Rivel: Laughing in tears", *Film und Frau* 26/1955

again addressed as "My dear Poet".[35] And in lavishly literary headlines that often played with alliteration one can perhaps discern his ambition. As early as the 1920s, Waldenburger, who had been born in Leipzig in 1903, had brought out a volume of poetry called "Dir Schönste der Frauen" (for you, the most beautiful of women). By 1927 he was the editor of various family magazines, then worked as an editor at Wilhelm Goldmann Verlag and finally, in 1929, was made chief editor of general interest magazines *Mein Blatt* and *Das Buch für Alle* at Verlag W. Vobach, Berlin; it was a position he was to retain until he was called up to serve in the Wehrmacht in 1942.[36]

We do not know what exactly prompted publisher Kurt Ganske to make Curt Waldenburger the first chief editor of a women's magazine that was still to be founded. At any rate, Rosemarie Günther, who was for many years a secretary at *Film und Frau*, suggests that it was Kurt Ganske who visited Waldenburger in Berlin in order to persuade the experienced journalist to come on board at the new magazine.[37] The background to this was Ganske's wish to place a magazine publishing house alongside the rapidly expanding readers' club ("Leserkreis Daheim") which his father Richard Ganske had founded in 1907. At the time, newspapers and magazines still had to receive a license from the Allies. Yet neither Ganske nor his co-publisher Martin Christensen, bore the burden of the past, i.e., had been card-carrying Nazis before 1945.[38] And Curt Waldenburger was also able to refer to himself as "denazified" as of July 1947,[39] and thus in August 1948 nothing stood in the way of

next spread: "A good friend of reality: Naïve painter Kurt Mühlenhaupt", *Film und Frau* 22/1962

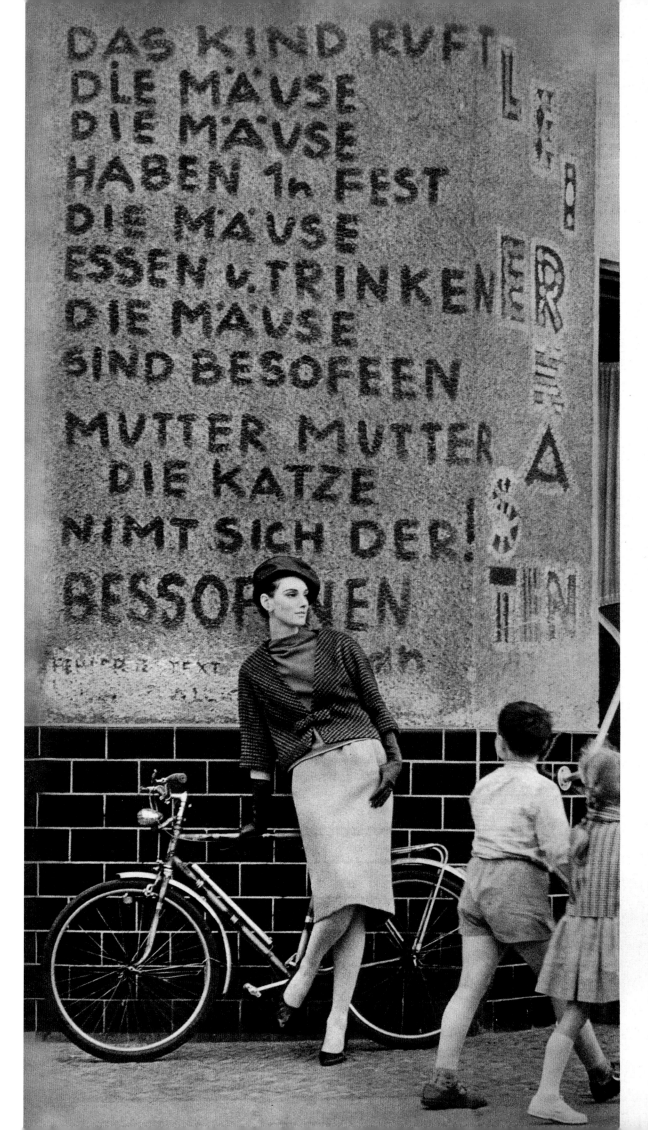

DAS KIND RVFT
DIE MÄVSE
DIE MÄVSE
HABEN 1n FEST
DIE MÄVSE
ESSEN v. TRINKEN
DIE MÄVSE
SIND BESOFFEN
MUTTER MUTTER
DIE KATZE
NIMT SICH DER!
BESSOFFNEN

Fortsetzung von Seite 6

ihn gerade die Lust zum Malen überkam. Sie überkam ihn ziemlich oft. Er malte Bild auf Bild, Landschaften, Interieurs, Stilleben, figurale Szenen, Porträts, halb surreale Bilder, wie die „Beherrscher des Mittelmeers", meist jedoch höchst reale Arbeiten, etwa sich selber als „Serienstanduhrenverkäufer". Jahrelang verkaufte er seine Bilder für zwei bis fünf Mark. Kunsthändler, die heute kaum noch ein Bild unter tausend Mark von ihm bekommen, zucken jedesmal schmerzlich zusammen, wenn sie von den Preisen hören, zu denen Mühlenhaupts Bilder noch vor ein paar Jahren zu haben waren.

Lange Zeit war der Maler zu schüchtern, sich als Schöpfer seiner Bilder zu bekennen. Selbstvertrauen gewann er erst, als ihn die Gründer der Galerie „Zinke", unter ihnen Robert Wolfgang Schnell und Günter Bruno Fuchs, entdeckt hatten und ermunterten. Er half ihnen gelegentlich mit Geld aus, wenn es nicht mehr für die Galerie-Miete oder den Druck des lyrisch-pamphletistischen „Zinke"-Flugblattes reichte; sie gaben ihm maltechnische Hinweise und verschleppten Journalisten und Kritiker in das Chaos aus Standuhren, Hirschgeweihen, Trichtergrammophonen, alten Möbeln und antiquarischen Büchern, in dem er sich eingenistet hatte. Von nun an entfaltete der Mann, der trotz etlicher Kriegsverletzungen ein Vitalitätsphänomen ist, eine staunenswerte Aktivität. Er veranstaltete vor seiner Trödelhandlung einen sonnabendlichen Bildermarkt, auf dem jeder ausstellen konnte, der fähig war, eine Leinwand mit Farbe zu bedecken; er gründete das Künstlerlokal „Leierkasten", in dem sein Vorzugsmodell Rosi streng, aber gerecht residiert; er gab eine Hauszeitschrift heraus, in der sich auch renommierte Lyriker und Graphiker zum Wort meldeten, und er tat dies alles, ohne seine Trödelhandlung, seine Malerei und seine Familie zu vernachlässigen.

Schon erzählt man sich in Berlin eine Reihe typischer Mühlenhaupt-Anekdoten. Ein Kreuzberger Bürger beispielsweise brachte eines Tages ein Bild zurück, das er vor einem Jahr für ganze fünf Mark erstanden hatte. Ihm, so behauptete der Käufer, gefalle das Bild ja sehr gut, aber seine Familie und seine Freunde könnten damit nichts anfangen und lachten ihn aus. Ob er das Bild nicht gegen Erstattung der fünf Mark zurückgeben könnte? Mühlenhaupt war dieses Angebot nicht zuletzt deshalb peinlich, weil er zufällig einen Mitarbeiter der Zeitschrift „Der Monat", der sich für seine Bilder interessierte, zu Besuch hatte. Er zog, in seinem Künstlerstolz gekränkt, einen Zwanzigmarkschein aus der Tasche, reichte ihn dem Käufer und nahm das Bild zurück. Der Journalist betrachtete das Bild und fragte:

„Was soll es kosten?"
Mühlenhaupt, noch immer ärgerlich, antwortete: „Hundert Mark."

Der Journalist zückte die Brieftasche und zahlte. Der Käufer, der die Szene mit ungläubigen Blicken beobachtet hatte, geriet fast aus dem Häuschen. Ein andermal kam ein altes Mütterchen zu Mühlenhaupt. Es hatte davon gehört, daß man bei ihm Bilder für fünf Mark kaufen konnte, hatte sich aber vorsichtshalber zehn Mark eingesteckt und war zu allem entschlossen. Es musterte rasch die Bilder, stürzte auf eines los, warf den Zehnmarkschein auf den Tisch und sagte: „Das kaufe ich."

Mühlenhaupt wollte das Bild aber gar nicht verkaufen, vor allem nicht für zehn Mark, denn seine Bilder kosteten damals schon achtzig bis hundert Mark. Das Mütterchen klammerte sich an das Bild fest und wollte keine Einwände gelten lassen. Mühlenhaupt hatte einen Einfall, sagte „Moment mal", ging in den Nebenraum zu seinem Bruder und bat ihn, in einer benachbarten Altwarenhandlung eine Heidelandschaft oder einen röhrenden Hirsch zu kaufen. Dann verwickelte er das Mütterchen so lange in ein Gespräch, bis sein Bruder mit dem neu erstandenen Bild eintraf.

Fortsetzung auf Seite 67

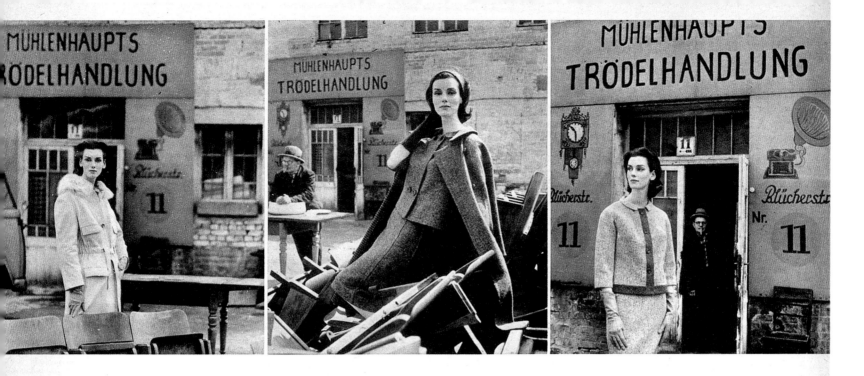

Duzfreund der Wirklichkeit

Alabasterfarbener Mantel aus Nappaleder mit großen Taschen und Luchskragen über beige - bräunlich - farbenem Tweedkleid. Modell: Heinz Oestergaard (Bild oben)

Ensemble aus reiner Wolle, bestehend aus Mantel und Deux-pièces. Zum Mantel wurde ein Doubleface verarbeitet, außen rauchbraun, innen giftgrün, zum Deux-pièces ein leichter rauchbrauner Wollstoff. Modell: Heinz Oestergaard (oben Mitte)

Sportliches Kostüm aus lose gewebtem braun-beige-farbenem Tweed. Verschluß und Jackensaum betont durch eine angewebte Kante aus unibraunem Tweed. Modell: Heinz Oestergaard (oben rechts außen)

Kleid mit angearbeiteter Kapuze aus grobgewebtem gelb - schwarzem Tweed. Der schräge Schnitt des Oberteils und die großen Wollborten an Kapuze und Ärmeln geben dem Modell ein sehr apartes Aussehen. Modell: Uli Richter (Bild rechts)

Alle Aufnahmen: F. C. Gundlach

Woll-Complet in honiggelb-braunen Farbtönen. Der Jumper wurde aus Jersey, der Rock aus Shetland und die kurze Jacke aus federleichtem Flausch gearbeitet. Ein Modell von Uli Richter, Berlin (Bild linke Seite)

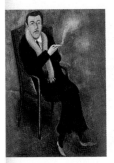
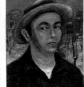

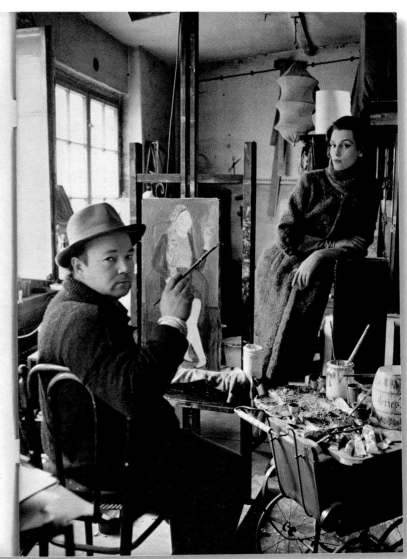

"A good friend of reality: Naïve painter Kurt Mühlenhaupt", *Film und Frau* 22/1962

approval of their jointly submitted "petition to publish a newspaper/magazine". The men finally agreed on the title of *Film und Frau* at the end of September 1948, whereby the "character of the magazine and its goals" remained unchanged, as they wrote in a communication to the "Consultative Press Committee".[40] The magazine license was issued as no. 36 on October 20, 1948 by the Senate of the Hanseatic City of Hamburg. And in early November was followed by the first issue of the new magazine *Film und Frau*.[41]

Helga Waldenburger designed the magazines.[42] It was she who defined the magazine's visual look, and even if it may be exaggerated to talk of 'art direction': *Film und Frau* differed from the majority of West German magazines primarily thanks to the graphic talent of Helga Waldenburger, née Pankoke. Without doubt, *Film und Frau* cannot be compared with its in-ternational rivals of the 1950s, such as *Vogue, Harper's Bazaar* or *Elle*, designed since the end of the 1950s by Peter Knapp.[43] For its day, the magazine was imbued with an unusual streak of clarity and rigorousness, evidenced by the generous presentation of images, the avoidance of ornamental frills, and the careful use of fonts, the sole Baroque touch being the use of gold as an ornamental colour. What we can be sure of is that before the war Helga Waldenburger attended the private Reimann College in Berlin, which was vaguely comparable to the Bauhaus. Most probably she came into contact with avant-garde ideas there, especially as after the Nazis had closed the Bauhaus down an entire series of important former Bauhaus lecturers (including Walter Peterhans) found at least temporary employment first with Albert Reimann and then with his successor Hugo Häring.[44]

However, F.C. Gundlach was not always in a position to be happy with the graphic presentation of his images. What he could to a certain degree control was the editing. Firstly by rigorously pre-selecting the images. And secondly by printing the important lead images larger than the others. The prints sized 30 x 40 cm already pointed the graphic designers in the right direction, as Gundlach submitted the other images sized 18 x 24 cm and later 24 x 30 cm. He could be sure that his name would be stated in a prominent position. Editors were painstaking when it came to references to authorship, and other photographers also profited from this, including Relang, Flöter, Rohrbach or Maywald and in particular Rosemarie Clausen, Karl Ludwig Haenchen, Ingeborg Hoppe, Karin Kraus, Harry Meerson, Herbert Tobias and Rolf W. Nehrdich (Gundlach's teacher in Kassel), who, how ironic Fate can be, tried at the same time as F.C. Gundlach to embark on a second career as a fashion photographer, but was definitely less fortunate than his erstwhile pupil.

F.C. Gundlach always saw himself as a magazine photographer. "My goal was always to see the printed page," he once insisted, which also says that he formulated his photographic agenda with a view to magazines' requirements.[45] For Gundlach this meant treading a thin line. Firstly, he had to invent images that were more than simply evidence in the sense of images for an mail-order catalogue – the latter genre also started reaching German homes in 1950s.[46] At the same time, *Film und Frau* was also primarily interested in fashion information, i.e., a photographic interpretation of clothes fashions that essentially enabled the women readers to copy the models portrayed. "If a fashion photo conveys or contains no fashion information then it has failed," commented F.C. Gundlach summarily, whereby this did not prevent him from seeking to establish his own personal visual idiom, a skilful use of models, or new ideas when choosing either the setting or the props for studio shots.[47] If we look at F.C. Gundlach's photographic oeuvre as a whole, then we can discern a number of strategies that enabled him to convey fashion information and also create images that did justice to the standards he set himself in light of the international fashion world. Firstly, F.C. Gundlach always worked in cycles. His fashion photography is serial. The individual image counts less than the logical sequence. Secondly, as early as his "Modebummel mit Nadja" (A fashion stroll with Nadja, 1951) we can see that F.C. Gundlach instils his fashion photography with a narrative element, embeds the images in a story that gives the sequence of images (often interrupted in the magazine by ads) an easily grasped overall cohesion. Thirdly, poses such as a 'step forwards' to illustrate the volume of a dress may explain the respective clothes fashion, but were also intended in a way to reflect the zeitgeist pattern, against the backdrop of women's changing role in society. Fourthly, the choice of the locations was intended to support the image. Only as an exception did F.C. Gundlach opt for a setting at loggerheads with the fashion, as in the case of the then renowned painter/poet and scrap merchant Kurt Mühlenhaupt.[48] And fifthly, not least the props are chosen carefully and recur as (at times decidedly ironic) quotations throughout a shooting. The dice, the "planche" (the seal ladder borrowed from a circus) are thus not just a backdrop, but support certain gestures or poses and also create an overall context. In this sense the sporting coupé he repeatedly included in the images mainly had two tasks to fulfil thanks to their being symbols of movement, travel, distance, and affluence: "Firstly they created continuity. You could make a series. And secondly you can drive a car anywhere."[49] Automobiles, with other words, were easily transported props that also disguised the bleak, often War-scarred urban landscapes of the day.

next spread: top left: "First look at new fashion", *Film und Frau* spring/summer 1957; bottom left: "Fashion line", *Film und Frau* spring/summer 1956; top right: "The sporty and elegant ensemble", *Film und Frau* 4/1961; bottom right: "Jean Luc Godard – The XI. Berlinale", *Film und Frau* 16/1961

DAS FUTTERAL-KLEID entspricht wie kein anderes der Vorliebe der modernen Frau für klare Linien und einfache Formen. Es ist schmal und schmucklos und wirkt allein durch sein Material und die Anmut der Trägerin! Dieses Modell ist von Horn

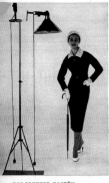

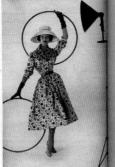

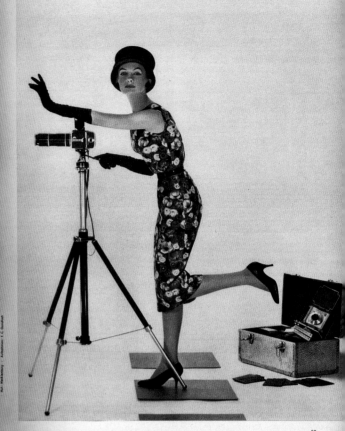

DAS SPENZER-KOSTÜM mit knapp hüftlangem Jäckchen repräsentiert einen neuen jungen Typ in der Vielzahl modischer Kostüm-Variationen. Hier stellt es sich aus marineblauem großfädigem Woll-Natté mit weißem Pikeekragen vor. Modell: Schwabe

DIE CAPE-JACKE ist eine sehr tragbare Abwandlung des Capes, das in dieser Saison erneut eine Rolle spielt und nicht nur Kleider, sondern vor allem viele Kostüme ergänzt. Dieses Modell mit breitem Schalkragen aus hellem Pepita ist von Stoebe-Seger

DAS HEMDBLUSENKLEID ist zwar nicht „neu", aber nach wie vor so modisch so aktuell, daß es unter den Favoriten genannt werden muß. Es erscheint vielfach bedruckt, wie dieses weiße Shantung-Kleid mit dem aparten Muscheldessin. Modell: Horn, Berlin

DER BOUTIQUE-STIL findet immer neue Anhängerinnen, und die Mode kommt diesen Wünschen entgegen, indem sie auch diesmal viele amüsante Vorschläge bereit hält. Dieses Boutique-Ensemble besteht aus Kleid mit gleichfarbiger Strickjacke. Modell: Horn

DAS BLUMENKLEID zählt zu den erklärten Lieblingen der kommenden Sommermode und darf in keiner Garderobe fehlen. Wer ganz up to date sein will, wähle eins der zauberhaften Rosenmuster! Dieses junge Röschen-Kleid ist von Stoebe-Seger, Berlin

DAS CHIFFON-KLEID, dessen Charme in dem fließenden transparenten Material liegt, ist wie geschaffen für festliche Sommerabende. Hier präsentiert sich ein Modell aus Jackross Chiffon in der typischen Ballerina-Silhouette. Modell von Gehringer & Glupp

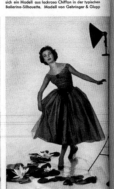

Hut: Mecklenburg · Aufnahmen: F. C. Gundlach

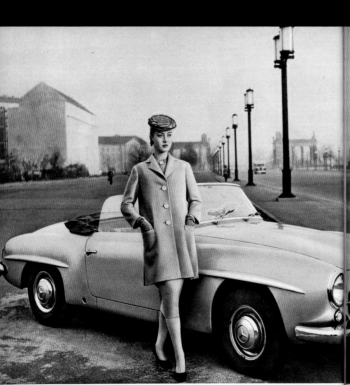

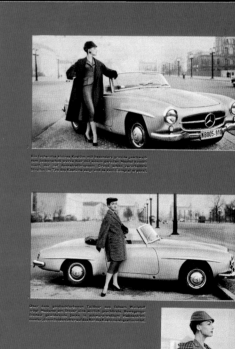

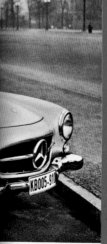

Ein fuchsrotes kleines Kostüm mit besonders graziös geschweiftem Jackenschoß wirkt hier mit einem geraden Mantel kombiniert, der zur dunkelrotbraunen Grund schön verarbeiteten Schottenkaro...

Über dem goldockerfarbenen Tailleur aus feinem Wollstoff trägt Madame ein Umschlagetuch...

Dem eleganteren Anlaß dient das damenhafte Complet. Hier besteht es aus schmalem Kleid und gerader Siebenachteljacke in leichtem gelbem Tweedgewebe. Zu Jackenfutter und Hutgarnitur gelb getupfte tabakbraune Seide.

O b Ost-West-Achse oder Washington Bridge, ob Corniche oder Champs-Élysées —
breite glänzende Straßen, schlanke Lampensilhouetten am Rand,
ein großer Himmel darüber oder zu seiten ein großes Meer,
führen überall in der Welt stadtaus und stadtein.
Immer weiter werden die Horizonte, die uns unterwegs umgeben,
immer großliniger die Kulissen der Bauten, die optisch die Fahrt begleiten.
Und unser Wagen ist wie ein Vogel im Sturzflug, der die Flügel unsichtbar eng anlegt.
Nichts Überflüssiges an Volumen und Umriß — das ist die Parole.
Wir passen uns an: schmale Kleider und Tailleurs,
geschmeidig und schnittig, darüber Jacke oder Mantel,
so bequem, daß sie sich gleichsam von selbst anzieh'n —
nichts, was uns beengt, nichts, was in uns in der Bewegung stört.

Modelle: Stoebe-Seger
Aufnahmen: F. C. Gundlach

Film und Frau

HEFT 17/X · 80 PF.

3. Vierteljahr 1958 · Verlagsort Hamburg

In Oesterreich S 6.50 · In der Schweiz Fr. -.90
In Schweden skr. 1.10 · In Italien L. 170.-
In Belgien F. B. 10.- · In U. S. A. und
Canada cts 30 · Printed in Germany

ITALIEN PRÄSENTIERT SEINE NEUE MODE ★

UNSERE SERIE: WIE KLEIDET SICH DER HERR!

S.S. "AMERICA" läuft aus

Eine Reise mit dem Schiff – das ist unser Vorschlag für Ihren Herbst- und Winter-Fahrplan.
Ob Sie unter der Flagge froher Ferien fahren oder im Interesse florierender Geschäfte, auf einem Frachter oder einem schnellen Schiff, immer wird sich Nützliches mit Angenehmem, Arbeit und Erholung, Ruhe mit Reiseabenteuern verbinden lassen.
In diesem Sinne wurde auch die Reisekleidung kombiniert: Sie sollen sich an Bord eines Luxusdampfers wie der "America" zwischen New York und Bremerhaven genauso glücklich fühlen wie auf einer Fahrt mit einem Frachter, der mal in Vigo, mal in Helsingfors die Ladung löscht und lädt.
Und mehr noch: auch an Land, das Sie nach Tagen oder Wochen erwartungsvoll betreten, werden Sie in diesen Film und Frau Modellen schön und chic zugleich gekleidet sein

Film und Frau MODELL „AMERIKA"

Das Reisecomplet besteht aus Rock, Jacke und Paletot, jedes Teil aus einem anderen Dessin eines besonders interessanten Woll-Compaxés. Der Rock aus 1 m/140 cm diagonal gestreifter reiner Wolle ist ganz einfach und gerade mit rückwärtiger Gehfalte. Die Jacke aus 1,50 m/140 cm im Pepito geweber reiner Wolle ist kragenlos und so weit gehalten, daß an kühlen Tagen dicke Rollkragenpullis und Schals darunter Platz finden. Der Paletot aus 3 m/140 cm reinwollenem Glencheck zeigt die modisch verbreiterten Revers und geräumige Taschen. Schnitte in den Größen 42, 44 und 46 zu DM 4,50. Hut: Gerda Wessinger; Schal: Gloria boutique; Handschuhe: Weigel; Schuhe: Bally/Prange

Wie im flirrenden Sonnenlicht, so im Glanz kristallener Lüster

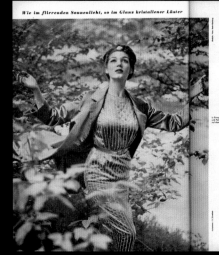
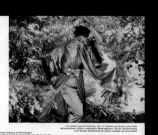
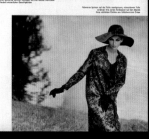

DAS MÄDCHEN UND DIE TAUBE
von Kurt Ziesel

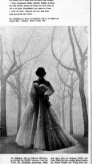

IN DER ALLEE

PELZMODE

zwischen
Bremen
und
New York

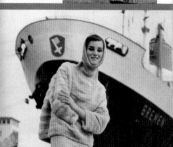

maestoso und adagio
BRAUTKLEIDER GROSSEN STILS

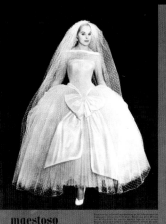
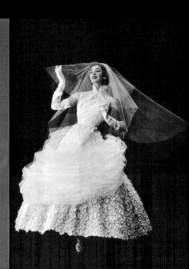

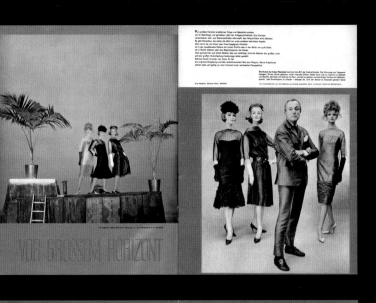

VON GROSSEM HORIZONT

FERIEN *in Sommerwind*

Gold- *staub* UBER DIE „BREMEN"

NEW YORK WELCOMES THE NEW BREMEN

dralon

ich fühle mich wohl

in Wäsche aus **dralon** EINE FASER

Mädchen in Weiß auf rotem Feld

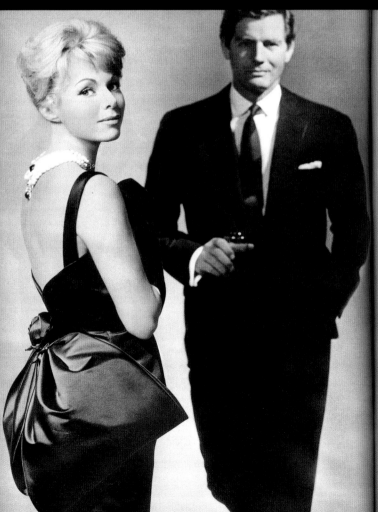

Entwürfe: Heinz Oestergaard
Aufnahmen: F. C. Gundlach

Paul Hubschmid

Marianne Koch

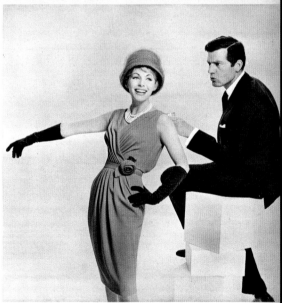

Bewunderung erwecken ohne aufzufallen, das ist der Traum schöner Frauen an „großen Abenden". Die Gala-Garderobe mit der reich drapierten Schärpe und dem sehr tief geführten Rücken-Dekolleté erfüllt diesen Traum. Auch bei internationalen Festlichkeiten gibt sie Erfolgssicherheit.

Film und Frau MODELL „RIZ-BAR"
Ein Partykleid aus
3,50 m/90 cm reinseidenem
schwarzem Duchesse.
Schnitte in den Größen
40, 42, 44 zu DM 2,80

Voller chevaleresker Anerkennung blickt Paul Hubschmid auf die bildhübsche Marianne, die sich in ihrem geradezu „hellenisch" geschnittenen Kleid ausgebreitet präsentiert. Vom Nachmittagstee bis zum Abendcocktail ist es Ausdruck vollendeter Eleganz, besonders wenn das Grün der Augen für den aparten Farbeffekt sorgt.

Film und Frau MODELL „DIDO"
Ein Nachmittagskleid aus 1,75 m/140 cm toledo-rotem, reinwollenem Ramain.
Schnitte in den Größen 42, 44, 46 zu DM 2,80

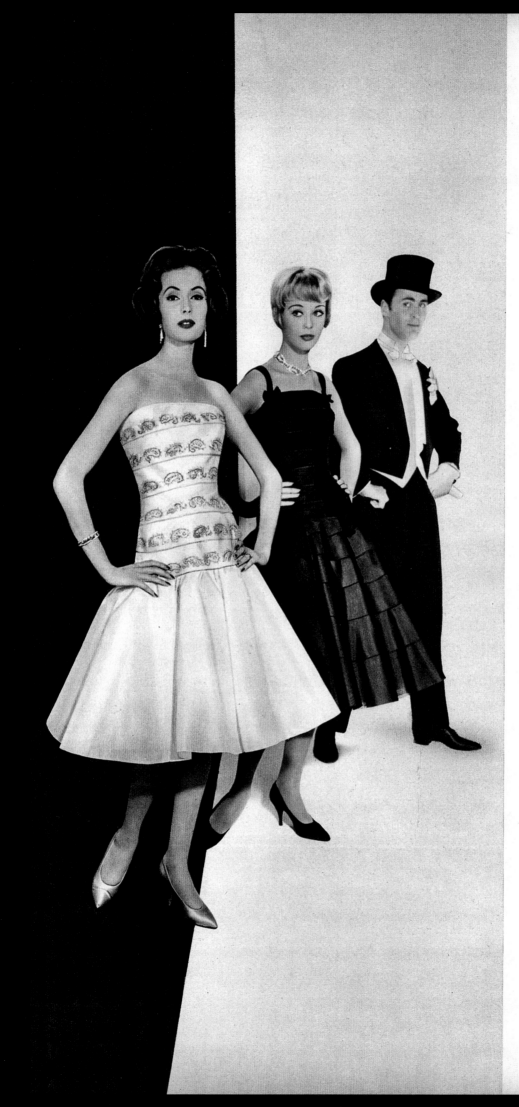

MODE MELODIE IN SCHWARZ UND WEISS

Dieses charmante Trio führt uns Schwarz auf Weiß und Weiß auf Schwarz vor, wie zauberhaft die Wirkung dieser beiden farblosen Farben sein kann, und zugleich, wie jung und anmutig die neuen kurzen Partykleider aussehen. Diese beiden sind im Typ verwandt und auch aus dem gleichen Material – matt schimmerndem Seidenorganza. Das weiße Kleid hat eine aus bestickten Blenden geformte lange Corsage und einen Rock im „Charleston-Stil". Das schwarze Modell besteht aus Blenden, die zum Saum breiter werden. Modelle: Schwichtenberg. (Links)

Im Schatten der eleganten Herrensilhouette im Frack präsentieren sich eine schwarze und eine weiße Dame. Dabei kommt eine sehr charakteristische Tendenz der Abendmode zum Ausdruck – die Vorliebe für den vorn ansteigenden Rock und für schleppenartige Weite im Rücken. Das tiefschwarze Samtkleid links zeigt einen weiten Doppelrock mit bestickten Säumen. Das weiße Shantung-Duchesse-Modell ist ein kurzes, schmales Kleid mit empireartiger bestickter Corsage und graziös geraffter loser Rückenbahn. Modelle: Horn. (Rechte Seite)

Aufnahmen: F. C. Gundlach

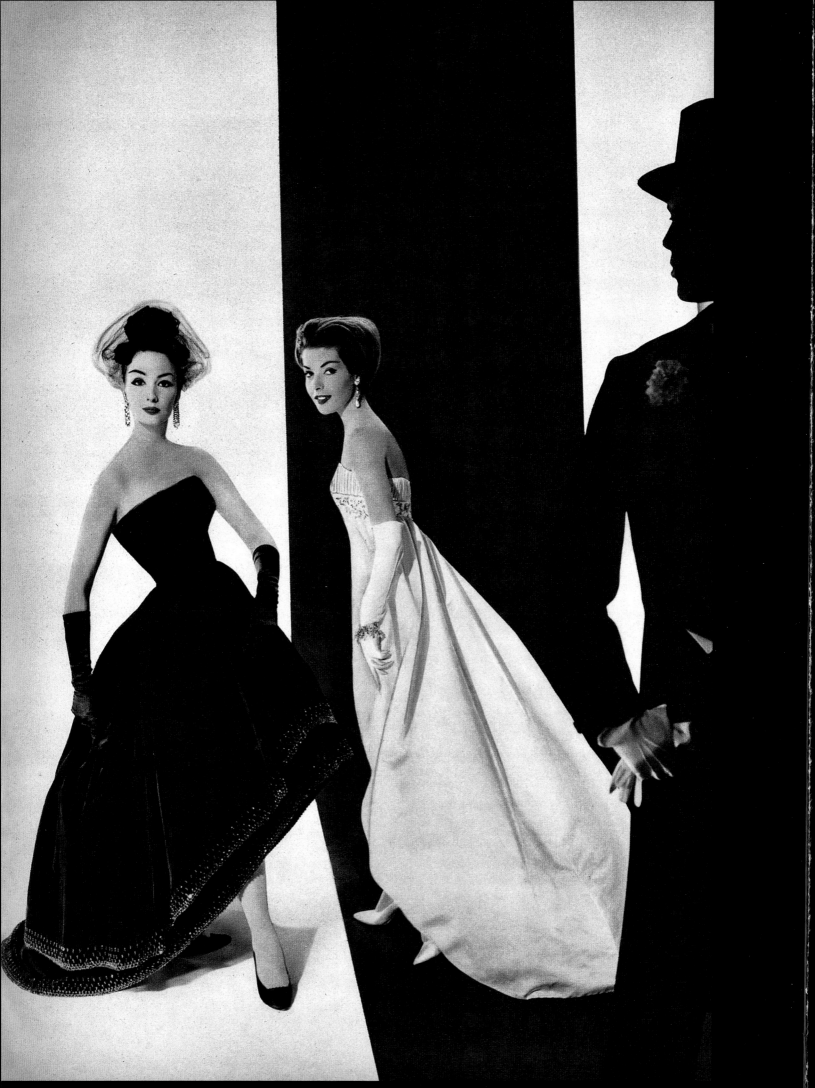

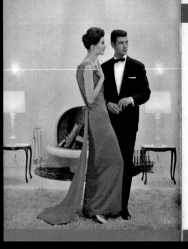

DER TYP BESTIMMT DEN STIL

aktiv, imponierend, selbstbewußt: die Karriere-Frau

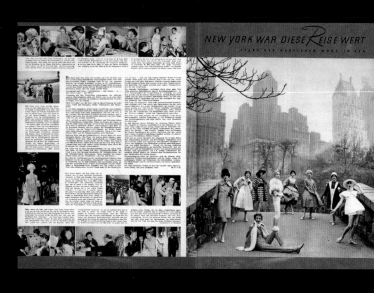

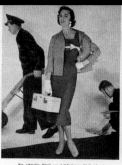
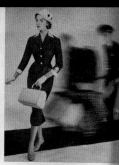

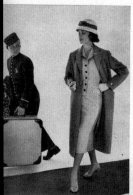

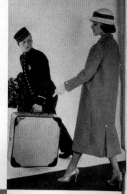

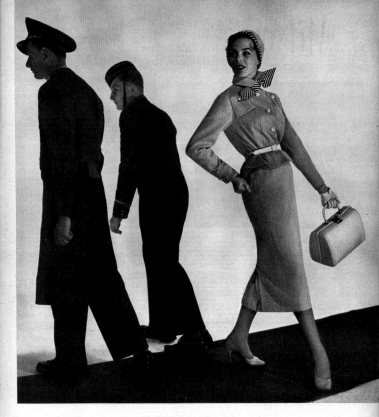

Sie fliegt

NACH ÜBERSEE

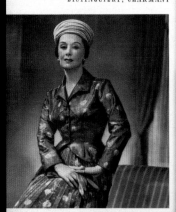
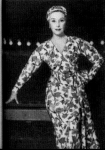

Lil Dagover

DISTINGUIERT, CHARMANT UND SCHÖN

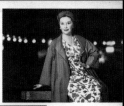

GROSSE KAROS — KLEINE KAROS:

ROT UND

SCHWARZ

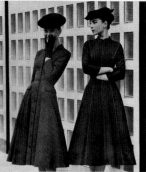

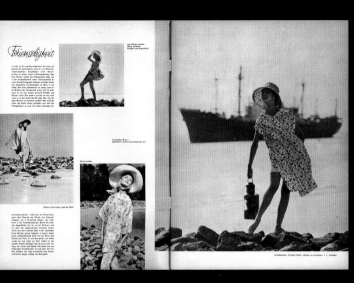

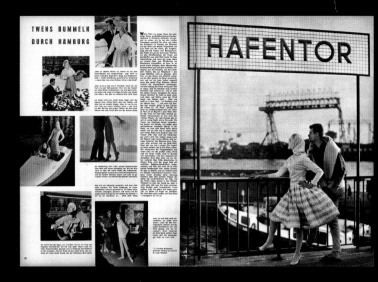

Ferienseligkeit

TWENS BUMMELN
DURCH HAMBURG

HAFENTOR

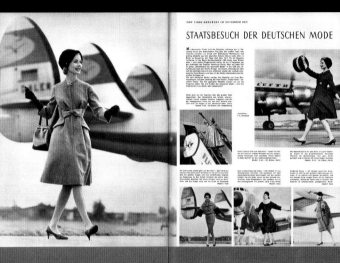

NEW YORK ERWARTET IM NOVEMBER DEN

STAATSBESUCH DER DEUTSCHEN MODE

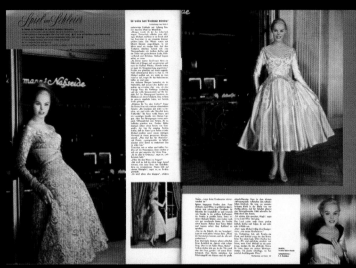

Spiel im Schleier

Modelle: SCHULZE-VARELL ● Farbaufnahmen: F. C. Gundlach

Strandanzug, bestehend aus dreiviertellanger Röhrenhose und asymmetrisch drapierter Tunika

Strandmäntelchen mit Fledermausärmeln und seitlichen Gehschlitzen

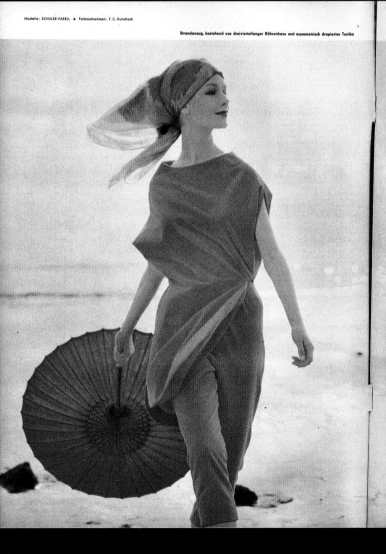

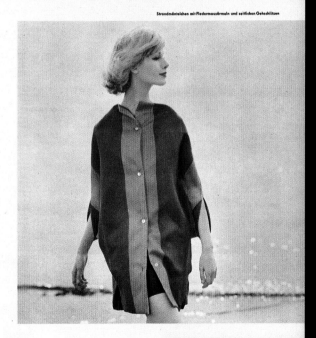

DAME AM STRAND

Das unnennbare Air der Damenhaftigkeit
noch im Strandanzug zu wahren —
für keine Frau ein allzu leichtes Beginnen,
wenn sie sich nicht einem Couturier
von angeborener Courtoisie anvertraut,
der Lösungen wie diese hier für sie findet.
Da schreien die Farben nicht grell gegen Meer, Sand und Himmel an —
da sind sie den sanften Tönungen der Morgenröte,
des Sonnenauf- und -untergangs abgesehen.
Da kommt nie der Eindruck von Entkleidetsein auf —
da ist die Silhouette bei aller Ungezwungenheit
von vollendeter Anmut und Diskretion.
Da wurden Kleider nur sozusagen zurückverwandelt in Gewänder,
und jede Frau, die sie trägt, könnte eine kleine Königin sein.

Zweiteiliger Sonnenanzug — die Träger sind auf dem freien Rücken gekreuzt

7

Humor ist doch die beste Medizin, sagte sich der junge Wiener Irrenarzt Dr. GUNTHER PHILIPP — und ging von der Psychiatrischen Klinik ans Kabarett. Komikernachwuchs ist rar, und das Leben ist viel zu ernst: Gunther Philipp wird es, nach eigenem Originalrezept, mit einer Mischung von Wiener Mutterwitz und Jazzrhythmen aufheitern helfen. In den Filmen „Eva im Paradies" und „Der Mann in der Wanne" hat er schon erfolgreich weiter in dieser Richtung praktiziert ● Aufnahme: Union-Film / F. C. Gundlach

Aufnahmen: F. C. Gundlach

Das sportlich elegante Ensemble

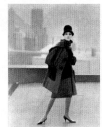

Der weite, im Dior-Stil gaufrierte Kragen eines sacht taillierten Jumperkleides legt sich auch über die gerade, kragenlose Paletotjacke, ein ebenfalls gaufriertes Helmhütchen ergänzt das eigenwillige Reise-Ensemble aus hellblauem Wollpanama (links und unten)

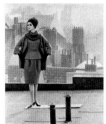

An ersten kühlen Frühlingstagen dominiert das Ensemble mit locker spielendem Jumperkleid und komfortabler Jacke, deren Länge recht variabel ist — manchmal bedeckt sie gerade die Hüften, meist jedoch nähert sie sich dem Kleidsaum. Die schönen, weichen Wollstoffe fügen sich einer schon nicht mehr neuen, doch erst jetzt vollkommen ausgereiften, locker fließenden Linie, einer sehr dekorativen Silhouette mit weicher Schulterrundung, mit vielen interessanten Ärmelformen und manchem überraschenden modischen Detail. Das Grundthema heißt sportliche Eleganz — manchmal wird das Sportliche, manchmal das Damenhaft-Elegante mehr betont, und gerade in diesem Wechsel liegt das Geheimnis des Erfolges. Das Tages-Ensemble kleidet junge Damen wie die reife Frau, es bewährt sich auf Reisen, in der Stadt und bei den vielen inoffiziellen Anlässen. Es besitzt jene Nonchalance, die so sehr en vogue ist, doch es dokumentiert zugleich schneiderische Raffinesse, und es gibt jeder Frau die Gelegenheit, ihre persönliche Note durch gewählte Accessoires zu unterstreichen.

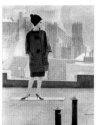
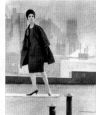

Taschen und Pomponknöpfe aus schwarzem Persianer korrespondieren mit einem Persianerhut. Zu Rock und siebenachtellanger Jacke aus anthrazit-weißem Tweed-Melange wird ein hüftlanger Wolljumper getragen

In locker spielenden Konturen präsentieren sich Kleid und Jacke aus schwarz-weißem Tweed. Die nur halblangen Ärmel lassen lange Lederhandschuhe sehen, Schal und Mütze, aus schwarzer Wolle gestrickt, betonen die sportliche Note . . .

Modelle: Topp & Franck — Modenhaus Alsterdamm — Hüte und Mützen: Topp & Franck, Hamburg

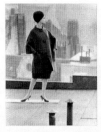
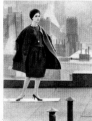

Eine weich gerundete Schulterlinie, schwarze Pomponknöpfe und gesteppte Taschen sind modische Attribute der kragenlosen, bequemen Jacke über einem sportlichen Kleid, beides aus grün-schwarzem Tweed gearbeitet. Dazu eine schwarze Strickmütze

Sehr tief angesetzte, in Falten gelegte Ärmel geben einem Paletot aus kobaltblauem Racine-Jersey die modisch legere Silhouette, das Jumperkleid aus gleichem Material wird nur locker gegürtet — ein Ensemble von sehr damenhaftem, sportlichem Chic!

Anders, als man denkt:

JEAN-LUC GODARD

Vielleicht ist es das Schweizerische in ihm, das ihn, den einunddreißigjährigen Pariser, bisweilen so unwirsch macht: auf einer Pressekonferenz während der letzten Berlinale gab es sich wie in einbockiges Kind und Dinge von sich, die er ganz offensichtlich selber nicht glaubte (etwa daß „Der Tiger von Eschnapur" Fritz Langs bester Film sei und den deutschen Intellektuellen nur der Sinn dafür fehle). Vielleicht aber war solches Verhalten auch die verzweifelte Notwehr eines Übersensitiven gegen die Flut blanker Neugier, die da auf ihn eindrang? Jean-Luc Godard ist keiner, der gern das Plauenrad der Publicity um sich schlägt. Am liebsten versteckt er sich hinter einer dunklen Brille — wie Wicki hinter seinem Bart — und schweigt. Sieht er nicht trotzdem und reden seine Filme nicht übergenug? Brauchen sie etwa eine Erklärung, sei sie noch so schmeichelhaft spitzfindig, feierlich oder frivol? Wie sagt Faulkner, den Ingmar Bergman zitierte, als man ihn nach Zukunftsplänen fragte? „Storys, über die man redet, schreibt man nicht." Nun, Godard schreibt auch im wörtlichen Sinne nicht viel — obwohl er es als Journalist, bei den „Cahiers du Cinéma" in Paris, doch jahrelang von Berufs wegen betrieben hat (nachdem er den düsteren Hörsälen der Sorbonne, gleich nach dem Studium generale, schleunigst entronnen war). Seine Drehbücher wären für einen normalen Produzenten eine beängstigend schmale Kalkulationsbasis. Aber der Produzent, der schon „Außer Atem", dann „Le petit soldat" (seine humoristische Attacke gegen die internationale Spionagearbeit und von der französischen Zensur leider übelgenommen und verboten) und nun „La femme est une femme" finanziert hat, Herr Georges de Beauregard, ist selber ein Ausnahmefall und auf Außerordentliches und Schwieriges (auch Luis Buñuel gehört zu seinen Schützlingen) geradezu versessen. „Wir erfinden die Szenen von Fall zu Fall miteinander", meint Godard, der sich bei der Begegnung zu zweien überaus sympathisch, freundlich und still vergnügt gibt, und er läßt einen seelenruhig glauben, daß seine ganze Filmerei sozusagen ein Spiel unter Freunden sei — ein Jux, den sie sich machen. Aber ist es nicht eben das Spiel, aus dem Kunst ersteht, die Improvisation, die unmittelbare Frische des Einfalls atmet, die schweifende Phantasie, die die eigenwilligste Form gebiert? Godard wird demnach mit seiner Frau Anna Karina, mit der er für „Une femme est une femme" zwei silberne Berliner Bären einheimste, nach New York reisen. Es schwebt ihm da eine Geschichte vor: Anna Karina, dieser süße, graziöse Clown, staunend, lachend, weinend zwischen den Oberdimensionen von Manhattan — auch dem Laien schwant bei dieser Idee allerlei Angenehmes. Und wenn Raoul Coutard, der Mann mit der springenden, tanzenden, rasenden und genüglich verweilenden Kamera, wieder dabei sein wird, kann es ja nicht fehlen. Auch dieser Coutard übrigens entspricht ganz und gar nicht der Vorstellung, die man sich hierzulande leichthin von den kecken jungen Männern des französischen Films macht: er wirkt ungemein bescheiden, fast scheu, und so, als habe er — vielleicht in Indochina, am Kyber-Paß, sein und Truffauts — das jungen Regisseurs von „Sie küßten und sie schlugen ihn" — optische Träume mit der Kamera verwirklichen.)
 G. A.

Stuhl: Dähler, Berlin

Jean-Luc Godard, Schöpfer der preisgekrönten Films „Eine Frau ist eine Frau", Regisseur des im Vorjahr auf der Berlinale gezeigten „Außer Atem", dokumentierte die vielzitierte Neue Welle durch Zurückhaltung. Bescheidenheit und klare, sachliche und saubere Leistung, im Gegensatz zur alten Welle der betriebsamen, großsprecherischen und allzu aufdringlichen „Leute vom Bau"

Im Scheinwerferlicht: DIE XI. BERLINALE

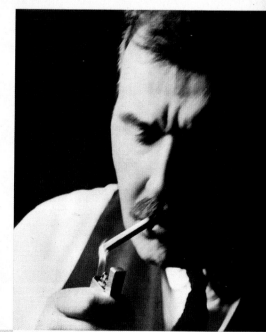

Genauso, wie man sich immer ärgern kann, kann man sich auch ganz natürlich immer freuen. Das gilt ganz besonders für die Internationalen Filmfestspiele in Berlin.
Fährt man unvoreingenommen, heiter und aufgeräumt zu diesem Festival des Films, ohne Muckertum und Sauertöpfigkeit im Gepäck, so ist es nach wie vor, ja, mehr denn je ein glanzvolles Ereignis, das getragen wird von der ehrlichen Arbeit vieler Gutwilliger, die nicht nach Selbstbestätigung streben, sondern ihr Bestes geben: vom Drehbuchautor angefangen, über Regisseure, Kameraleute bis hin zu den Darstellern.
Bernhard Wicki und seine Mannschaft aus dem Film „Das Wunder des Malachias" sind dafür das schönste Beispiel. Tag und Nacht, wochentags und sonntags, stand der Regisseur hinter dem Schneidetisch, um den Film noch bis zur angesetzten Uraufführung in eine befriedigende Fassung zu bringen. Schon die Dreharbeiten hatten die Nerven aller zum Zerreißen angespannt, denn Wicki ist nicht der Mann, der zur Bequemlichkeit den Weg des geringsten Widerstandes geht. Er setzt durch, was ihm allein richtig scheint. Daß es Produzenten fand, die dafür Verständnis zeigen, ist ermutigend, genauso wie es ermutigt, daß er Schauspieler zusammenführte, die seinen Idealismus, seinen Eifer teilen, die sich von ihm mitreißen ließen.
Ein Film ist in 100 Minuten gezeigt. Und wenn er gut ist, wird er zu einer bleibenden Erinnerung, zu einem Traumbild der Phantasie. Aber welche Arbeit, wie viele Sorgen, Aufregungen, welche Gedanken und Planungen an ein solches Werk mit 100 Minuten Spieldauer gewendet werden müssen, wird allzu gern vergessen. Gewiß spielt es für den Film,

wenn er erst einmal im Kino an der nächsten Ecke läuft, keine Rolle mehr. Aber bei Filmfestspielen ist die Arbeit das Wesentliche; denn sie soll hier gewürdigt werden, ihr soll hier in festlichem Rahmen Beifall gezollt werden.
Berlin ist dafür geeignet wie kaum eine zweite Stadt in der Welt. Nicht nur, weil Berlin zu den traditionsreichsten Städten des Films gehört, nicht nur, weil Berlins derzeitige Lage, die Menschen, das Publikum hier aufgeschlossener, interessierter als anderswo macht, nicht nur, weil hier jede erforderliche Kulisse von großen Festsälen und repräsentativen Lichtspielhäusern besteht: es ist die prickelnde Atmosphäre einer lebendigen Weltstadt überhaupt, die das Festival in Berlin rechtfertigt.
Sicher ist es traurig, daß viele deutsche Stars, die ihre Karriere, ihre Popularität

Bernhard Wicki legte auf den Internationalen Berliner Filmfestspielen dieses Jahres Zeugnis dafür ab, daß es weder eine Filmkrise zu geben braucht noch Sorge um den guten Film sein „Wunder des Malachias" ist ein Meisterwerk der Schauspielerführung, der Inszenierung, der Besetzung. Die Festspielfassung wurde erst in allerletzter Minute fertig, sie ist auch nach die endgültige Form: Wicki, vom Ehrgeiz besessen, mit dem „Wunder des Malachias" einen Meilenstein der Filmgeschichte zu schaffen, hat den Film im Schnitt noch verbessern (Bild oben)

Aufnahmen: F. C. Gundlach

Als beste Schauspielerin wurde Anna Karina für ihre Leistung in „Eine Frau ist eine Frau" von der Festspiel-Jury ausgezeichnet. Die junge, quicklebendige, elfenzarte Dänin, die vor ihrer Filmarbeit als Fotomodell gearbeitet hat, hat mit Jean-Luc Godard verheiratet. Feinnervigkeit und Eleganz machen sie ebenso liebenswert wie ihr koboldhafter Sinn für Humor. Bei der Preisverteilung weinte Anna Karina vor Freude . . . (links)

13

Wir sehen hier die noble Haltung aristokratischer Souveränität, deren spröde Kühle Kennzeichen verfeinerter Eleganz ist. Krönung des statuarischen Aufbaus der sorgsam gesetzten Beine, des ausgewogenen Winkelmaßes der Arme und des leicht geneigten Hauptes ist fraglos jene Miene sicherer Überlegenheit, die allein das Bewußtsein schenkt, korrekt gekleidet, modisch up to date zu sein ...

Herausfordernde Wirklichkeitsnähe, aggressive Frische und belebende Spannkraft dieser Gebärde liegen schon in der fließenden Bogenlinie, die von der Schulter über die Hüfte zum weit herausgestellten Fuß gleichsam wie das Rund der straff gespannten Waffe Tells die Stellung skizziert. Der Kontrapunkt der Komposition: die fast gerade Linie Schulter-Hüfte-Fuß auf der anderen Seite

Schmetterlingshaft beschwingt, ganz und gar Ausdruck beglückenden Frohsinns und jugendlicher Unbefangenheit (schönster Schmuck jeder Frau!), so bietet sich dieses Beispiel dar. Sinkt die eine Hand vom Abschiedwinken nieder, so greift die andere doch schon zum Gruße vorwärts: wahrhaftig in diesem tiefen Sinn Gleichnis unseres Lebens in seinem Wandel zwischen Kommen und Gehen

Die Rhythmik elastisch federnder Schritte, die Musikalität anmutigen Ganges, die feine Illusion tänzerisch leichter Bewegung besticht bei dieser Pose, an der nichts Gewolltes störend den Sinn verwirrt. Die Unmittelbarkeit des Eindrucks wird noch dadurch erhöht, daß das Antlitz sich nicht bedrückt zu Boden senkt, sondern, in freier Würde dem Licht zugewandt, Spiegel freudiger Empfindung ist

Kecke Gesundheit strahlt diese Gebärde aus: wie die Plastik einer sieghaften Diskuswerferin, eines in der Arena triumphierenden Zweikämpfers bezaubert die Gestalt in ihrem gelösten Hochgefühl, Bewunderung erweckend und entgegennehmend. Der sichere Stand der Beine vermittelt den Eindruck lebensnahen Tatmenschentums: alles in allem eine Pose, die sportlichen Schöpfungen angemessen ist

Ungewöhnlicher Reiz geht von der fast technisch zu nennender Klarheit des Aufbaus und der Gestaltung aus, mit der die Schlichtheit dieser Figur in wenigen kühnen Strichen entworfen wurde. Kargheit der Gestik verinnerlicht das Gesamtbildnis, wirkt läuternd in dem Wust des Gewohnten und Routinehaften, mit dem die Modefotografie oft zu kämpfen hat. Eine überzeugend moderne Haltung!

Von Freimut künden der offene Gang, das erhobene Haupt, der weitausgreifende Schritt und die schwungvoll bewegten Arme. Wohltuend sachlich, unkompliziert, einem optimistischen Zukunftsglauben zugetan, so stellt sich das Schrittbildnis eines modebewußten Fotomodells vor. Alles schnöd Zaghafte ist verbannt, fundiertes Selbstbewußtsein gibt der Körperhaltung flirrende Anmut

Das erhebende, erleichternde Gefühl des Wohlbefindens – wer hätte es nicht beim Anblick der Pose, die von Bequemlichkeit, lustvoller Leichtigkeit kündet? Die modische Kreation als Hülle wird zum Federkleid der Lerche, träumerisches, widerstandsloses Schweben deutet sich an. Jugend ist Trunkenheit ohne Wein, sagt der Dichter. In seinem Sinne ist diese Gebärde Symbol der Jugend

Elfengleiches Dahingleiten gibt der Pose die Schwerelosigkeit einer Sylphidensymphonie. Deuten die sanft markierenden Hände die Richtung an, so verleiht das ausgestellte, erhöhte Bein der Figur den schönen, zauberisch leichten Schwung, dessen belebende Wirkung in der Komposition fast körperlich spürbar ist. Dennoch: ein stiller Hauch der Wehmut verklärt die Haltung liebenswürdig

ÜBER DIE KUNST, MODISCH ZU POSIEREN

Wir wählten als Demonstranten einen Herrn, dessen Betrachten jegliche Assoziation an die Reize weiblicher Schönheit verbietet, um so die Gebärden der Anmut wirkungsvoller in den Vordergrund zu rücken. Bewußt verzichteten wir auch auf Attribute modischer Zier bei der Demonstration, damit die Aufmerksamkeit des Betrachters ausschließlich dem Wesentlichen, der Gebärde und Haltung, zugeneigt bleibt.

Im Mittelpunkt aller Bemühungen um die Anmut der Erscheinung muß die zuchtvolle Beherrschung des Körpers stehen. Nicht schludrige Formlosigkeit von Gang und Stand – allzuoft von Unverständigen mit Natürlichkeit verwechselt – gewährt volle Befriedigung des Anblicks. Nein, nur das straffe Diktat des Willens über jeden Nerv, jede Sehne, jeden Muskel allein kann den Weg zur Vollkommenheit ebnen.

Was aber bedeutet Vollkommenheit? Zweierlei gilt es da zu beachten: einmal muß die Harmonie von Modell und Modell gegeben sein; das heißt vom Modell der Robe, des Complets, des Ensembles (oder was immer sonst es gerade vorzuführen gilt) und dem Fotomodell, dem anmutvollen weiblichen Wesen. Ein Badeanzug etwa – um als Beispiel die luftigste Kreation der Mode zu wählen – sollte mit jener statuarischen Grandezza gezeigt werden, mit der ein Praxiteles oder Phidias seine steinernen und doch so belebten Figuren zu gestalten wußte, über deren marmorne Blöße der keusche Blick hinweggeht, um vom Ideal des Ausdrucks gefesselt zu werden. Ein Pelzmantel – um den diametralen Gegensatz künstlerischer Modegestaltung ebenfalls nicht außer acht zu lassen – verlangt eine andere Auffassung des Haltungsbegriffs. Hier ist tierhafter Sinn vonnöten, das Erspüren, das Erahnen der Bewegungsrhythmik jener vierfüßigen Freunde der Mode, die das kostbare Material des Pelzwerks lieferten. Sei es das zarte Gelock eines Karakullämmleins, der seidige Hauch eines Nerzes oder die wattegleiche Schmeichelei des Pelzes unseres schönsten Edelnagers, des Bibers – immer wird beim Vorführen der Preziosen aus dem Reich der Rauchwaren ein wenig von dem verlangt, was auch den natürlichen Träger zu seinen Lebzeiten auszeichnete: Geschmeidigkeit, elegante Grazie oder Freude an freiheitlicher Bewegung.

Vollkommenheit indes bedeutet noch etwas anderes: Bewegung in der Erstarrung. Das mag widersinnig klingen, ist's aber nicht. Denn das Foto hält einen kurzen Moment nur fest, bei guter Beleuchtung oft nur ein Tausendstel einer Sekunde, eine flüchtige, verwehte Partikel des Daseins. In diesem – fast scheut man sich, das Wort zu benutzen, weil es einen viel zu langen Zeitraum zu begrenzen scheint – in diesem – nun, sei's drum – in diesem Augenblick also muß die berufene Jüngerin der Mode nicht nur, wie schon erwähnt, ihre beherrschte Anmut, sondern auch die Koordination ihres Wesens mit der Schöpfung des Couturiers hineininterpretieren.

Genug der Vorrede. Nur das gute Beispiel kann überzeugen. Daher sind Sie eingeladen, Ihren Blick für das Bestimmende in der hohen Kunst des modischen Posierens an unserer Galerie ausgewählter, ja erlesener Bilder zu schärfen und zu schulen.

Impulsive Freude, Frische ermutigender Weltläufigkeit, Großzügigkeit und selbstverständliches Meistern des grauen Alltags – all das liegt in dieser Gebärde gelassener Herzlichkeit. Und außerdem ein solides Quantum an Sinn für Humor. Ganz in diesem Sinn wünschen durchaus ernsthaft sowohl der Demonstrant als auch die Redaktion allen Leserinnen und Lesern ein erfreuliches 1961

Ihre „Film und Frau"

Für die Galerie der modisch überzeugenden Posen stellte sich liebenswürdigerweise Herr Rudolf Platte zur Verfügung. Die Regie lag – wie die Aufnahme der Beispiele – in der Hand von Herrn F. C. Gundlach. Die erklärenden Worte besorgte F. C. Piepenburg

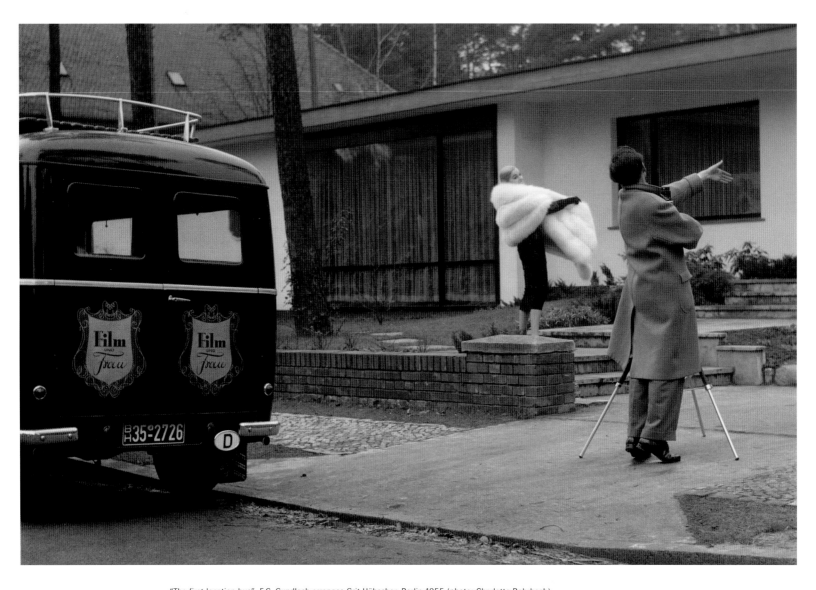

"The first location bus", F.C. Gundlach arranges Grit Hübscher, Berlin 1955 (photo: Charlotte Rohrbach)

previous spread: "Rudolf Platte: On the art of posing in style", *Film und Frau* 26/1960

In the person of Helga Waldenburger, F.C. Gundlach met an imaginative designer who knew a thing or two about photography. She was admittedly not of the same calibre as particularly the art directors from the United States, yet she really did justice to the serial, at times even cinematic character of F.C. Gundlach's pictures. What springs to mind here is Rudolf Platte's parody on "the art of posing fashionably", a spontaneous and very joyful piece performed in between scenes – while Platte's partner was getting changed.[50] Or "Zweikämpfe mit dem Florett"[51] (duel with floret) or "Mädchen in Weiß auf rotem Feld"[52] (girl in white on a red field), two features from the world of sport that in their layout seem a continuation of 19th century chronophotography. It was unusual for models to be photographed without background, such as in "Mädchen, Männer, rasende

Räder ..."[53] (girls, men, spinning wheels). Rather, standard design with playful variations made for full-spread leads (predominantly on the right-hand side) that were combined with smaller motifs from the series and ever-changing headings, drawn by Friedrich Dreyer.[54] Often, and unusual for the time, full-page bleed photographs were used which gave a special presence to the motifs. Rarely did photographs run across the fold, as shown in the lavishly designed feature "Die Modelinie" (the fashion line), featuring models from agencies Staebe-Seger and Elise Topell, and models Püppi and Schlippi.[55] Berlin, as so often, served as the setting, more specifically, the still existing northern bend of the Avus and the bleak postwar *Straße des 17. Juni* (named thus in 1953), which were skilfully pushed into the background by the transverse elegance of gleaming chrome automobiles.

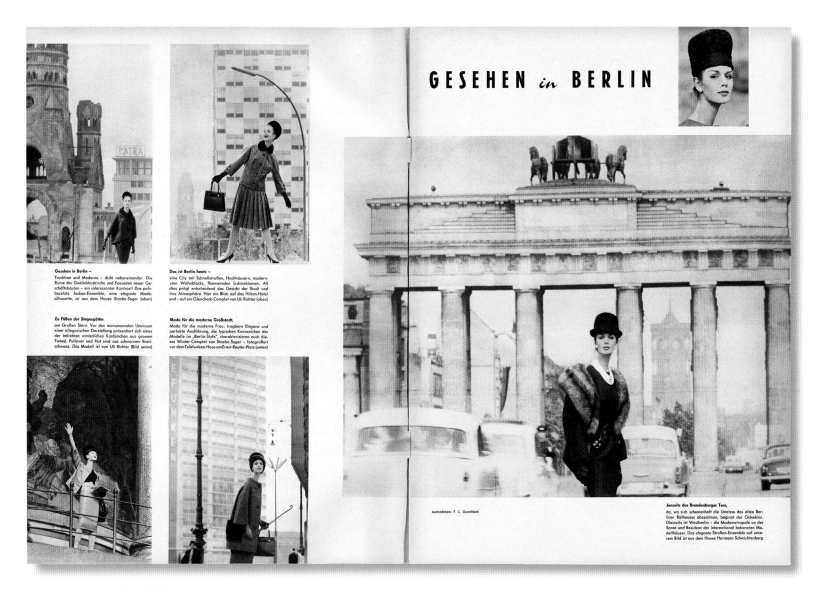

Gesehen in Berlin –
Tradition und Moderne – dicht nebeneinander. Die Ruine der Gedächtniskirche und Fassaden neuer Geschäftsbauten – ein interessanter Kontrast! Das pelzbesetzte Jacken-Ensemble, eine elegante Modesilhouette, ist aus dem Hause Staebe-Seger (oben)

Zu Füßen der Siegesgöttin
am Großen Stern. Vor den monumentalen Umrissen einer allegorischen Darstellung präsentiert sich eines der beliebten winterlichen Kostümchen aus grauem Tweed. Pullover und Hut sind aus schwarzem Breitschwanz. Das Modell ist von Uli Richter (Bild unten)

Das ist Berlin heute –
eine City mit Schnellstraßen, Hochhäusern, modernsten Wohnblocks, flimmernden Lichtreklamen. All dies prägt entscheidend das Gesicht der Stadt und ihre Atmosphäre. Hier ein Blick auf das Hilton-Hotel und – auf ein Glencheck-Complet von Uli Richter (oben)

Mode für die moderne Großstadt.
Mode für die moderne Frau: tragbare Eleganz und perfekte Ausführung, die typischen Kennzeichen der Modelle im „Berlin-Style", charakterisieren auch dieses Winter-Complet von Staebe-Seger – fotografiert vor dem Telefunken-Haus am Ernst-Reuter-Platz (unten)

Aufnahmen: F. C. Gundlach

Jenseits des Brandenburger Tors,
da, wo sich schemenhaft die Umrisse des alten Berliner Rathauses abzeichnen, beginnt der Ostsektor. Diesseits ist Westberlin – die Modemetropole an der Spree und Residenz der international bekannten Modellhäuser. Das elegante Straßen-Ensemble auf unserem Bild ist aus dem Hause Hermann Schwichtenberg

"Seen in Berlin", *Film und Frau* 3/1961

Unlike their peers from the United States, West German fashion photographers had to portray fashion in an environment marked by war and destruction – it was part of their daily business. There was no explicit "ban" on showing ruins, as F.C. Gundlach remembers, rather it was tacitly agreed to leave out the ugly scars of recent history, which is why monuments such as the Brandenburg Gate, the Victory Column, the Congress Hall, the Memorial Church (perceived not so much as a ruin but a symbol) or the Olympia Stadium made for suitable locations. The dialog between fashion and architecture works almost as a leitmotif in F.C. Gundlach's early fashion photography – with architecture spanning a colourful mix of historical structures, future-embracing new buildings (such as the Hilton in Berlin) and graffiti-clad walls in the Berlin district of Kreuzberg.

The working conditions on set stood in stark contrast to the glamour radiated by *Film und Frau* – demanding of F.C. Gundlach improvisation skills, resourcefulness and the ability to think on his feet. "We were the poor," says the photographer who has kept the Paris appearances of the young Richard Avedon in good memory.[56] If Gundlach booked a taxi to take his model to a suitable location for the shoot, Avedon had hired an entire bus. The girls did their own hair, and there was no sign of stylists or make-up artists. Gundlach compensated for the shortcomings by using his imagination. The same applies to his later studio work. To give an example: When there were no props to be found in Charlotte Rohrbach's Berlin studio, the photographer simply resorted to the photographic equipment available, namely lamps and tripods. Not only do they give a

next spread: "The fashion line", *Film und Frau* spring/summer 1956

Die Modelinie

Ganz offensichtlich
tendiert die Haute Couture der ganzen Welt immer mehr dahin,
weniger mit einer allgemein verbindlichen
und in jeder Saison atemraubend neuen Linie zu überraschen,
als von Fall zu Fall die einzelne Frau ihrem Typ gemäß
und jederzeit zweckentsprechend anzuziehen.
Das führt zu einer Vielfalt und Freiheit der Auswahl,
von der die meisten unter uns sehr beglückt sind.
Aber so etwas kommt nicht von ungefähr.
Wir selbst sind im Grunde die Urheber dieser Entwicklung.
Mode ist ja keine Erscheinung, die in und für sich existiert.
Sie spiegelt das unausgesprochene Wollen der Frau jeder Epoche,
auf das die Couturiers besonders feinnervig – wie Antennen auf Schwingungen – reagieren.
Seit geraumer Zeit also spüren sie:
die Frau will nicht mehr nur gefallen, sie will sich vor allem in ihrer Haut –
und im Bereich der Zivilisation ist das Kleid ein Teil von ihr –
wohl, aktionsfähig und sicher fühlen.
Denn das Leben trägt sie ja gewissermaßen nicht immer auf Händen,
es fordert von ihr Entscheidungen,
rückt sie rücksichtslos in den Blickpunkt der Öffentlichkeit,
rangiert sie ein, ohne ihr eine Sonderstellung zu gewähren – kurz,
es verlangt nicht in erster Linie ihren Charme, sondern ihre Persönlichkeit.

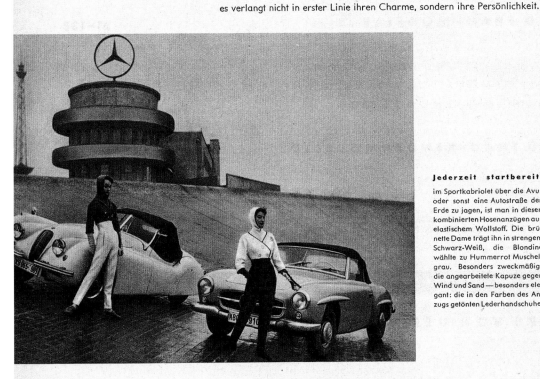

Jederzeit startbereit,
im Sportkabriolet über die Avus
oder sonst eine Autostraße der
Erde zu jagen, ist man in diesen
kombinierten Hosenanzügen aus
elastischem Wollstoff. Die brü-
nette Dame trägt ihn in strengem
Schwarz-Weiß, die Blondine
wählte zu Hummerrot Muschel-
grau. Besonders zweckmäßig:
die angearbeitete Kapuze gegen
Wind und Sand – besonders ele-
gant: die in den Farben des An-
zugs getönten Lederhandschuhe.

Beides ins rechte Licht zu stellen, das liebenswert Weibliche nicht zu verleugnen
und doch der Frau ein beschwingendes Gefühl von Unabhängigkeit zu geben –
das ist ein Rezept, an dem die Mode lange herumdestilliert hat,
und gerade in dieser Saison ist es ihr, scheint uns, vollendet gelungen.
Wir werden nicht mehr gezwungen, Sklavinnen der modischen Tageszeiten zu sein –
die Gelegenheit, der Anlaß, wir selbst bestimmen die Linie.
Diese Linie bewegt sich innerhalb eines gegebenen Umrisses,
der an sich nichts Extravagantes hat, aber gerade daher Variationen in Fülle ermöglicht.
Das Spiel der Nuancen – sehr feiner Nuancen – ist in unsere Hand gegeben.
Es scheint ganz einfach, doch verlangt es einen sicheren Blick für Wesen und Wirkung.

Modelle: Staebe-Seger · Aufnahmen: F. C. Gundlach

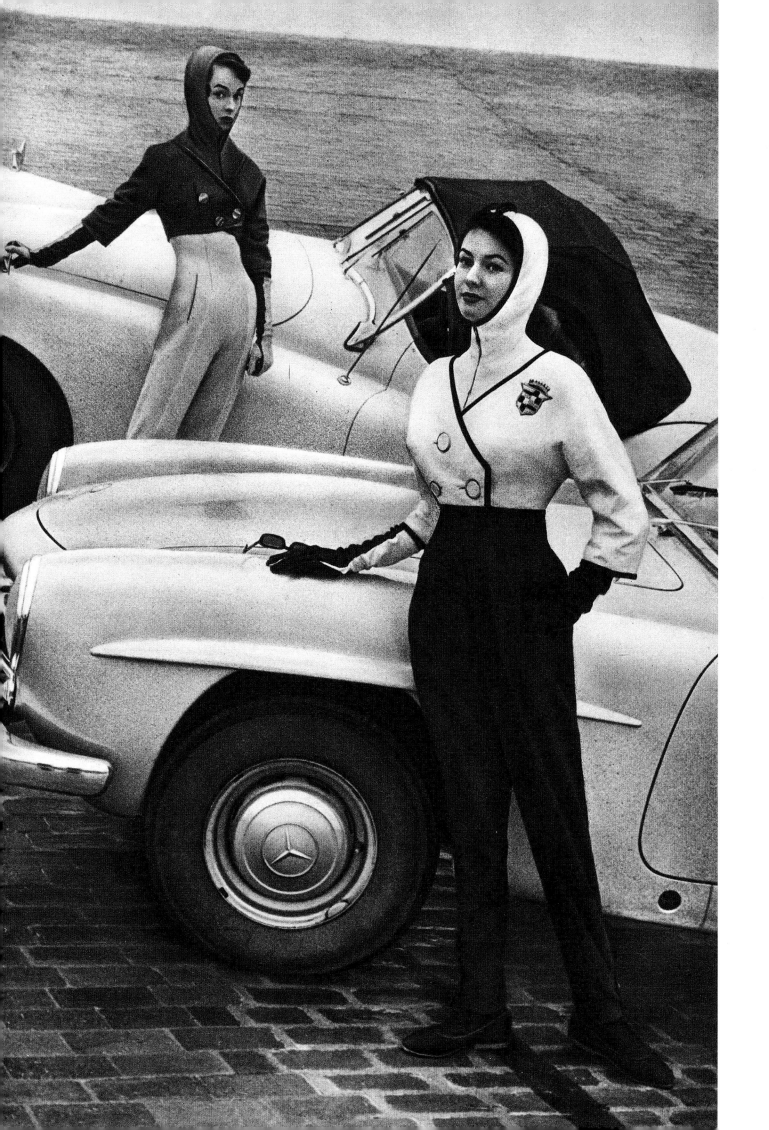

Falke Fashion

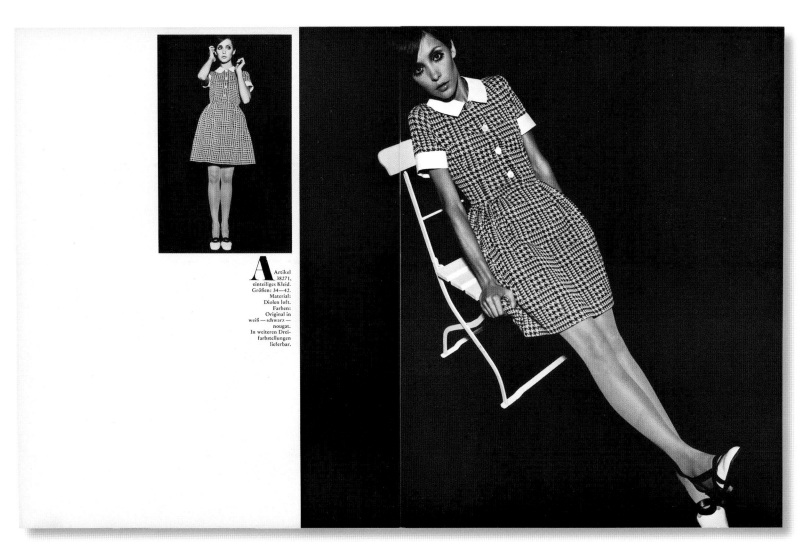

Artikel 38271, einteiliges Kleid. Größen: 34—42. Material: Diolen loft. Farben: Original in weiß — schwarz — nougat. In weiteren Dreifarbstellungen lieferbar.

Falke Fashion 1969/70

wonderful filigree structure to the pictorial space, they also draw attention on the medium itself.[57] From the mid-1950s, work was increasingly moved to the studio. This meant that photo shoots were no longer dependent on the weather and could be done at night – a crucial advantage given the time pressure imposed by the Haute Couture. In Paris F.C. Gundlach was able to use a rented studio initially set up by "Picto" founder Pierre Gassmann,[58] at first on Rue de la Comète 17, subsequently at Montparnasse (Rue Delambre), often with Regina Relang doing her own work on the floor below.[59] Studio shots depicting the creative fashion that had come out of the recently established fashion studios in Berlin were mainly done on Kurfürstendamm 213 (on the corner of Uhlandstrasse). The *Film und Frau* editorial team had owned a studio on the building's mezzanine floor since 1958. During the annual film festival these upper-class premises typically served as the set for the photographic series "film stars in fashion". The concept was part of the special, even typical, services offered by the magazine and perhaps came closest to fulfilling the promises made on its cover.

There is far more to F.C. Gundlach's work for Lufthansa, still a young company at the time, than fits an anecdote. It began with a job commission from *Stern* magazine and involved a feature on the first transatlantic flight of the re-established airline scheduled for June 1955.[60] What was originally intended as a (albeit never realized) reportage, became under Gundlach's guidance the perfectly staged ground show, with booked models, professional lighting and final results that impressed the Board of Lufthansa, and many others besides. As a result, Gundlach was appointed the company's unofficial "house photographer". He was responsible for communicating the visual image of the up-and-coming corporation, photographing for advertising material and brochures

next spread: *Conrad Jung & Co* 1962

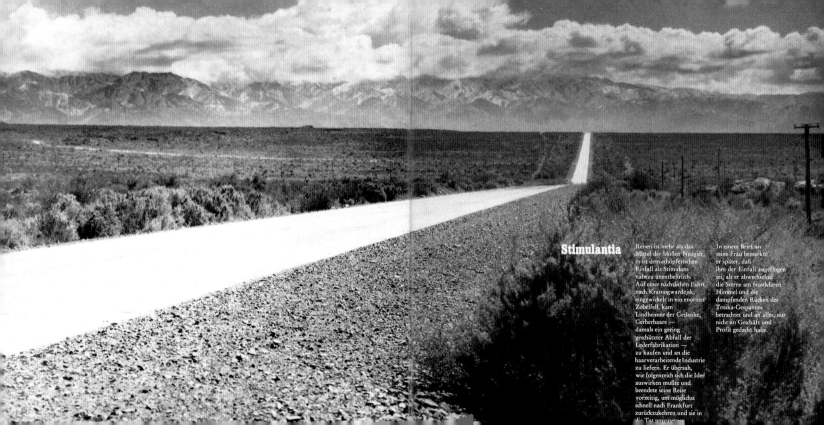

Stimulantia

Reisen ist mehr als das Mittel der bloßen Neugier; es ist dem schöpferischen Einfall als Stimulans nahezu unentbehrlich. Auf einer nächtlichen Fahrt nach Krasnogwardejsk, eingewickelt in ein enormes Zobelfell, kam Lindheimer der Gedanke, Gerberhaare — damals ein gering geschätzter Abfall der Lederfabrikation — zu kaufen und an die haarverarbeitende Industrie zu liefern. Er übersah, wie folgenreich sich die Idee auswirken mußte und beendete seine Reise vorzeitig, um möglichst schnell nach Frankfurt zurückzukehren und sie in die Tat umzusetzen.

In einem Brief an seine Frau bemerkte er später, daß ihm der Einfall zugeflogen sei, als er abwechselnd die Sterne am frostklaren Himmel und die dampfenden Rücken des Troika-Gespannes betrachtet und an alles, nur nicht an Geschäft und Profit gedacht habe.

ALTE SPUREN DER MODERNE

1958 münden die
Reiserouten des
Unternehmens in den
traditionellen
Einkaufsrevieren
Ostasiens. Das einstige
Handelsvolumen hat
sich vervielfacht.
Auf den Spuren
Lindheimers führen die
Wege nach Indien,
Japan, China und in die
ferne Messestadt
Kanton.

Im Garten Gethsemane lustwandelt Mr. G. Unter einem Ölbaum hält er inne. Guten Tag, Ölbaum, sagt er. Wie ist das werte Befinden? Sie sind sehr höflich, sagt der Ölbaum. Das ist so meine Art, sagt Mr. G. Übrigens vergaß ich, mich vorzustellen, verzeihen Sie. Oh bitte, unterbricht ihn der Ölbaum, Ihr Name ist unwichtig. Wenn ich nicht irre, sind Sie ein Mensch. Allerdings, erwidert Mr. G. Und Sie werden mir zugeben, daß dieser Umstand die Würde Ihres Alters mehrfach aufwiegt. Was das Alter betrifft, so mögen Sie recht haben, sagt der Ölbaum, denn ich zähle erst zweitausend Jahre. Aber die Würde . . . ? Ich möchte Sie beileibe nicht kränken, verehrter Ölbaum, sagt Mr. G. - doch es ist erwiesen, daß der Mensch an der Spitze einer Entwicklung steht, in der Ihresgleichen ziemlich den Anfang bildet. Eine eitle Hierarchie, lieber Herr, sagt der Ölbaum. Gestern standen unter meinen Ästen zwei junge Männer. Ich sah an meiner faltigen Rinde hinunter und beneidete sie um ihre glatte Gestalt. Soweit es sich erkennen ließ, hatte Praxiteles ihren Entwurf geliefert. Anfangs redeten sie recht gescheit und benahmen sich manierlich. Doch dann fingen sie an, über mein Alter zu streiten. Ein nichtiger Anlaß zum Disput, wie mir scheint. Aber sie suchten und fanden ihn wie alle Menschen, wenn sie nur wollen, und sie wollen immer. Bald schlugen sie mit den Fäusten aufeinander los. Ihre ebenmäßigen Gesichter bluteten und sahen ungemein vulgär aus. Als dem einen das Nasenbein gebrochen und dem anderen ein Auge zugeschwollen war, einigten sie sich auf eine Schätzung von siebenhundert Jahren. Zweitausend, meine Herren, warf ich ein. Halt's Maul, riefen sie zurück und gingen davon. Schönheit und Würde hatten sehr gelitten. Haben Sie jemals Bäume sich verprügeln gesehen, lieber Herr? Natürlich nicht, sagt Mr. G. Aber hätten Sie Ihrer frühen Erinnerung - um gerecht zu sein - nicht doch ein vorteilhafteres Beispiel für das Bild vom Menschen entnehmen sollen? Ich weiß schon, was Sie meinen, sagt der Ölbaum. Doch ich war damals erst dreiundsiebzig Jahre alt. Sie werden verstehen, daß mir die Sache nicht mehr genau im Gedächtnis ist. Und sagen Sie selbst, mein Herr: Hat das Beispiel wirklich soviel Schule gemacht? Ihre Rinde, lieber Ölbaum, ist von eigenartiger Schönheit, bemerkt Mr. G. und nimmt sich vor, alle Bäume dieser Welt in Zukunft höflich zu grüßen.

Mr. G. schnallt sich an. Aeroplan zu neuen Ufern, aero, aero plan. Aeroschraube eins dreht sich träge. Irgendwo aus dem Aeromotor paßt ein Qualmfähnchen, und Schraube eins surrt glitzernd im Aerokreis. Schraube zwei, Schraube drei, Schraube vier. Draußen wird es aerolaut sein. Der Kommandant wünscht einen guten Flug. Mr. G. wünscht es auch. Die Stewardeß verteilt Vitaminbonbons und Fröhlichkeit. Ein Mannequin der Technik, kommt es Mr. G. in den Sinn. Ob der Pilot einen Looping beabsichtige, will Mr. G. wissen. Das Mannequin verneint. Dann sei das Anschnallen wohl überflüssig, meint Mr. G. Eine Sicherheitsvorschrift, sagt das Mannequin. Ob der Start mißlingen werde, erkundigt sich Mr. G. Ausgeschlossen, sagt das Mannequin. Dann werde ich mich abschnallen, beschließt Mr. G. Bitte nicht, sagt das Mannequin. Warum nicht, wundert sich Mr. G., wenn ein Mißlingen ausgeschlossen ist? Es ist nahezu unmöglich, verkündet der Engel und entschwebt. Aha, sagt Mr. G. Die Maschine rollt. Langsam wie ein Güterzug. Die Tragflächen vibrieren. Stoppt am Startpunkt. Holt Atem, tief Atem. Frei. Mr. G. spürt die Rückenlehne. Die Passagiere überbieten sich an Gleichmut. Die Piste wird streifig. Ein Herr blättert in der Financial Times. Die Motoren geben ihr Bestes. Die Piste wird samtweich. Mr. G. spürt das Sitzpolster. Die Piste entfernt sich. Schrebergärten, Mietskasernen, Stadtviertel, ein schräger Horizont. Es ist gelungen, und Mr. G. wundert sich. Er fliegt nicht das erstemal. Oh nein. Aber er ist so altmodisch, sich zu wundern. Jedesmal aufs neue. Von oben sehen Weiden und Wälder überall gleich aus. Fast gleich. Mr. G. späht nach Schlagbäumen, rot-weiß-, grün-weiß-, schwarz-weißgestreiten Schlagbäumen. Doch er sieht keine. Er bemüht sich vergeblich, die Nationalität der Wellen auf dem Meer auszumachen und die Staatsangehörigkeit von Wolken und Eisschollen zu erraten. Der Herr nebenan blättert immer noch in der Financial Times. Da unten auf den Weiden, in den Schrebergärten, Mietskasernen, Wäldern, auf dem Wasser und den Eisschollen leben Menschen; weiße, dunkelhäutige, schlitzäugige, satte und hungrige, lieben sich wenig und bauen Kanonen. Und Mr. G. begreift es von oben nicht besser als unten, warum sie das tun, und ist so fortschrittlich, sich zu wundern. Jedesmal aufs neue.

aspekte 60
previous spread: *aspekte 60*

for many years. Since 1962/63, he worked within the new, strictly modern corporate image developed by a team from Ulm University of Design, including Otl Aicher, Hans Roericht, Tomás Gonda, Fritz Querengässer, and Hans G. Conrad.[61] Gundlach was paid by way of free flights upon his own request. "It simply meant that I got to go to New York far more often," the photographer explains. And beyond: For him, the world – at least as far as it concerned Lufthansa destinations – was coming within reach. This happened at a time when many a German's wanderlust necessarily ended in the Bavarian Alps. In New York, Gundlach was introduced to Eileen Ford, founder of the first-ever model agency in 1946. His portrayal of Richard Avedon at work culminated in a series published in *Film und Frau* and emphasized Gundlach's continued interest in the work of his international peers.[62] The fact that they had agents to represent

them was for Gundlach as surprising as it was plausible. Gundlach can potentially be regarded as the first German photographer to embrace this model, something that – though at first belittled by those around him – allowed him to focus on the real work. Likewise, Gundlach was unorthodox in the choice of his Hamburg studio, preferring function over beautiful appearances. The Hamburg bunker from World War II, at first glance a wholly uninviting place that even carried negative connotations, soon became a sought-after address for fashion photographers from Germany, Austria and Switzerland.

Illustrated above has been the institutionalized background, as it were, for his work in fashion that since his Stuttgart days had become consistently more professional and by far outreached the editorial in *Film und Frau*. Old-established textile manufacturers or fashion labels of international rank, in-

Mr. G. steht vor dem Spiegel. Wirst du jemals ein seriöser Mensch werden, lieber G.? Es sieht nicht so aus, bester G.-zissus, sagt Mr. G. aus dem Spiegel zu Mr. G. Die Arbeit ist mir heute widerlich, sagt Mr. G. zu seinem Schreibtisch. Erzähl' mir gefälligst etwas neues, sagt der Schreibtisch zu Mr. G. Ihr seid wenig galant, meine Freunde, ich werde also Roman besuchen; das hatte ich schon lange vor, sagt Mr. G. und schließt die Haustüre hinter sich. Auf der Straße wartet eine blaßblaue Wolke. Er nimmt Platz, nennt die Adresse, und die Wolke setzt sich in Bewegung. In eiligen Fällen zieht Mr. G. die dunkelblauen Wolken vor, die bekanntlich schneller sind. Wenn man dagegen Zeit genug hat, sollte man sich eine hellblaue leisten. Es reist sich komfortabler und genußreicher. Roman war Mr. G.'s Schulbanknachbar auf der Untersekunda. Vor zwanzig Jahren. Ein Ausbund an nichtsnutzigen Einfällen, ein lustiges Haus und bis zur Prima zu einer Art von minderjährigem Bonvivant herangereift. Nicht zuletzt sein weltgewandter Umgang mit den höheren Töchtern des benachbarten Lyzeums verschaffte ihm die Bewunderung seiner Gefährten, deren Versuche, ihm nachzueifern, Parodien blieben. Bevor die hellblaue Wolke sich niedersenkt, kreist sie über dem Schulhof eines Lyzeums, das der Behausung von Roman genau gegenüberliegt. Dies dürfte kein Zufall sein, denkt Mr. G. und ist in den Anblick des Liebreiz-bevölkerten Platzes so versunken, daß er nicht bemerkt, wie die Wolke sanft aufpuft und ihn vor einem Entree mit Messingschild entläßt. Hallo, bist du es, lieber G.? Mr. G. dreht sich sich um. Hallo, Roman, ja ich bin's. Zwanzig Jahre seit damals, aber ich bin's. Tritt ein, lieber G. und trenn dich von diesem Bild der Verwahrlosung, sagt Roman. Es ist, teurer Roman, doch nicht der Hof des Lyzeums, von dem du solchermaßen redest? sagt Mr. G. Derselbe, sagt Roman. Aber darf ich dich erinnern, lieber Roman, beginnt Mr. G. ... Nicht nötig, mein Bester, sagt Roman. Ich erinnere mich recht wohl und verzeichne mit Abscheu, daß die Grazie unseres jugendlichen Überschwanges von dereinst dem bloßen Laster und der Dekadenz, kurz, der Verderbnis aller Sitten gewichen ist! Grundgütiger Himmel, möchtest du dich nicht entsinnen, lieber Roman, daß du dich just der Worte bedienst, die dein Vater (Gott hab ihn selig) auf den Lebenswandel seines Sohnes bezog! Genau die gleichen Worte, nur zu anderer Zeit, sagt Mr. G. Stimmt, lieber G., sagt Roman, es war freilich ein weiser Vorgriff auf die Katastrophe einer Generation, deren Väter zu sein nunmehr wir die traurige Ehre haben. Und jetzt tritt ein; meine Familie wird sich freuen. Nein danke, ein andermal, haucht Mr. G. und läßt sich auf eine dunkelblaue Wolke fallen, die ihn behende zu seinem Schreibtisch entführt. Und Mr. G. notiert in seinem Tagebuch: Es gibt pausbäckige Jünglinge, deren Geist gestorben ist, bevor sie selber begonnen haben zu leben. Es gibt kahlköpfige Männer, deren Geist taujung ist, während ihr Körper sich schon anschickt zu vergehen. Schade nur, daß letztere entschieden in der Minderzahl sind.

cluding Jobis, Diolen, Maris, Zweigler, Van Delden and Nino[63], counted among Gundlach's clients as did the globally operating fur industry, which became aware of his particular aptitude for working with fur, a very difficult material. His collaboration with Falke, manufacturer of high-quality knitwear and jersey wear located in the Westphalian town of Schmallenberg, spanned many years of intensive work and produced impressive results in print. The collaboration in this case was kicked off with a letter from Klaus Gerwin dated January 1959, in which Franz A. Falke GmbH along with the affiliated W. Uhlmann GmbH, Lippstadt showed an interest in "having their products photographed" by Gundlach.[64] What began with a three-page briefing (including a range of "ideas on the nature of good fashion photography") became a special challenge for F.C. Gundlach practically overnight as he was given enormous cre-

ative freedom with the catalogues and brochures for Falke and Uhlmann/Uhli. The driving force behind this enterprise remained the above-mentioned Klaus Gerwin, painter, sculptor, graphic designer and artistic consultant for Falke, who signed responsible for the company's external communication. We can assume that it was Gerwin who encouraged Gundlach to break new ground in his interpretation of fashion and to explore his limits. That said, even from the first correspondence it seemed understood that they shared the same views. Those Falke brochures demonstrate more strikingly than some of the editorials the changes in fashion and fashion photography since the end of the 1950s, moreover, with the onset of the new decade the changing everyday environment was reflected in advertising media on a whole. Perhaps Falke cannot be classified as "avant-garde"; however, it was nonetheless closer to the pulse of a

beginning new era than some of the editorials. As far as F.C. Gundlach's fashion photography is concerned, it meant working with a new, less lady-like female type, assuming sporty gestures and poses, returning resolutely to a pictorial language in the tradition of reportage and using locations that no longer bore the names of Olympic Stadium or Avenue Montaigne (until 1957 headquarters of the late Christian Dior), but Cape Town or Argentina. F.C. Gundlach's photography found its equivalent in the layout that under Gerwin's responsibility defined the trends of the time. Superb examples include the 1961 Uhli brochure and a special print designed by Klaus Gerwin (alias "Mr. G."), headed "aspekte 60" and illustrated with photographs by F.C. Gundlach. It was intended to advertise the new MAN gravure-rotary press. The fact that both titles were spelled in lower-case letters in itself stood as a sign, as reference made to modern magazine concepts propagated by the likes of *magnum* (from 1954) and particularly *twen* (from 1959).[65] Stylistic effects such as the ample use of images, full-page bleed presentations of single motifs, abundant use of white space (in other words, unprinted areas with "pictorial" effects), modern typography including the "Hohe Twen" font favoured for headings by art director Willy Fleckhaus, negative type, isolated motifs without a background and the ironic use of historicizing elements (such as the pointing hand) unmistakably attest to the influence exuded by legendary teen magazine *twen* also and especially on the world of advertising.[66]

At first glance, *twen*, published as from April 1959 in Cologne and later in Munich and *Film und Frau* seemed to share no common ground: The former was somewhat "catholic" in attitude while the latter sought to promote discreet elegance. Yet there are parallels, linking *Film und Frau* and *twen* with other examples from the "illustrated modern era".[67] To begin with, both magazines were driven less by publishing calcula-

tions than a journalistic vision. At that, they were true products of their time. *Film und Frau,* in this sense, was perfect at embodying the dreams, the longing for political stability and prosperity in the materialistic 1950s, while *twen* provided guidance and orientation in the turbulent decade that was to follow. From the point of view of cultural historiography it may be difficult to pinpoint as to when the 1960s occasionally referred to as "hinge decade"[68] actually began. Was it in 1961 when the young and charismatic John F. Kennedy was elected President of the United States? Was it the Schwabing youth riots of 1962, the Spiegel affair of 1962 or the Auschwitz trials from 1963-65? Or did this decade not actually begin until Mary Quant appeared in her famous miniskirt in 1965? One thing is undisputed, namely that this era heralded a new female type who could be aggressive and sexy like Brigitte Bardot, boyish like Jean Seberg or cheeky like Audrey Hepburn, by all means defying the type of the "young lady" such as propagated by *Film und Frau.* However, it was not until the launch of *twen* that the generation of twenty-somethings finally got their own label, enabling it to set itself apart from the "adult world" in terms of fashion, attitudes and behaviour. Up until the early 1960s, F.C. Gundlach photographed extensively for *Film und Frau,* from mid-1955 also in colour.[69] However, as the photographer remembers, as from the late 1950s, the magazine's inner stringency and outside reputation was dwindling. In 1969, the Jahreszeiten Verlag took over from Gruner + Jahr *Petra* magazine (sub-headline: "Die Frauenzeitschrift ohnegleichen"), founded in 1964 by the legendary Hans Huffzky[70], launched with much ado and by then stagnating. In the same year, *Petra* was merged with *Film und Frau* (as from 1966 published under the title *Die moderne Frau*). Two decades following its first issue *Film und Frau* was history.

By this time, F.C. Gundlach had long since changed sides and opened for himself a new, journalistically

Die andere Romy Schneider

Frankreich befiehlt dir, gesund zu bleiben!" steht in graziöser Schrift unter einer Porträtzeichnung von Romy Schneider in dem unverkennbaren Strich von Jean Cocteau. Sie hängt in der ebenso eleganten wie gemütlichen Wohnung der Schauspielerin in der Rue Messine und ist eine Erinnerung an die schlimmen Tage vor der Premiere von „Schade, daß sie eine Dirne ist", als Romy mit einer Blinddarmentzündung ins Krankenhaus gebracht werden mußte. In der Erinnerung erscheinen diese Tage freilich in einem verklärten Licht. Nicht nur, weil die Premiere dann zu einem derartigen Triumph wurde, daß das Stück hundertfünfzigmal über die Bühne ging. Vor allem denkt Romy dankbar daran, daß sie noch nie im Leben mit so vielen Beweisen der Freundschaft und Zuneigung überschüttet wurde wie in dieser kritischen Situation. Die ganze Prominenz von Paris bedachte sie mit Blumen, Grüßen und guten Wünschen, von denen nicht wenige so rührend waren wie die von Jean Cocteau. Es zeigte sich, daß die kleine Deutsche, die in einer Zeit der beruflichen Krise so viel Mut und Kraft bewiesen hatte, längst zum Liebling von Paris geworden war. Heute, da sie gewissermaßen schon als Pariserin anerkannt ist (sie hat ein verblüffend elegantes Französisch gelernt), hat sie mit Einladungen zu Abendessen, Parties, Landausflügen überschüttet. Zwischendurch holt sie sich Rat bei ihrer Freundin Simone Signoret, wie sie sich bei so viel Aufmerksamkeiten am diplomatischsten verhält. Schließlich kommt auch noch ein Anruf aus New York, von Alain Delon, der mit Christian-Jaque durch Amerika reist, um den Film „Marco Polo" vorzubereiten.

Im Jahre 1961 schien die Karriere Romy Schneiders beendet. Sie hatte zuletzt in „Katja" und in „Die schöne Lügnerin" gespielt; beide Filme waren Mißerfolge. Romy Schneider war das Opfer zu vieler Ratgeber geworden, die sie verwirrt hatten. So entschloß sie sich, künftig nur noch auf den Mann zu hören, der ihr bereits von „Katja" und „Die schöne Lügnerin" abgeraten hatte: den jungen französischen Schauspieler Alain Delon, mit dem sie sich um diese Zeit auch verlobte. Er lehrte sie, auf die richtigen Aufgaben zu warten und die schlechten Angebote radikal abzulehnen, wie hoch die Gage auch immer sein mochte.

Die Befolgung dieses Ratschlags, der Einsicht, Mut und Geduld von ihr forderte, trug schon in einem Jahr reiche Frucht. Die „richtigen Rollen" kamen 1961. Romy Schneider spielte unter der Regie von Visconti auf der Bühne „Schade, daß sie eine Dirne ist" und vor der Kamera die Hauptrolle in einer Episode in „Boccaccio 70". Louis Malle engagierte sie für die Hauptrolle seines Films „Der Kampf auf der Insel", wie er sagt, „weil es in Frankreich keine junge Schauspielerin gibt, die diese Rolle spielen kann". Malles ehemaliger Assistent Alain Cavalier, der mit diesem seinen ersten eigenen Film inszeniert, sieht in seiner Hauptdarstellerin bereits eine neue Jeanne Moreau. Und Sascha Pitoëff, einer der berühmtesten und anspruchsvollsten Theaterleute Frankreichs, gab ihr schließlich die Hauptrolle seiner „Möwe"-Inszenierung, mit der er und Romy Schneider sich zur Zeit auf Auslandstournee befinden. In Paris hatte die Rolle in derselben Inszenierung Delphine Seyrig, die Hauptdarstellerin von „Letztes Jahr in Marienbad", gespielt. Mit anderen Worten: Romy Schneider repräsentiert heute das französische Theater im Ausland. Doch bei allem Stolz, den sie darüber empfindet, daß sie wieder eine erfolgreiche Schauspielerin geworden ist, daß sie sich der Freundschaft vieler Künstler erfreut und an Seine ihr Glück gefunden hat, klingt Wehmut in ihren Worten mit, wenn sie sagt, daß sie gern in Deutschland Theater spielen würde. Es wäre eine verwandelte Romy Schneider, die dann zu uns käme. Eine künstlerisch und menschlich gereifte Schauspielerin, die ohne Hochmut oder Bitterkeit sagen kann, daß das Ende ihrer ersten deutschen Karriere ein großes Glück für sie gewesen ist. — ee —

DER BETROGENE
„Der Kampf auf der Insel" —
Romy Schneider filmt wieder

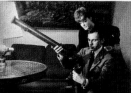

Anne (Romy Schneider) ist eine kapriziöse junge Frau, die dem Leben leidenschaftlich zugetan ist und sich über alle Konventionen lachend hinwegsetzt (Bild links) ● Sie liebt ihren Mann Clément (Jean-Louis Trintignant), sie hat seinetwegen ihre Karriere als Schauspielerin aufgegeben, doch könnten die beiden glücklicher miteinander sein

Denn Clément hat sich einer Untergrundorganisation verschrieben. Er ist ein idealistischer junger Mann, begeisterungsfähig, aber auch aufbrausend und unbesonnen. Als er wieder einmal seiner Frau wegen ihrer bewegten Vergangenheit eine Eifersuchtsszene macht, verläßt sie ihn (links)

Der Chef der Untergrundorganisation gewinnt immer größeren Einfluß auf Clément und stiftet ihn schließlich zu einem Attentat auf einen prominenten Politiker an. Nach während sich Clément zu dieser Aktion vorbereitet, kehrt Anne zu ihm zurück (Bild links)

Die Wahrheit erfährt sie jedoch erst, als die Tat schon geschehen ist. Obwohl sie das Verbrechen verabscheut, begleitet sie ihren Mann auf der Flucht. Clément findet Unterschlupf bei seinem Jugendfreund Paul, der auf einer abgelegenen Seine-Insel eine kleine Druckerei betreibt und sehr zurückgezogen lebt (Bild links)

Aufnahmen: F. C. Gundlach (3), ringpress-Vogelmann · Pallas (9)

11

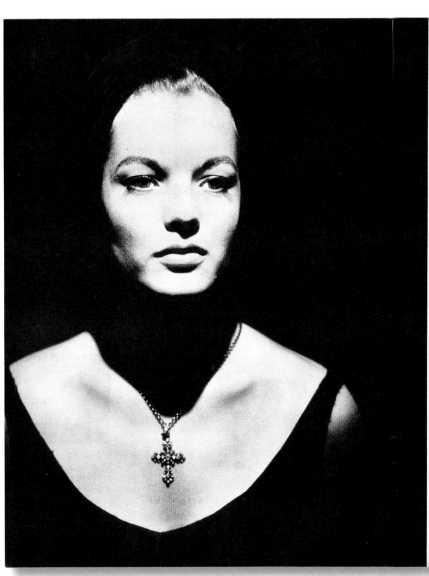

"A different Romy", *Film und Frau* 11/1962

very successful fashion chapter. For quite some time, as a letter dated January 1963 would suggest, there must have been differences between him and the editorial staff of *Film und Frau*.[71] Parts of a fashion series shot in Berlin in October had obviously failed to elicit the approval of Erika Berneburg, who succeeded Helga Waldenburger as the editor responsible for "fashion and graphic design", which gave F.C. Gundlach the impression that working together on the fashion design of the current issues was simply "out of the question". As a result, he felt no longer "bound by the verbal agreement, valid for many years, that obliged him not to work for other women's magazines," it says in the letter that marks the end of F.C. Gundlach's engagement with *Film und Frau*, even if his photographs continue to be published until 1965.[72] A first meeting between F.C. Gundlach and Barbara Buffa, responsible for the fashion section of *Brigitte* is supposed to have taken place as early as in 1962, marking the start of two decades of intensive collaboration. She has known F.C. Gundlach since 1962, says Barbara Buffa, however, she very likely became aware of his work much earlier than that. She got to know him as a man who was "open-minded, honest, liberated, true and unprejudiced," she writes. "His earnestness, endurance, perseverance, patience, calm disposition, reliability and indefatigability are matched with self-discipline, diffidence and independence."[73] The chemistry between them was right from the beginning, says Buffa, who would have produced more than 5.500 fashion pages with F.C. Gundlach by the time she left the editorial team in 1981. All things considered, it was an important and intensive time for F.C. Gundlach before the backdrop of pro-

next four spreads: "The renovated Romy", *twen* 7/1961; "This summer: lots of black and white", *Brigitte* 4/1966; "New and fancy on a simple dress: checkerboard patterns", *Brigitte* 4/1966; "Small rhombuses, large rhombuses in navy blue and white", *Brigitte* 4/1966; "New fashion", *Brigitte* 18/1967

Auch dieses Mädchen rechts sieht wieder einmal ganz anders aus, als man nach ihrem Namen erwartet hätte. Aber es ist sie: Romy Schneider. Der Herr unten ist nicht ihr Freund Alain mit der Wunderlampe, sondern Thomas Milian. Nie gehört? Nun, man wird noch. Er ist der Partner Romys in ihrem neuen Film, den Italiens Star-Regisseur Visconti dreht. Ein neuer Start für eine renovierte Romy, einst Ehren- und Spitzenjungfrau des deutschen Schnulzenfilms.

In der Schule wurde uns früher eindrucksvoll erklärt, warum Unglück doch nicht unbedingt Unglück sein muß. Man erzählte uns dort mit bewegter Stimme die rührende Geschichte von einem Mann, der einen Dampfer verpaßt. Nun steht er haareringend und händeraufend am Ufer. Dann aber berichtet man ihm, daß der Dampfer mit Männern und Mäusen untergegangen sei, wie das Dampfer so an sich haben. Nun hadert der Mann nicht mehr, rauft und ringt nicht länger. Unglück wurde Glück. Allerdings hatte ich schon damals das Gefühl, daß die Geschichte sehr viel weniger rührend ist, wenn man sie aus der Perspektive derer betrachtet, die mit dem Dampfer untergehen. Für die moderne Schulpflege sollte man darum vielleicht Romys Geschichte wählen. Sie hatte einst viel Glück, war reich und schön und tugendsam. Dann fiel sie in Liebe und in Ungnade. Wer so offensichtlich einem französischen Jüngling seine deutsche Tugend schenkt, der kann nicht länger unsere Romy sein. Aber Romys Unglück war gar kein Unglück. Obwohl sie nun hart arbeiten mußte. Sie spielte Theater und hatte wider Erwarten sogar Erfolg. Und nun filmt sie sogar wieder. In einem Vertrag von internationalem Rang, den sie vermutlich nie erreicht hätte, wenn sie im deutschen Film weiter Königkinder verkörpert hätte. Und wenn sie jetzt Glück hat, dürfte sie bald besser im Geschäft sein als je zuvor. Der Sprung vom Genie-Küken des Kölner Verzehr-Zars und Gabelbissenkonzerns zur freien und arbeitsamen Verlobten hat ihr gut getan. Wie vielen Kindern, die eines Tages erwachsen werden. Unglück war eigentlich Glück. Und was so schön ist: Kein Dampfer mußte extra dafür untergehen.

Soviel für heute über Romy. Im nächsten Heft werden wir mehr über die erstaunliche Karriere des deutschen Filmengelchens a. D. bringen.

Dieter Thoma

DIE RENOVIERTE ROMY

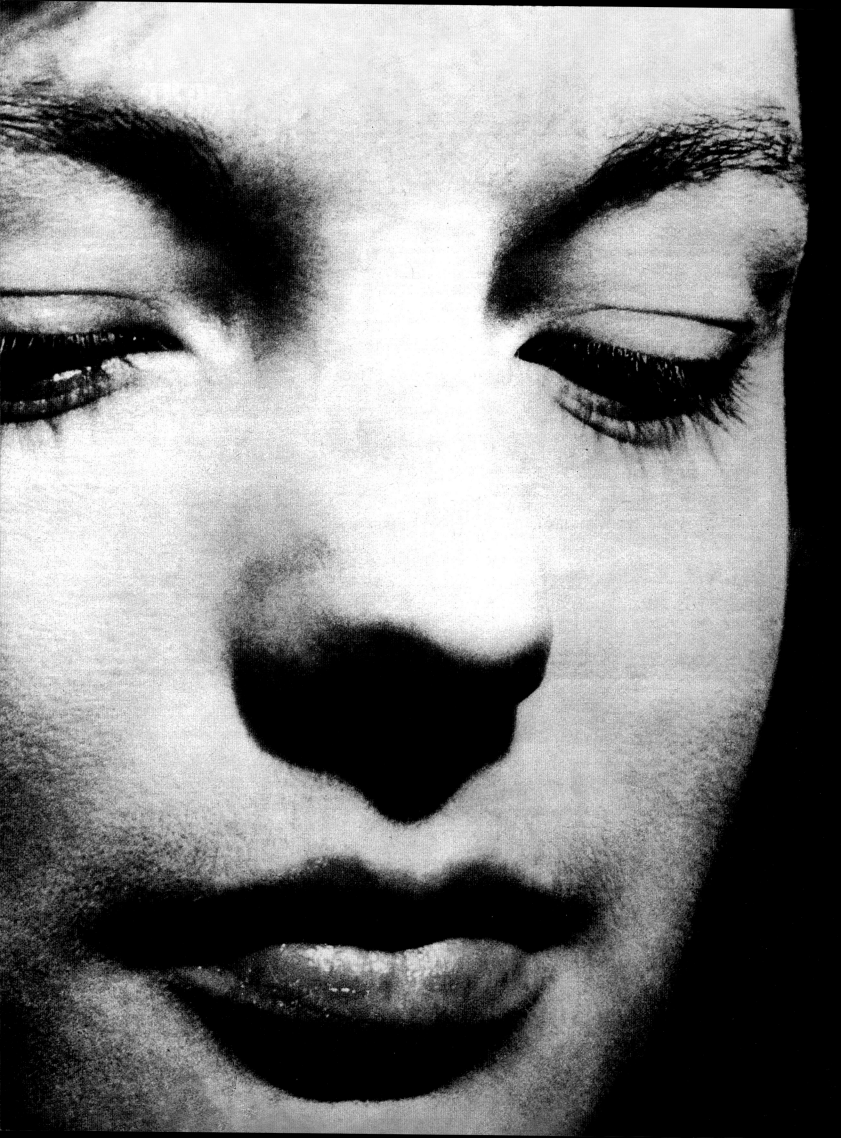

Auch in diesem Sommer: viel Schwarz und Weiß

Schneeweiße Ripsbänder (oben) sind schmalspurig aufgesetzt und betonen den asymmetrischen Schnitt des schwarzen Jerseymantels. Knöpfe und Schnalle in neuer Viereckform sind mit schwarzen und weißen Emaille-Plättchen besetzt. Circa-Preis 590 bis 650 Mark. Modell: Lend, Paris.

Wie mit dem Lineal gezogen wirken die akkuraten weißen Blenden an diesem schwarzen Wollkostüm (rechte Seite). Passend dazu eine schwarze Lacktasche mit weißem Streifen (La Bagagerie, Paris). Circa-Preis 280 bis 310 Mark (Kostüm). Modell: Lucien Léman, Paris. Fotos: F. C. Gundlach.

Neu und schick an schlichten Kleidern: Schachbrett-Karos

Schachbrett-Karos, in Schwarz-Weiß oder bunten Farben zusammengewürfelt, sind neuer Schmuck an schlichten Sommerkleidern. Linke Seite: Ein strahlend weißes Sommerkleid mit exakt eingesetzten Karos in drei verschiedenen Lilatönen. Vier andere Farben: Braun, Blau, Gelb und Schwarz. Die kleine Kuverttasche ist aus Ripsbändern geflochten (La Bagagerie, Paris). Kleid: Circa-Preis 80 bis 90 Mark. Modell: Chiwitt. Links: Hier haben Sie die neuen Schachbrett-Karos Schwarz auf Weiß und Weiß auf Schwarz. Das Kleid ist aus leinenartiger Zellwolle und auch in Dunkelbraun mit Weiß zu haben, Circa-Preis 130 bis 145 Mark. Modell: Doolittle. Ohrclips: M. Moritz. Fotos: F. C. Gundlach.

Alles über Preise: Für alle Modelle, die wir Ihnen von Seite 4 bis 27 und von Seite 48 bis 71 dieses Heftes zeigen, nennen wir Ihnen teils Circa-Preise in Form von Preisspannen, teils Festpreise oder unverbindliche Richtpreise. Die Circa-Preise sind unverbindliche Preisangaben und haben lediglich die Aufgabe, Ihnen eine ungefähre Vorstellung des jeweils notwendigen Kaufbetrags zu geben. Da sie alle in unserer Redaktion errechnet sind, kann es sein, daß die in den Geschäften geforderten Preise unsere Preisspannen über- oder unterschreiten. Bei einigen Badeanzügen und Wäschemodellen tauchen teilweise Begriffe wie „Festpreis" oder „unverbindlicher Richtpreis" auf. Diese Modelle sind nach Mitteilung der Hersteller entweder im Preise gebunden (Festpreis) oder mit einem unverbindlichen Richtpreis beim Bundeskartellamt angemeldet. Unsere Preisangaben gelten immer nur für den Originalstoff bzw. die Garnqualität des jeweiligen Modells.

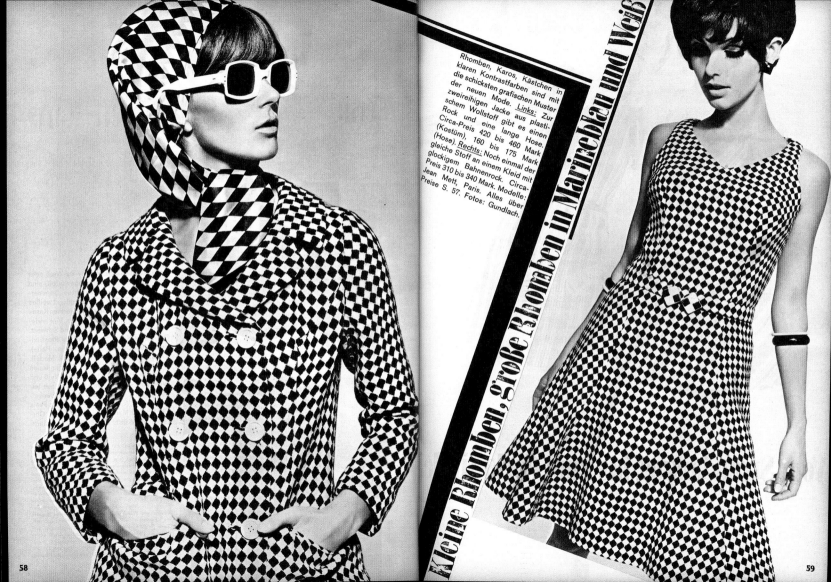

Rhomben, Karos, Kästchen in klaren Kontrastfarben sind mit die schicksten grafischen Muster der neuen Mode. **Links:** Zur zweireihigen Jacke aus plastischem Wollstoff gibt es einen Rock und eine lange Hose. Circa-Preis 420 bis 460 Mark (Kostüm), 160 bis 175 Mark (Hose). **Rechts:** Noch einmal der gleiche Stoff an einem Kleid der glockigem Bahnenrock. Circa-Preis 310 bis 340 Mark. Modelle: Jean Mett, Paris. Alles über. Preise S. 57. Fotos: Gundlach.

Kleine Rhomben, große Rhomben in Marineblau und Weiß

Tages- und Cocktailkleider, Kostüme, Mäntel und Hosenanzüge – alles zum Kauf
– zeigen wir Ihnen auf den Seiten 4 bis 48. Auch für Sie ist das Richtige dab

Die neue Mode

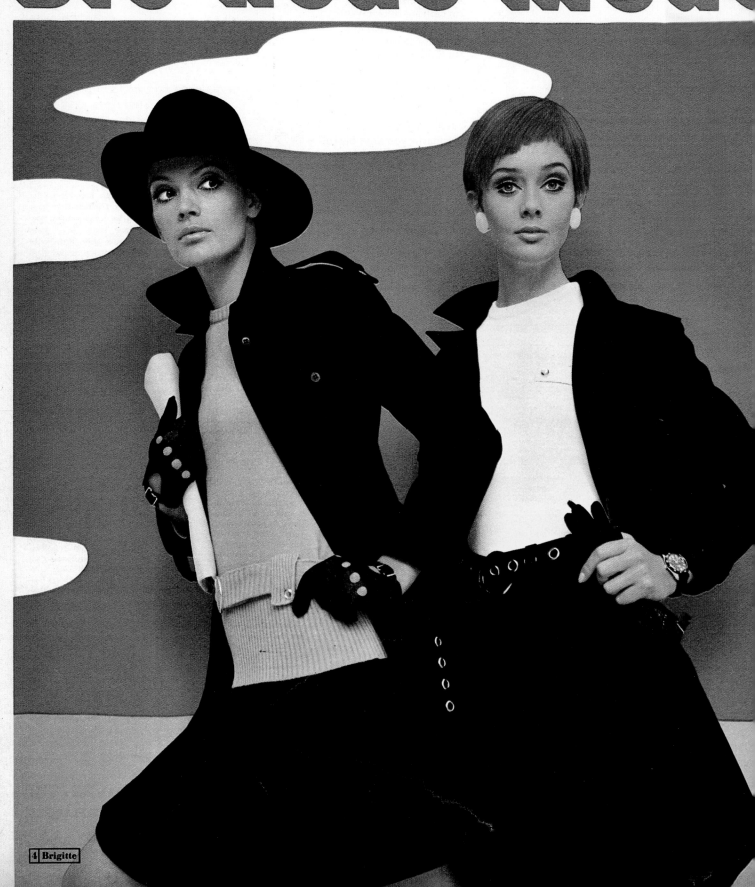

ntwortlich
len
itte-Modeteil:
ara Buffa

Linke Seite außen: Mantel mit passendem Rock aus schwarzem Trevira-Woll-Ga-
bardine. Modelle: Chiwitt. Circa-Preis Mantel: 205 bis 230 Mark. Rock 60 bis 70
Mark. Dazu ein langer Pullover mit Gürtel. Modell: Hessenthaler für Chiwitt. Circa-
Preis 55 bis 60 Mark. Daneben: Sportkostüm aus dem gleichen Material wie der
Mantel. Modell: Chiwitt. Circa-Preis 170 bis 190 Mark. Rechte Seite: Zu schwarzen
Röcken werden lange, leuchtend farbige Pullover mit Gürtel getragen. Modell:
Chiwitt. Circa-Preis 60 bis 70 Mark, Pullover: Hessenthaler für Chiwitt, Circa-Preis
55 bis 60 Mark. Tasche mit Silbergürtel: La Bagagerie. Lederhandschuhe: Fontana.
Armbanduhr: Uhren-Becker, beide Hamburg. Frisuren mit Sechser- und Korken-
zieherlöckchen: Peter Polzer, Hamburg. Alles über Preise lesen Sie auf Seite 42.

Fotos: F. C. Gundlach Zeichnungen: Elke Otto

Brigitte 5

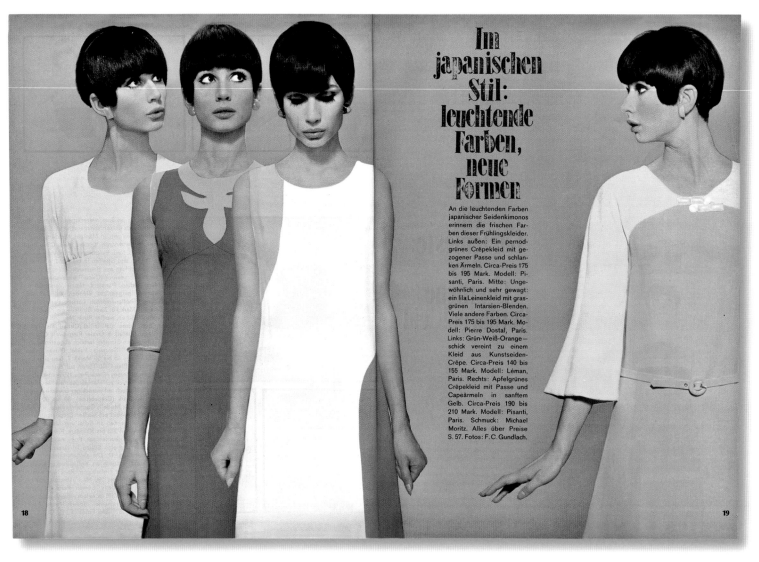

Im japanischen Stil: leuchtende Farben, neue Formen

An die leuchtenden Farben japanischer Seidenkimonos erinnern die frischen Farben dieser Frühlingskleider. Links außen: Ein pernod-grünes Crêpekleid mit gezogener Passe und schlanken Ärmeln. Circa-Preis 175 bis 195 Mark. Modell: Pisanti, Paris. Mitte: Ungewöhnlich und sehr gewagt: ein lila Leinenkleid mit grasgrünen Intarsien-Blenden. Viele andere Farben. Circa-Preis 175 bis 195 Mark. Modell: Pierre Dostal, Paris. Links: Grün-Weiß-Orange — schick vereint zu einem Kleid aus Kunstseiden-Crêpe. Circa-Preis 140 bis 155 Mark. Modell: Léman, Paris. Rechts: Apfelgrünes Crêpekleid mit Passe und Capeärmeln in sanftem Gelb. Circa-Preis 190 bis 210 Mark. Modell: Pisanti, Paris. Schmuck: Michael Moritz. Alles über Preise S. 57. Fotos: F. C. Gundlach.

"In Japanese style: bright colors and new designs", *Brigitte* 4/1966

found social and cultural changes, most apparently expressed in fashion. What at the end of the 1950s timidly appeared on the fashion horizon, i.e., jeans, unisex styles and miniskirts, soon morphed into a revolution with irreversible consequences, helped along also and specially by fashion designers such as André Courrèges and Pierre Cardin, whose rigidly structured, clear cuts designed for a new female image posed a particular challenge to F.C. Gundlach.

It is obvious that a magazine that has been around for more than a century, survived four political systems, witnessed and reflected the profound social and cultural changes of the 20th century necessarily must reinvent itself from time to time. The clearest sign of change in *Brigitte* was the title (the magazine was originally called: *Dies Blatt gehört der Hausfrau!* – This magazine belongs to housewives!). Also in terms of its blend of topics and visual layout, it

was often cherished for its efforts of portraying the spirit of the times, however, without fundamentally questioning the originally chosen path. *Brigitte* certainly never was a high-society product in the style of prominent US magazines – including the likes of *Vogue, Vanity Fair* or *Harper's Bazaar* – that were the key institutions of luxurious lifestyle and fashion, affording a hint of glamour on paper even in more moderate homes. *Brigitte* was on a par with its readership, promising practical advice on everyday issues, something that over the years evolved into regular features. Labels such as "*Brigitte* Fashion", "*Brigitte* Furniture" or "*Brigitte* Diet" were more than journalistic means that helped structure the architecture of a single issue – over time they became trademarks. The fashion part, considerably fleshed out since the 1950s, was the main vehicle to transport the image of *Brigitte. Brigitte* fashion was "stylish, natural, smart",

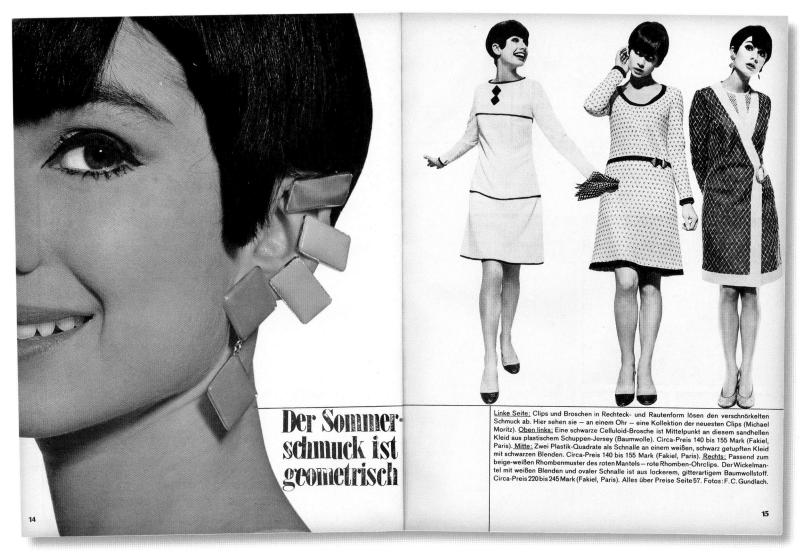

Der Sommer-
schmuck ist
geometrisch

14

15

"Summer jewelry is geometric", *Brigitte* 4/1966

also affordable, and it is hardly an exaggeration if we say that the editorial team's talent to "combine cheap flimsy clothes with expensive labels into a harmonious overall image" had "gradually changed women's buying behaviour."[74]

Evidently, this was based on a concept. In the 1960s and 1970s – the period relevant to us – this concept was supported by Barbara Buffa. Born in 1926 like F.C. Gundlach, she graduated from the Weimar Art Academy and subsequently trained as a dressmaker, before joining the *Brigitte* editorial team in 1957. Until her retirement in 1981, she promoted tirelessly and with great enthusiasm what has gone down in the history of fashion as "Buffa"-style. Here, style must be understood rather as a harmonious composition of fashion that drew inspiration from a variety of sources, including elements of couture as well as the French prêt-à-porter promoted with great zest by

Buffa, young labels or transatlantic influences, from sports fashion to casual wear. It was hard to put a finger on what actually defined *Brigitte*-style fashion, as one editorial commented, nonetheless it made "women more beautiful, young, stylish and lovely".[75] If Barbara Buffa was flitting restlessly between international fashion shows, using her trained eye and pairing her curiosity with her ideas of what constituted modern femininity to devise ever new trends, it was on F.C. Gundlach to portray these as faithfully as possible. Over roughly two decades, the pair worked as a congenial team comprising fashionable ingenuity and the medial communication thereof.

F.C. Gundlach's involvement with *Brigitte* began long before a draft contract was eventually devised in 1965. Nevertheless, the two-page document highlights the magazine's intention to have the photographer fully on board of the editorial team. 200 fashion

next two spreads: "James Blond is chasing the beautiful mask", *Brigitte* 1/1966

203

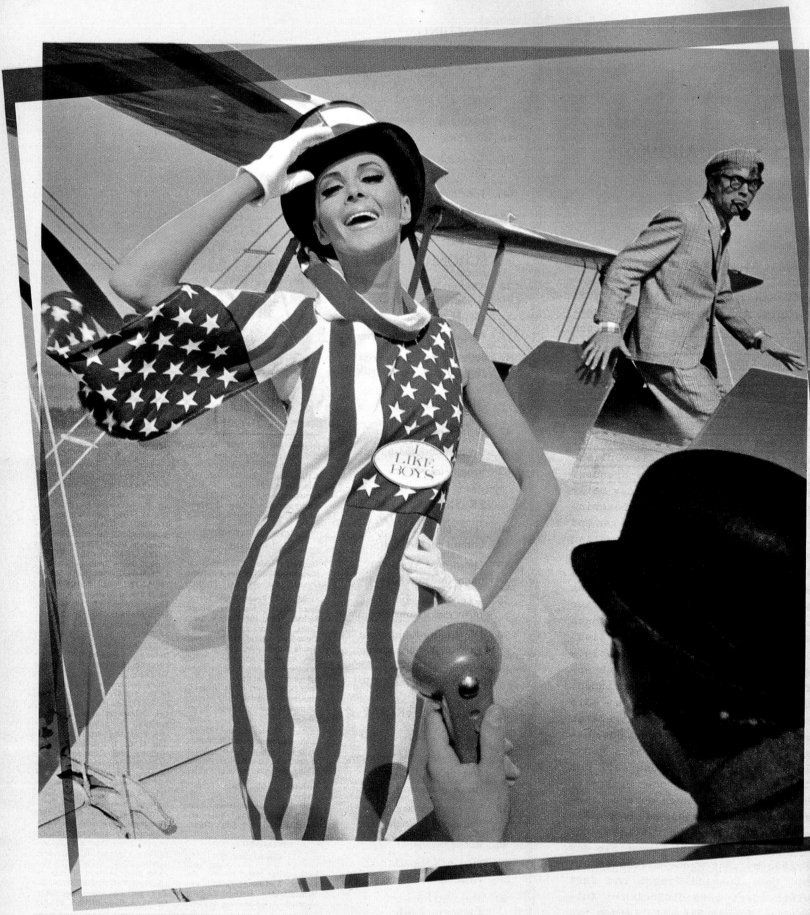

unbekannte, genannt die 'schoene maske' soeben gelandet. wahrscheinlich gefaehrliche agen-
tin. die verdaechtige traegt ein leichtes faehnchen, bedruckt mit streifen und 52 himmels-
koerpern (bogenmodell 1 e 1 in gr. 42). james blond, als tourist getarnt, durchsucht flug-
zeug und nimmt dann die verfolgung auf. die erste spur fuehrt ins karnevalszentrum koeln.

**(Un)verantwortlich
für den
Faschings-Modeteil:
Barbara Buffa**

an alle +++ an alle +++ hier beginnt brigittes faschingsgrossproduk-
tion mit vielen mitwirkenden und 12 kostuemen zum nachschneidern ++++

James Blond jagt die schöne Maske

in den hauptrollen

gil barber, london, als musterdetektiv james blond 0066
wilhelmina, new york, als schoene maske

ferner

1 supersportwagen
4 indianer
3 hamburger schutzpolizisten
1 assistent fuer qualm und rauch
1 sicherheitsingenieur
3 ganoven
1 pferd

und viele andere

drehbuch: die brigitte-moderedaktion
an der kamera: f.c. gundlach
kostueme: alke schmoldt und karin jaroschak
schnittbogenbestellung seite 47
jede aehnlichkeit mit lebenden oder frei erfundenen persoen-
lichkeiten wuerde uns maechtig freuen

'was haben sie mit den hauseigenen badetuechern gemacht?' begehrt der verwalter des tuerkischen bades zu wissen. schoene maske hat die tuecher mit wenigen handgriffen in ein apartes badekostuem verwandelt (bogenmodell 8 e 1 in groesse 38). mit unbehagen fuehlt sie den bannenden blond-blick dampfend heiss in ihrem nacken.

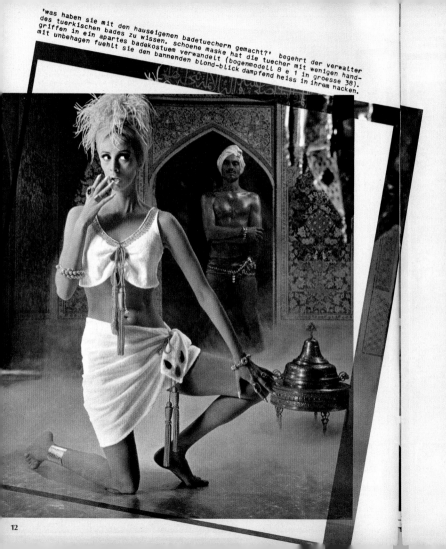

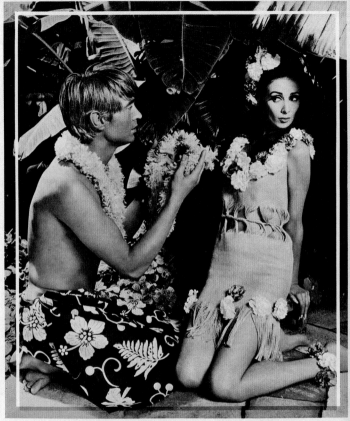

sensation ... schoene maske und blond in hawaii. sie traegt ein gelbes rupfenkleid, besetzt mit bonbonbunten blueten und laesst sich die linden luefte und james blonds komplimente um die taille wehen (brigitte-bogenmodell 9 e 1 in groesse 38). aber ein rest misstrauen ist geblieben: 'beweise mir erstmal deine liebe' fordert sie kokett.

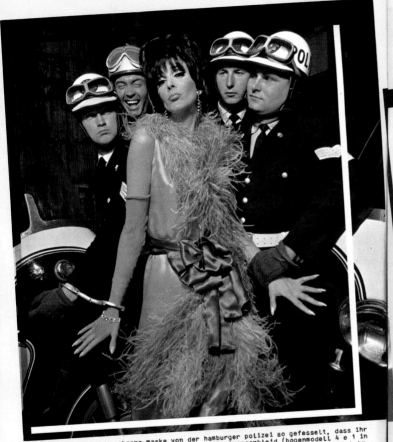

nach wilder jagd wird schoene maske von der hamburger polizei so gefesselt, dass ihr nicht mal zeit zum umziehen bleibt. im einfachen strassenkleid (bogenmodell 4 e 1 in gr. 38) wird sie auf der reeperbahn gefasst. blond (als polizist getarnt) lacht hohn.

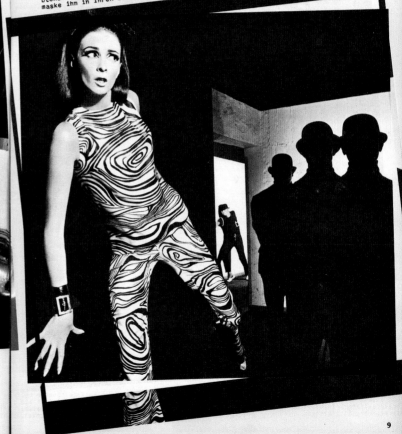

der polizei entkommen, geraet schoene maske unter die ganoven. im handbemalten tarn-anzug (bogenmodell 5 e 1 in groesse 38) versucht sie, sich an die wand zu druecken. blond – im hintergrund – schlaegt die dunkelmaenner gleich darauf nieder und schoene maske ihn in ihren bann. er ahnt: vermeintliche agentin ist harmloser, als sie tut.

8

9

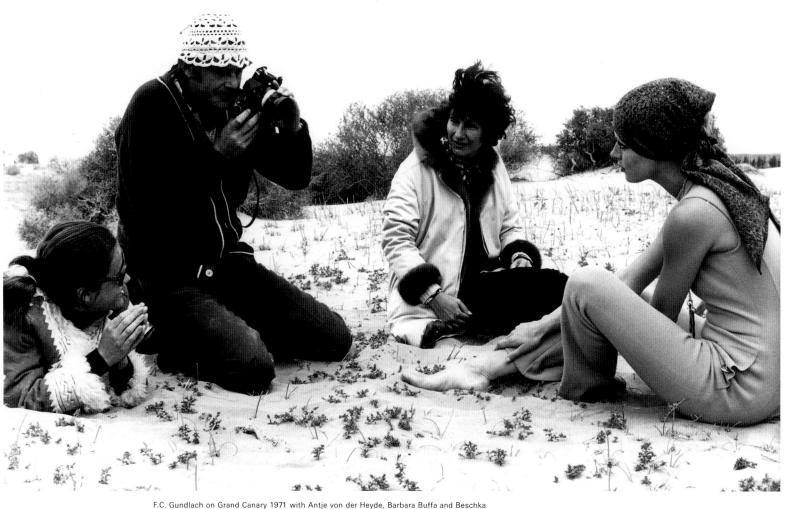

F.C. Gundlach on Grand Canary 1971 with Antje von der Heyde, Barbara Buffa and Beschka

pages were guaranteed per year. "Based on the currently agreed fee of DM 300 per page, the annual salary amounts to DM 60.000. This sum shall be paid in full even if, contrary to expectations, the scope of work should happen to be less. Should more than 200 pages be produced per annum, this fee will increase accordingly."[76] In return, Gundlach was expected to maintain his distance to the competition, including magazines such as *Für Sie, Film und Frau, Praline, Petra, Freundin* and *Constanze.* As "non-competing magazines" were regarded the weekly glossy magazines and the gutter press. Gundlach's work in advertising was neither touched by the agreement.[77] These were enviable conditions, yet F.C. Gundlach's work was subject to increasing editorial influence as a consequence. He comments in hindsight that he had enjoyed far more creative freedom at *Film und Frau.* That said, with *Brigitte* he was privileged to work for

a women's magazine that enjoyed one of the highest circulations not only in the German-speaking world, and with Barbara Buffa, a fashion editor with whom he got along right from the start. This may also explain why other, previously very successful fashion photographers, among them Charlotte March (born in 1930) as well as Rico Puhlmann, Michael Doster, Gerd Preser and Marc Hispard, who worked for *Brigitte* on a regular basis, now became second choice. "Buffa and I, we were two of a kind," F.C. Gundlach points out. "I made proposals, she made proposals, and then we simply pieced it all together."[78] Even if the era of self-made clothing was drawing to a close, even if the fashion discourse was no longer driven by those much cited "buttons and bows" – the primary objective continued to be that of providing information on fashion, while compositions that were experimental or explored the limits of fashion photography,

Brigitte

C 1940 D

Mode:
Für jeden Typ für jedes Alter

23. Juni 1964 · 90 Pfennig
Österreich: S 7.—
Italien: L. 170.—
Schweiz: sfr 1.10

13

Brigitte

Das grosse Osterheft mit 45 Seiten Sonderteil:

Machen Sie mehr aus Ihrer Wohnung!

6

Brigitte

Mode für Wind und Wetter
Sonderteil: Die besten Köche Europas verraten ihre Geheimnisse
Wieviel Freizeit brauchen grosse Töchter?

7

Brigitte

In diesem Frühling sind Sie natürlich schön!

8

Brigitte

C 1940 D

Die neue Mode

4

Brigitte

C 1940 D

DAS BUNTE WEIHNACHTSHEFT

25

Brigitte

C 1940 D

Ein Fotomodell wird gemacht

Großes Traum-ABC: Deuten Sie Ihre Träume!

26

Brigitte

C 1940 D

DIE SCHÖNSTEN KOSTÜME FÜR FASCHING UND KARNEVAL

Brigitte

C 1940 D

Ab jetzt in jedem Heft: Brigittes Modellschnitt in Originalgröße

EXTRA! GRATIS!

Den Schnitt für dieses vielseitige Kostüm finden Sie in der Heftmitte

10

Brigitte

C 1940 D

Sommerfrisuren! Sommerkleider!

Extra: Der Schnelle Schnitt in Originalgröße

11

Brigitte

C 1940 D

Das Ferienschönheitsheft

Extra: Der Schnelle Schnitt in Originalgröße

12

Brigitte

C 1940 D

Ihr Sommerkleid, in Paris entworfen, von Ihnen genäht!

Extra: Den Schnitt für dieses Kleid finden Sie in der Heftmitte

13

Brigitte

C 1940 D

MODE

Die neue Linie

Die neuen Schnitte

...und ein originalgroßer Modellschnitt!

17

Brigitte

C 1940 D

Das grosse Modeheft

4

Brigitte

Mode für Sonne und Strand

Sonderteil: Hübsch gedeckte Tische

8

Brigitte

C 1940 D

6o Seiten Mode

Jersey für alle Sommertage

10

Brigitte

C 1940 D

Wie kurz darf Ihr Rock sein?

Ausländer über deutsche Mädchen

16

Brigitte

C 1940 D

Die neue Mode
- die neuen Schnitte

18

Brigitte

C 1940 D

18 Seiten Schönheitstips zur neuen Mode

Mode & Schönheit

5

Brigitte

C 1940 D

100 Kleider unter 100 Mark
Sonderteil: Die schöne Haut

Brigitte

Die neuen Mäntel

Neue Serie von Ursula Lebert:
Die gute Ehe

19

Brigitte

Haarkuren Haarteile Haartönung und
Alles für Ihr Haar!

21

Brigitte

Das festliche Heft

26

Brigitte

Süß anzusehen
leicht
nachzuschneidern
für
wenig Geld:
DIE
PERFEKTE
FERIEN-
GARDEROBE

9

Brigitte

SOMMER!
Kleider, die alle
Männer mögen
URLAUB!
Wer wird Ihr Flirt –
was wird daraus?
FERIEN!
Souvenirs
zum Selber-
machen

Brigitte

DIE
MODE
FÜR
HERBST
UND
WINTER

17

Brigitte

GROSSER
SONDERTEIL:

schicke
Strick-
modelle

19

Brigitte

Großer
farbiger
Sonderteil:
Die
perfekte
Gastgeberin

22

Brigitte

NEU!
GRATIS!
EXTRA!

BRIGITTES
MODELL-
SCHNITT IN
ORIGINAL-
GRÖSSE

3

Brigitte

Zum Herausnehmen in Originalgrösse
BRIGITTES SCHNELLER SCHNITT
50
SEITEN:
DIE
NEUE
MODE
EINMALIG!
DAS REGAL ZUM
SELBERBAUEN
NEU!
DER BRIGITTE-
STAMM-
TISCH
4

Brigitte

Extra!
Brigittes
Schneller
Schnitt
in Original–
grösse
HÜBSCHE
KLEIDER
AUS NEUEN STOFFEN

Brigitte

Dieses Heft
macht
Sie schick
für den
Sommer

Die
ideale
Feriengarderobe

Brigitte

Neu:
Frisuren
im
Brigitte-
Stil

Die
neue
Bademode

Brigitte

Zum Selbermachen:
Neun schicke
Morgenröcke

NEUE SERIE:
EIN KIND
KOMMT
AUF
DIE WELT

EXTRA:
Der Schnelle
Schnitt
in
Originalgröße

22

Brigitte

Die schönsten
neuen Mäntel
Sonderteil:
Gestrickt
& gehäkelt

Diesen Mantel
können Sie
selbst machen

20

Extra: Brigittes Schneller Schnitt in Originalgröße

Brigitte

Weihnachts-
geschenke
wie noch
nie!
Zum Kaufen
und zum
Selber-
machen

Diesen Muff können
Sie selbermachen

23

Brigitte

Toll!!!
Toll!!
Toll!

Die
schönsten
Kostüme
für
Fasching
und
Karneval

Brigitte vom 4. Januar 1966

1

Brigitte

Die
neuen
Mäntel
und
Kostüme

19

Sonderteil:
Strick- und Häkelmode

Brigitte

Das festliche Heft
26

Brigitte

DIE
NEUE
MODE

4

Brigitte

Ihre neue
Feriengarderobe

Brigitte

Ganz neu:
Paris!
Sportlich
in Samt
und
Seide
Alles
zum Selbermachen

10

Brigitte

...viele schöne
Sommersachen
zum Kaufen und zum Selbermachen

12

Brigitte

Das große Modeheft

Brigitte

Sonderteil:
Zeit
sparen
Geld
sparen

Was
Männer ihren
Frauen
verschweigen

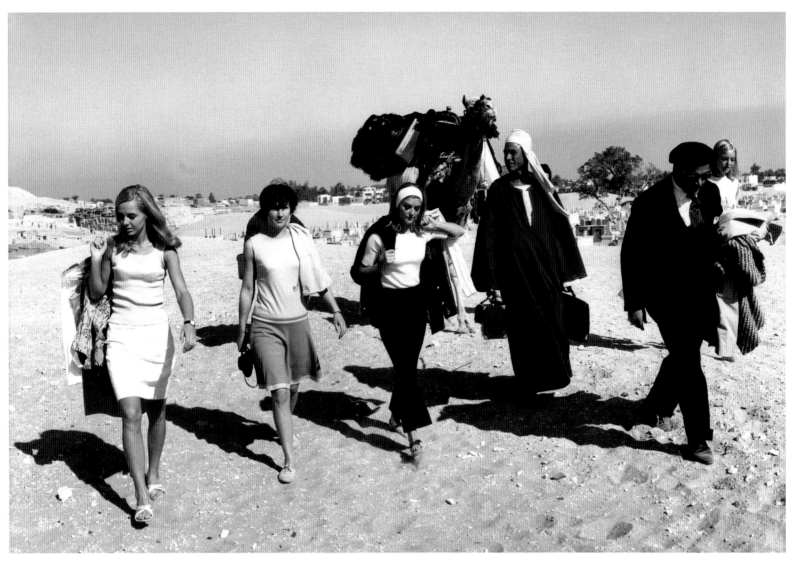

Barbara Buffa and the models Karin Mossberg, Micky Zenati and Ann Zoreff for *Brigitte*, Gizeh/Egypt 1966

such as realized around that time by Peter Knapp for the French *Elle*, were simply out of the question in *Brigitte*. To put it positively: F.C. Gundlach succeeded in surprising the readership with his fresh, innovative, even fanciful and always amazing fashion photography that captured the magazine's spirit. In his work, he conveyed what was internally referred to as "typical Brigitte", and yet he always remained true to himself. He was both providing a service and using his creativity, a photographer who "convincingly adapted to the changing fashions".[79]

Even more so than the "invisible" editor-in-chief, Peter Brasch, it was Barbara Buffa who stood for a magazine concept that by "systematically accentuating the practical part" sought to assert a kind of *Brigitte* style that embraced attributes such as "desentimentalization, pragmatic thinking or aesthetic clarity" as it did "open-mindedness for a better life –,

uncluttered and less stuffy".[80] *Brigitte* fashion was "young, smart (not 'chic'!), cool and easy to wear", it could be "purchased or self-made, it was affordable and very versatile", and it was presented according to journalistic principles.[81] The concept was optimally realized by having F.C. Gundlach on board the editorial team, who himself had a clear vision of fashion and who quickly grasped her ideas, as Barbara Buffa points out. Photography remained on the serving end in the sense that it provided information on fashion. Perhaps the days when fashion pictures were expected to be precise representations "down to the last thread" were over. Nonetheless, flattering and attainable, fashion required to be depicted in a way that was technically sound, clear and easy to read – no less. This meant no blurring or smearing, no deliberate bending of the rules in the service of an aesthetic pretence seeking to triumph over fashion. It

next spread: "Autumn fashion", *Brigitte* 18/1965

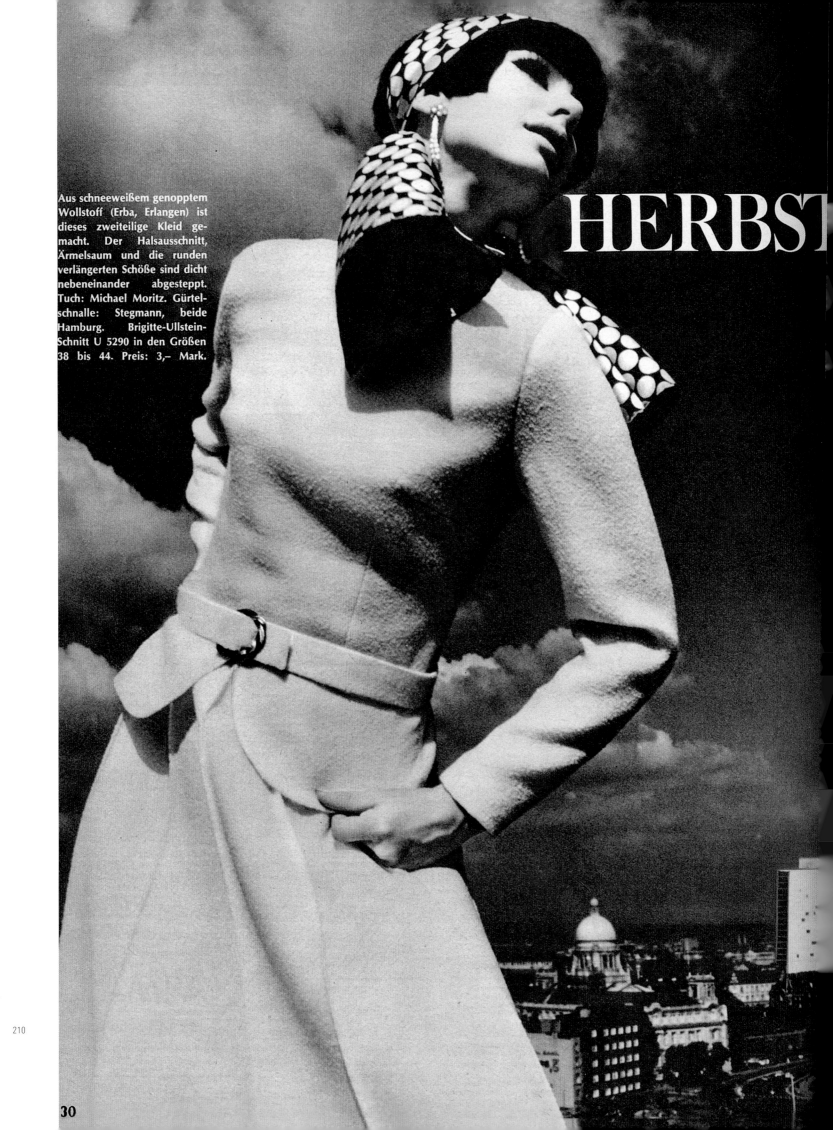

Aus schneeweißem genopptem Wollstoff (Erba, Erlangen) ist dieses zweiteilige Kleid gemacht. Der Halsausschnitt, Ärmelsaum und die runden verlängerten Schöße sind dicht nebeneinander abgesteppt. Tuch: Michael Moritz. Gürtelschnalle: Stegmann, beide Hamburg. Brigitte-Ullstein-Schnitt U 5290 in den Größen 38 bis 44. Preis: 3,– Mark.

HERBST

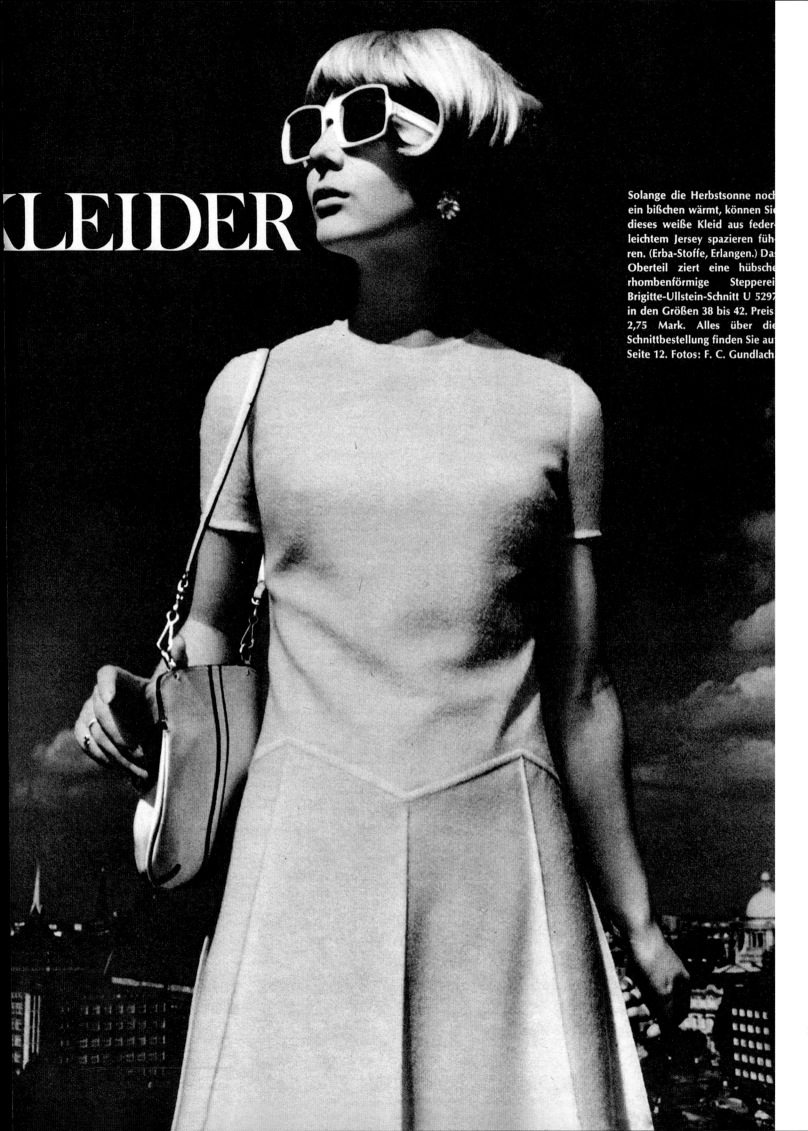

KLEIDER

Solange die Herbstsonne noch ein bißchen wärmt, können Sie dieses weiße Kleid aus federleichtem Jersey spazieren führen. (Erba-Stoffe, Erlangen.) Das Oberteil ziert eine hübsche rhombenförmige Stepperei. Brigitte-Ullstein-Schnitt U 5297 in den Größen 38 bis 42. Preis 2,75 Mark. Alles über die Schnittbestellung finden Sie auf Seite 12. Fotos: F. C. Gundlach.

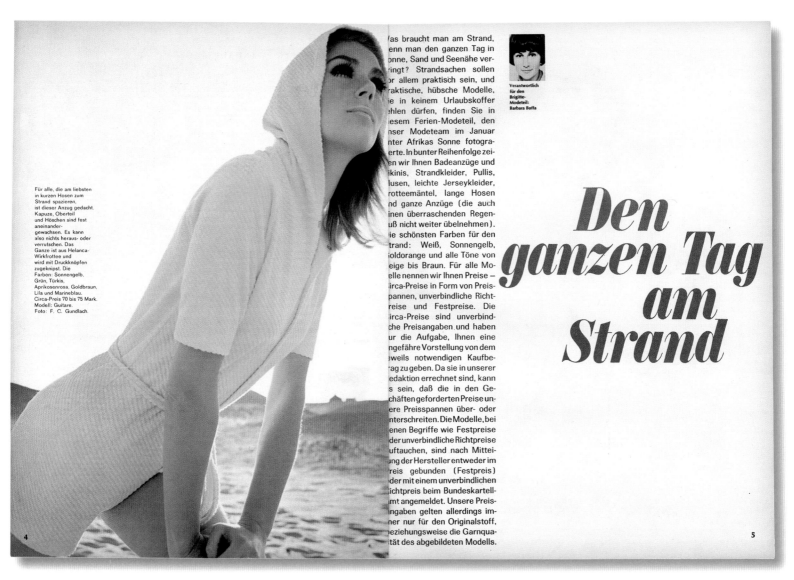

4

Den ganzen Tag am Strand

5

"All day at the beach", Gizeh/Egypt 1966, in: *Brigitte* 8/1966

was popular to display F.C. Gundlach's compositions with a plain layout as it focused the attention on the models. Added to this were mostly longer captions in large typography, often designed as run-arounds, in themselves image effects. With a view to make the layout more dynamic, headlines, captions, images often ran across the page diagonally, a design that may have been inspired by the 1960s editions of *Elle* in the same way as the occasionally employed stampfont.[82] Large and small elements, clothes and accessories, fashion en gros and en detail were commonly combined, and even though this created movement on the double-spreads, it reduced F.C. Gundlach's compositions to hardly more than "raw material". That said, the objective was not photography for photography's sake, but photography as a means of communication.

As early as in the 1950s, Gundlach had established a dialog between art and his fashion productions. In the age of Op and Pop, of Vasarely, Warhol or Lichtenstein and a fashion movement boasting compatible cuts and colours, the idea suggested itself again, and in the 1960s and 1970s culminated in a series of particularly striking fashion interpretations. Art could be used to inspire very simple or very dramatic studio backgrounds alike. In turn, actual works from young artists served as visual "background music", as was the case with David Hockney, a young artist relatively unknown at the time. Gundlach discovered his large-scale works at Hamburg's Neuendorf gallery (also residing in the bunker) and, after consulting with Barbara Buffa, integrated them in a fashion shoot by way of front projection.[83] Less popular was the use of narrative strategies, as employed in the carnival production "James Blond jagt die schöne Maske" (James Bond chasing the beautiful mask), a production heavily influenced by 1960s cinema and

212

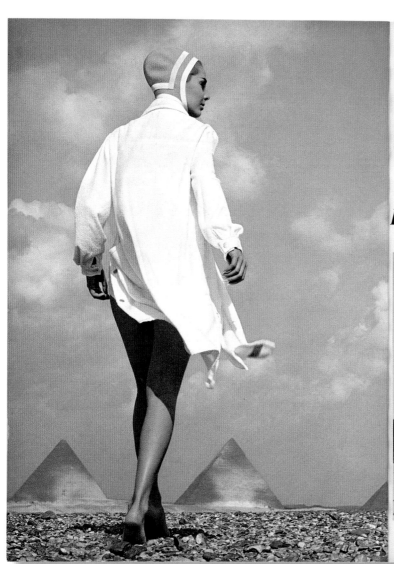

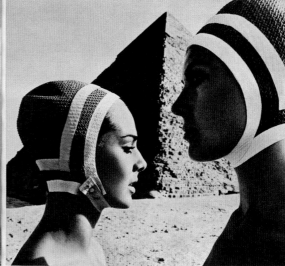

Den ganzen Tag am Strand

Foto unten: Bunte Bade-
kappen im Renn-
Fahrerstil mit weißen
Blenden und
Kinnband sind das Neu-
este für den Sommer
Modelle: Radium, Köln.

Linke Seite und Foto
oben: Weiß ist die
schönste Farbe für
Bademäntel, weil diese
Farbe braune Haut
so gut zur Geltung bringt.
Auf dem großen
Foto links sehen Sie die
Rückansicht, auf dem
kleinen Foto oben
das Profil des weißen
Frotteemantels,
der in 24 verschiedenen
leuchtenden oder
gedämpften Farben
zu haben ist. Der
Schnitt: kleine
Kragen, abgesteppte
Passe, aufgesetzte
Vierecktaschen und
geschlitzte Seiten-
nähte. Wichtig: auch
Bademäntel sind
kniekurz! Modell: Egeria.
Unverbindlicher
Richtpreis: 75 Mark.
Fotos: F. C. Gundlach.

"All day at the beach", Karin Mossberg, Gizeh/Egypt 1966, in: *Brigitte* 8/1966

featuring Wilhelmina for one last time. Held in high regard by F.C. Gundlach, the model was yet felt to be too "ladylike" – at least not "typical *Brigitte*". New faces dominated the scene, among them the young Sophie Derly – not unlike Audrey Hepburn in type – who had posed for Gundlach as early as in 1964.[84]

Gundlach was known to be innovative, including his willingness to pursue new paths in terms of photography and camera technology. Following in the footsteps of the likes of William Klein, Jeanloup Sieff or Art Kane, from the mid-1960s, he was particularly fond of using the 28mm wide-angle lens as his preferred means of expression. Not only did it mean working at close range to the models with more direct interaction and allowing him, for example, to "smooth out a crease with one hand" while looking through the camera's viewfinder. The wide-angle also provided a steeper perspective and a high depth of

focus. In the words of Gundlach, "It requires you to be very precise with the image composition as each inconsistency immediately shows."[85] It was probably Peter Brasch who stopped him short. As Barbara Buffa remembers, the editor-in-chief in fact "hated" wide-angle aesthetic.[86] Particularly a series shot in Egypt and Kenya in 1966 – a 100-page production intended for several issues – caused much conflict and almost led to a break between those involved. "At the time," so Gundlach, "the team consisted of the editor, three models, one photographer and one assistant. The series took three weeks to produce – a considerable effort in terms of organization. These pages were subsequently published under the heading 'Spending a whole day on the beach'. With the pyramids shown in the background, this title is absolute nonsense of course. The editor-in-chief initially refused to have the pages published. Barbara Buffa […] and I fought

next page: *Chic*, 11/1957

213

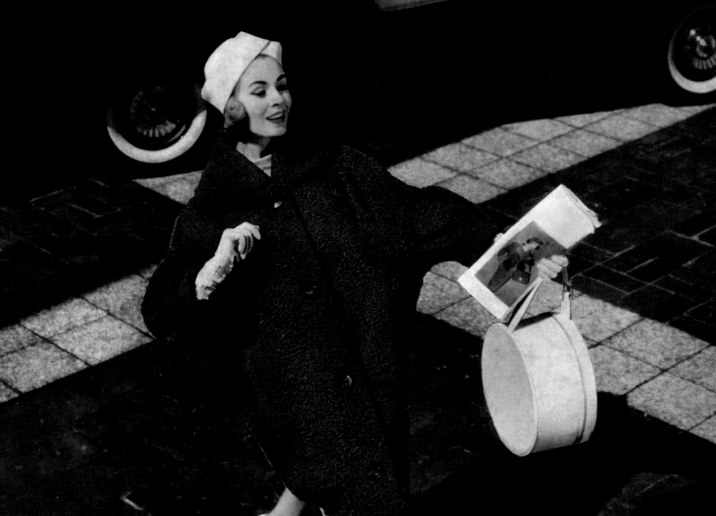

chic

HEFT 11
NOVEMBER 1957
10. JAHRGANG
CÖLN AM RHEIN
PREIS DM
ÖSTERREICH
SCHWEIZ

Lady
Die Zeitschrift für Schönheitspflege

Tierhafte Anmut
durch entspannte Haltung!
Festliche Frisuren- und
Make-up-Vorschläge
Lady liebt Parfüm und Pelz

DEZEMBER 1957
DM 9.50
Fr. 1.50 / S. 12.–
KONSTANZ

No. 25 · JAHRGANG IV · MÜNCHEN, 26. JUNI 1962

Q QUICK

In diesem Heft
grosses Ferien-Preisrätsel

War das
Vera Brühne-Urteil
gerecht?
**Anatomie
eines
Prozesses**

Alle Grazien standen Pate:
Mode, leicht wie der Sommerwind
Bildbericht im Heft

JAHRGANG 38 · 21. JUNI 1967 · Nr. 472 · Fr. 1.50

annabelle

Unser Wettbewerb	Entdecken Sie IHRE Schönheit	Expo 67:	Neuer Roman:
«Ideale Schweizer Frau»: Sämtliche Preise		Guide für Nachteulen, Gourmets, Touristen und Shopping Girls. Von Raffael Ganz	Serbischer Sommer, die zärtliche Geschichte einer grossen Liebe

Mode
für den
Sommersport

Lady

Schmuck
Parfum
Pelz

JANUAR 1963
DM 3.40/Fr. 2.–/S. 12.–

chic

PARISER
MAKE-UP

PELZ
UND
MODE

„der herr"
IM
OKTOBER

DAS
PROBLEM
DES
MONATS

OKTOBER 1958
VERLAGSORT KÖLN
DM 2,–
SCHWEIZ sfr. 2.–
ÖSTERREICH S 12.–

MADAME

MADAME in New York
Sommerkleider
Mode am Strand
Gentleman-Look
Interview mit Curd Jürgens

MÜNCHEN · JUNI 1959 · DM 2.50
Österreich S 18.– Schweiz sfr. 2.50

JAHRGANG 33 · 25. AUGUST 1961 · N° 434 · Fr. 1.50

annabelle

Entdecken Sie Ihre Schönheit
Annabelle schlägt vor:
Reitferien · Pilzferien

**DIE
NEUE
MODE
AUS
PARIS**

annabelle

Von Lampen, Leuchtern und Laternen
Annabelle schlägt vor: Ferien für Manager
Arthur Schnitzler neu entdeckt

Die neue Mode aus Paris, Rom und Florenz

**12
REVUE**

Der Roman
auf den REVUE
stolz ist:
**Mütter
und
Töchter**

Maria Schell

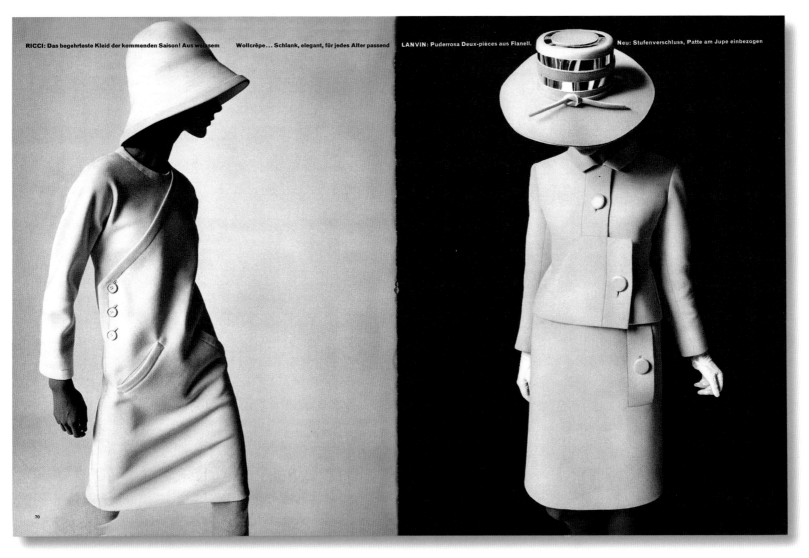

"The most wanted dress of the next season", *Annabelle* 408/1966

nail and tooth for their publication. We even went so far as to threaten to hand in our resignations."[87] Eventually, "Spending a whole day on the beach" was published in *Brigitte* 8/1966, comprising no fewer than 28 pages. In retrospect, the series qualifies as one of F.C. Gundlach's key publications in the 1960s.

Even if for the period of the 1960s and 1970s, F.C. Gundlach's name will always remain closely associated with *Brigitte*, market leader among the "mixed women's magazines" in West Germany, we must not forget that this was by no means his only platform. Other magazines for which he worked include *Madame* (published in Munich) and the Swiss magazine *Annabelle*. Differing from Brigitte in terms of concept and particularly graphic design, they were clearly not considered competition. Both magazines were more faithful in their presentation of Gundlach's compositions, often working with full-page spreads.

Typography and white space exuded elegance, thereby drawing attention to the often purist interpretation of fashion in Gundlach's work. "The concept of reduction," the photographer says with emphasis, "was crucially important for me, it meant stepping away from my own views and focusing entirely on the trendy accessory, on the actual style of fashion intended by the fashion designer".[88]

F.C. Gundlach was actively involved in fashion photography until the late 1980s, working predominantly for *Brigitte* – a unique coalition insofar that perhaps no other photographer commissioned by a magazine has influenced style over such a long period of time. Gundlach's fashion photography has shaped *Brigitte*, or rather: The photographer and editorial team together found a unique and unprecedented form of representation, achieving a balance, as it were, between fashionable information and photographic innova-

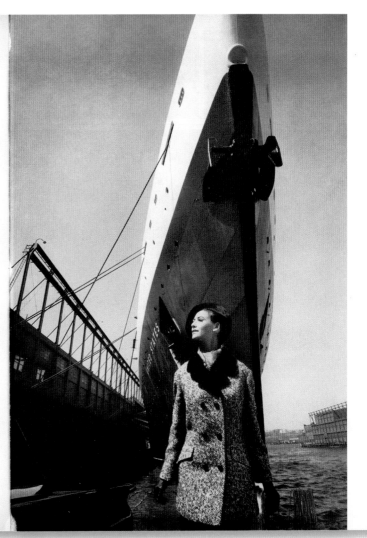

"On board of a luxury liner", *Madame,* July 1957

tion. It is obvious that Gundlach, in keeping with the spirit of the times, had to reinvent himself over and again. Gundlach proved to have a most amazing flair for upcoming trends, a "knack" for things to come, something that also marks the collector in him. Ever since the 1970s, his passion for collecting has extended his flair for pictures into the private realm. What started out as visual art or "art with photography" has by now zoomed in on the "human image in photography" – in the sense that it broadens the notion of portrait to include fashion and reportage. The fact that "applied" photography has long since found its way into the museums and is valued, purchased and collected by many will be of great satisfaction for F.C. Gundlach and confirm that it was the right professional path for him to choose. For all his life, he had seen himself as someone who provides services to others, as a photographer commissioned by the print media – and yet as a visionary who knew exactly when *his* picture was "completed and when the shoot was done".[89]

ENDNOTES

1 *Der Stern*, no. 49, 1958. The issue featured a strongly cropped version of the shot, sized only 4.5 x 3.3 cm.

2 Alexey Brodovitch. Hommage au plus grand directeur artistique de tous les temps", in: *Photo*, no. 182 (Special: Paris Capitale de la photo), November, 1982, p. 45.

3 See "Funny Face" (1957) with Audrey Hepburn and Fred Astaire in the main roles.

4 See Norberto Angeletti / Alberto Oliva: *In Vogue. The illustrated History of the World's most Famous Fashion Magazine*. New York 2006.

5 Martin Harrison: *Appearances: fashion photography since 1945*. London 1991, p. 14.

6 Ibid., p. 68.

7 In extenso on this F.C. Gundlach: "Aussagen über die eigene Arbeit," MS, F.C. Gundlach Archive, Hamburg.

8 Martin Harrison (see note 5), p. 18.

9 See Wilhelm Marckwardt: *Die Illustrierten der Weimarer Zeit: Publizistische Funktion, ökonomische Entwicklung und inhaltliche Tendenzen*. Munich 1982, p. 4.

10 Private Lehranstalt für Moderne Lichtbildkunst Rolf W. Nehrdich, Kassel, Querallee 31 (formerly: Kurfürstendamm 45).

11 See letter of recommendation written by Rolf W. Nehrdich to Sonja Georgi of July 18, 1949, Archiv Stiftung Gundlach, Hamburg. The two other letters of recommendation were addressed to Regi Relang and Friedrich Aschenbroich.

12 Mario von Bucovich: *Berlin. Geleitwort von Alfred Döblin*. Berlin 1928. Gundlach was gifted the book "in memory of our 5th Christmas at war, 1943" by his comrades in the 4th Flak Battery.

13 Walther Heering (ed.): *Das goldene Buch der Rolleiflex*. Harzburg 1936.

14 Eric Borchert: *Mein Objektiv sieht Europa. Ein Zeiss Tessar Buch*. Halle 1938.

15 "In einer Nacht vor Tobruk," Eric Borchert's last photo-story with references to the "war correspondents" who had fallen in North Africa, in: *Berliner Illustrierte Zeitung* (sic!), no. 46, November 13, 1941.

16 Lazi's studio became a veritable magnet for young photographers, among them Peter Keetman, who together with Wolfgang Reisewitz and others was received by Lazi in 1948.

17 See interviews of F.C. Gundlach conducted by Hans-Michael Koetzle, Sebastian Lux and Ulrich Rüter, Oct. 5–10, 2007 in Hamburg.

18 See Ingeborg Hoppe's written "confirmation" of Sept. 28, 1951. According to it, in the period Jan. 1 – Dec. 31, 1950, F.C. Gundlach received as salary the gross sum of DM 2.420.

19 *Funk-Illustrierte*, edited by Georg Schwarz, editorial desk: Hans Lengerer, deputy: H.D. Schmoll.

20 The "Fashion worlds" show (with a catalogue brought out by Verlag Frölich & Kaufmann) launched as an international travelling exhibition in 1985 in Rheinisches Landesmuseum, Bonn.

21 Dec. 25, 1952 marked the official beginning of a regular TV program in West Germany. On the "triumph of TV" see also: Wulf Herzogenrath, Thomas W. Gaethgens, Sven Thomas & Peter Hoenisch (ed.): *TV-Kultur. Das Fernsehen in der Kunst seit 1879*, (Dresden, 1997).

22 See "Onassis: Du musst winken, Christina!," in: *Deutsche Illustrierte*, no. 32, 1953.

23 See "Carmencita Franco. Die Tochter des Caudillo," in: *Deutsche Illustrierte*, 1953.

24 See "Nippons Uhren schlagen schneller," in: *Frankfurter Illustrierte*, no. 19, 1961, pp. 6–7.

25 See "Baumeister der Tropen: Oscar Niemeyers 'Urwaldvilla'," in: *Film und Frau*, no. 1, 1957, pp. 14–7. 80–3.

26 See "Bungalow eines Modefotografen … auch so wohnt man in Amerika," in: *Film und Frau*, no. 4, 1959, pp. 80–83.

27 See "So sah ich Hongkong – So ist Tokio – So sah ich Bangkok," in: *Film und Frau*, no. 5, 1963, pp. 98 ff.

28 See "Film und Frau in fernen Städten. New York, gesehen mit den Augen des Malers Reinhold W. Timm und des Fotografen F.C. Gundlach," in: *Film und Frau*, no. 18, 1963, pp. 76–83.

29 See Adelheid Rasche / Christina Thomson (eds.): *Christian Dior und Deutschland 1947 bis 1957*. Stuttgart 2007.

30 As early as 1936, the young Walter Dickhaut, who lived in the Rhineland, had fled Germany after being brutally interrogated by the Gestapo. In France he made friends with Hans Siemsen, who turned Dickhaut's recollections into a volume critical of the Hitler regime ("Geschichte des Hitlerjungen Adolf Goers"). After being interned and emigrating to the United States, the two were separated again in 1941, as Dickhaut, who had been a member of the Hitler Youth, was refused a residence permit for the United States and had to move on, to Cuba. The fate of Dickhaut and Siemsen should been seen in the context of the Nazis' persecution of homosexuals.

31 See note 17.

32 Ibid.

33 See "365 Tage und 1 Kostüm," in: *Film und Frau*, no. 3, 1953, pp. 14–15.

34 See letter from Friedrich Carl Piepenburg to Hans-Michael Koetzle, August 8, 2007.

35 See letter from Otto Kellner to Curt Waldenburg, May 7, 1961. Archiv Stiftung Gundlach, Hamburg.

36 See the file from "Beratender Ausschuss für das Pressewesen in der Hansestadt Hamburg. Presse-Fragebogen," Aug. 11, 1948. Hamburg State Archive, Ausschuss für das Pressewesen 39, vol. 36.

37 See interview of Rosemarie Günther conducted by Hans-Michael Koetzle on November 10, 2007 in Hamburg.

38 See "Presse-Fragebogen" on Martin Christensen, August 11, 1948 and "Presse-Fragebogen" on Kurt Ganske of August 10, 1948, Hamburg State Archive, Ausschuss für das Pressewesen 135-4, 39, vol. 36.

39 According to the "Licensing Adviser / Information Services Division", Waldenburger had been "denazified in Berlin and this had been confirmed by the Allied High Command on July 23, 1947". Hamburg State Archive, Ausschuss für das Pressewesen 135-4, 39, vol. 36.

40 Ibid.

41 "The issues bore no date; but the horoscopes for 'birthday children' reveal that the first issue very probably came out in early November 1948 published by Hamburg's 'Stimme der Frau'." Quoted from Sylvia Lott: *Die Frauenzeitschriften von Hans Huffzky und John Jahr. Zur Geschichte der deutschen Frauenzeitschrift zwischen 1933 und 1970*. Berlin 1985, p. 387.

42 The imprint lists her under "Fashion editing and graphic design".

43 For details see Hans-Michael Koetzle: "Peter Knapp. Créateur sans frontières", in: Gabriel Bauret: *Peter Knapp*. Paris 2008.

44 See Hans M. Wingler (ed.): *Kunstschulreform 1900–1933*. Berlin 1977, pp. 246–261.

45 Hans-Michael Koetzle in conversation with F.C. Gundlach, Dec. 8, 2007 in Hamburg.

46 Josef Neckermann founded Neckermann Versand KG in April 1950. That same year, the first catalogue came out with a print run of 100.000 copies.

47 See note 45.

48 "Duzfreund der Wirklichkeit. Der naive Maler Kurt Mühlenhaupt," in: *Film und Frau*, no. 22, 1962, pp. 6–9.

49 See footnote 45.

50 "Über die Kunst, modisch zu posieren," in: *Film und Frau*, no. 26, 1960, pp. 2–3.

51 "Zweikämpfe mit dem Florett," in: *Film und Frau*, no. 24, 1957, pp. 132–135.

52 "Mädchen in Weiss auf rotem Feld," in: *Film und Frau*, no. 20, 1957, pp. 24–27.

53 "Mädchen, Männer, rasende Räder …," in: *Film und Frau*, no. 9, 1961, pp. 12–14.

54 Friedrich Dreyer is mentioned in the editorial for the first time in 1963 (issue 6). Rosemarie Günther remembers that Dryer was there "from the beginning". See interview Hans-Michael Koetzle with Rosemarie Günther on November 10, 2007 in Hamburg.

55 "Die Modelinie," in: *Film und Frau*, Modesonderheft Frühling/Sommer 1956, pp. 20–23.

56 See note 17.

57 "Erster Blick auf die neue Mode," in: *Film und Frau*, Modesonderheft Frühling/ Sommer 1957, pp. 18–27.

58 For a detailed account on Pierre Gassmann see: Hervé Le Goff: *Pierre Gassmann. La Photographie à l'épreuve*. Paris 2000.

59 See note 17.

60 "Das fliegende Hotel," in: *Stern*, no. 34, 1955.

61 For a detailed account see: Herbert Lindinger (ed.): *Die Moral der Gegenstände. Hochschule für Gestaltung Ulm*. Berlin 1987, pp. 146–147.

62 "Dick Avedon fotografiert," in: *Film und Frau*, no. 14, 1956, p. 22.

63 The textile manufacturer who was based in Norhorn (Lower Saxony) went bankrupt in 1996. An exhibition featuring industrial and fashion photography from the com pany's archive which had been preserved was run towards the end of 2006 at Stadt- museum Povelturm (Nordhorn).

64 See letter from Klaus Gerwin to F.C. Gundlach vom 11. Januar 1959. Archiv Stiftung Gundlach, Hamburg.

65 For a detailed account see: Margarethe Szeless: *Die Kulturzeitschrift ,Magnum'. Photographische Befunde der Moderne*. Marburg 2007.

66 Hans-Michael Koetzle (ed.): *twen. Revision einer Legende*. Munich 1995.

67 See Patrick Rössler (ed.): *Moderne Illustrierte – Illustrierte Moderne. Zeitschriften- konzepte im 20. Jahrhundert*. Stuttgart 1998, p. 22.

68 See Axel Schildt / Detlef Siegfried / Karl Christian Lammers (eds.): *Dynamische Zeiten. Die 60er Jahre in den beiden deutschen Gesellschaften*. Hamburg 2000, p. 13.

69 Since as far back as the beginning of 1954 *Film und Frau* used colour printing inside the magazine. Gundlach's first verifiable publication in colour was the cover of Modeheft Herbst/Winter 1955/56 (published in September), followed by "Spiel im Schleier" featuring Grit Hübscher as a model, in: *Film und Frau*, no. 25, 1955, pp. 4–5.

70 For a detailed account see: Sylvia Lott: *Die Frauenzeitschriften von Hans Huffzky und John Jahr. Zur Geschichte der deutschen Frauenzeitschrift zwischen 1933 und 1970*. Berlin 1985.

71 See letter from F.C. Gundlach to Curt Waldenburger from January 22, 1963. Gundlach Foundation archive, Hamburg.

72 Ibid.

73 See letter from Barbara Buffa to the author, undated (October/November 2007).

74 See Hannelore Schlaffer: "Fasten, joggen, selber nähen. Für die Frauenzeitschrift 'Brigitte' bedeutete Modeberatung immer auch Charakterbildung. Eine deutsche Institution wird 50," in: *Die Zeit*, no. 20, May 6, 2004, p. 41.

75 See *Brigitte*, no. 8, April 13, 1965.

76 See draft agreement from July 1, 1965. Gundlach Foundation archive, Hamburg.

77 Ibid.

78 See note 45.

79 See Sylvia Lott-Almstadt: *Brigitte 1886-1986. Die ersten hundert Jahre. Chronik einer Frauenzeitschrift*. Hamburg 1986, p. 259.

80 DIVO-Leseranalyse (1964), ibid., p. 232.

81 Ibid., p. 260.

82 See "Die neue Mode," in: *Brigitte*, no. 4, 1966, pp. 14–49.

83 "Die neue Frühlingsmode," in: *Brigitte*, no. 5, 1969, pp. 4–39.

84 "Die neue Mode aus Berlin, München, Paris," in: *Brigitte*, no. 4, 1964, pp. 4 ff.

85 See Klaus Honnef (ed.): *F.C. Gundlach – Modewelten. Photographien 1950 bis heute*. Berlin 1986, p. 26.

86 Interview Hans-Michael Koetzle with Barbara Buffa on November 9, 2007 in Hamburg.

87 F.C. Gundlach: "Modewelten. Eine kurze Einführung in eine wahre Geschichte der Modephotographie," in: *Regina*, 1997, p. 24.

88 See Margit Tabel-Gerster: *Der Fotograf ist ein Dienstleister. Ein Gespräch mit F.C. Gundlach*. Hamburg 1988, p. 54.

89 F.C. Gundlach: "Modewelten. Eine kurze Einführung in eine wahre Geschichte der Modephotographie," in: *Regina*, 1997, p. 24.

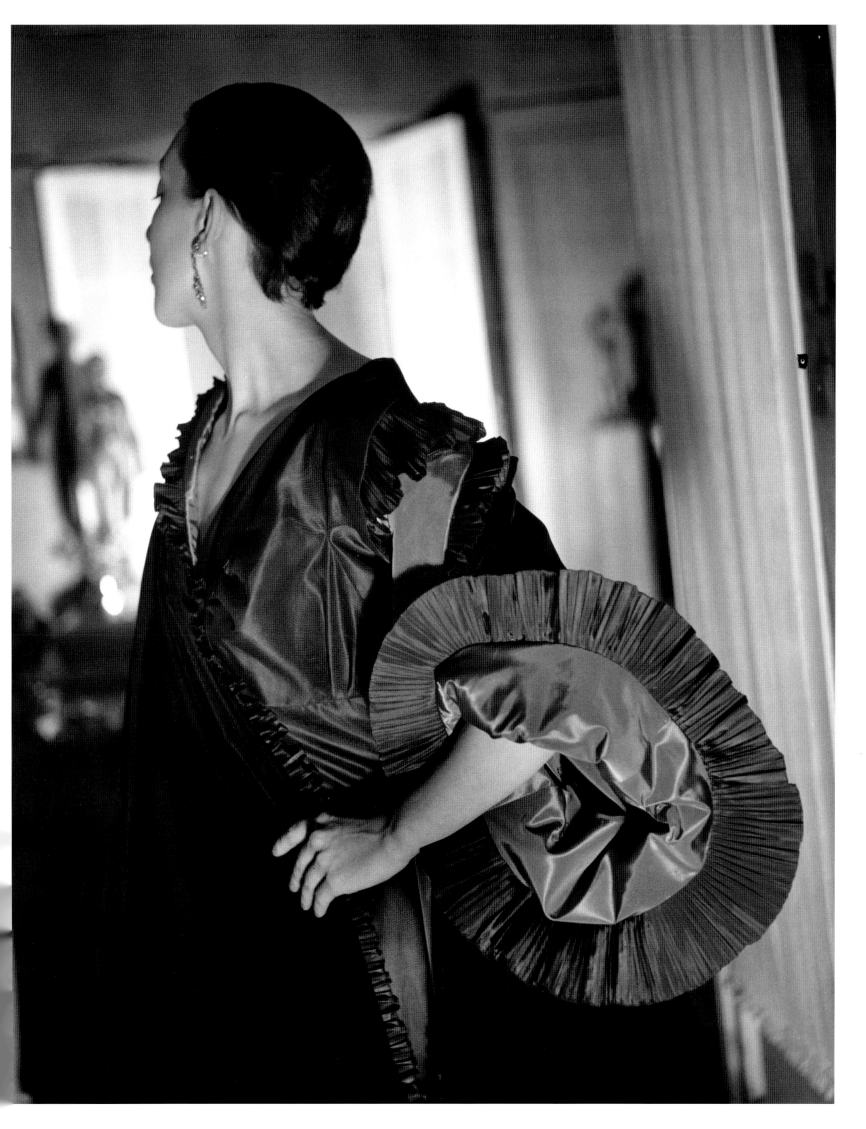

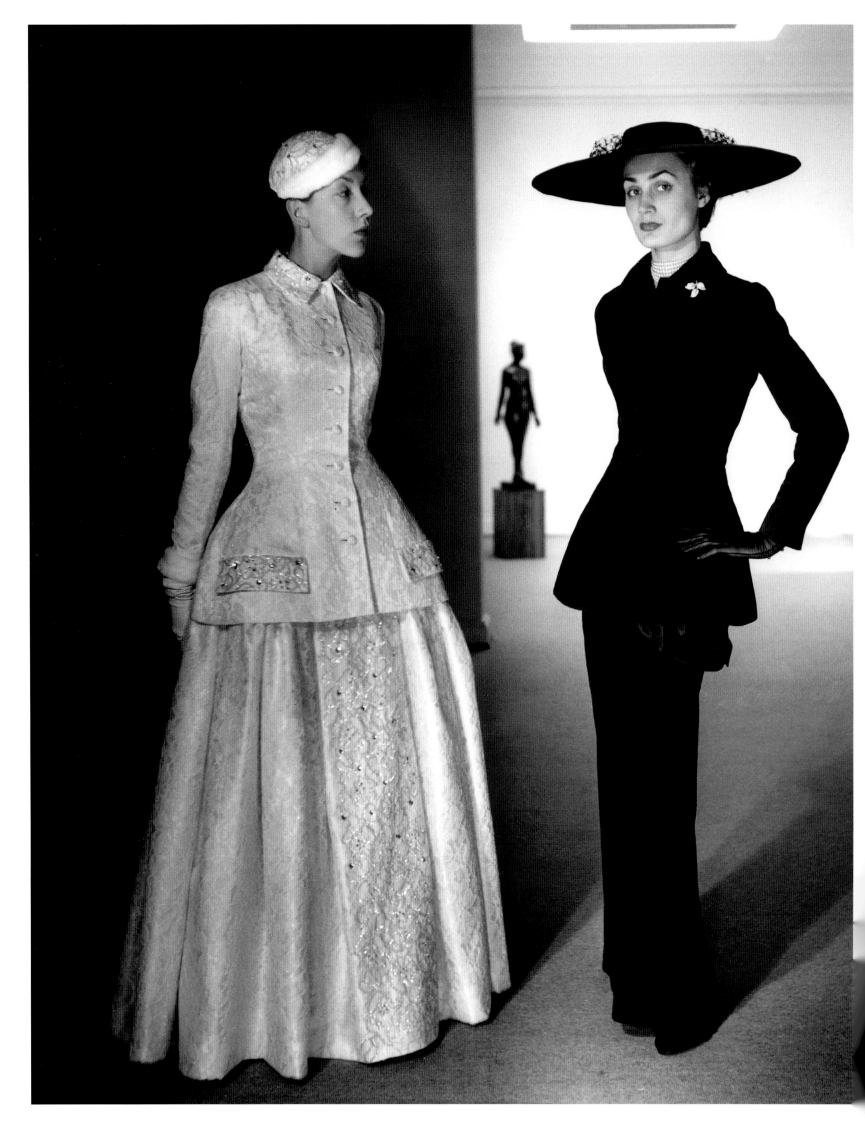

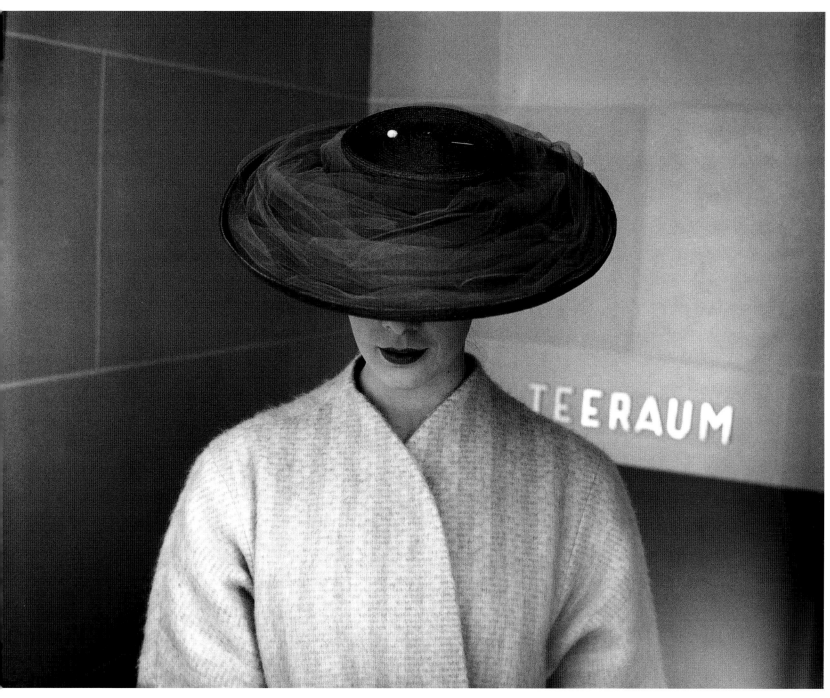

"The hat", Renate von Arnim, hat by Mecklenburg, Hamburg 1956, in: *Film und Frau* 11/1956

left page: "In the salon of Helle Brüns", Hamburg 1954, in: *Film und Frau* 24/1954

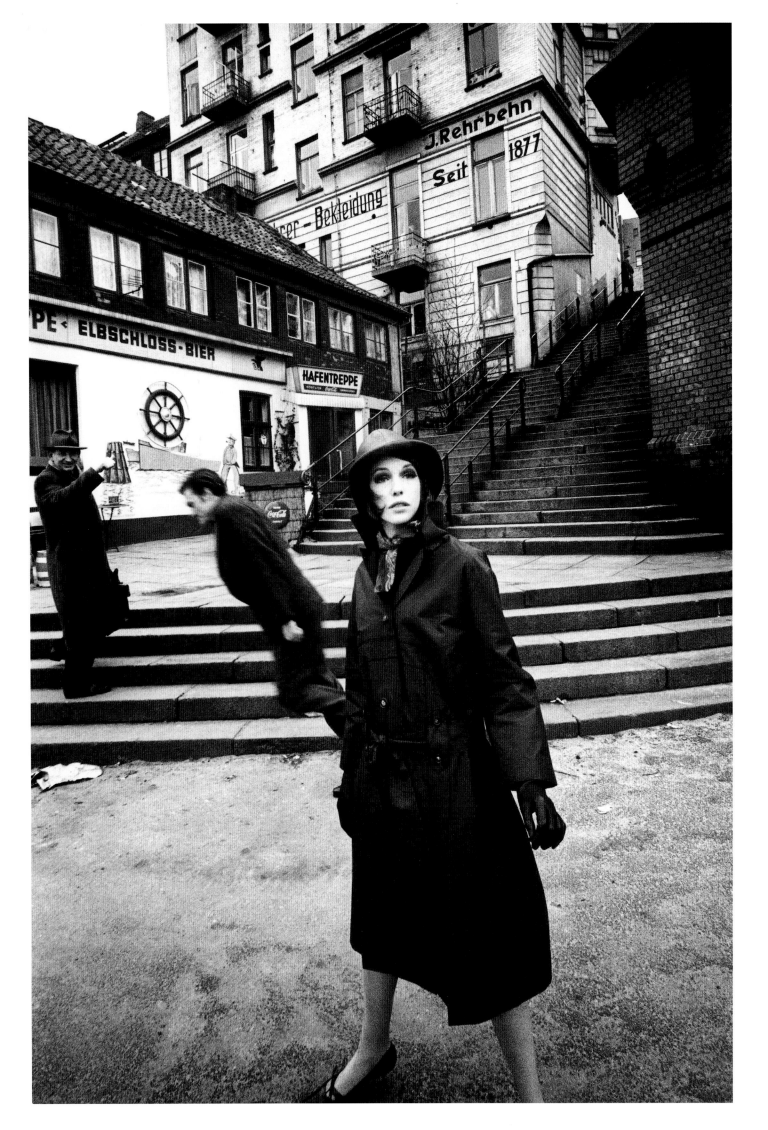

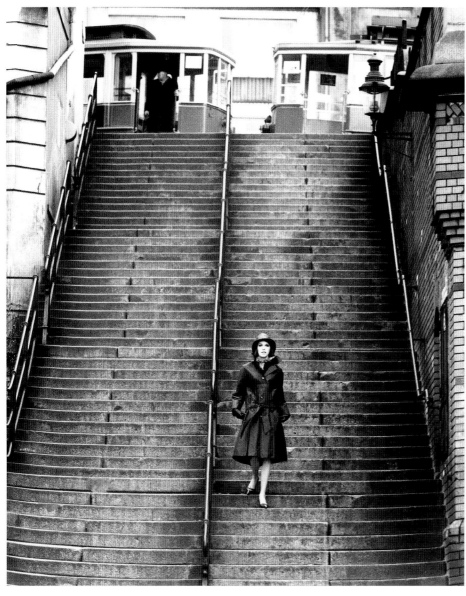
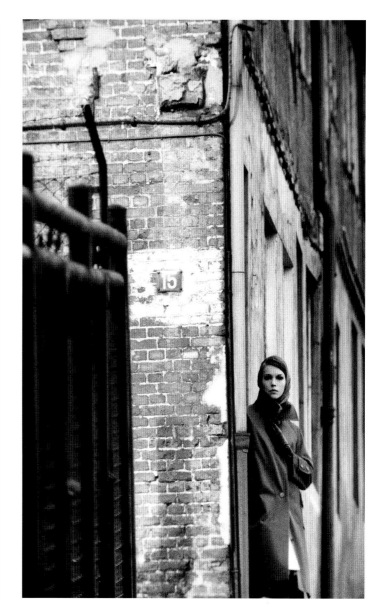

"The stairs at the Pinnasberg", coat by Nino, Hamburg, St. Pauli 1958

"Hamburg St. Pauli", coat by Nino, Hamburg 1958

left page: "Encounter on the Hafenstraße", coat by Nino, Hamburg, St. Pauli 1958

next spread: "The quayside bar", coat by Nino, Hamburg 1958

Lo Olschner, sleeping gown by Vollmöller, St. Gallen 1955, in: *Film und Frau* 18/1955

right page: Jeannette Christiansen in a poncho, Marrakech 1973

next spread: Marie-Louise Steinbauer, ensemble by Topp + Franck, Hamburg 1961, in: *Film und Frau* 4/1961

"Autumn fashion", Hamburg 1965, in: *Brigitte* 18/1965

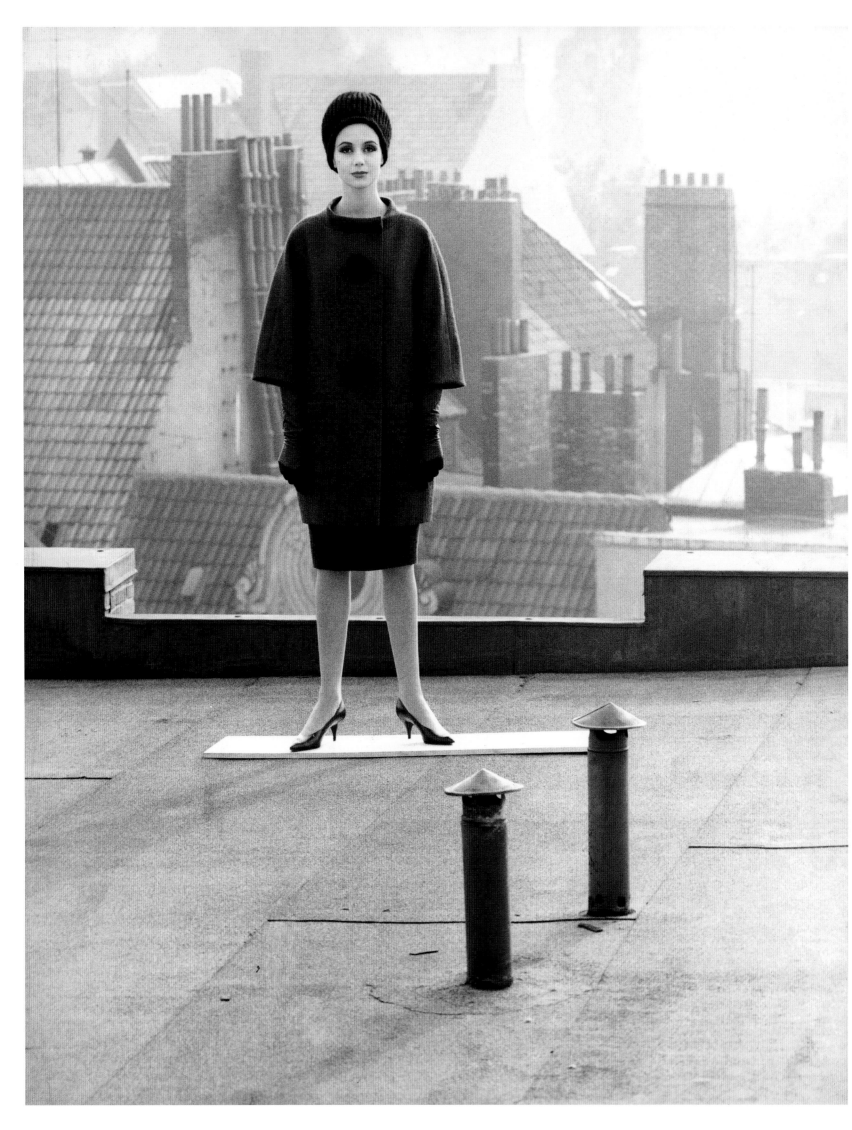

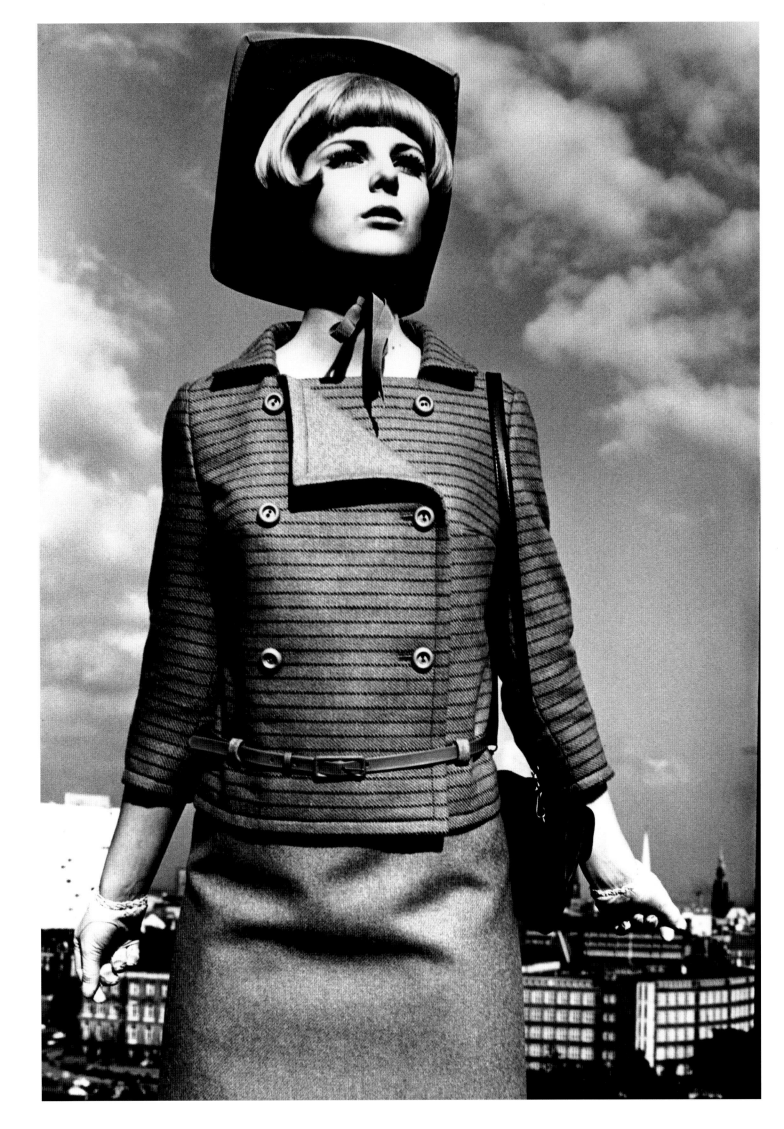

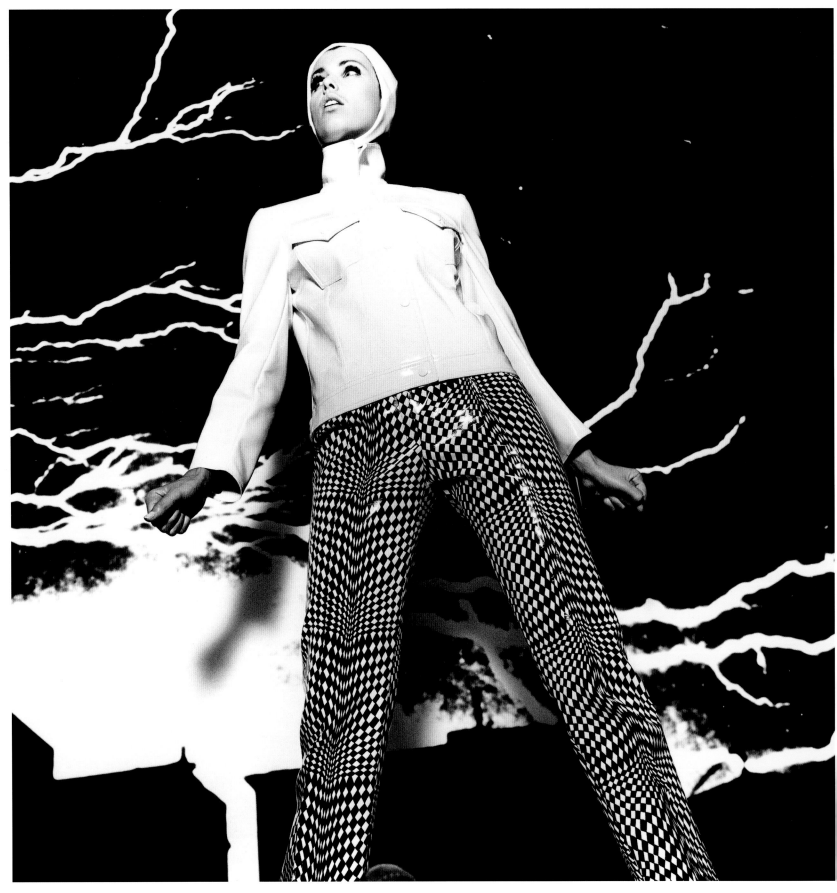

"Rain coats for any weather", Mareike, Hamburg 1966, in: *Brigitte* 4/1966
previous spread: Portrait, Hamburg 1958
Sophie Derly, Hamburg 1963

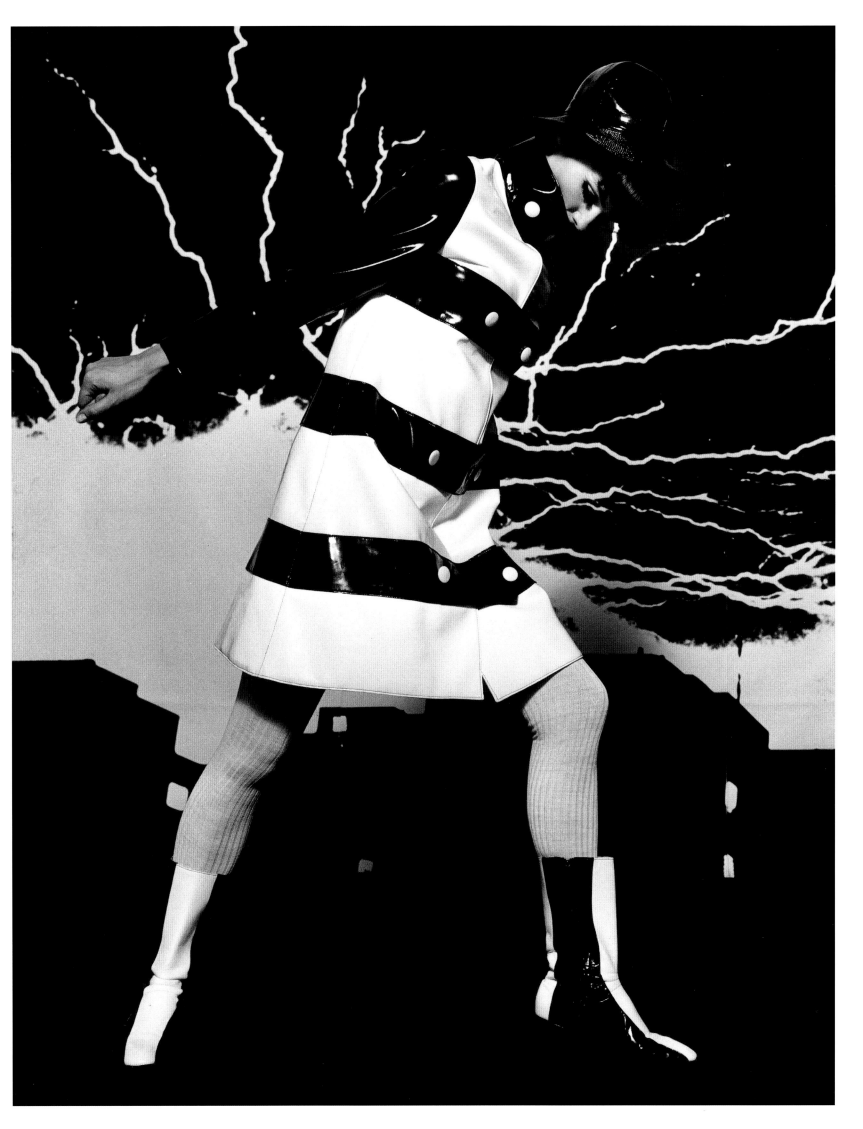

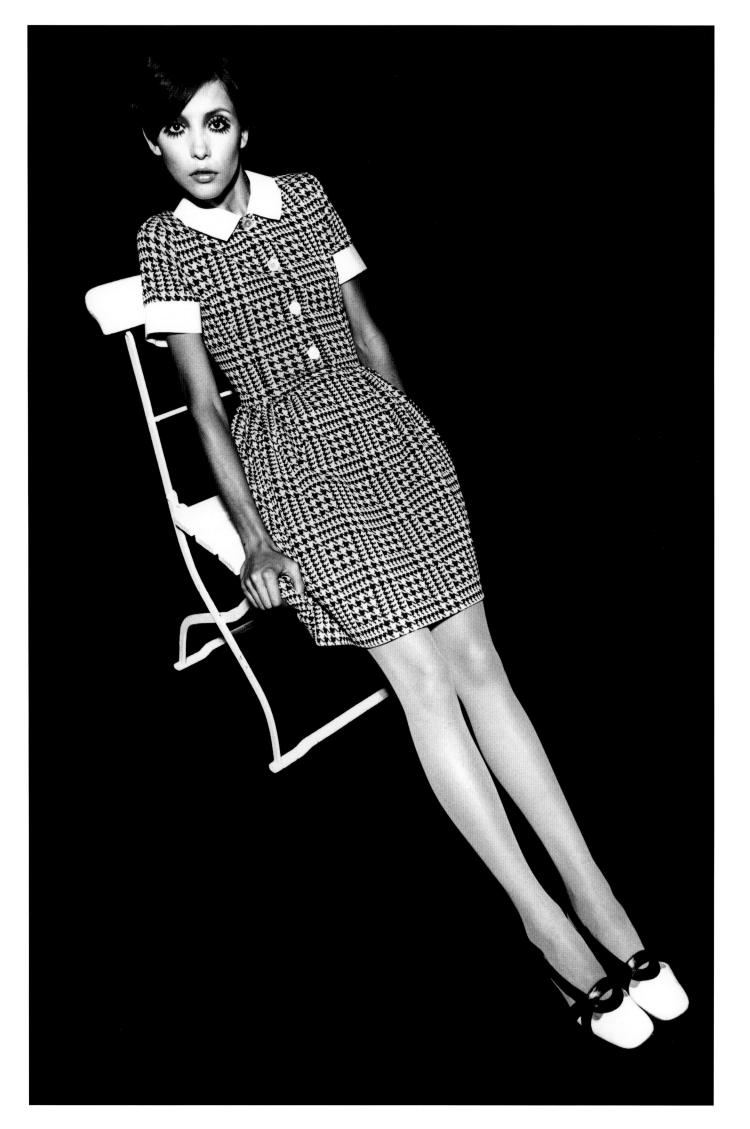

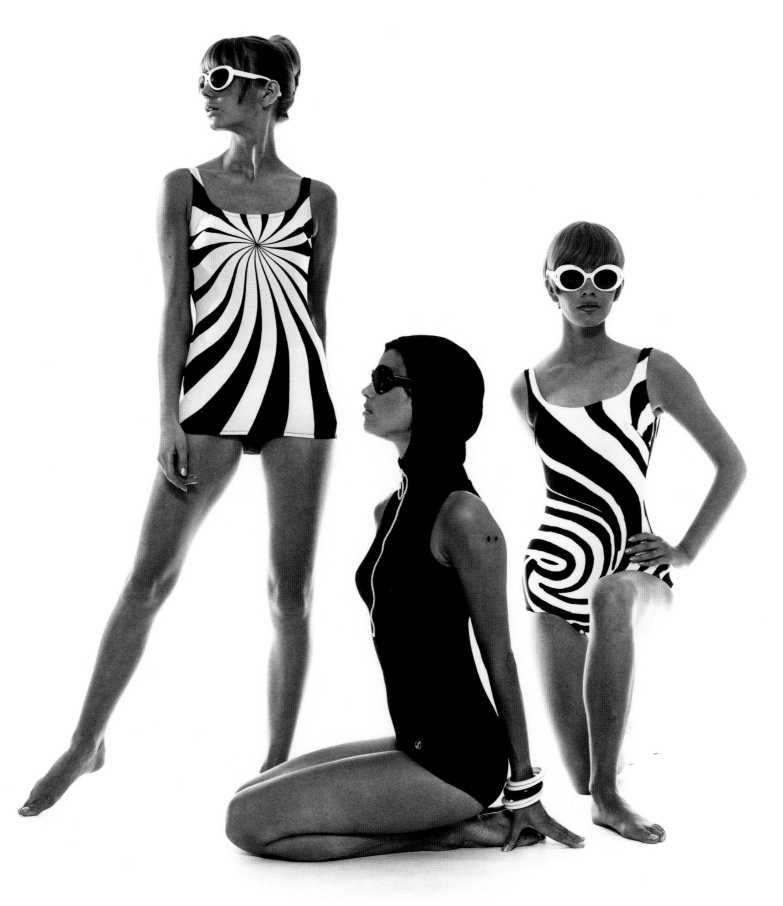

Op Art-bathing suits, Hamburg 1966, in: *Film und Frau* spring/summer 1966

left page: "Op Art-fashion", Cathy Dahmen, dress in hound's tooth design by Falke, Hamburg 1969, in: *Falke Fashion* 1969

next spread: Cathy, Birgitta and Sunny for *Falke Fashion*, Hamburg 1969

Simone d'Aillencourt, mini dress by *Falke Fashion*, Hamburg 1967, in: *Falke Création* 67

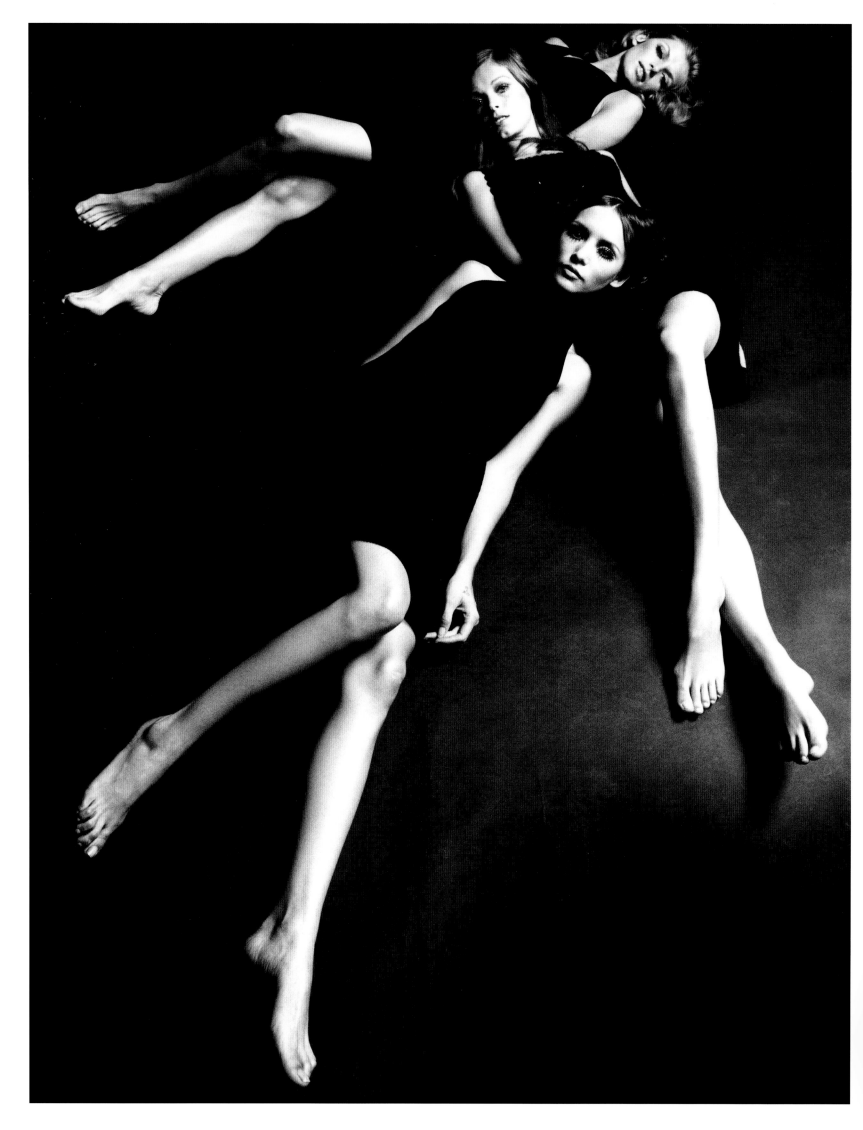

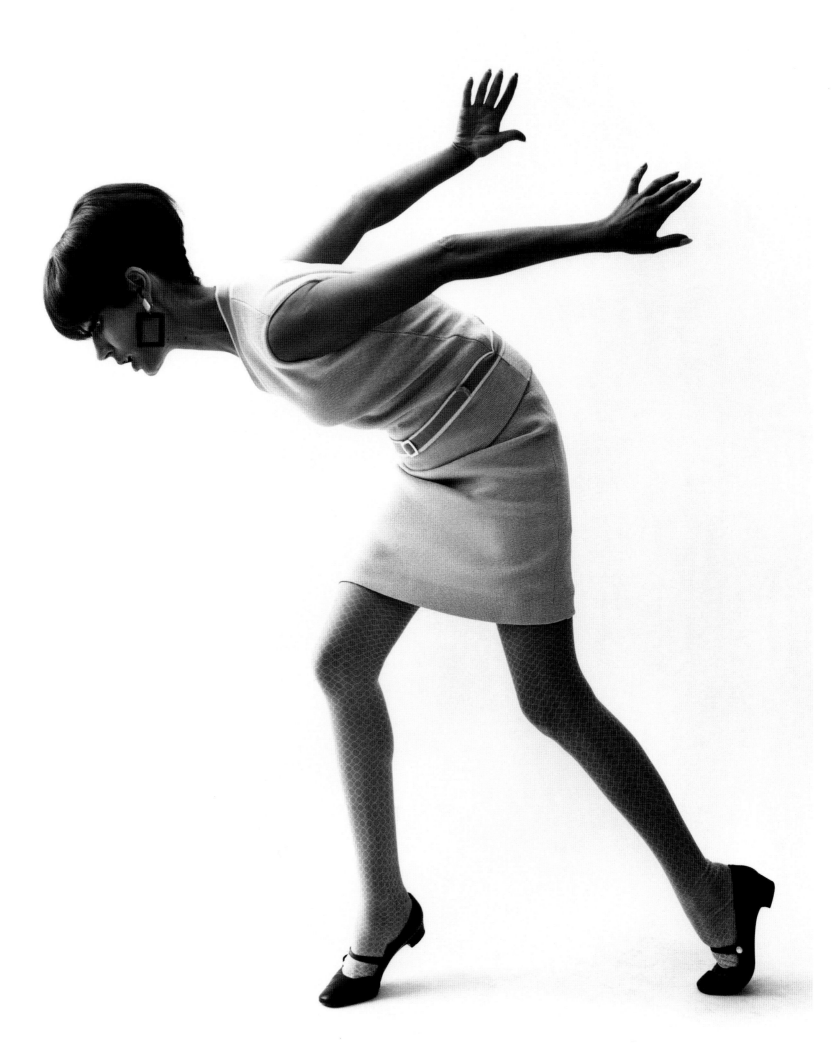

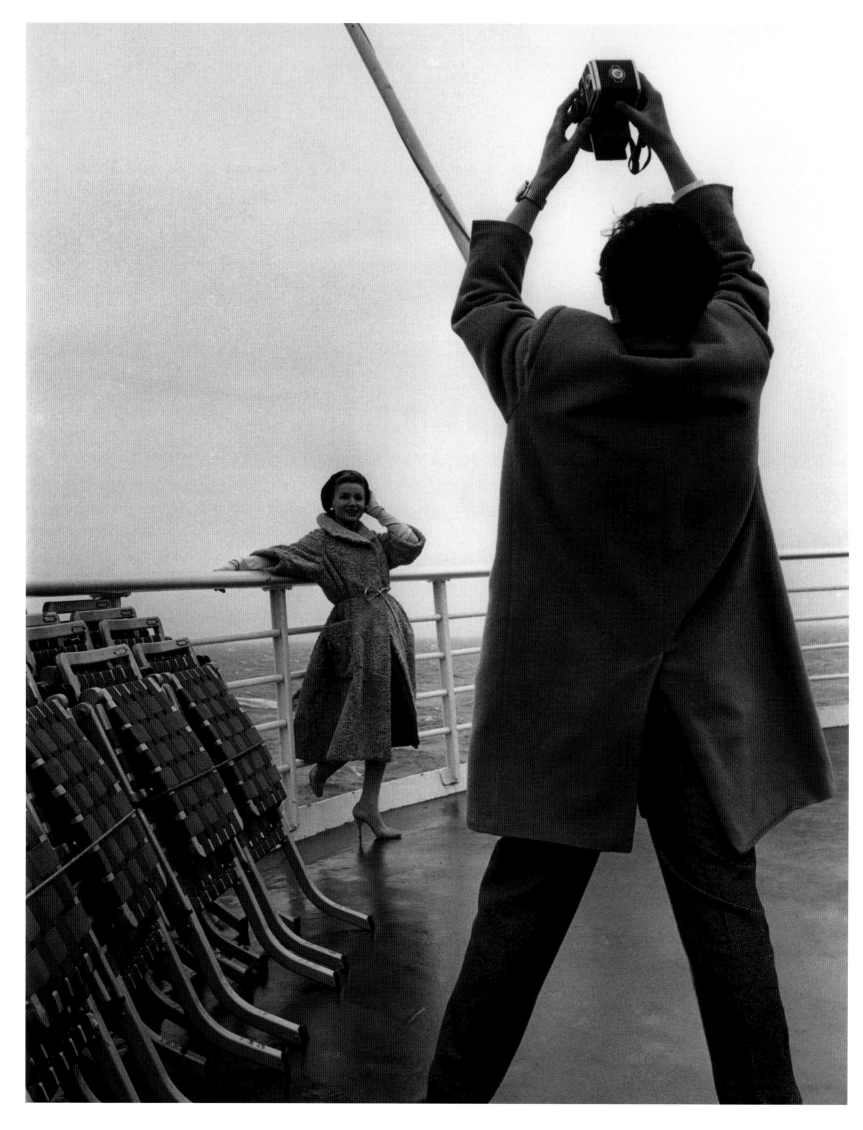

THE STAGED WOMAN

THE MODEL IN THE
WORK OF F.C. GUNDLACH

Ulrich Rüter

Models are the fashion photographer's "accomplices". We can hardly imagine fashion without it being presented on the body, and it seems to enjoy little success to boot. In the course of his career as a fashion photographer, F.C. Gundlach has worked with countless photo-models. Many of them have remained unknowns; they have gone down in a historical archive of umpteen thousand collection pictures and catalogue productions. Some faces, however, have remained in the public eye. This presence not only comes from the one great fashion shot, but is above all also the result of the creative alliance between photographer and model. These pictures particularly catch our eye when looking through F.C. Gundlach's work. They have retained their vivacity, charm and grace. It is only when we go through the archive carefully step by step that links and correlations become clear between the respective models and the photo assignments for magazines and adver-

tising campaigns. Gundlach embarked on an intensive collaboration with some of them lasting several years, based on a mutual friendship and the fun they found in creative experimentation. Yet only in rare cases did he maintain private contact with his models through the years, and in even rarer cases over decades.

The terms mannequin and photo-model[1] are often used synonymously, although in the actual job descriptions there are considerable, historical differences. Even though most photo-models also performed on the cat walk in fashion shows or worked as mannequins in a fashion house at the start of their career, what is required of a photo-model differs significantly from what is required of a runway mannequin, who has to present fashion with flowing movements. In contrast, a photo-model has to move in sequence, grasp the effect of the two-dimensional presentation of fashion and support it by means of advantageous

F.C. Gundlach on the SS United States 1959

241

BETTINA

Bettina Graziani (1925-2001) was one of the first top models in France to have taken the leap from fashion store mannequin to photo-model of international acclaim. The model, whose real name was Simone Bodin, was given the pseudonym Bettina by Jaques Fath when she launched her career as an in-company model, swiftly becoming the most important model at Hubert de Givenchy and Christian Dior. In the early 1950s, F.C. Gundlach also had the opportunity to do a shoot with her, featuring items from the Dior collection.

In the mid-1950s, her unhappy affair with Prince Aly Khan catapulted Bettina into the gossip columns of the yellow press. In 1960, the prince tragically died in a car crash, while Bettina survived with severe injuries. Later she opened her own fashion studio, only to withdraw from the public eye soon thereafter.[15]

poses. "The photo-model had to structure the photographer's vision, unfold her beauty while keeping still in the interplay of light and shadow. The camera has a merciless eye. Many mannequins hated it because of that."[2] The art lay in the model's ability to flirt with the camera lens, to select the appropriate gestures and poses intuitively from her repertoire. Photo-models also had a much higher standing than catwalk models, meaning that a precise differentiation was often important for an appropriate distinction.

When F.C. Gundlach made fashion photography the focus of his work in the early 1950s, there were hardly any professional photo-models around. Even in the 1960s there was not a single model agency in Germany. Personal contacts and a close network for private deal-making were a must. Today, in contrast, a photographer has thousands of models to choose from in Germany, and internationally the number would seem to be infinite. All types are available and countless agencies are constantly offering the latest model catalogues.

In the 1950s and 1960s, F.C. Gundlach attended countless fashion shows. He wanted to develop a feel for the designers' latest trends. It was only when he looked at thousands of models at the same time that the contemporary leitmotif emerged which he then attempted to realize with the right mannequins and photo-models. "Of course, you can always take a great model and a great outfit and make a picture, but it won't necessarily be in keeping with the trend. And there are wonderful outfits that look fantastic in motion, when a model wears them on the runway, but in a photo look completely dull, boring."[3] The fashion house shows took place during the day, the collections being presented on the catwalks. At night, a few select photographers were allowed to 'borrow' their favourite parts of the collection. The competi-

Bettina, ensemble by Christian Dior, Paris 1952

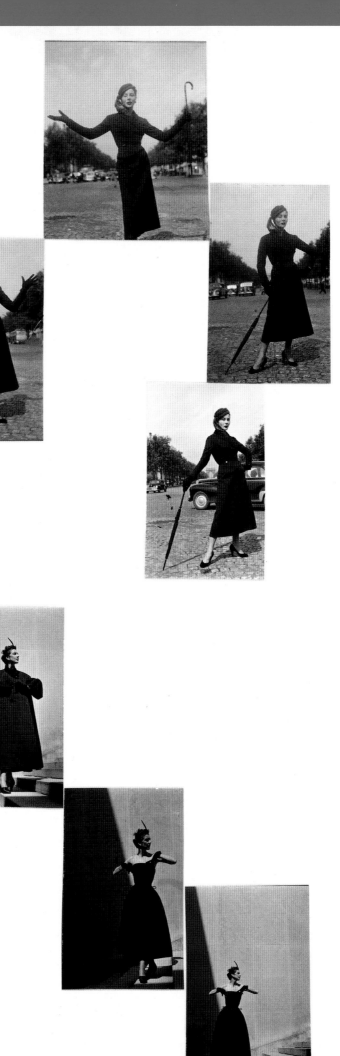

tive pressure was enormous, as every photographer wanted precisely those dresses who represented the new line especially impressively. There was not much time to take the photos, and the models' reliability was particularly important. Whereas initially it was the presenters and mannequins, meaning the couture houses' own models, who were booked for photo shoots, from the late 1950s it was professional photo-models. On the one hand, the model had to "understand" the outfit and be able to present it appropriately, on the other she also had to correspond to the photographer's vision. "The seemingly artificial stance, the careful selection of matching accessories, the rigid pose all appear to reduce the role of the model to that of an ornate clothes stand. Yet this is certainly not the case. It is indeed exceptionally difficult to infuse an outfit with life such that it appeals to a wide public. F.C. Gundlach, the great fashion photographer, looks throughout the whole of Europe for his models. He finds this the most difficult and arduous part of his professional work."[4]

The longer photographer and model work together, the greater the degree to which closeness and harmony infuse the final result. The favoured type of woman in the 1950s and early 1960s was very ladylike, meaning that models could remain within the industry considerably longer and thus intensify their collaboration with the photographer.

With increasing professional success and photographic experience, F.C. Gundlach was able to prepare his fashion features in detail, by himself deciding the concepts for location, light and the models. Although the editors of *Film und Frau*, his most important client from the early 1950s, set the themes, the photographer was free to realize them as he wished. Yet only at that moment when the model also added her experience and attitude to life, when personality and pose, location and setting were in harmony, was the result a perfect picture, the successful photo shoot.

However, the model had to suppress her personality to such an extent that it did not detract from her actual task of conveying the current style and she was perceived simply as a particularly beautiful representative of a fashion line or item of clothing. If her personality did take on significance in her shoots, it was to support her role as "ambassador of fashion" and nothing else. This often proved to be a tightrope walk in advertising for cosmetics. Although the face should be recognizable, it should in no way overly detract from the product.

Many companies and product representatives also valued the public image of models outside the magazine branch. This meant the models enjoyed an opportunity for public appearances outside the actual fashion scene. Social events such as premieres, balls and receptions were the best stages on which to publicly spotlight the models as personalities. Then the magazines would report on these events in such a way that readers would get the feeling they were participating in the models' lives beyond the photo studios and runways too. Taking the example of *Film und Frau*, we can identify typical fundamental structures in its reporting on and evaluation of the life of the model. "Back then", recalls F.C. Gundlach, "in the 1950s, movies and movie stars had a much greater significance than today, and fashion was also something exclusive, removed from everyday life and not part of it, as it is today. Like the movies, fashion was simply a dream."[5] The haute couture he photographed was unaffordable for most readers of *Film und Frau*. For example, in 1955 a Parisian designer dress cost between 100,000 and 750,000 francs. The magazine's photo-models had the job of giving life to that dream of an uncomplicated, luxurious life.

Leafing through *Film und Frau* magazines, it becomes clear that even as early as the 1950s, the profession of photo-model was seen as a dream job. According to the editors, it was not actually a profes-

"The program of new fashion", *Film und Frau* fall/winter 1953/54

Programm DER NEUEN MODE

SUSANNE
unser Titelbild,
Miß Germany 1950,
Reiterin aus Passion.
Hobbies: Teen-ager-Modelle
und Mannequin

zeigt Ihnen die Garderobe großen Stils für eine Frau von Welt auf den Seiten 1–7, 12, 13

GABY
bisher Star-Mannequin, jetzt Ehefrau und rechte Hand von Hubs Flöter und sein liebstes Fotomodell.
Hobbies: Autofahren und Hubs,

führt Ihnen elegante Komplets, Kostüme und Kleider in sanften Farben und sanften Formen vor, auf den Seiten 4–9, Golf- und Skisport treibt sie auf den Seiten 39–44.

CANDY
1,70 groß, Taillenweite 54 cm, entdeckt von „Film und Frau", Mannequin bei Oestergaard, Lieblingsmodell von F. C. Gundlach. Beruf: Fotomodell und Hausfrau,

sehen Sie in schicken Separates und Kostümen auf den Seiten 10–11, 20–21, in Schwarz mit Weiß und Pelzen auf Seite 24 bis 56 und vielen „Film und Frau"-Modellen auf den Seiten 68, 84, 87, 90, 94, 118.

INGE
1,78 m groß, Mannequin bei Gehringer & Glupp, dunkle Stimme, dunkle Augen, Lieblingsbeschäftigung: fremde Sprachen und Reisen in den Süden,

finden Sie — zwiefach verpackt — in damenhaften Straßenkleidern und Kostümen auf den Seiten 6–9.

KARIN
Dame der Gesellschaft und gute Hausfrau, seit Jahren beliebtes Fotomodell.
Hobbies: Golf, Autofahren, Skilaufen, Reisen.
Trinkt nicht, raucht nicht, schläft viel,

erscheint in schönen Kleidern zum Cocktail und am Kamin auf den Seiten 16–17, 22 und in schicken, tragbaren und sportlichen „Film und Frau"-Modellen auf den Seiten 64–66.

IRINA
in München zu Hause, dunkle Augen, dunkles Haar, erfolgreichstes und beliebtestes Mannequin bei Schwichtenberg, gern gesehen und fotografiert von Charlotte Rohrbach,

gefällt als schöner Gast beim herbstlichen Turf in Kostümen für Madame auf den Seiten 32–35 und trägt weiße Garnituren auf den Seiten 110–111.

PUPPI
Typ des jungen Mädchens, wohnt bei den Eltern, verkaufte früher Goldpfeil-Taschen, führt jetzt bei Staebe-Seger schicke Kleider für die junge Dame vor,

wurde in kapriziösen Cocktailkleidern und aparten Tageskleidern fotografiert auf den Seiten 14–15, 36–37.

SCHLIPPI
distinguierte blonde Schönheit,
Typ:
Lady bis in die Fingerspitzen,

sehen Sie in eleganten Kleidern mit Jacken und Stolen aus warmer Wolle, die Madame gefallen, auf den Seiten 36–37.

KARIN
(Remsing), nicht verwechseln mit Fotomodell Karin.
Beruf: Schauspielerin.
Hobby: Schauspielerin.
Glücklich verheiratet,

begegnet Ihnen als bezaubernde Braut auf den Seiten 62–63 und lädt Sie ein zur Schau der „Film und Frau"-Modelle auf Seite 61.

INGRID
bekannt als die junge Schauspielerin Ingrid Andree von Film und Bühne.
Hobby: Fotomodell für „Film und Frau",

ließ sich für unsere jungen Damen in Oestergaard- und „Film und Frau"-Modellen fotografieren auf den Seiten 28, 50–51.

HELGA
Südseeschöne aus Berlin-Neukölln, mit langen, schwarzen Haaren, frisch verheiratet, jüngstes Mannequin bei Horn, Berlin,

zeigt Ihnen festliche Kleider für den Abend auf den Seiten 18–19.

HILDEGARD
entdeckt von „Film und Frau" und erstmals fotografiert von Norbert Leonard, Hausmannequin bei Sommermeier-Modelle, zwischendurch glückliche junge Ehefrau und Mutter,

kegelt, tanzt und steht Modell als junge Dame zwischen Schule und Beruf auf den Seiten 52–53, 80–83, 142–145.

ANNELIESE
(Kaplan), bekannt als Kunststudentin und Filmmatrose in „Käpt'n Bay-Bay", wohnt bei ihren Eltern in Hamburg.
Hobbies: Angeln und neuerdings Chauffieren,

führt für „Film und Frau" viele kleine Kleider vor auf den Seiten 52–53, 142–143 und eine kleine Garderobe von „Film und Frau"-Modellen auf den Seiten 70, 74–75, 88–89, 92–93, 102–103, 117.

BAMBI
auf der Kunsthochschule in Berlin bekannt und beliebt als Kathrinchen.
Berufsziel: Modegraphikerin und Modeschöpferin.
Hobbies: Mannequin bei Lindenstaedt und Brettschneider und Schneidern,

treffen Sie in College-Kleidern in der Bibliothek auf den Seiten 48–49 und mit weißen Krägelchen auf den Seiten 110–111.

MARION
auf der Schulbank entdeckt, auf vielen Modefotos gesehen.
Beliebter und seltener Typ des deutschen Teen-agers,

und das kleine Fräulein zwischen Schule und Beruf auf den Seiten 52–53.

ELFI
viel geliebter und diskutierter Typ, Ihnen aus „Film und Frau" seit fünf Jahren bekannt, Garçonne-Typ mit südlichem Charme und südlichem Akzent, Salzburgerin.
Hobbies: bei Horn vorführen und für sich Kleider entwerfen und nähen. Tüchtige Hausfrau und Geschäftsfrau,

verbringt in aparten Kostümen mit Ihnen einen Oktobertag in der Stadt auf Seite 31.

FERNER WIRKEN MIT: BRIGITTE · BUSSI · CHRISTA · DAGMAR · DIDO · HÜBSCHER · INA · INGE · KARIN · LINDA · LOUISA · MARION · MONIKA · YVETTE

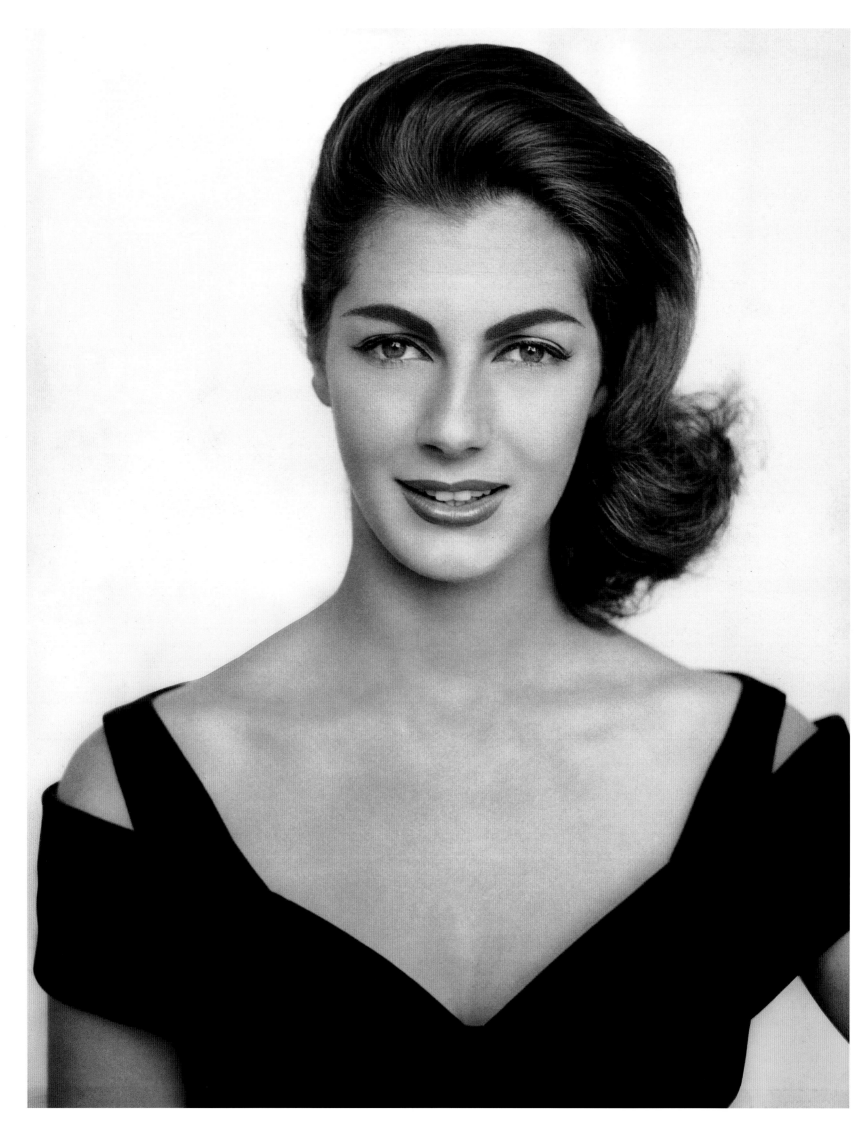

sion, because it could not be learnt. Quite simply, either you had the prerequisites or you did not. The view conveyed in *Film und Frau* was that above all, you could not practice this occupation for long. In this context, it served as a transition to successful integration in the patriarchal society, in which a woman's goal was to get married and have a family. *Film und Frau* did not contest the contradiction between "real" work and enjoyable modelling for pure fun, which thus became typical of the ambivalent attitude towards the gainful employment of women in the 1950s. Although a mannequin's work was presented as a challenging job full of deprivations, it was never allowed to look like work. Discipline and endurance were qualities that could also be applied to other professions.

The photo-model became the editorial team and the photographer's accomplice as they all strove to set the stage for dreams and illusions that particularly during the 1950s served to mask post-war realities. The glamour and elegance of *haute couture*, the abundance of the fabrics, the splendour of the furs and evening gowns, the game with precious accessories – the desired artificial result was already created during the shoot, for example, by having pencil skirts pinned even tighter. It was brought to perfection by retouching in the graphic design, mostly through some additional tightening of the waist, which produced supernatural fashion elves for the printed issue. Thus productions appeared to be fairy tales and stories of elegant ladies, of rich and, above all, beautiful, spoiled and carefree dream girls who, on their holidays, at balls, while taking a stroll around town or in their perfect homes simply had fun posing for the photographer.

Aside from Susanne Erichsen – the epitome of the German post-war "Fräulein-Wunder" (Miss Miracle), at the beginning of the 1950s F.C. Gundlach based his female image primarily on photo-model Candy. A typ-

ical blonde, Candy Tannev had international appeal and, alongside Susanne Erichsen, she was extremely successful as a German "export hit": "Even Regi Relang said, *Candy, you are the only German who has made it big. The other one, Erichsen, is not so appealing.* She is right in saying so because as a type, Susi is far too serious," Candy remarked with confidence.[6] A Dior story in *Deutsche Illustrierte* introduced her as follows: "Candy is the only German girl to have made it in Paris. She is one of the highest paid and most sought-after photo-models, and there is barely a free slot in her diary from 9 a.m. to 7 p.m."[7]

Katharina Denzinger and Grit Hübscher were also part of the group of photo-models who regularly worked with F.C. Gundlach alongside Susanne Erichsen, Candy Tannev and Elfi Wildfeuer. Readers of *Film und Frau* were able to take a lively interest also in the lives of these two models. The cover girl of no. 22/1953 was introduced as follows: "Katharina is the name of the striking girl with the short black crop and a pair of sparkling dark eyes in an ivory-coloured face. However, since she debuted as a mannequin at Modehaus Lindenstaedt und Brettschneider in Berlin, she has been known to the world merely as 'Bambi'. With the timid grace of a delicately limbed deer she moved through the show rooms, occasionally daring to cast a shy glance at the audience from her ever so slightly frightened eyes. Nonetheless Bambi is a young lady who knows what she wants. With her dainty feet and ankles firmly on the ground, she is focused on achieving her ambitions. Presenting fashion is for her a means to an end. Her dream is eventually to design her own clothes and present them – or rather, have them presented – in her own boutique in the not too distant future. Her chosen path requires her to take many steps – as a mannequin, photo-model, fashion illustrator and graphic artist and, what is more, she will have to pass the final exam at the Berlin Fashion Academy. May we wish Bambi the very best for her

SUSANNE ERICHSEN

"Back then, I had no idea that this is actually not a taught profession. Sure, some skills can be acquired, but what is crucial to the job, namely discipline, a will of iron, endurance and a good sense of your body, those things must be in your genes. It is the only way in which your charisma will make it past the initial success and ultimately help you to foster a career in modelling."[16] It was more due to chance that Susanne Erichsen (1925–2002) was discovered in Munich by Lore Wolff, fashion editor of Heute magazine, which prompted her to work as a mannequin and photo-model. Winning the Miss Germany competition in September 1950 marked the beginning of her international career. Her profession stood in stark contrast to her immediate post-war fate which for two years had taken her to a Soviet labour camp.

Alongside Gaby von Cleef, Susanne Erichsen was the most photographed model on the cover of *Film und Frau*: "We thought the refined appearance of the Berlin star mannequin was the epitome of ladylike elegance."[17] In 1952, she was "ambassador of German fashion" in the United States, where she was celebrated as the prototype of the post-war German "Miss Miracle".[18] In the years to follow she commuted between her New York and Berlin domiciles. Besides working as a model, she also designed her own fashion line called Susanne Erichsen Teenager Modelle, however, her company went bankrupt in the early 1960s. After the end of her modelling career, she founded a mannequin and modelling school in Berlin in 1967, which she ran until 1977. Her autobiography published shortly after her death not only depicted her apparently glamorous dream career but also portrayed the dark sides of her life including her pill addiction, anorexia, and depression.

career."[8] As it turned out, subsequent to her modelling career Katharina Denzinger did indeed work as a graphic artist at *Harper's Bazaar* and later became a Professor of Graphic Art and Painting at Parson Design School in New York.[9]

Film and Frau actually idealized the notion of the happy marriage an opportunity for models to find their true calling. In 1955, Grit Hübscher was still being highly praised for "preserving her youthful features"[10], only two years later she was congratulated on her future married life: "Last year the cool blonde went on a world tour, did a fashion shoot for the prestigious *Vogue* magazine, and subsequently flew to Sidney where she was introduced to cannery own-

Susanne Erichsen and her Afghan hounds, Paris 1954, in: *Deutsche Illustrierte* 42/1954

next spread: Susanne Erichsen, ensemble by Christian Dior, Paris 1954, in: *Deutsche Illustrierte* 42/1954

Susanne Erichsen, cocktail dress by Christian Dior, Paris 1954, in: *Deutsche Illustrierte* 42/1954

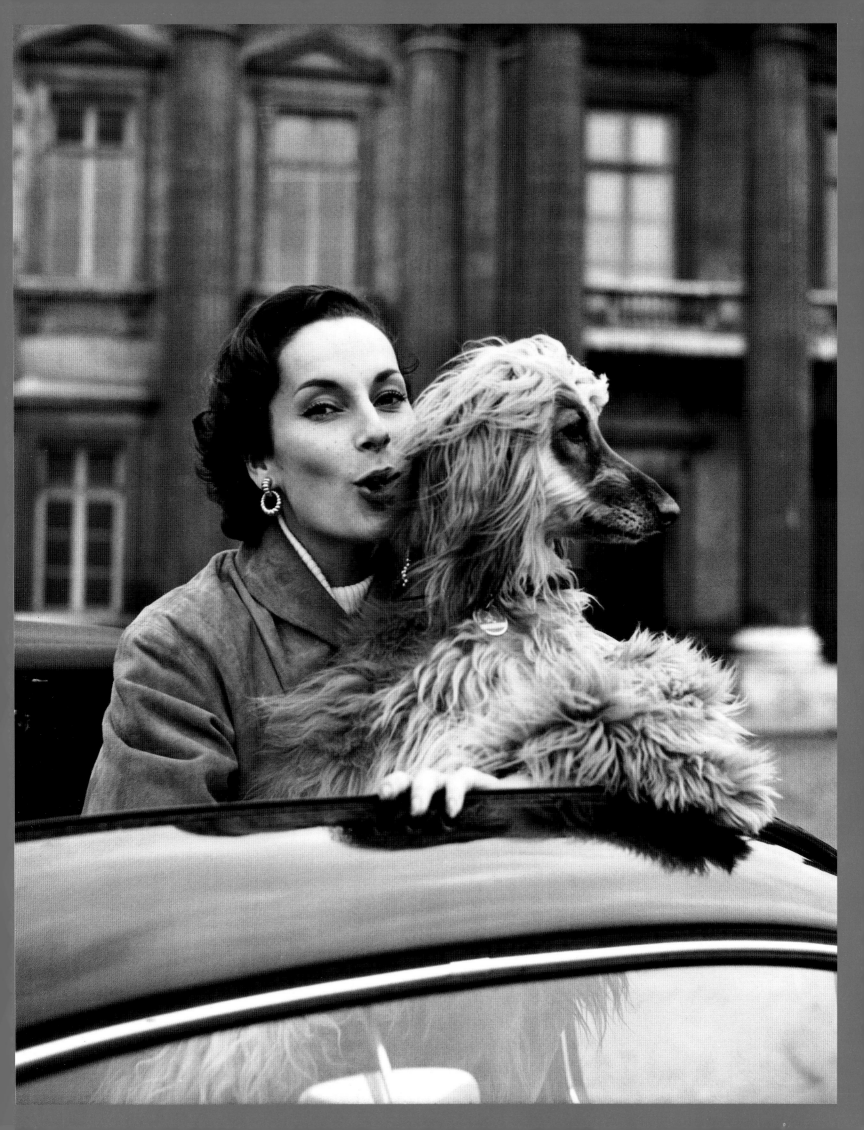

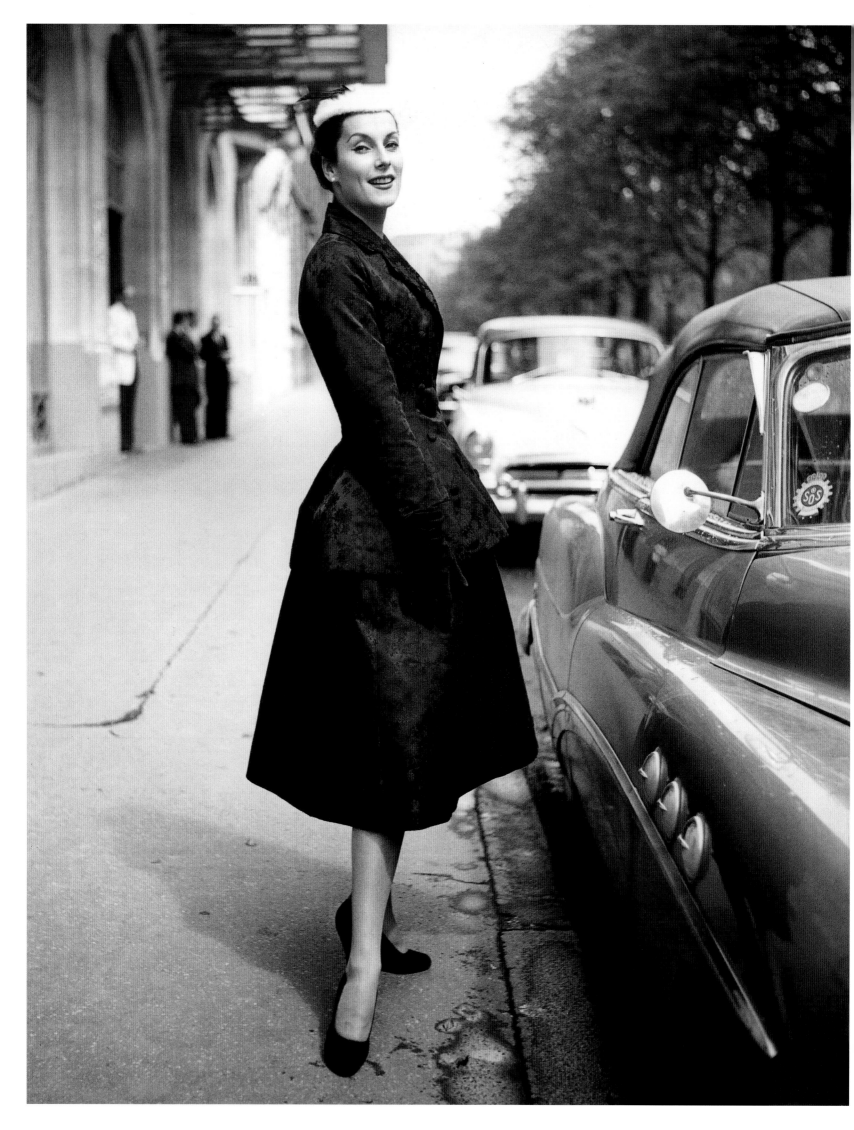

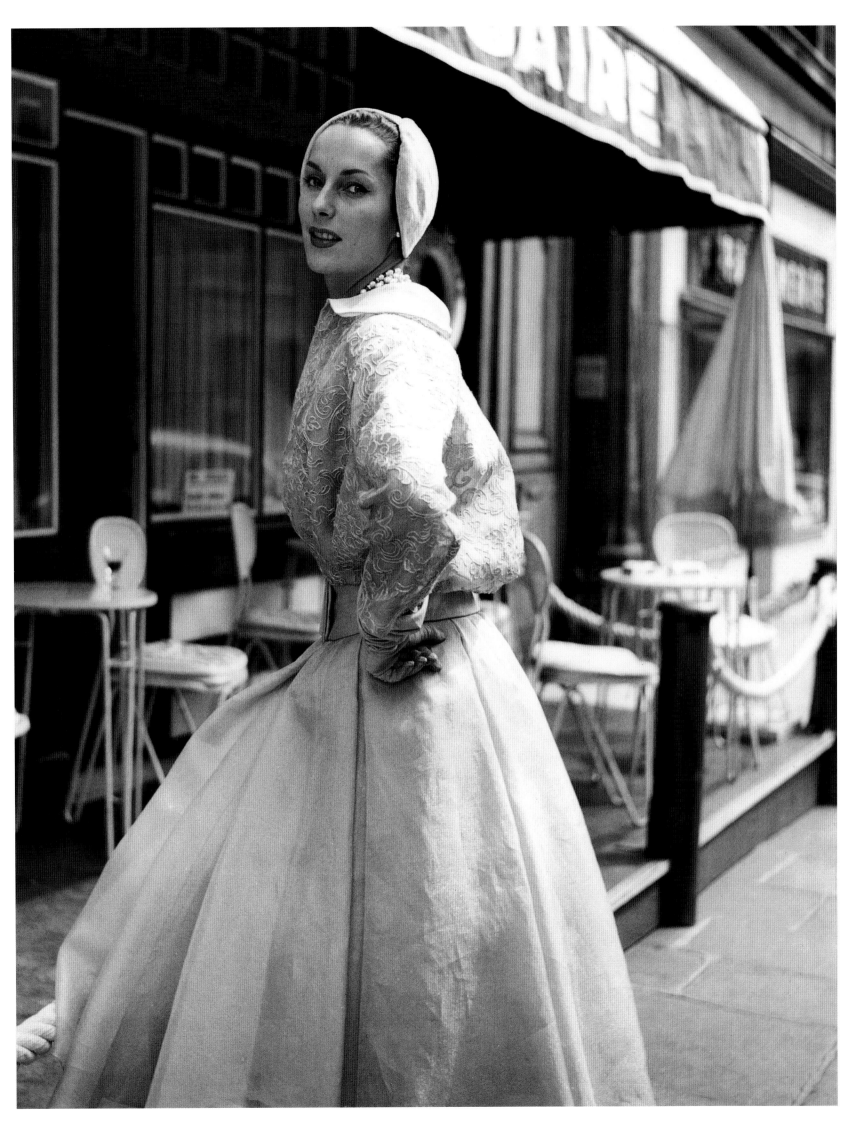

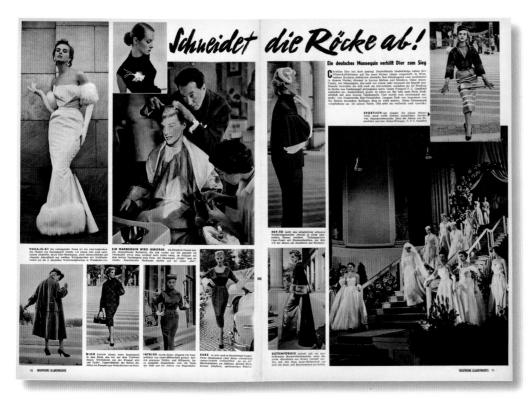

"Cut the skirts", *Deutsche Illustrierte* 41/1953

Bambi, *Film und Frau* 22/1953

er Richard Dixon, and the two of them fell in love. They have long since enjoyed life as a happy couple. We do hope that on their travels across Europe they will find the time to swing by Grit's old friends in Germany. We are thrilled for Grit to have found such happiness, yet sad at having to bid farewell to such an attractive mannequin who will be sorely missed in the fashion world."[11]

After working as a photo-model, many girls subsequently opted for a career in the fashion and modelling industry. They became fashion editors – the best known is probably Grace Coddington – or they established their own model agencies, such as Wilhelmina Cooper in New York, or Karin Mossberg and Christa Fiedler in Paris. Or, like Simone d'Aillencourt in Paris or Susanne Erichsen in Berlin, they opened mannequin schools.

Model agencies have their roots in the United States, with John Robert Powers thought to be the founder of the first-ever agency. Professionalizing his placement services for photographers and actors resulted in the publication of the first model catalogue in 1932. This form of placement served the growing need in the advertising industry and the advertising and fashion photography for new faces and professional models. In the mid-1950s, Dorian Leigh

opened her first agency in Paris; however, models in Europe continued to work independently for quite some time. At the beginning of the 1960s, the New York modelling agency business had finally caught on and pushed aside the European structures. Ford Models, founded by Eileen and Jerry Ford in 1946, was the world's leading placement agency. F.C. Gundlach was introduced to Eileen Ford, "godmother of the model industry", on his first visit to New York in 1956. She became his most important business partner in the United States. In the mid-1960s, New York was the centre of the model industry with the five New York top agencies Ford Models, Plaza Five, Stewart, Fances Gill and Paul Wagner said to have made 7.5 million dollars per year for model placements in the print media alone. Inexperienced models were paid 40 dollars per hour while top models earned 60 dollars, less ten percent commission. In 1964, Wilhelmina was New York's top model, and she was a much sought-after star in Europe, too: "Her look became the look of the day," Jerry Ford explains in retrospect.[12]

The 1960s mark the transition from *haute couture* to prêt-à-porter fashion, with fashion designers making the switch from making exquisite fashion pieces for a small elite to producing fashion collections

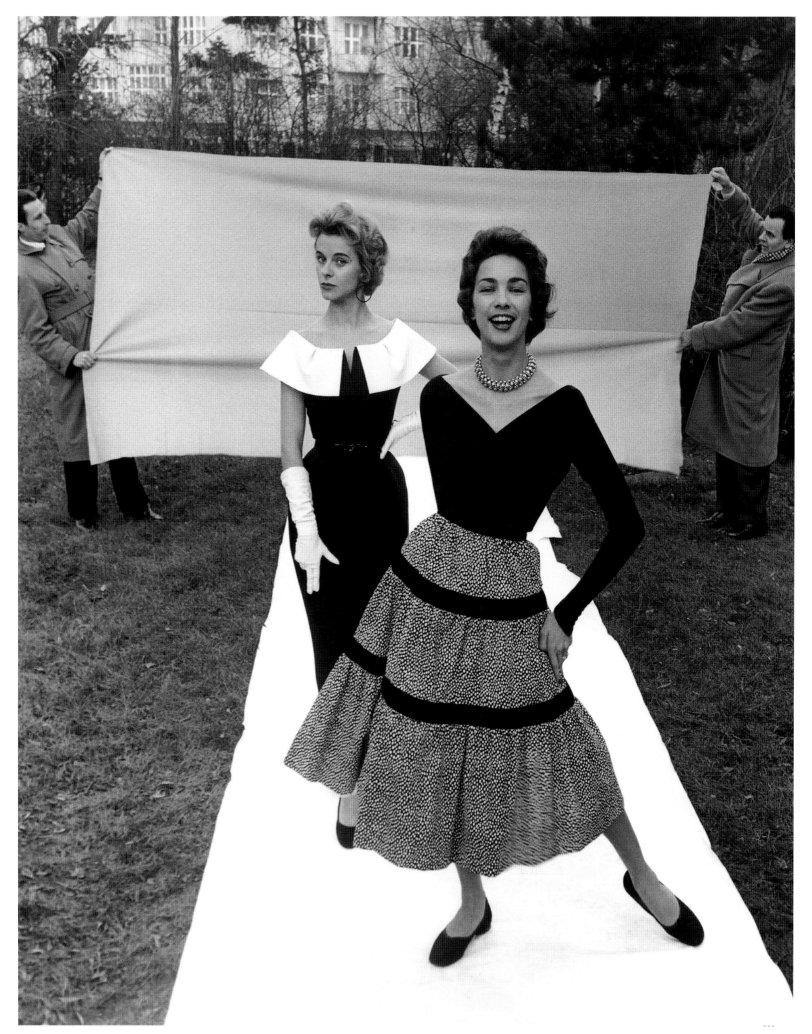

"Fantasy in black an white", Candy Tannev and Elfi Wildfeuer, editor in chief Curt Waldenburger and his driver assisting, Berlin 1954, in: *Film und Frau* spring/summer 1954

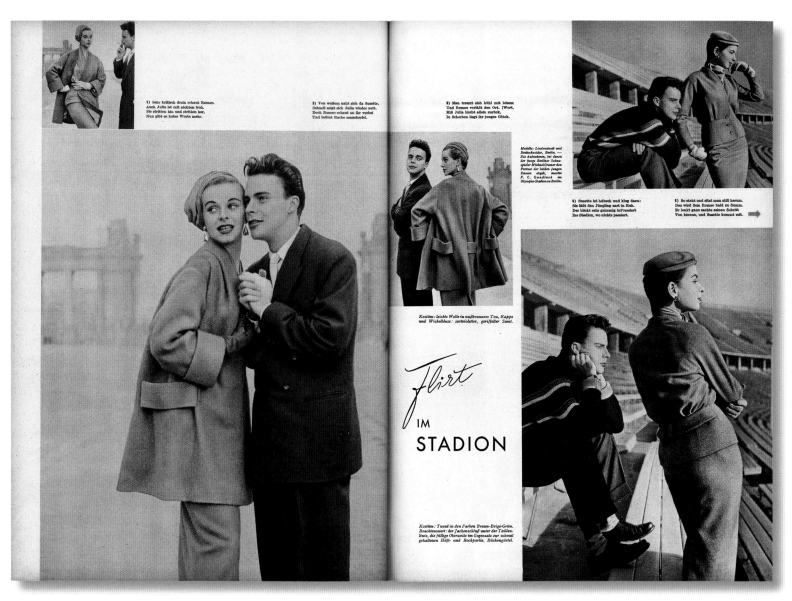

Flirt

IM
STADION

"Flirtation", *Film und Frau* spring/summer 1954

at affordable prices for as wide a female clientele as possible. In F.C. Gundlach's career, the changing times are essentially manifested in his move to *Brigitte* magazine. F.C. Gundlach's oeuvre is a vivid reflection of the changes in fashion from exclusive designer pieces to casual clothes. This change, which coincided with the establishment of a new female image, is furthermore reflected in the models: Static, artificial poses were gradually replaced by what seemed to be spontaneous movements and vitality. Moreover, under his exclusive contract with *Brigitte* travelling to locations the world over became increasingly important. Whereas during his time at *Film und Frau* he was at liberty to realize photographic images as he saw fit, for *Brigitte* he now had to consider the wishes of a magazine with a print run that was far larger. His close collaboration with Barbara Buffa, manag-

ing editor of the fashion section, produced the bulk of F.C. Gundlach's oeuvre until 1981.

The fashion presentation in *Brigitte* was subject to a long selection process. Buffa attached great importance to natural looking fashion and wanted models to appear as an integrated part of the shot. She always selected both the clothes and the photographers and models with the magazine's target audience in mind. Most importantly for her was that the fashion was recognized, thus a compromise had to be made between interesting and appealing photography and what the readership was willing to accept.

During his time at *Brigitte*, F.C. Gundlach witnessed the arrival of a new type of photo-model in the photo spreads. The elegant lady was ultimately pushed aside by the dynamic and active young woman who functioned as a self-confident role model for

254

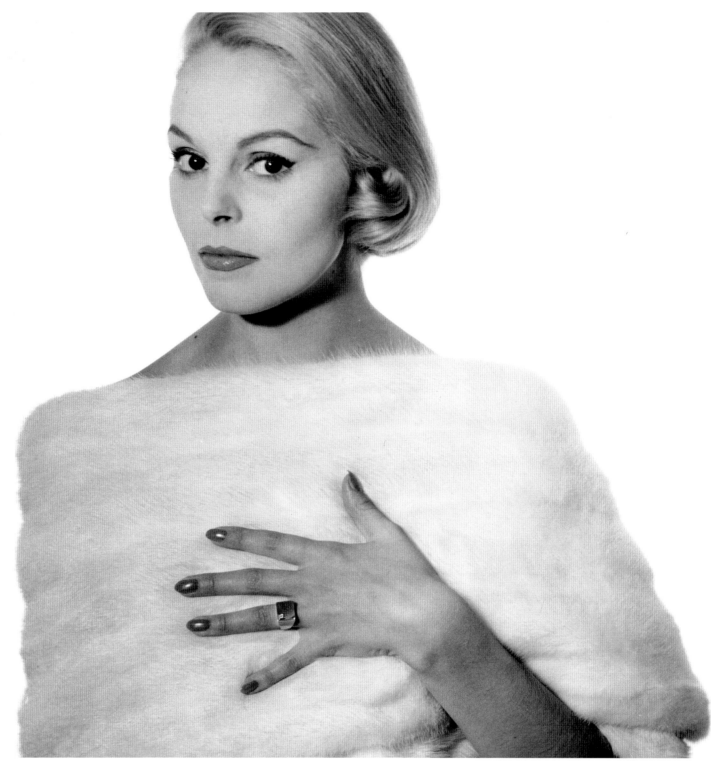

Grit Hübscher, white mink stole by Berger, Berlin 1953, in: *Film und Frau* 1/1955

Brigitte readers. Mickey Belverger, Gudrun Bjarna-dottir, Cathy Dahmen, Karin Mossberg, Gunel Person, Beschka Tolstrup, Ann Zoreff and even Grace Coddington perfectly fitted this new type of model. The extent of these radical changes becomes clear in the photographs F.C. Gundlach did with Simone d'Aillencourt[13] from the late 1950s through the early 1970s. To begin with, the images showed an elegant lady of indefinite age; by the middle of the 1960s,

Gundlach, in keeping with the mini fashion, was portraying as a cheeky girl with a bob. Amazingly, she did not seem to have aged during this last decade, on the contrary, she seemed to be getting visually younger until at the end of the photo series she easily passed for the elegant lady's daughter.[14]

Models are no doubt a photographer's most important partners, yet their contribution to the finished photograph is hardly discernible, which is also the in-

GITTA

"Being a good photo-model is a job, not a cakewalk."[19] Gitta Schilling belonged in the group of models with whom F.C. Gundlach worked intensively for several years. The first shots for Deutsche Illustrierte were produced in 1958. Above all, Paris collections were photographed for magazines such as Film und Frau, but also Stern and Quick.

While still training as a dressmaker at Modehaus Hans Fredeking in Berlin, Gitta Schilling began to present teenage fashion as an in-company model. Upon completion of her apprenticeship she changed to Uli Richter, where she worked as an in-house mannequin. Before long she became independent as a sought-after photo-model. Even after she relocated to Munich, Gitta Schilling managed all her appointments herself. Only in the United States she was introduced to the market by Eileen Ford as her agent. Following a number of intensive and successful years working as one of Europe's most famous photo-models she retired from the modelling business.

Cool and distinguished, Gitta Schilling was the epitome of the ladylike woman. Thanks to her enthusiasm and ambition, she had established herself as a successful "brand" within just a few years. "Well, I was Gitta, so I needed to look like her." Oozing confidence, she thus explains her role and why she refused to play to particular fashions or wishes of her clients. It was understood that models looked after their own hair and make-up. Gitta Schilling regarded her work as a close cooperation between herself and the photographer. In her perfectionism she even went so far as to have a mirror placed next to the camera which allowed her to control the way she looked: "I wanted to check the fit of my dress and fix it if necessary, I did not want to leave this up to the photographer. Only if the dress is a perfect fit and everything else is in order do facial expressions become important." Looking back, Gitta Schilling commends F.C. Gundlach on the respect he showed her during the years of working together, for his sure sense of style as regards background and image design and the way in which he included the model in the overall composition.

Gitta Schilling, evening dress by Uli Richter, Berlin 1962, in: *Film und Frau* 26/1962

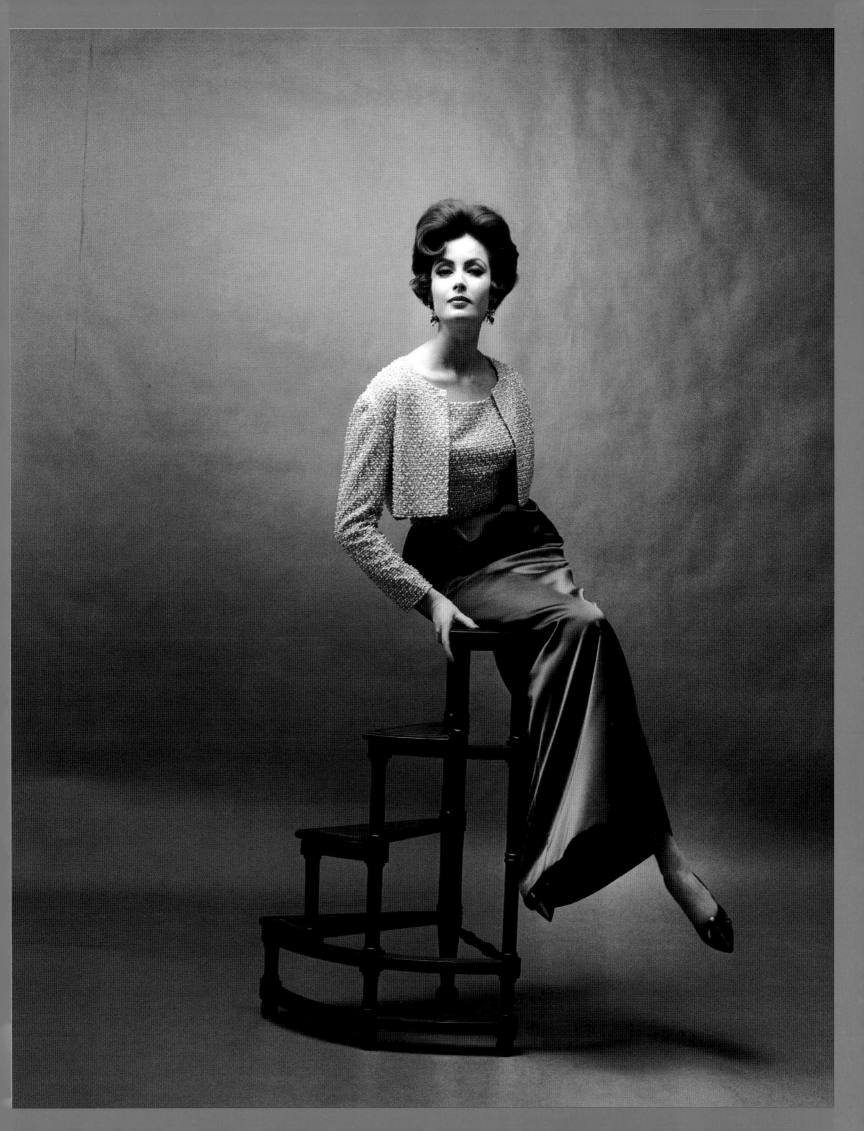

Eileen and Jerry Ford, Walter Lautenbacher for *Constanze*, F.C. Gundlach for *Brigitte* and Rico Puhlmann for *Petra*, Berlin 1965

tention. Originally, fashion photography was primarily concerned with depicting fashion. The era of the so-called supermodel, which sensationalized shots for depicting particular models' faces, did not take off until the 1980s. In contrast, the decades when F.C. Gund-lach worked for a number of different clients primarily focused on the collections. And yet the same principle applied: No matter how appealing a collection may have been – unless it was suitably presented by a photo-model it simply did not cause a stir.

"James Blond is chasing the beautiful mask", Wilhelmina, Hamburg 1966, in: *Brigitte* 1/1966

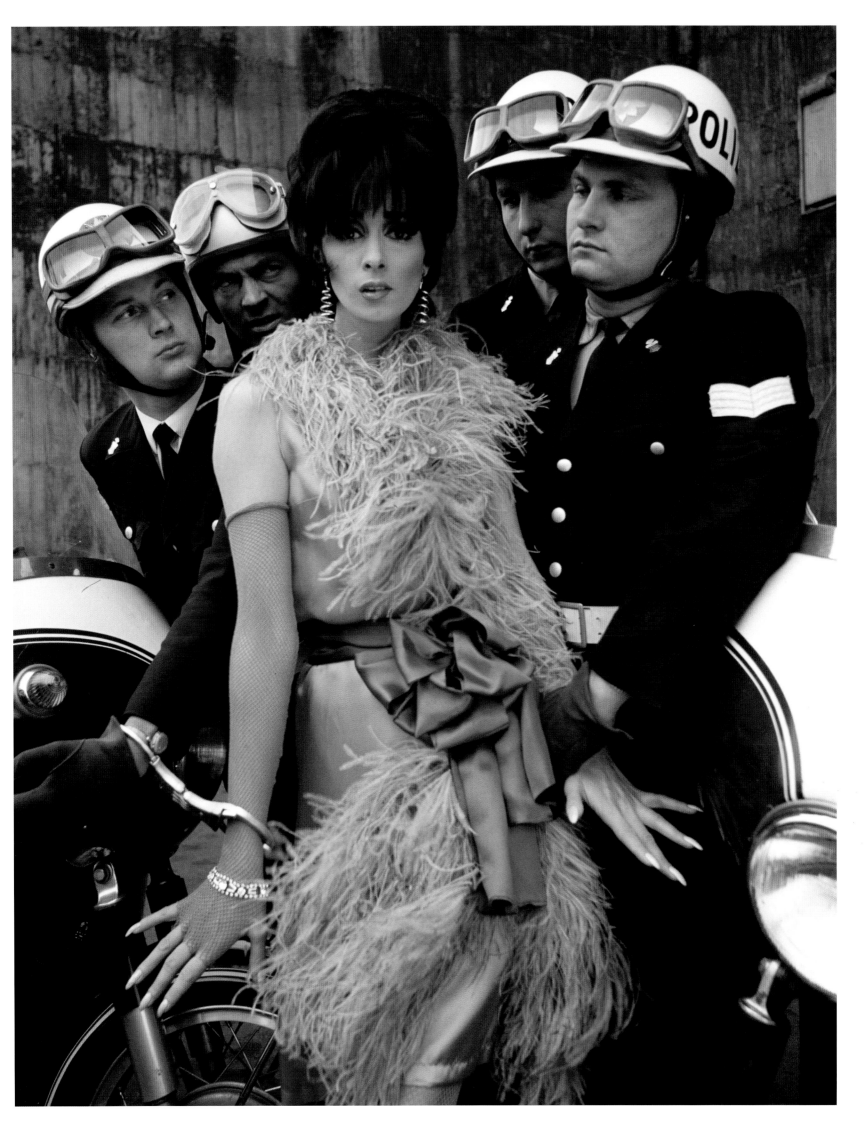

WILHELMINA

"My dear F.C., it would be such a pleasure to work in Hamburg once again." Such are the opening lines of a letter written by Wilhelmina in February 1964. At the time, she was still under contract at Ford Models and was regularly booked by F.C. Gundlach – particularly for fur shoots. Wilhelmina was one of the few models to maintain a close working relationship with Gundlach throughout the years. She was also among his circle of friends. Many shots from their extensive collaboration are among the key works in the photographer's oeuvre. Wilhelmina herself selected the famous portrait Dark Mink as the central image for her agency brochure. The shot had originally been intended for the cover of the Film und Frau special issue on fashion, Fall/Winter 1964/65. Of considerable value, the fur coat became a means of payment to compensate for the low fee originally negotiated for the complete fur series.[20]

The documents in Gundlach's archive show her to be a most reliable and friendly partner, who regularly and exclusively worked with F.C. Gundlach. Even at a reduced rate: In 1964, she received just 600 deutschmarks for a day's work, despite the fact that "I would usually charge 750 deutschmarks in Europe, but I know what you are like!!! In any case, I would like to support the people I know and my favourite friends and their business."

In the 1960s, Wilhelmina ranked among the most famous models in the United States, "she was the last star of the couture era".[21] Her face graced more than 250 magazine covers, and she holds a proud record with no less than 28 cover appearances on the American Vogue. F.C. Gundlach photographed her for the covers of Film und Frau, Brigitte and Annabelle, among others.

Gertrude Wilhelmina Behmenburg was born in the town of Culemborg, Holland, in 1940 to a German father, a butcher, and a German mother, a dressmaker. Wilhelmina spent her childhood years in the German town of Oldenburg before the family relocated to Chicago in 1954. Two years later, while accompanying a friend to a modelling school, it was her who was accepted on the course – not her friend! As from 1957, she began doing beauty contests under the name of Winnie Hart. Even before she finished school she was booked by the first Chicago agency "Models Bureau". Having slimmed down considerably and changed her name to Wilhelmina, she kick-started her career in 1960, receiving further support mainly from agency boss Eileen Ford. Four years later, she was considered a New York top model, earning 100,000 dollars per year. She was known as being extremely professional, arrived at the studio with perfect make up and had with her a wide range of hair pieces. However, she later confessed that she always felt insecure.

Wilhelmina with arctic fox hat, Hamburg 1964

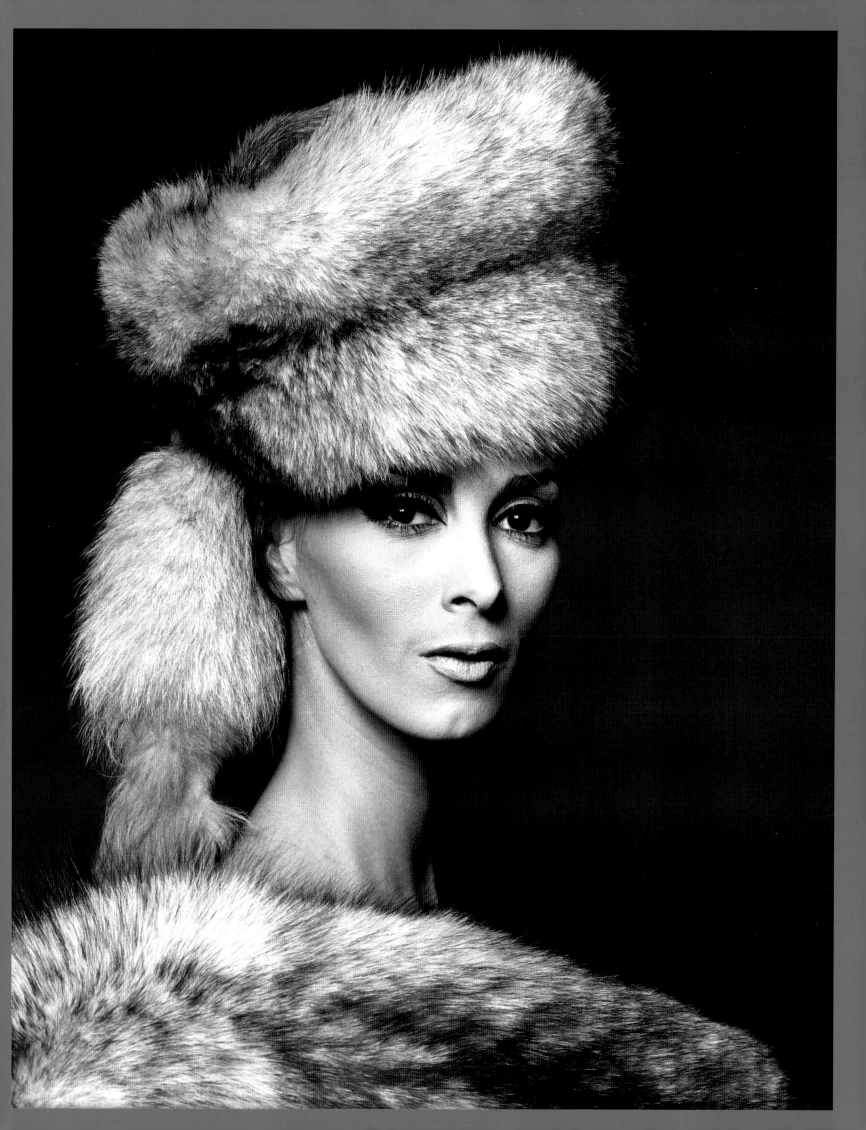

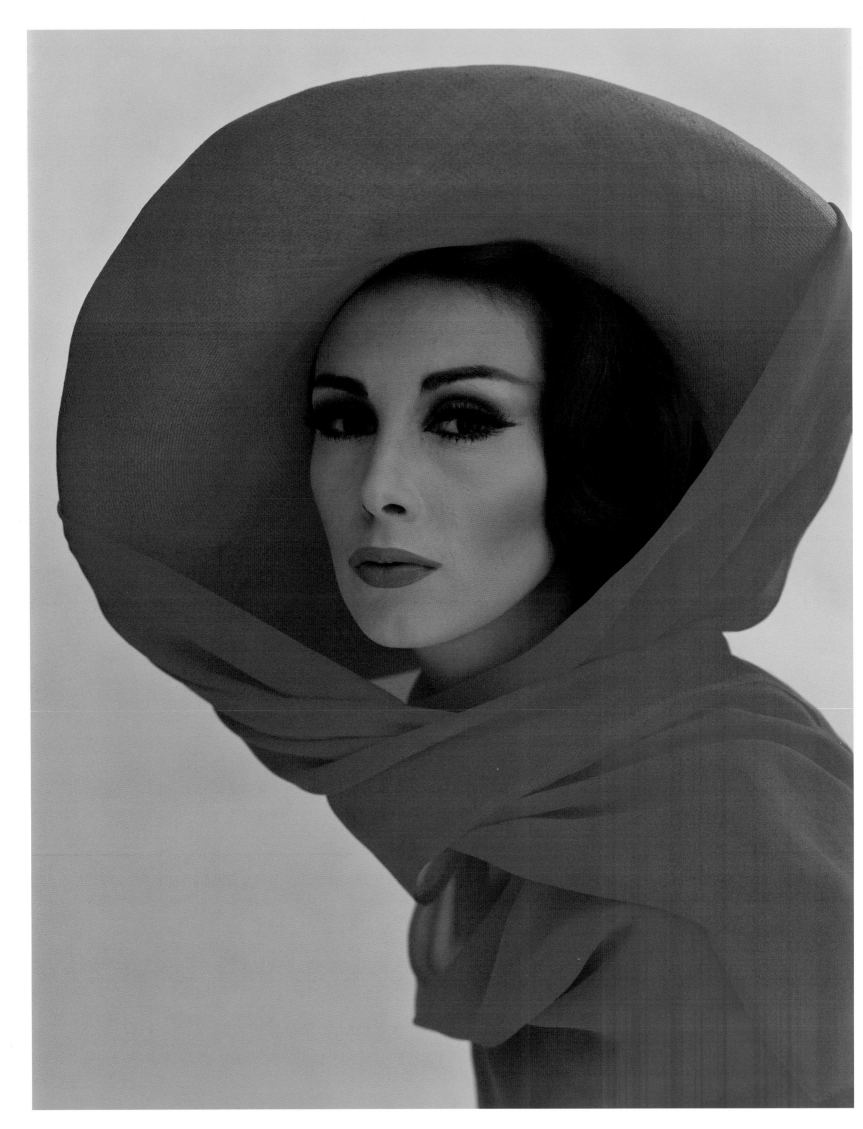

"To be successful as a model is a really tough business. But to stay successful it is even tougher again. If you don't do as you're told, you can soon fade into oblivion."[22] In the mid-1960s, Wilhelmina was barely affordable for European productions, which is why F.C. Gundlach "highly appreciated that each year, Wilhelmina would stay with [him] for two or three weeks, in spring and in fall, just to work with [him], obviously [they] knew each other and [they] were friends."[23]

Wilhelmina left Ford Models at the pinnacle of her career because she wished to establish her own agency together with her husband Bruce Cooper in April 1967. If, to begin with, the boss herself contributed decisively to the agency's turnover with 17,000 dollars in the first month alone, it was not long before Wilhelmina Models became the biggest competition for Ford Models. With an annual turnover of eleven million dollars, it was the second most important agency in the US in 1979.

As manager of the agency, Wilhelmina witnessed the rapid changes in the model industry first hand during this time, before dying of cancer in 1980, aged only 40. "Perhaps I am one of very few people fortunate enough to have stood on both sides of the beauty-business fence in such a short span of time."[24] Shortly before her death, her portrait was on the cover of Fortune and illustrated an article about the tough competition in the model scene, which was taking a nasty turn and yet more lucrative than ever for some. In the article, Wilhelmina is described "as a secret victim".[25] She had flawless beauty, yet she always seemed aloof. Her eyes wide apart in her stern and narrow face, her cool and distant gaze, her mouth with the usually tightly closed narrow lips and her long swanlike neck were instantly recognized as her trademarks. "Willie" was known as a manager who cared for her agency, who looked after her models like a mother and who promoted coloured models to combat racism in the industry. As is revealed in her later biographies, however, beneath the perfect surface she battled with an unstable personality who popped pills and chain-smoked to stay slim, who endured an unhappy marriage with a violent and abusive husband and who beneath the shallow perfection had lost her own identity. Even her daughter Melissa, aged 12 at the time of her mother's death, suspects that "she would have preferred to kill herself with cigarettes rather than having to bear this dreadful and incomplete existence."[26] The American dream career had turned into a personal tragedy. This naturally sheds doubts on her success and the advice she gave to young women in her 1978 publication The New You.

In the 1990s, the agency was sold to Dieter Esch. In 1996, his daughter published a scandalous book The Wilhelmina Guide to Modelling, in which she uncovered what had been previously considered strictly-kept secrets about model management and common business practices. The agency, which recently celebrated its 40th anniversary, has long since been integrated into a consortium.

"Fashion studio", Wilhelmina, Hamburg 1965

KARIN MOSSBERG

"Dream job? Yes, for a few years"[27]: Karin Mossberg (born in 1944) perfectly fitted the new type of photo-model to follow on from the elegant lady-like mannequins of the early 1960s. As the "blonde Swede with ideal proportions and the fresh beautiful face"[28] she was representative for a whole row of sporting, seemingly very natural models who embodied the new taste of self-confident women as of the mid-1960s. The type was defined less by worldly gesture and allures, and more by mobility and self-confident youthfulness. Above all in his work for Brigitte magazine preferred to work with this type of model.

After training as a medical assistant, Karin Mossberg was 'discovered' in Stockholm and was hired at the age of 19 by the Paris Planning Service agency in Paris. She achieved real fame with the ads for Air France. Asked in 1967 how she saw her future, she replied: photo-modelling "is a dream job for three to five years. And then you have to do something else. I want to open a gallery or an ad agency or a boutique. I would love most of all to get into film."[29] Karin Mossberg did in fact try her hand at acting, but there is evidence only of her taking part in one movie. In the feature, which the reference works term a "cult-trash film" she played a rich heiress who tries to kill her step-mother (Lana Turner) by means of LSD.[30] In 1976, Karin Mossberg founded her own modelling agency, Karin Models. Whether she set it up using only her own funds or was supported by Eileen Ford is a matter of controversy.[31] After many a success, in the 1980s the agency found itself in difficulties but has nevertheless survived to this day, having been bought up by controversial French model-mogul Jean-Luc Brunel.

Karin Mossberg and Karl Fehrmann, evening dress by Nina Ricci, Paris 1966, in: *Moderne Frau* 21/1966
next spread: "Slow", Karin Mossberg, Nairobi/Kenya 1966, in: *Brigitte* 9/1966
Karin Mossberg, coat by Nina Ricci, Paris 1966, in: *Moderne Frau* 21/1966

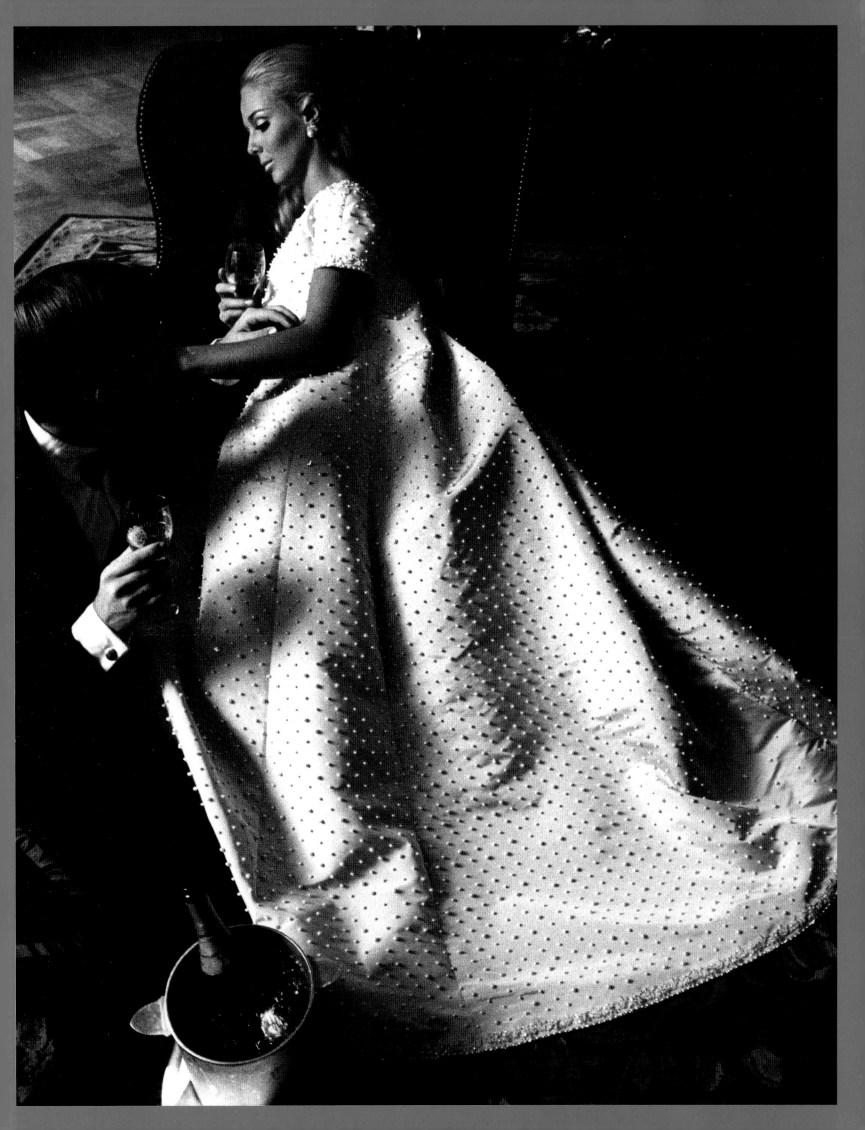

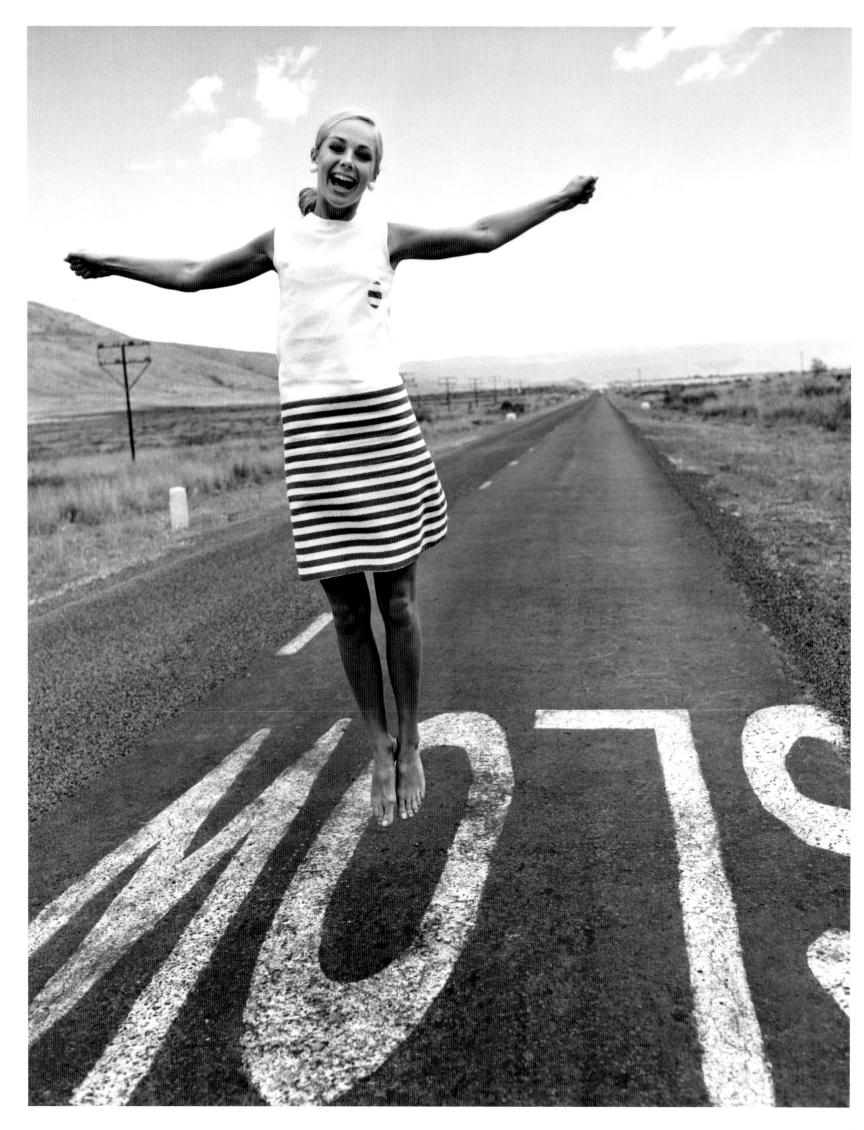

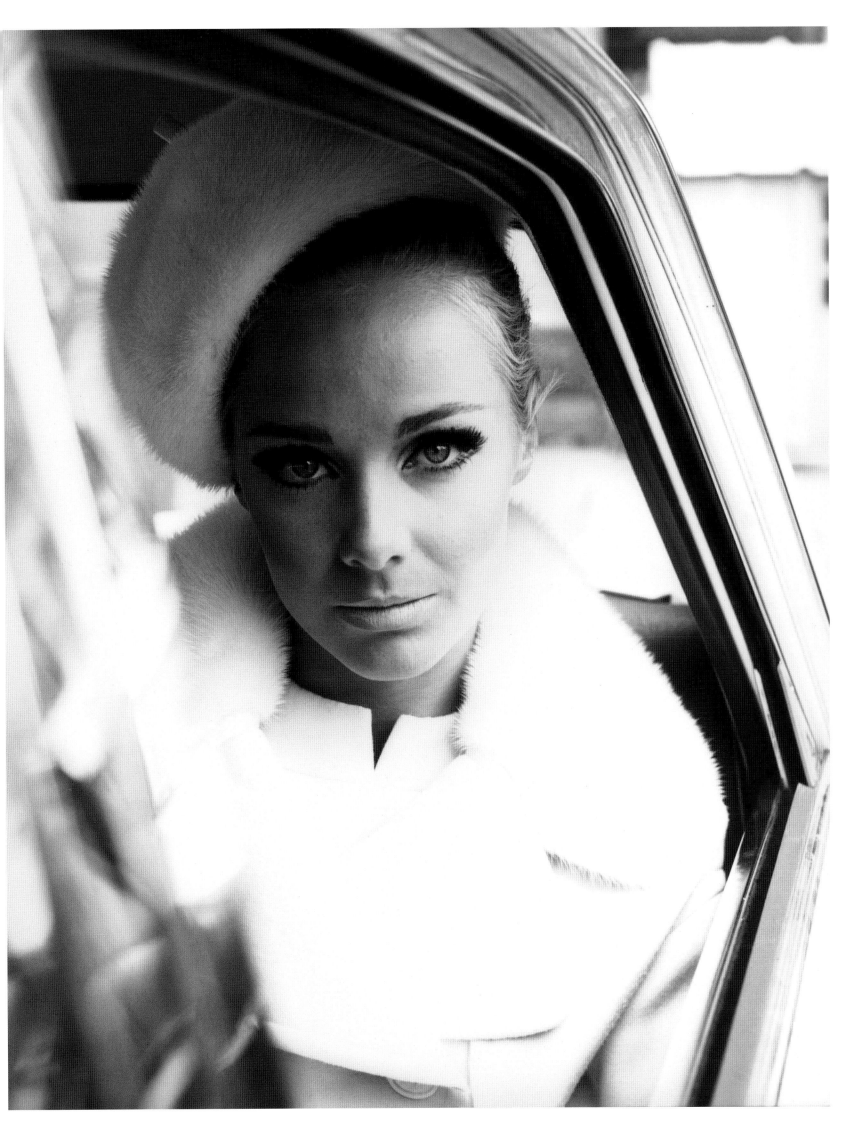

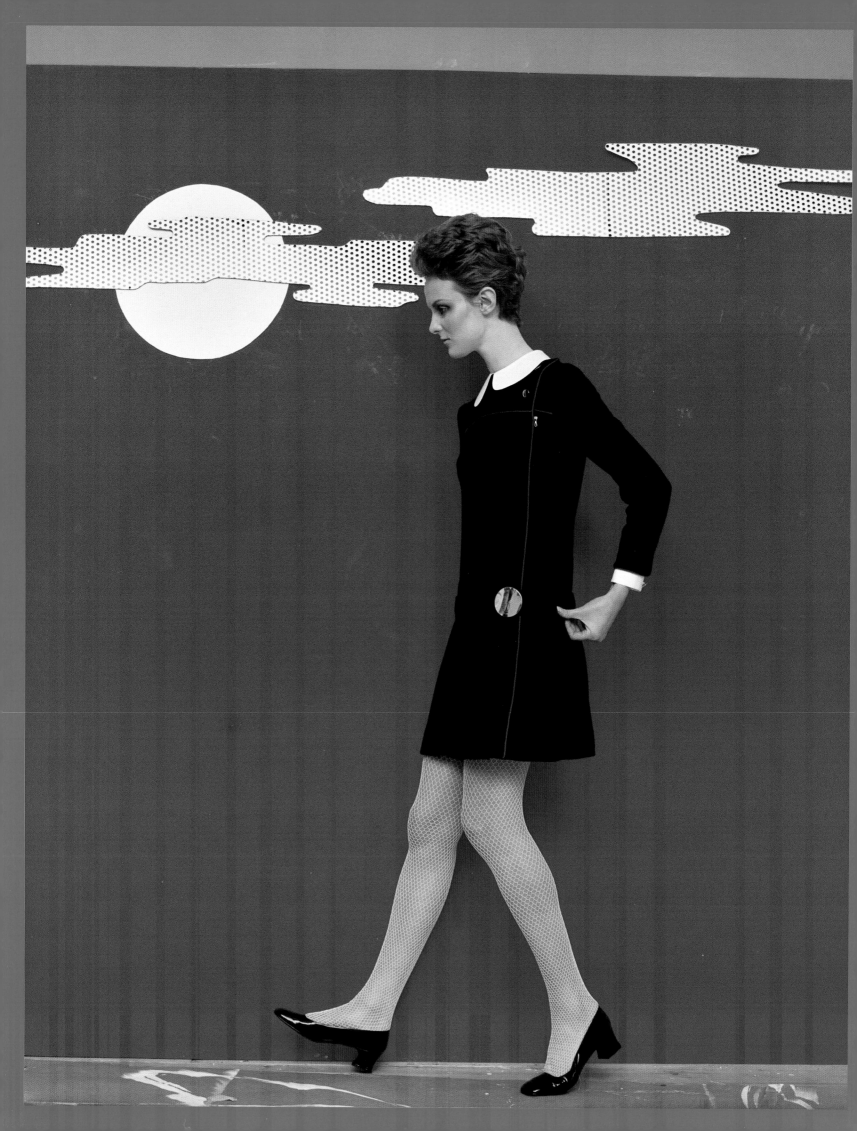

GRACE CODDINGTON

Alongside Twiggy and Jean Shrimpton Grace Coddington (born in 1941) was one of the most important British models of the 1960s. At the age of 18, she won a modelling competition held by British Vogue. In 1968, Vogue hired her as fashion editor, a position she held until moving to Calvin Klein as head of design in 1987. One year later, she switched to American Vogue, and has been Creative Director there since 1995, meaning she is one of the most influential women in the US fashion business.[32]

ENDNOTES

1 The word *model* has in recent years become accepted parlance for models of either sex.

2 Susanne Erichsen (together with Dorothée Hansen): *Ein Nerz und eine Krone. Die Lebenserinnerungen des deutschen Fräuleinwunders.* Munich 2003, p. 178.

3 "Wir haben damals Märchen erzählt", F.C. Gundlach interviewed by Simone Reber, SFB July 16, 2001.

4 Dr. Ulrich Mohr: *Das Bildnis der Eva.* Hamburg 1959, p. 52.

5 Quoted from Claudia Winkelmann: "F.C. Gundlachs 'Modewelten' als Spiegel der Zeit", in: *Textil-Wirtschaft* no. 41, 9.10.1986, p. 30.

6 Candy Tannev in a letter to F.C. Gundlach of Oct. 08, 1954, in which despite her schedule being full she asks Gundlach for an additional shoot.

7 "Mode aus 1001 Nacht. Marion und Star-Fotograf F.C. Gundlach berichten aus Paris," in: *Deutsche Illustrierte,* Stuttgart, 3.10.1955, p. 4.

8 *Film und Frau,* 22/1953, p. 55.

9 Alongside Katharina Denzinger, who worked as a model under her pseudonym 'Bambi', there was also Bambi Rosenquist, a model from Stockholm, with whom F.C. Gundlach also worked in the 1950s.

10 *Film und Frau,* 1/1955, p. 32

11 "Goldstaub – im Berliner *Film und Frau-*Studio aufgewirbelt," *Film und Frau,* 16/1957, p. 24.

12 Michael Gross: *Model. Das hässliche Geschäft der schönen Frauen.* Munich 1996, p. 237.

13 Simone D'Aillencourt (born in 1930) debuted as a model in 1954 in Paris and through 1969 was one of the most successful international models. In 1969, she opened her own agency, Modèle International in Paris.

14 See Klaus Honnef (ed.): *ModeWelten. F.C. Gundlach – Photographien 1950 bis heute.* Hamburg 1986, pp. 260–261.

15 Bettina Graziani published her autobiography: *Bettina by Bettina.* London 1965.

16 Susanne Erichsen / Dorothée Hansen (see note 2), pp. 165–166.

17 *Film und Frau,* Special issue on fashion, Spring/Summer 1952, p. 66.

18 See also Adelheid Rasche: *Botschafterinnen der Mode. Star-Mannequins und Fotomodelle der Fünfziger Jahre in internationaler Modefotografie. Susanne Erichsen – Denise Sarrault – Elfi Wildfeuer.* Berlin 2001.

19 All quotes from an interview Hans-Michael Koetzle conducted with Gitta Schilling on Nov. 26, 2007 in Munich.

20 According to F.C. Gundlach, the coat was made by Pelzhaus Berger in Hamburg and had a value in excess of 25,000 deutschmarks.

21 Michael Gross (see note 17), p. 232.

22 Ibid., p. 237.

23 F.C. Gundlach interviewed by Simone Reber, (see note 3).

24 Wilhelmina: *The New You.* New York 1978, p. 10.

25 Michael Gross (see note 17), p. 232.

26 Ibid., p. 234. Fashion journalist and writer Gross was able to study the Wilhelmina Estate. The family's main wish was that "the truth be revealed behind the legend" (p. 588).

27 Heidi Schulze-Breustedt: "Traumberuf? Ja – für ein paar Jahre," in: *Brigitte* 18/1967, pp. 174–181.

28 Ibid., p. 175.

29 Ibid., p. 181.

30 The film "The Big Cube," (USA/Mexico, 1968, directed by Tito Davison), premiered on August 8, 1969, but swiftly disappeared in the archives.

31 Michael Gross (see note 17), p. 363.

32 Grace Coddington and Michael Roberts (eds.): *Grace. Thirty Years of Fashion at Vogue.* Göttingen, 2002.

33 *FotoMagazin,* 8/1970, pp. 88–89.

"Pop Art-fashion", Grace Coddington, mini dress by Daniel Hechter, Hamburg 1967, in: *Brigitte* 18/1967

Grit Hübscher, white sateen coat by Sinaida Rudow, Berlin 1954

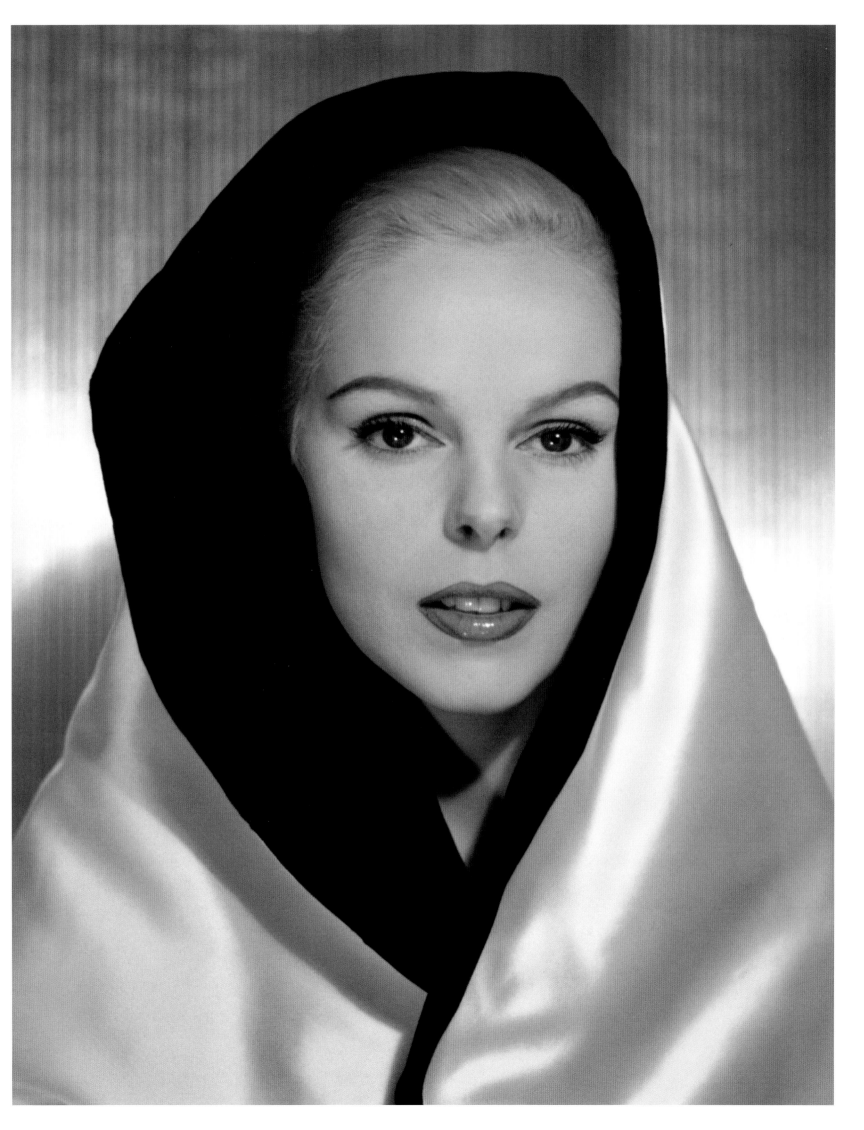

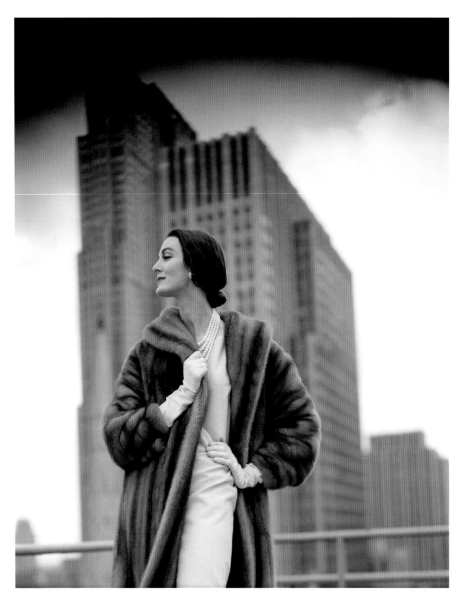

Carmen, mink coat by Levermann, New York 1958, in: *Madame* 8/1958

right page: Gitta Schilling, cocktaildress by Schulze-Varell, Hamburg 1964

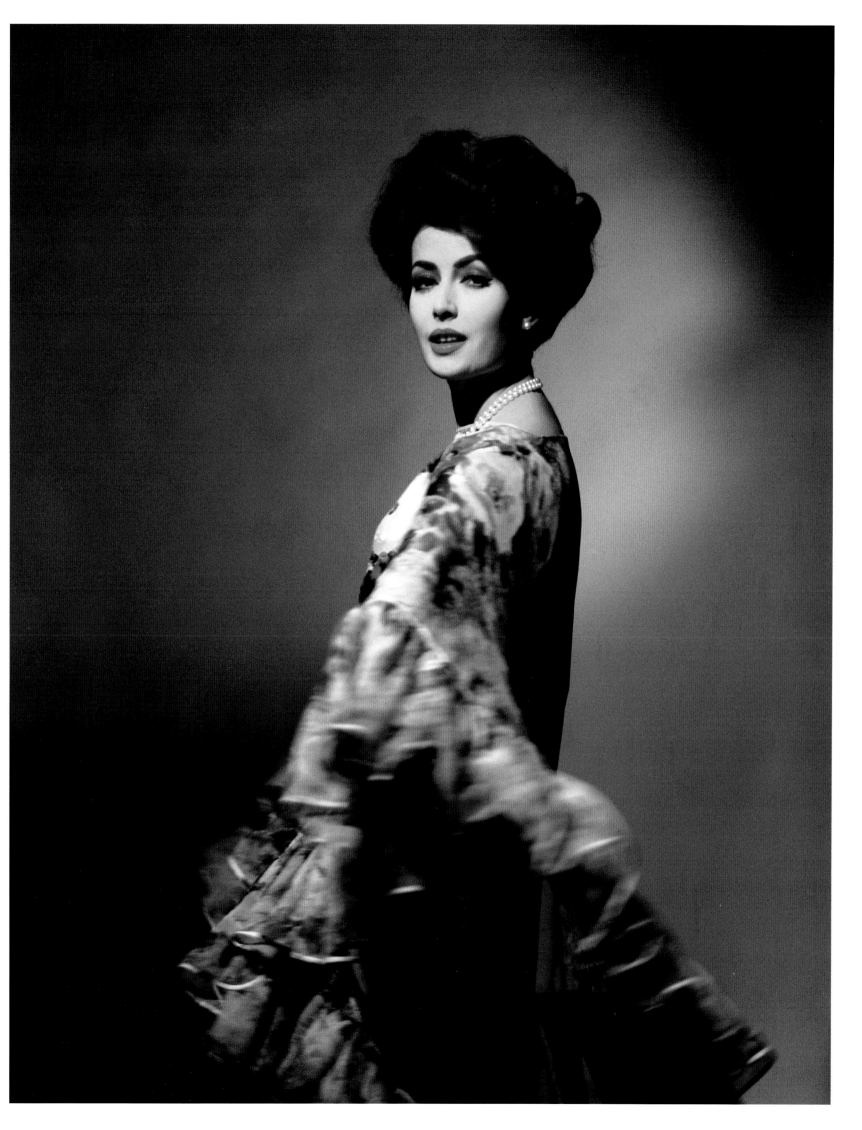

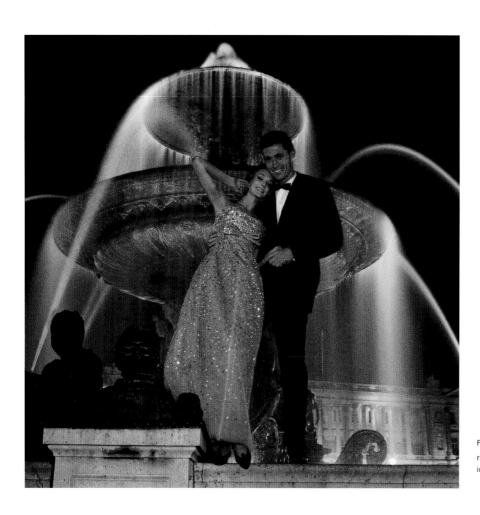

Place de la Concorde, Paris 1962

right page: Gitta Schilling, ensemble by Schulze-Varell, Hamburg 1962,
in: *Film und Frau* 17/1962

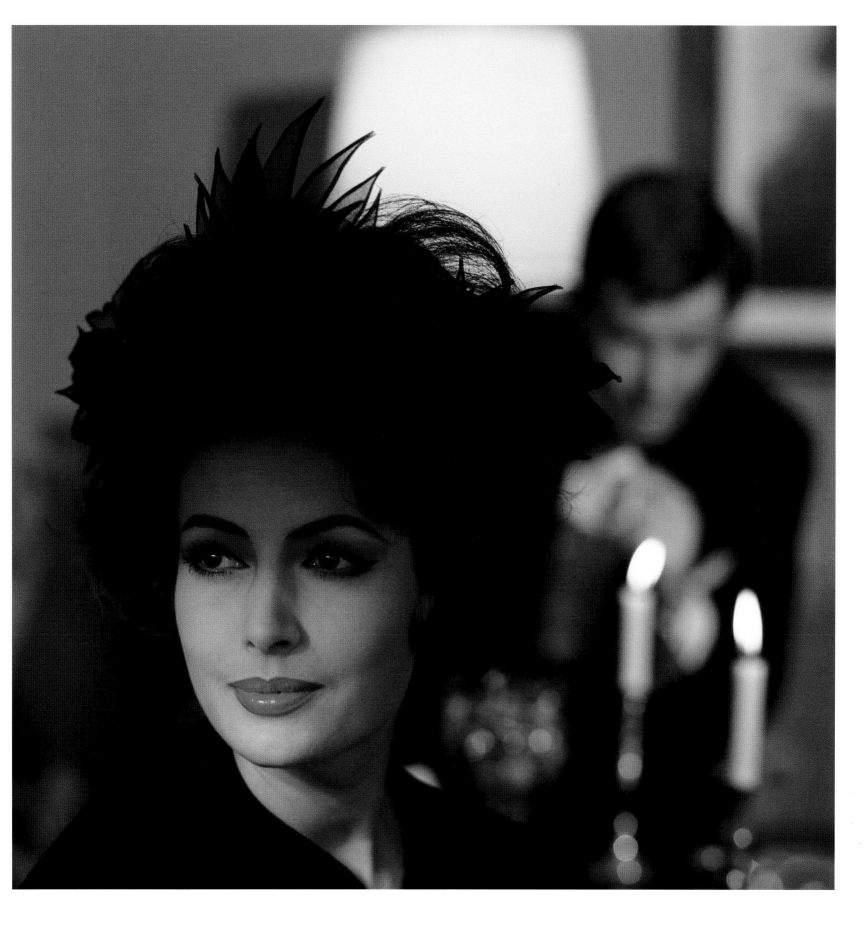

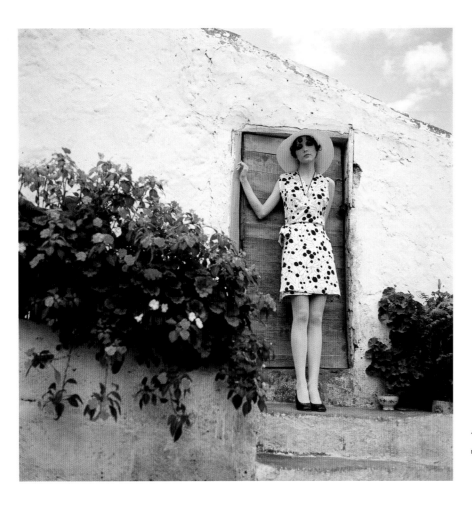

"Flower Power", Cathy Dahmen, Tenerife 1968, in: *Brigitte* 11/1968

right page: "Embroidered and flowered", Cathy Dahmen, Tenerife 1968, in: *Brigitte* 11/1968

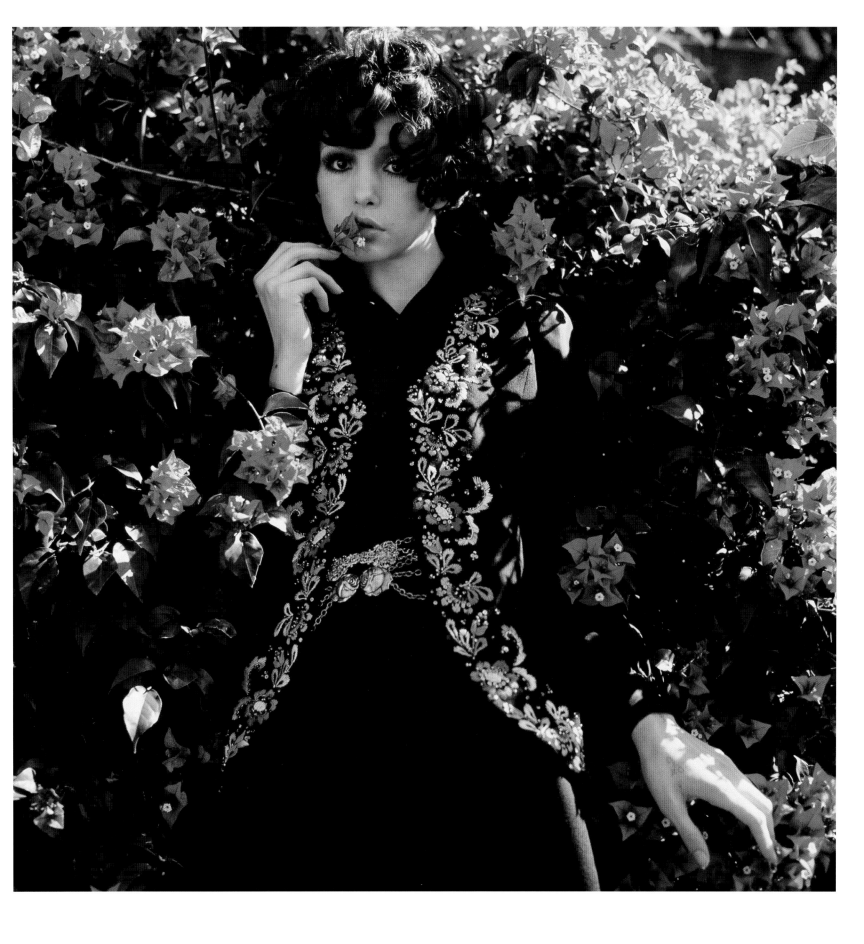

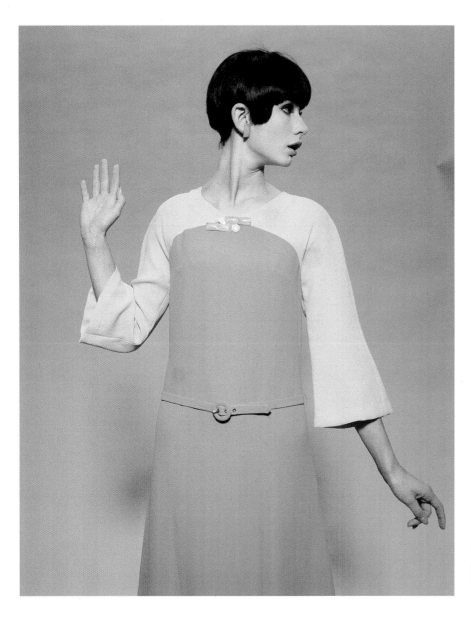

"Pop Art-fashion", Mickey, crêpe dress by Pisanti, Paris 1966, in: *Brigitte* 4/1966

right page: "Pop Art-fashion", Grace Coddington, mini and blouse by Missoni, Hamburg 1967, in: *Brigitte* 18/1967

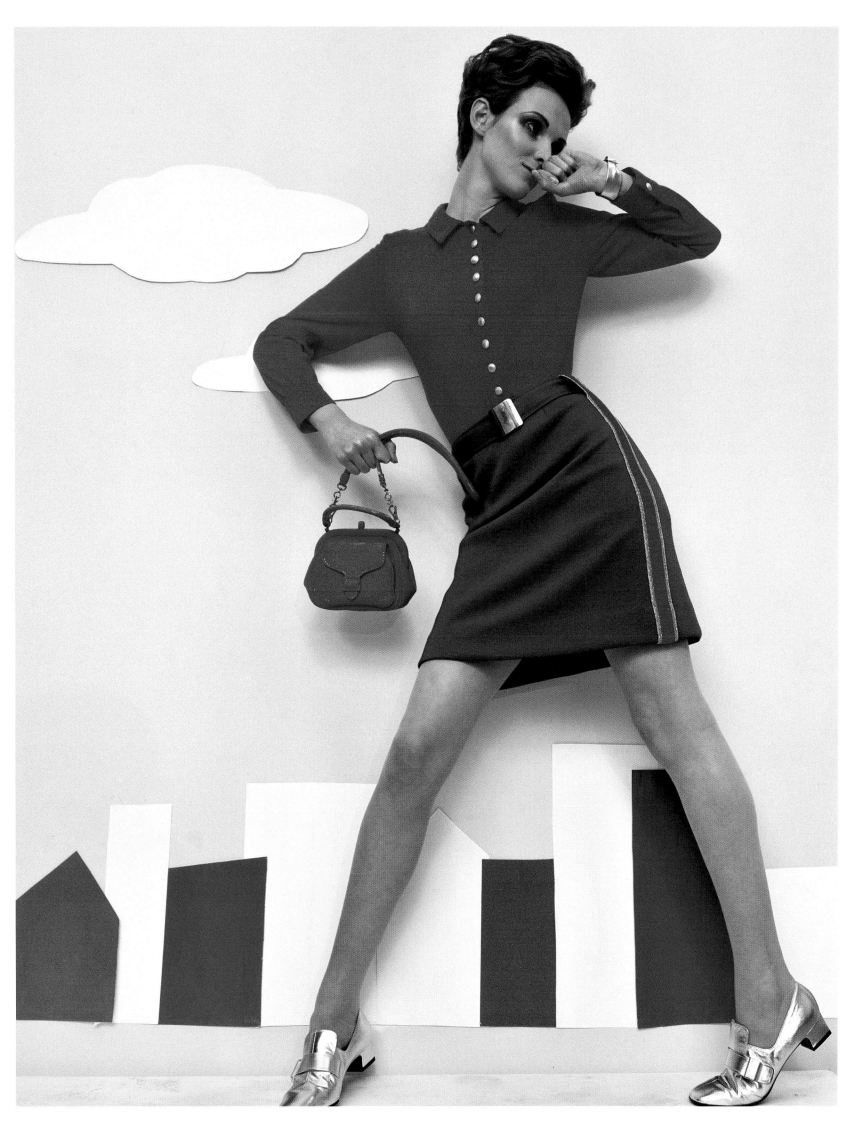

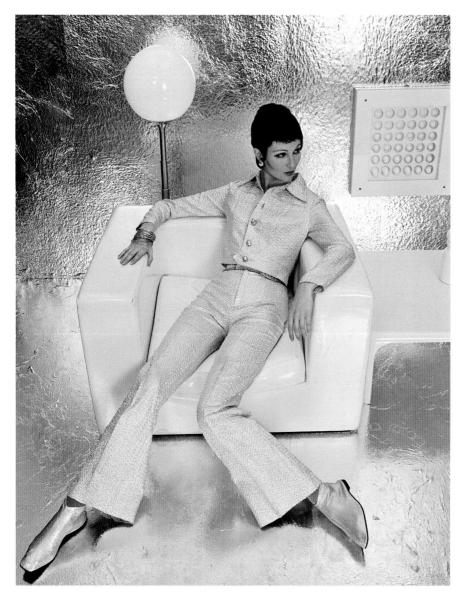

"Pop Art-fashion", Hamburg 1966

right page: Evening dress by Lauer-Böhlendorff, Berlin 1963, in: *Film und Frau* 5/1963

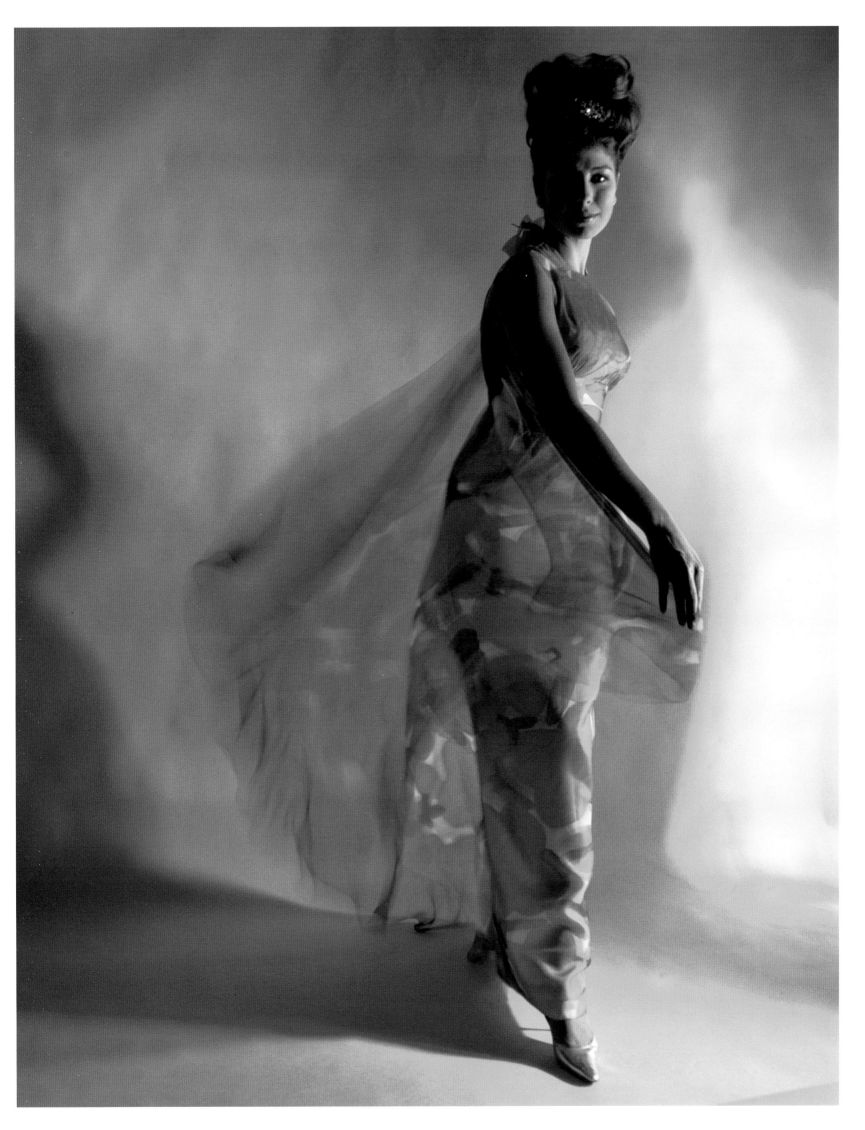

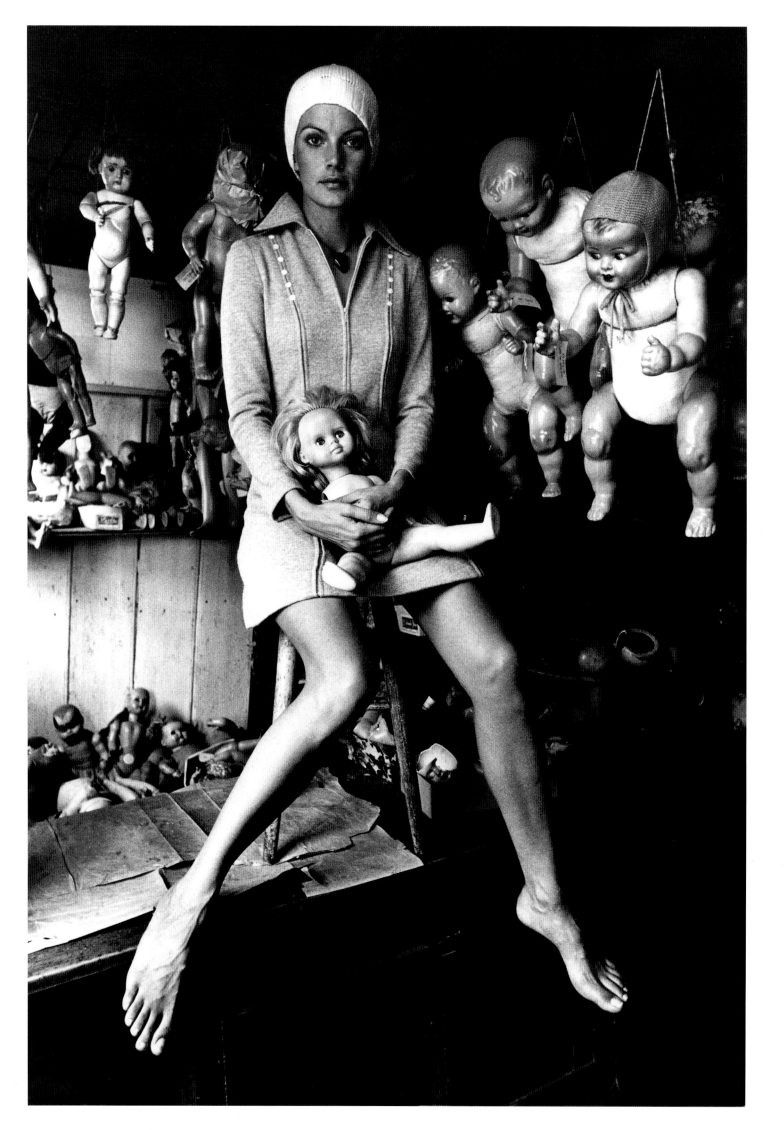

SHOOTING IN BUENOS AIRES

Rarely do reports on F.C. Gundlach's photography cast a glance behind the scenes. In the lengthy list of publications there is only one single report on the actual photo sessions, entitled "Modefotografie auf Reisen. Über die Arbeit von F.C. Gundlach" (fashion photography on a trip. About F.C. Gundlach's work) which appeared in *FotoMagazin*, no. 8, 1970. Readers were offered a background story on a trip the team took to Buenos Aires in December 1969 and January 1970.

"In fall 1969, under contract to plastic fibres makers Enka Glanzstoff, an ad agency planned and organized the production of advertising for both the spring and summer season for Diolen-Apart-Webware and Diolen-Loft-Wirk- und -Maschenware. [...] The photo job was awarded to photographer F.C. Gundlach, who is renowned in the industry. [...] While still in Hamburg, there were discussions with the client on the individual models, how to group them, and the colour combinations. Detailed attention was paid to choosing the accessories. Once a decision had been reached on what angles and images were to populate the ads, it remained to discuss the respective themes, the predominant colour tones and the clothes. [...] However, this only involved defining the overall idea and not, as is otherwise customary, deciding everything down to the last detail and in line with layouts — after all, in terms of presentation fashion ads somehow reflect the notion of editorial illustration in women's magazines and therefore require a certain degree of leisurely vibrancy and serial qualities.

On behalf of Diolen the ad agency procured the clothes themselves from seamstresses, while the stylist purchased the accessories in line with what her boss, Gundlach, wanted.

A great deal of administrative work was required by the photographer's team, which was led by studio manager Kurt Kirchner: An organization plan was prepared and the relevant arrangements made for the photographer and his assistant including the travel schedule, hotel bookings, a rental car at their destination with a local driver, arrival and departure plans, working itineraries for the models and shooting plans. Documents were prepared, applied for and a customs guarantee obtained, authorizing a bank to cover possible obligations the photographer might occur with the Argentine customs office, an invoice for the clothes, certified by the Argentine Consulate, a list of all the camera equipment, a telex covering the booking and prices for the four photo-models Françoise Rubartelli, Birgit Larsson, Sunny von Fürstenberg and Gudrun Bjarnadottir, a list of all the clothes to be shot, including the accessories, a list of the latter, papers for the rental car, and business visas.

First day on the road: The photographer, with all his experience, takes the clothes collections along in his personal luggage. And some of the clothes are also included in

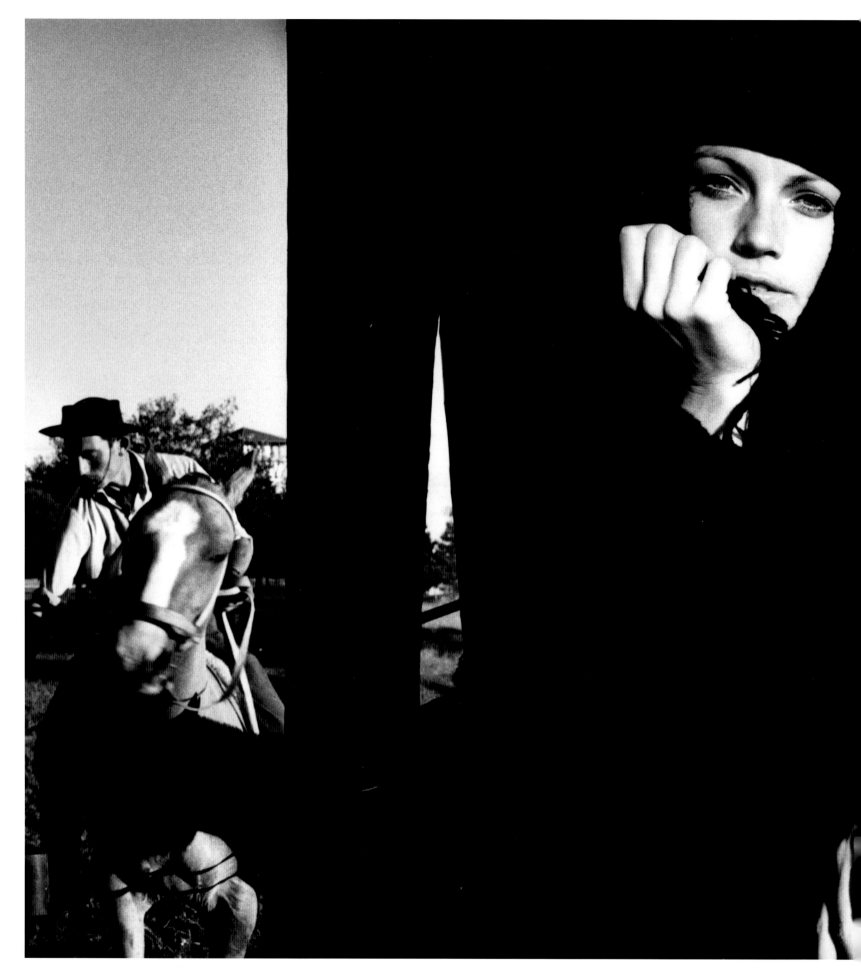

Birgit Larsen, Buenos Aires 1970, in: *Falke Fashion* 1970/71

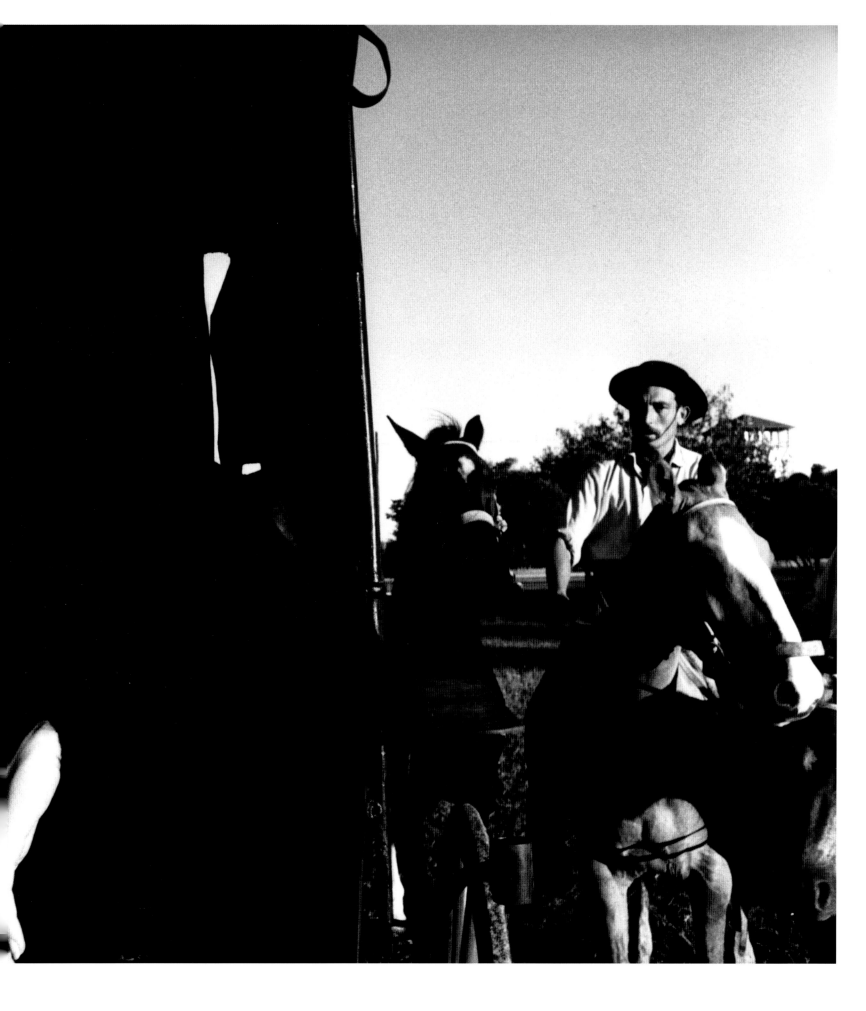

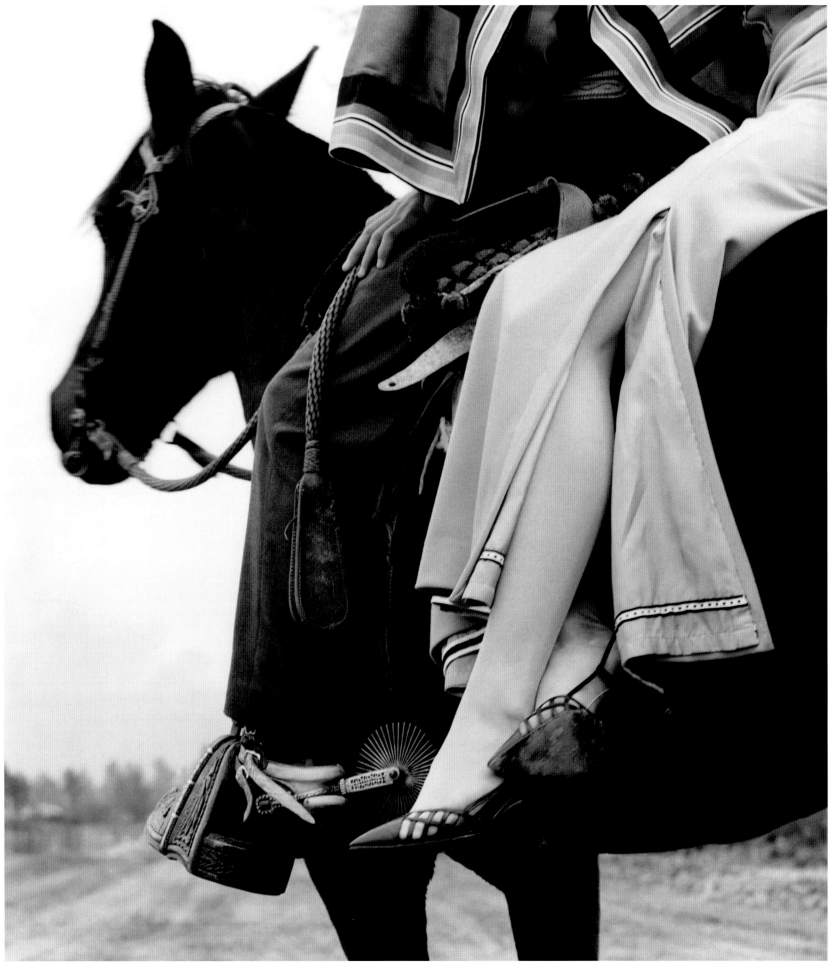

"Side-saddle", Buenos Aires 1970, in: *Falke Fashion* 1970/71

the models' suitcases. The rest is sent by air freight to Buenos Aires. At the destination, the references the group had with them were scrutinized to see which persons locally might be of use. Only someone local, in this case a student of philosophy who had spent a few terms studying in Germany, will be able to judge, whether it is appropriate to give a tip when receiving authorization for a photograph, or whether this will be considered insulting, and when it is best to be polite or simply ignore people's protestations. And the man needs to understand how a photo shoot works, and of course know the location well. That same day the team starts scouting possible locations. On the basis of his list of themes, Gundlach visits the yacht marina, the airport, the amphitheatre, the university, the race track, the minigolf course, a hotel entrance, a park with benches, a lake with a rowing boat, a shopping high street, the right spot for a BBQ, where best to go for a walk with a hat, the right beach to stand an easel, a cycle trip to a hacienda, and much more besides. On location he photographed each potential scene using a Polaroid and glued the shots in his work-schedule. Where appropriate he added the time of day required, depending on the elevation of the sun, or where photography was not permitted (for example, at the airport). In the mean time, team members were busy procuring the missing props, such as flowers, bicycles, and Torero hats. Then a firm schedule was compiled, including the day of the shoot, the clothes model, the colour combinations, the accessories, the photo-models, the theme (setting), props and extras (e.g., Lufthansa bag, flight plan and flowers at the airport, or man in sailing gear at the yacht marina).

On the third and following days: The actual shoot begins. Gundlach does not use a light meter and instead takes black-and-white Polaroids for each theme, writing a number on each that is then the number for the theme itself. The exposure is then corrected by consulting the test picture. The original of each shot is dispatched to the studio in Hamburg. The photographer kept a photocopy with his other documents and materials. And to be sure of things he took so-called 'tests': Using a separate colour film with the same emulsion as that used for the original shots, he takes 4-5 shots of each theme. The test films and the originals are sent by air freight and with an accompanying telex to Hamburg for development. Hamburg answered by telex how the film material looked after first developing the test film and then after the main exposures: In other words, for which theme numbers there was no material at all, which images were okay and where there were enough photos. Gundlach was then able to reshoot the themes still required immediately on location and make adjustments to the camera settings as needed.

The fact that despite this procedure and the organization there was still enough time for everything, and space for creativity, is not just a fact but was the clear intention behind the military precision of the preparations. Precisely thanks to it, the photographer was able to work better, because he was already aware of the imponderables, such as wrong exposure times and developments and was able to correct things while still on the road."[33]

BIOGRAPHY

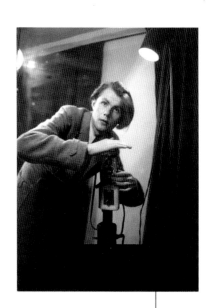

July 16, 1926	Born in Heinebach in Hesse, Germany
	His parents Heinrich Gundlach (1894–1954) and Katharina Gundlach, née Nöding (1896–1968)
	manage the inn "Zum Löwen" in Heinebach
1936	First camera, an Agfa-Box with an automatic release
1938	Sets up his own darkroom
1936–1943	Jacob Grimm Gymnasium (high school), Rotenburg/Fulda
1943	War-time school diploma, deployment in a flak unit
1945	In January, posted to the frontline near Wroclaw
	End of January, wounded and relocated in hospital train to the West
	As of April, POW in an American camp
	End of April, relocated to encampment in Rennes, France, Cage 12
	End of August, hunger-induced typhoid and tuberculosis in a camp in the Auvergne near Oradour
1946	Transferred to the POW hospital in Göppingen, later to Melsungen

F.C. Gundlach, Hamburg 2002 (Photo: Esther Haase)

Foto: Gundlach/Columbia Film

Sophia Loren

Ufa/Film-Foto Reproduktion verboten.

1947–1949	Studied photography at the "Private Lehranstalt für Moderne Lichtbildkunst" (Private Academy for Modern Photography) under Rolf W. Nehrdich in Kassel
1948	While college was closed due to coal shortage, he opens a photo studio in Heinebach with fellow student Constanze Kupferberg. Closure three weeks later due to a court injunction filed for by the Photographers' Guild
1949–1953	Works as assistant in various studios: July 28 to September 15, 1949 operator in the Hollywood Studio (Ernst O. Keller Photo Studio) in Wiesbaden September 16 to December 31, 1950 assistant to Ingeborg Hoppe in Stuttgart Till 1953, freelance assistant to Harry Meerson in Paris
as of 1949	Publishes works in radio and TV magazines such as *Film-Revue, Funk-Illustrierte* and *Gong* Portraits of stars, photojournalism and fashion reports in illustrated magazines such as *Elegante Welt, Film und Frau* and *Stern*
1950	First trip as a photographer to France
1951	October 27 to November 27, exhibition "F.C. Gundlach" at the Librairie Jean Robert, Paris

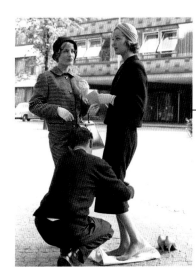

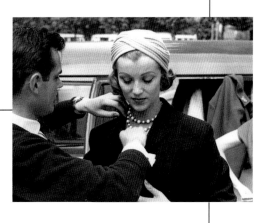

1952	On August 1, registers business in the city of Stuttgart as "photojournalist"
	Founds Studio 50 with Hans Dieter Schmoll and Horst Jerichow
	Publishes works in broadcasting and fashion magazines, also under the pseudonyms
	"Fenner Photo" and "Davidis", advertising shots for Heinzelmann and other clients
1953	Starts working intensively with *Film und Frau*, for which he photographs more than 100 front
	covers by 1966 and more than 2,500 pages in the fashion editorial section
1956	Relocates to Hamburg
1954–1966	In addition to working for *Film und Frau*, assignments for *Constanze*, *Stern*,
	Quick and other magazines

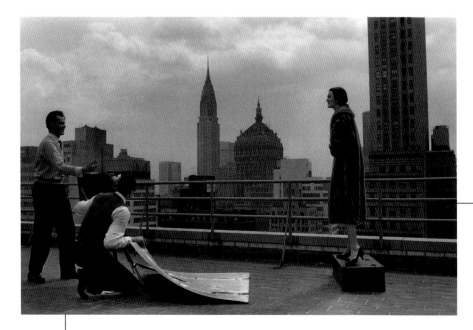

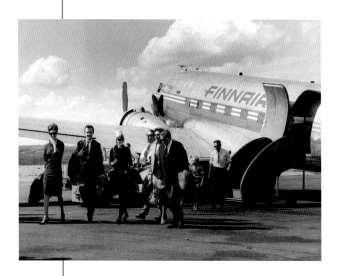

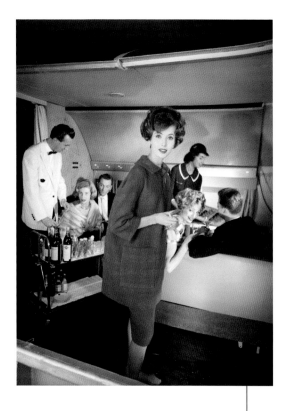

Works on location in Africa and Asia, North, Central and South America

Advertising shots for Jobis, Maris, IWS and for furriers such as Saga, Thompson and Berger

as of 1955 Works for Deutsche Lufthansa, photographs on inauguration flight of Lufthansa's North America route, the first flight to South America with the Super Constellation and many other flights

1963 Starts working intensively with the magazine *Brigitte*, for which he photographs more than 186 front covers and more than 5,500 pages of editorial fashion photography by 1986

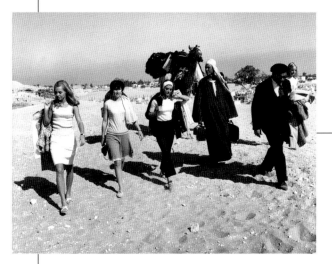

1966 Taken under exclusive contract by *Brigitte*

1966–1986 Works on location in Africa, Asia, North and South America

 In addition to working for *Brigitte* continues to publish works in *Annabelle*, *Revue*
 and other magazines

 Commercial work for Falke Fashion, Van Delden, Sinz and others

1967 Establishes the company CC (Creative Color GmbH)

1971 Founds the company PPS. (Professional Photo Service), a service provider for photographers
 with b/w and colour laboratories, rental studios and a photography book store

1972	Member of DGPh, the German Photographic Association, serves from 1976 to 1996 as a Member of its board
1975	Establishes PPS. Gallery F.C. Gundlach, where by 1992 he presents some 100 thematic exhibitions and solo shows
1976–1987	Board Member of BFF (German association of freelance photographers); as of 1988, honorary member of executive board
1980	Member of the Deutsche Fotografische Akademie (German photographic academy)
1988	Professor at the Hochschule der Künste, Berlin (Berlin university of arts)
as of 1989	Curator of photographic exhibitions
1992	Sells the PPS. group
1997	Awarded the Federal Cross of Merit on Ribbon
1999	Initiates the Triennial of Photography in Hamburg
2000	Establishes the F.C. Gundlach Foundation with the aim of maintaining and expanding the collection "Das Bild des Menschen in der Photographie" (the image of mankind in photography), as well as his own oeuvre, and ensuring their scholarly preservation and development Honorary Professor at the Hochschule für bildende Künste, Hamburg (college of fine arts, Hamburg)
2001	Awarded the Kulturpreis der Deutschen Gesellschaft für Photographie (German photographic association's cultural prize)
2003	Founding Director of the House of Photography (Haus der Photographie), Deichtorhallen Hamburg Assignes the F.C. Gundlach collection "Das Bild des Menschen in der Photographie" on permanent loan to the Free Hanseatic City of Hamburg
2005	Reopening of the House of Photography with the exhibition "Martin Munkacsi – Think while you shoot"
2006	Awarded the Medaille für Kunst und Wissenschaft of the Hamburg Senate (medal for art and science)
as of 2003	Expansion and reorganization of the F.C. Gundlach Foundation
2008	Verleihung der Ehrenbürgerwürde der Gemeinde Alheim/Heinebach
2009	Als erster Fotograf wird F.C. Gundlach mit dem Forum-Preis der Textilwirtschaft ausgezeichnet

EXHIBITIONS

SOLO SHOWS
(selection)

1951 *F.C. Gundlach*, Librairie Jean Robert Paris
1986 *ModeWelten. F.C. Gundlach. Photographien 1950 bis heute*, Rheinisches Landesmuseum, Bonn; 1986 Neue Galerie, Kassel; 1986 Academy of Arts, Berlin; 1987 Museum für Kunst und Gewerbe, Hamburg; 1988 Kunstverein, Frankfurt/Main; 1988 Fotoforum Bremen; 1988 Kunstverein, Erlangen; 1989 Neue Galerie des Joanneums, Graz; 1990 Goethe-Institut Nancy, Paris, Marseille, Rotterdam
1992 *Die Geschichte der Pose*, Mois de l'image, Nancy
1997 *Zeitgeist Becomes Form*, American Fine Art, New York
1999 *Die Pose als Körpersprache*, Fotomuseum Braunschweig; 2000 Kunstverein, Halle/Saale; 2001 Moscow House of Photography; 2001 Staatliche Museen zu Berlin – Kunstbibliothek; 2003 Städtische Galerie, Iserlohn
2001 *F.C. Gundlach – A Passion for Photography*, Galerie Kicken, Berlin
2004 *Sophisticated Lady*, Bread & Butter, Berlin
Bilder machen Mode, Neue Galerie des Joanneums, Graz
Die Pose als Körpersprache II, Kirchensälchen, Heinebach
F.C. Gundlach – Mode und Porträts, in focus Galerie, Cologne
2005 *Die sechziger Jahre*, Zephyr – Raum für Fotografie, Mannheim
Wählergunst – Wählerkunst. Die kleine Rache des Souveräns, Goethe-Institut, Hamburg
2006 *Color*, Galerie Kicken, Berlin
Fashion Photography, Galerie 206, Berlin
F.C. Gundlach – Fashion Shots 50s-60s-70s, Cook Fine Art, New York
2007 *Film und Frau. Ein Traum in Braun und Gold*, Ganske Verlagsgruppe, Hamburg
Die Pose als Körpersprache III, Stadtmuseum, Münster
2008 *F.C. Gundlach. Das fotografische Werk*, Haus der Photographie, Deichtorhallen, Hamburg
2009 *F.C. Gundlach. Das fotografische Werk*, Martin-Gropius-Bau, Berlin
2010 *F.C. Gundlach @ kicken II*, Galerie Kicken, Berlin

GROUP EXHIBITIONS
(selection)

1975 *Fotografie 1929–1975*, Württembergischer Kunstverein, Stuttgart
1979 *Deutsche Photographie nach '45*, Kunstverein, Kassel
1982 *Lichtbildnisse – das Portrait in der Photographie*, Rheinisches Landesmuseum, Bonn
1983 *Vom New Look zum Petticoat. Modefotografie der 50er Jahre*, PPS. Galerie, Hamburg
1985 *Aufbaujahre – 3 Photographen: Fritz Eschen, F.C. Gundlach, Otto Borutta*, Berlinische Galerie, Berlin
1985 *Das Selbstportrait im Zeitalter der Photographie*, Musée Cantonal Lausanne
1985 *50 Jahre moderne Farbphotographie 1936– 1986*, Photokina, Cologne
1990 *Modefotografie von 1900 bis heute*, Kunstforum Länderbank, Vienna
1991 *Schulze-Varell, Architekt der Mode*, Stadtmuseum, Munich
1993 *Berlin en Vogue. Berliner Mode in der Photographie*, Berlinische Galerie; 1993 Museum für Kunst und Gewerbe, Hamburg; 1993 Fotomuseum im Stadtmuseum, Munich
1995 *Bildermode – Modebilder. Deutsche Modephotographie 1945–1995*, Kunstbibliothek Berlin; 1995 Kunsthalle, Bremen; 1996 Corgin Gallery, Washington; 1996 Boston Art Institute; 1997 Pat Hearn/Morris Healy Gallery, New York; Milan, Rome, Genua, Tokyo, Peking, Seoul, Singapore, Novosibirsk, Omsk, Petersburg and other venues
1996 *Twen – Revision einer Legende*, Stadtmuseum, Munich; 1996 Kunsthaus, Hamburg; 2002 Biblioteca Nacional de España, Madrid and other venues
1997 *Someone else with my fingerprints*, David Zwirner Gallery, New York and other venues
1997 *Deutsche Fotografie. Macht eines Mediums 1870–1970*, Kunst- und Ausstellungshalle der Bundesrepublik Deutschland, Bonn
1999 *Wohin kein Auge reicht*, Deichtorhallen, Hamburg
2000 *Mode – Körper – Mode*, Museum für Kunst und Gewerbe, Hamburg
2001 *Botschafterinnen der Mode*, Kunstbibliothek, Berlin
2003 *Von Körpern und anderen Dingen*, City Gallery, Prague; 2004 Museum Bochum; **2004** Deutsches Historisches Museum, Berlin; 2004 Moscow House of Photography
2004 *Parameter of Life*, Stiftung Wörlen, Passau
2005 *Entrez lentement*, Politecnico di Milano, Milan
2005 *Die fünfziger Jahre – Alltagskultur und Design*, Museum für Kunst und Gewerbe, Hamburg
2005 *Braut Moden Schau*, Altonaer Museum, Hamburg
2006 *Hildegard Knef. Eine Künstlerin aus Deutschland*, Deutsche Kinemathek – Filmmuseum, Berlin
2007 *Christian Dior und Deutschland, 1947 bis 1957*, Staatliche Museen zu Berlin – Kunstbibliothek
Uli Richter. Eine Berliner Modegeschichte, Staatliche Museen zu Berlin – Kunstgewerbemuseum
Karin Stilke: Ich bin ein Sonntagskind. Erinnerungen eines Fotomodells, Museum für Kunst und Gewerbe, Hamburg

CURATOR OF EXHIBITIONS
(selection)

1988 *Sammlung Gundlach: Kölner Künstler fotografieren*, Kunstverein Cologne
1989 *Das Medium der Photographie ist berechtigt, Denkanstöße zu geben*, Kunstverein Hamburg and other venues
1990 *Photography has the right to make you think*, Fotofest Houston
1992 *Fotografie nach allen Regeln der Kunst – Die Sammlung F.C. Gundlach*, Fotoforum Bremen
1993 *Berlin en Vogue. Berliner Mode in der Photographie*, Berlinische Galerie; 1993 Museum für Kunst und Gewerbe, Hamburg; 1993 Fotomuseum im Stadtmuseum, Munich
1995 *Bildermode, Modebilder*, Institut für Auslandsbeziehungen, Stuttgart
1996 *Das deutsche Auge. 33 Photographen und ihre Reportagen* (as Chairman of Arbeitskreis Photographie; Deichtorhallen, Hamburg)
1998 *Emotions & Relations: Nan Goldin, David Armstrong, Mark Morrisroe, Jack Pierson, Philip-Lorca diCorcia*, Kunsthalle, Hamburg
1999 *Wohin kein Auge reicht*, Deichtorhallen, Hamburg
2000 *Mode – Körper – Mode, 100 Jahre Modephotographie*, Museum für Kunst und Gewerbe, Hamburg
2003 *Operation Gomorrha. Der Hamburger Feuersturm 1942* (in collaboration with the Landesbildarchiv, the Denkmalschutzamt Hamburg and Prof. Ingo von Münch), Deichtorhallen, Hamburg
2005 *Martin Munkacsi – Think while you shoot*, Haus der Photographie, Deichtorhallen, Hamburg, 2006 Martin-Gropius-Bau, Berlin, 2007 International Center of Photography, New York, 2006 Museum of Modern Art, San Francisco
2006 *The Heartbeat of Fashion. Sammlung F.C. Gundlach*, Haus der Photographie, Deichtorhallen, Hamburg
2007 *Mode:Bilder. Sammlung F.C. Gundlach*, NRW-Forum, Düsseldorf
2010 *Andreas Mühe - Werkschau 2*, Galerie Camera Work, Berlin

BIBLIOGRAPHY

MONOGRAPHS

Honnef, Klaus (ed.): *ModeWelten. F.C. Gundlach. Photographien 1950 bis heute.* Berlin 1986.

Gundlach, F.C.: *F.C. Gundlach – Fashion Photography 1950–1975.* Cologne 1989.

Gundlach, F.C.: *F.C. Gundlach – Die Pose als Körpersprache.* Cologne 2001.

Landesmuseum Joanneum, Bild- und Tonarchiv (ed.): *Bilder machen Mode – F.C. Gundlach.* Graz 2004.

Honnef, Klaus, Hans-Michael Koetzle, Sebastian Lux and Ulrich Rüter (ed): *F.C. Gundlach. Das fotografische Werk*, Göttingen 2008.

PUBLICATIONS AS (CO-)EDITOR OR COORDINATOR

Steinorth, Karl and Gundlach, F.C. (eds.): *Foto-Design als Auftrag.* Stuttgart 1982.

Gundlach, F.C. (ed.): *Vom New Look zum Petticoat. Deutsche Modephotographie der fünfziger Jahre.* Berlin 1984.

Arbeitskreis Sommer der Photographie, Denis Brudna, F.C. Gundlach, Enno Kaufhold, Hans Meyer-Veden (eds.): *Photographie in Hamburg. 150 Jahre 1839–1989.* Hamburg 1989.

Kunstverein Hamburg and Gundlach, F.C. (eds.): *Das Medium der Fotografie ist berechtigt, Denkanstöße zu geben. Sammlung F.C. Gundlach.* Hamburg 1989.

Gundlach, F.C. (ed.): *Zwischenzeiten. Bilder ostdeutscher Photographen 1987–1991,* (Düsseldorf, 1992).

Gundlach, F.C. and Richter, Uli (eds.): *Berlin en vogue. Berliner Mode in der Photographie.* Tübingen and Berlin 1993.

Gundlach, F.C. (concept and compilation): *Bildermode-Modebilder. Deutsche Modephotographien 1945–1995.* Stuttgart 1995.

Arbeitskreis Photographie Hamburg e.V. (ed.): *Das deutsche Auge. 33 Photographen und ihre Reportagen. 33 Blicke auf unser Jahrhundert.* Munich 1996.

Hamburger Kunsthalle (ed.): *Emotions & Relations – Nan Goldin, David Armstrong, Mark Morrisroe, Jack Pierson und Philip-Lorca diCorcia.* Cologne 1998.

Arbeitskreis Photographie Hamburg e.V. in collaboration with Zdenek Felix, overall coordination F.C. Gundlach: *Wohin kein Auge reicht. Von der Entdeckung des Unsichtbaren.* Hamburg 1999.

Gundlach, F.C. and Philipp. Claudia Gabriele (eds.): *Mode-Körper-Mode. Photographien eines Jahrhunderts. In: Dokumente der Photographie 5.* Hamburg 2000.

Gundlach, F.C. (ed.): *Martin Munkacsi.* Göttingen 2005.

CATALOGUES AND PUBLICATIONS ABOUT THE F. C. GUNDLACH COLLECTION

Kunstverein Hamburg and Gundlach, F.C. (eds.): *"Das Medium der Fotografie ist berechtigt, Denkanstöße zu geben." Sammlung F.C. Gundlach.* Hamburg 1989.

Felix, Zdenek (ed.): *A Clear Vision – Photographische Werke aus der Sammlung F.C. Gundlach.* Ostfildern 2003.

Haus der Photographie, Deichtorhallen Hamburg (ed.): *The Heartbeat of Fashion – Sammlung F.C. Gundlach.* Bielefeld/Leipzig 2006.

Haus der Photographie, Deichtorhallen Hamburg (ed.): *American Beauties.* Hamburg 2007.

Haus der Photographie, Deichtorhallen Hamburg (ed.): *Maloney, Meyerowitz, Shore, Sternfeld. New Color Photography der 1970er Jahre,* Hamburg 2008.

TEXTS BY F. C. GUNDLACH

1976 "Eigenschaften des Foto-Designers" (together with Jochen Harder), in: Bund Freischaffender Foto-Designer e.V. (ed.): *BFF-Mitgliederliste 1976,* Stuttgart 1976, pp. 305–306.

1978 "Zum Thema des Tages. Foto-Design zwischen Kunst und Kommerz," in: *BFF-Publikation Nr. 5,* Stuttgart 1978, pp. 1–2.

1982 "Foto-Design als Auftrag," in: Steinorth, Karl and Gundlach, F.C. (eds.): *Foto-Design als Auftrag.* Stuttgart 1982, p. 7.

An introduction, in: *BFF-Publikation Nr. 8,* Stuttgart 1982, pp. 1–2.

1984 Preface, in: Gundlach, F.C. (ed.): *Vom New Look zum Petticoat. Deutsche Modephotographie der fünfziger Jahre.* Berlin 1984, p. 7.

"Vom New Look zum Petticoat" (together with Ingeborg Koch), in: Gundlach, F.C. (ed.): *Vom New Look zum Petticoat. Deutsche Modephotographie der fünfziger Jahre.* Berlin 1984, pp. 8-13.

"Alte Hüte. Der Hamburger Fotograf F.C. Gundlach in Wort und Bild über die Mode der 50er Jahre," in: *Photo* (Munich), Nr. 1, January 1984, pp. 28-37.

1985 "F.C. Gundlach," in: *Aufbaujahre. 3 Fotografen – Fritz Eschen, F.C. Gundlach, Otto Borutta.* Berlin 1985, pp. 31–32.

1987 Preface to the BFF year book 1987, in: Bund Freischaffender Fotodesigner (ed.): *BFF-Jahrbuch 1987,* Stuttgart 1987, p. 6.

1988 "Fotografie und Neue Medien," in: *'88. Forum Fotografie,* Baden-Baden 1988, pp. 65–73.

1989 "Das Medium der Fotografie ist berechtigt, Denkanstöße zu geben," in: Kunstverein Hamburg and Gundlach, F.C (eds.): *"Das Medium der Fotografie ist berechtigt, Denkanstöße zu geben." Sammlung F.C. Gundlach.* Hamburg 1989, pp. 8–10.

Introduction, in: Arbeitskreis Photographie (ed.): *Mit Photographie umgehen. Gebrauchsweisen der Photographie.* Hamburg 1989, pp. 14–15.

F.C. Gundlach on the anniversary of photography: "Dieses Medium hat unser Weltbild völlig verändert," in: *Hamburger Morgenpost,* June 22, 1989, p. 40.

1991 "Fotos, die lügen? Fotografie und Neue Medien," in: *PROFIFOTO* (Düsseldorf), Nr. 3, 1991, pp. 46–50.

"Bilder machen Mode. Der Hamburger Starfotograf F.C. Gundlach kommentiert Klassiker aus seiner Sammlung," in: *Szene Hamburg,* Nr. 11, 1991, pp. 26–34.

1992 Preface, in: Gundlach, F.C. (ed.): *Zwischenzeiten. Bilder ostdeutscher Photographen 1987–1991.* Düsseldorf 1992, p. 5.

1993 Introduction, in: Gundlach, F.C. and Richter, Uli (ed.): *Berlin en vogue. Berliner Mode in der Photographie.* Tübingen, Berlin 1993, pp. 10–12.

"Die Berliner Mode in der Fotografie," in: *PROFIFOTO (*Düsseldorf), Nr. 5, 1993, pp. 32–35.

1994 "F.C. Gundlach, in: Margit Tabel-Gerster: *Hamburger Persönlichkeiten.* Hamburg 1994, pp. 186–187 and 255.

1995 "Bildermode-Modebilder. Deutsche Modephotographien 1945–1995," in: Gundlach, F.C. (conception and compilation): *Bildermode-Modebilder. Deutsche Modephotographien 1945–1995.* Stuttgart, 1995, pp. 7–9.

"Fotovisionen eines Fotografen," in: Streubel, Wolfgang (ed.): *Fotovisionen 2000. Neue Bildtechnologien – Neue Perspektiven der Kommunikation zwischen Bildanbieter und Bildnutzer* (Festschrift BPAB). Berlin 1995, p. 71 and 73.

1996 Introduction, in: Arbeitskreis Photographie Hamburg e.V. (ed.): *Das deutsche Auge. 33 Photographen und ihre Reportagen. 33 Blicke auf unser Jahrhundert.* Munich 1996, pp. 7–9.

"Von den 'Filmstars in Mode' bis zur 'Dame in Schwarz'. Heinz Oestergaards Moden für 'Film und Frau'," in: Vogel, Margrit (ed.): *Stoff zum Träumen. Wie Heinz Oestergaard Mode machte.* Berlin 1996, pp. 65–71.

"Leiden und Leidenschaften eines Sammlers," in: Weiermair, Peter (ed.): *Aspekte und Perspektiven der Photographie*. Regensburg 1996, pp. 23–33.

"Doch welche Liebe rechnet sich schon … Zur Psychopathologie des Sammelns," in: *Hamburger Abendblatt*, July 20/21, 1996.

"Foto-Visionen eines Fotografen," in: *brennpunkt. Magazin für Fotografie* (Berlin), Nr. 3, 1996, pp. 14–15.

"Standpunkt: Das 'stille Bild'," in: *Photo Presse* (Hann. Münden), Nr. 32, 1996, p. 3.

"Leiden und Leidenschaften eines Sammlers," in: *PROFIFOTO* (Düsseldorf), Nr. 4, 1996, pp. 26–29.

"Leiden und Leidenschaften eines Sammlers," in: *Photo Presse* (Hann. Münden), Nr. 39, 1996, pp. 18–20.

1997 "Grünes Licht für ein Festival der Fotografie. Hamburgs Bedeutung als Foto-Metropole wird in der Hansestadt selbst immer noch nicht genügend gewürdigt," in: *Die Welt* (Hamburg), September 30, 1997, p. 35.

1998 "Emotions & Relations," in: Hamburger Kunsthalle (ed.): *Emotions & Relations – Nan Goldin, David Armstrong, Mark Morrisroe, Jack Pierson und Philip-Lorca diCorcia*. Cologne1998, pp. 11–14.

"Die Furchen der Leidenschaft. In Irving Penns Meisterwerk liest F.C. Gundlach die Geschichte eines Künstlerlebens," in: *ZEIT magazin* (Hamburg), Nr. 31, July 23, 1998, p. 10.

1999 "Wohin kein Auge reicht …," in: Arbeitskreis Photographie Hamburg e.V. in collaborationo with Zdenek Felix, overall coordination F.C. Gundlach: *Wohin kein Auge reicht. Von der Entdeckung des Unsichtbaren*. Hamburg 1999.

"Photo-Künstler: Die Maler mit der Linse," in: *Bild Zeitung* (Hamburg), May 18, 1999, p. 10.

2000 "Mode – Körper – Mode," in: Gundlach, F.C. and Philipp, Claudia Gabriele (eds.): *Mode-Körper-Mode. Photographien eines Jahrhunderts*, Dokumente der Photographie 5. Hamburg 2000, pp. 9–14.

"Alter Meister in neuem Licht. Späte Ehre für einen Pionier: Eine Ausstellung und ein neues Buch feiern den Fotografen Herbert List," in: *Die Woche* (Hamburg), Feb. 4, 2000, p. 42.

2001 Preface, in: Gundlach, F.C.: *F.C. Gundlach – Die Pose als Körpersprache*. Cologne 2001, p. 5.

2002 Preface, in: Herzau, Andreas: *Me, Myself + I*. Hamburg/Heidelberg 2002, pp. 4–6.

"Dem Auge die Uniform ausziehen," in: *art. Das Kunstmagazin* (Hamburg), Nr. 2, 2002, pp. 42–45.

2003 "Mein Freund Carlo," in: Wangenheim, Wolfgang von (ed.): *Homo Sum. Konrad Helbig*, (Heidelberg, 2003), pp. 8–9.

"Guten Appetit, Gruß und Kuss!" in: Peters, Babette (ed.): *Können Designer kochen? Geschichten und Rezepte aus kreativen Küchen*. Hamburg 2003, p. 62.

"Manipulation der Bilder. Rezension von Susan Sontags 'Das Leiden anderer betrachten'" in: *Die Welt* (Berlin), Dec. 7, 2003.

2004 Preface*:* "Eine neue Art von Kunsthalle (together with Robert Fleck and Helmut Sander)," in: Deichtorhallen Hamburg (ed.): *Wer bietet mehr. Fünfzehn Jahre Deichtorhallen*. Hamburg 2004, pp. 9–12.

"50 Jahre PTI, Birthday Greetings," in: *Photo Technik International* (Hamburg), Nr. 4, 2004, p. 55.

2005 "Meine Hoch-Zeiten. Persönliche Erinnerungen an die Brautmoden-Photographie," in: Hedinger, Bärbel and Julia Berger (eds.): *Braut Moden Schau. Hochzeitskleider und Accessoires 1755–2005*. Munich 2005, pp. 74–83.

"Ein Spurenleser der Schöpfung im 20. Jahrhundert. Zum Tode von Peter Keetman," in: *Bulletin der Deutschen Fotografischen Akademie* (Cologne), Nr. 21, April, 2005, p. 52.

"Meine Traumstadt," in: *DIE ZEIT Geschichte* (Hamburg), Nr. 3, 2005, p. 33.

"Traumhaft ist machbar," in: Najjar, Michael: *Japanese Style*. Berlin 2005, pp. 6–7.

"Träume nach der Dunkelheit," in: *DEUTSCH Magazine* (Berlin), Nr. 12, pp. 33–37.

"Als aus jungen Damen Teenager wurden," in: *DEUTSCH Magazine* (Berlin), Nr. 13, pp. 21–25.

"Strictly Black & White," in: *DEUTSCH Magazine* (Berlin), Nr. 14, pp. 19–23.

"Als Pyramiden noch am Meer standen," in: *DEUTSCH Magazine* (Berlin), Nr. 15, pp. 25–31.

"Ein sensibler Einzelgänger. Wilfried Bauer: F.C. Gundlachs Würdigung nach dem dramatischen Tod," in: *Hamburger Abendblatt*, Dec. 17, 2005.

2006 "The Heartbeat of Fashion. Zur Einleitung," in: Haus der Photographie, Deichtorhallen Hamburg (ed.): *The Heartbeat of Fashion. Sammlung F.C. Gundlach*. Bielefeld 2006, pp. 8–11.

Greeting, in: Rüter, Ulrich (ed.): *Think while you shoot – Martin Munkacsi und der moderne Bildjournalismus. Beiträge des Symposiums im Haus der Photographie* (22 and 23 April 2005). Hamburg 2006, p. 7.

"Das kleine Schwarze," in: *DEUTSCH Magazine* (Berlin), Nr. 26, pp. 23–27.

"Pop Art goes Fashion," in: *DEUTSCH Magazine* (Berlin), Nr. 17, pp. 25–29.

"Es wird wieder geheiratet," in: *DEUTSCH Magazine* (Berlin), Nr. 18, pp. 30–35.

"Die Pausen-Models," in: *DEUTSCH Magazine* (Berlin), Nr. 19, pp. 25–29.

"Revue der Stars," in: *DEUTSCH Magazine* (Berlin), Nr. 20, pp. 25–29.

"Shooting 2005," in: *DEUTSCH Magazine* (Berlin), Nr. 21, pp. 25–29.

2007 "Peter Keetman, BMW-Kotflügel, 1956," in: Kicken, Annette and Förster, Rudolf and Simone (eds.): *Points of View. Masterpieces of Photography and Their Stories*. Göttingen 2007, p. 287.

2008 „Mein Leben in Bildern", in: *Zeit Magazin Leben* (Berlin), Nr. 15, April 3, 2008, S. 24–29.

„Romy Schneider", in: Freddy Langer: *Frauen die wir liebten. Filmdiven und ihre heimlichen Verehrer*, Munich 2008, S. 14–15.

„Berlin Chic", in: Romy Übel and Kay Alexander Plonka (Ed.): *14 oz., Fourteen Ounce Berlin*, Berlin 2008, S. 30–39.

„Views of an unknown country", in: André Lützen: *Before Elvis there was nothing*, Heidelberg 2008, S. 7.

2009 „40 Jahre BFF. Vergangenheit, Gegenwart und Zukunft einer Institution / 40 Years of BFF. Past, Present and Future of an Institution", in: Norbert Waning, Bund Freischaffender Foto-Designer e.V. (Hg.): *BFF-Jahrbuch 2009*, Ostfildern-Kemnat 2009, S. 7–15.

„Esther Haase. Tango", in: Jörg T. Böckeler, InterContinental Düsseldorf (ed.): *Vertical Gallery I: Esther Haase Photographien*, Düsseldorf 2009, (German / English; no page numbers)

2010 „Andreas Mühe. Werkschau 2", in: *1997–2010. Andreas Mühe*, Köln 2010, S. XLII.

297

REGISTER

Names and publications are registered, though not F.C. Gundlach as well as Film und Frau and Brigitte. Italicized numbers refer to images.

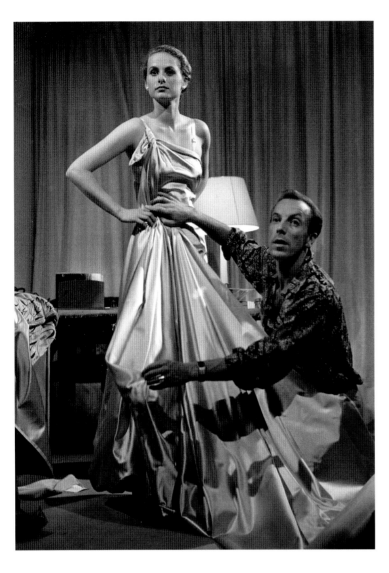

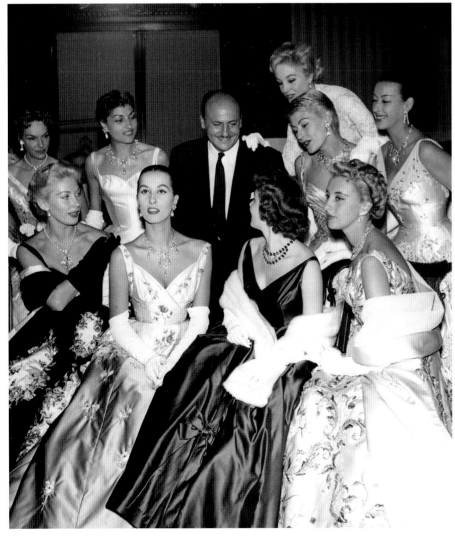

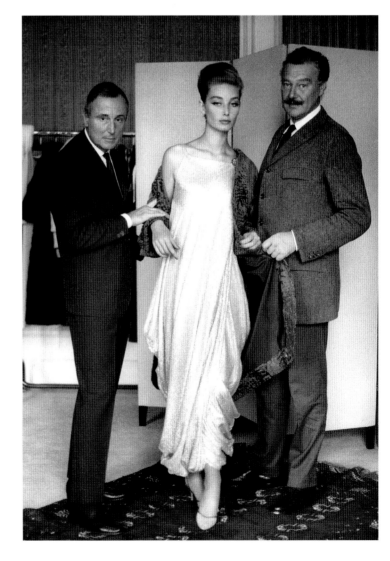

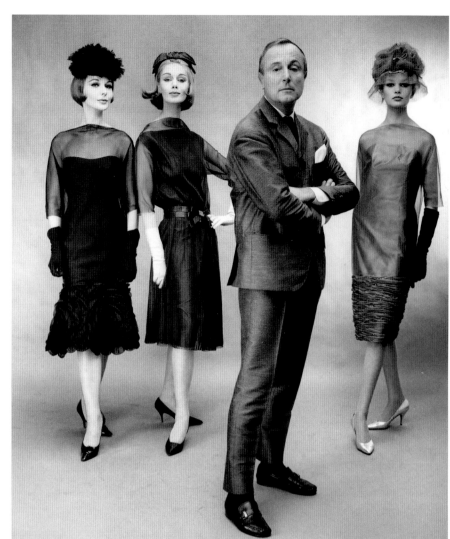

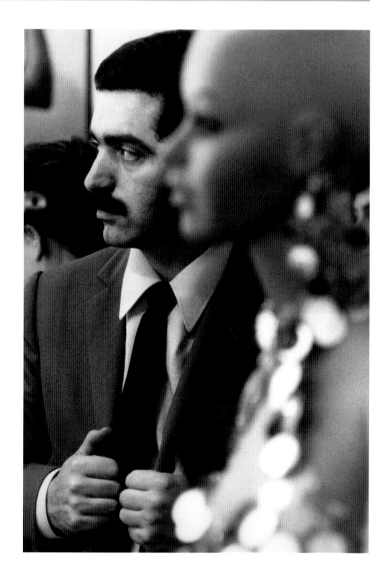

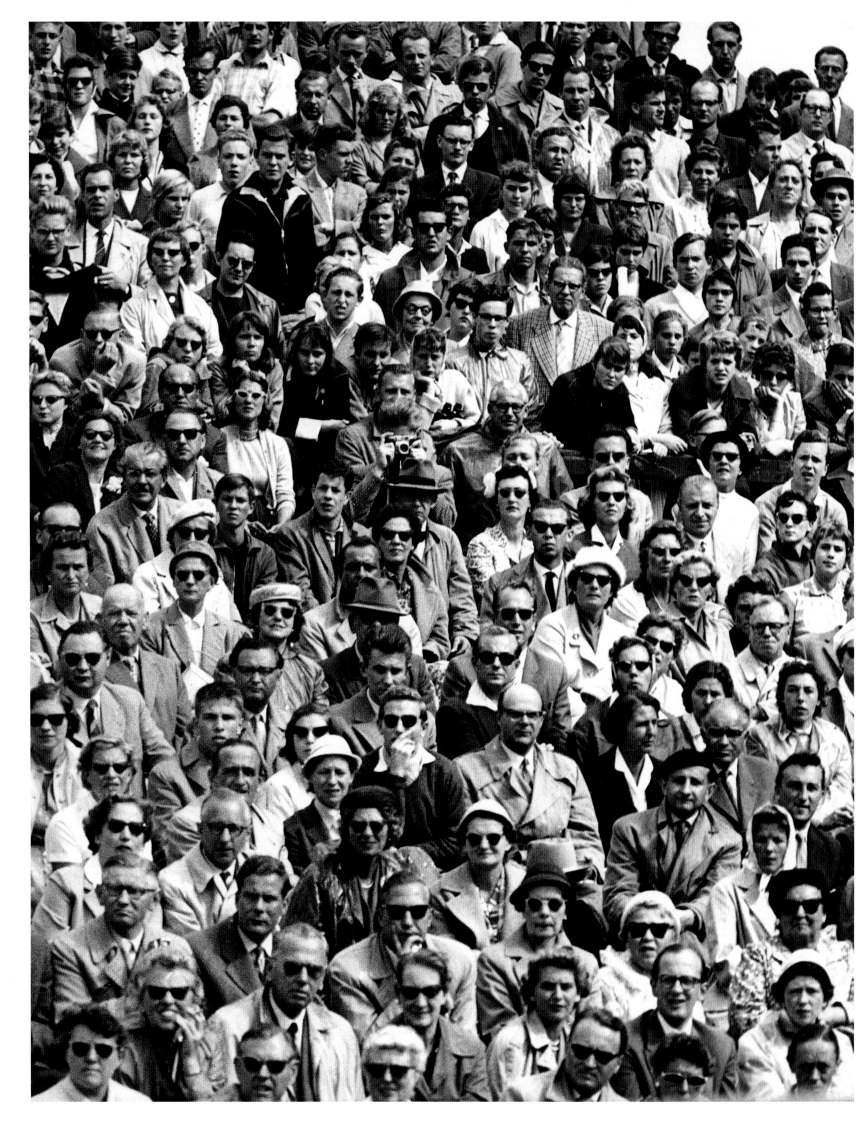

AUTHORS

KLAUS HONNEF, born in 1939 in Tilsit. Journalist and exhibition organizer. Co-organized documenta 5, documenta 6 and from 1974–99 was director of exhibitions at Rheinisches Landesmuseum Bonn. In 1980, Professor for Photographic Theory at Kunsthochschule Kassel. Numerous exhibitions and catalogues, most recently *Heinz Hajek-Halke. Form aus Schatten und Licht* (2005), *Martin Munkacsi* (2005) and together with Gabriele Honnef-Harling *Von Körpern und anderen Dingen* (2003).

HANS-MICHAEL KOETZLE, born in 1953 in Ulm. Journalist and exhibition organizer. 1996–2007 editor in chief of the international award-winning magazine *Leica World*. Countless exhibitions and catalogues, most recently *René Burri Fotografien* (2004), *Lexikon der Fotografen* (2002), *Fleckhaus* (1997) and *twen – Revision einer Legende* (1996).

SEBASTIAN LUX, born in 1971 in Göttingen. Since 2003 staff member of Stiftung F.C. Gundlach, where he has worked on exhibitions and catalogues, most recently *Bilder machen Mode* (2004), *Martin Munkacsi* (2005) and *FashionRoom* (2009).

ULRICH RÜTER, born in 1965 in Hamburg. Since 2002 staff member of Stiftung F.C. Gundlach, where he has worked on exhibitions and catalogues, most recently *Martin Munkacsi* (2005), *Die Pose als Körpersprache* (2007) and *FashionRoom* (2009).

Tennis tournament at the Rothenbaum, Hamburg 1957, in: *Film und Frau* 20/1957